Traveling the Rainbow

Traveling the Rainbow

The Life and Art of Joseph E. Yoakum

Derrel B. DePasse

Museum of American Folk Art / New York
University Press of Mississippi / Jackson

www.upress.state.ms.us

Copyright © 2001 by Derrel B. DePasse

All rights reserved

Manufactured in Canada

05 04 03 02 01 4 3 2 1

Library of Congress Cataloging-in-Publication Data

DePasse, Derrel B., 1948–2000
 Traveling the rainbow : the life and art of
 Joseph E. Yoakum / Derrel B. DePasse.
 p. cm.
 Includes bibliographical references and index.
 ISBN 1-57806-311-6 (cloth : alk. paper)–ISBN
 1-57806-248-9 (pbk. : alk. paper)
 1. Yoakum, Joseph, 1886–1972. 2. Artists–
 United States–Biography. 3. Outsider art–
 United States. I. Title.

N6537.Y6 D47 2001
759.13–dc21
 00-032057

British Library Cataloging-in-Publication Data available

For my parents, Al and Jo, who first showed me the path of beauty.

I can not find enough rainbow ways to travel upon—I am Navajo: a person traveling the rainbow.
 —Jim McGrath

Contents

Foreword VII

Preface IX

Acknowledgments XI

CHAPTER **1.** The Artist and the Journey 3

CHAPTER **2.** The Artist and the Circus 27

CHAPTER **3.** The Artist and the Railroad 45

CHAPTER **4.** The Artist and Native American Culture 65

CHAPTER **5.** The Artist and African American Culture 87

CHAPTER **6.** Materials, Methods, and Motifs 97

CHAPTER **7.** The Artist in Context 109

Notes 117

Chronology 129

Permanent Collections 133

Exhibition History 135

Bibliography 141

Photo Credits 155

Index 157

Foreword

This is a drawing like the ones in the art museum.
Keep it for the rest of your life to remember me by.
—Joseph Yoakum

Derrel DePasse never met Joseph Elmer Yoakum. The artist died in 1972, well before her life-changing encounter with his work. Once introduced to his power-laden drawings, however, she became so captivated by his magic that she spent her last decade in his thrall. Her relationship with the artist was intimate, intense, and insistent. Moments stolen here and there, time borrowed from the demands of her career, were given over to a search for clues that would help unlock the secrets of his life's journey and creative gifts. The result is this significant and endlessly fascinating book.

Yoakum was a traveler and a teller of tales. The stories that he told of near and distant places may have bespoken a great wanderlust, a passion to embrace and comprehend the natural world, but they were so unlikely as to appear fanciful. Even those who recognized the genius of this courtly, reticent but quietly humorous man during his lifetime discounted many of his accounts of global peregrinations as fables. Derrel DePasse proves otherwise.

One of the important contributions of *Traveling the Rainbow* is her demonstration that Yoakum's artwork is a mirror of an integrated life, fully and unapologetically lived. Her reading of his drawings is like the breaking of an intricate code; it is nothing less than a tour de force.

It is not difficult to understand why the author of this volume should have been drawn so irretrievably into Yoakum's world. His work is utterly compelling. On the wall opposite my desk are two small drawings by the artist, one depicting the Black Hills of South Dakota, executed in pen, the other a watercolor of the lake country of northwest Maine. From time to time, as I work, I find myself looking up at these dreamy images. Yoakum's Black Hills are rendered with poetic restraint and economy of line like two massive hemispheres of brain tissue, their undulating ridges and crevices suggesting the cerebral cortex as much as a topographical map. (At other times I think that I see suggestions of the features of two women in this work, about to square off against each other.) The composition of the watercolor is no less stylized, but it is dominated by rich fields of color, the lake at its center deep and cold and primeval. I have studied these drawings hundreds of times, but I never tire of them.

Yoakum was a self-taught artist, a fact that tells us little about his work but much about the way others have received and related to it. Creating outside the structures and systems of the art world, self-taught artists are often celebrated for their autonomy from established or emerging traditions in art history, but they rarely are under-

stood or appreciated in the full contexts of their creativity. Regrettably, the result has been a kind of collective deracination of a whole class of artists based solely on their lack of formal education, and a literature with little substance or depth. Although Yoakum has fared better than others in this regard—in part because his cause was taken up during his lifetime by a talented group of artists who were associated as teachers or students with the School of the Art Institute of Chicago—DePasse has produced the first rounded, fully nuanced portrait of the artist and his work. Approaching her subject without bias, she explores the ideas, intentions, references, antecedents, sources, and techniques that inform his drawings, delving deeply at the same time into family lore and memory, official records and local history to reclaim a life that reads like a remarkable adventure story.

In her pursuit of Yoakum, Derrel DePasse has left few stones unturned. The artist has long been recognized as a visionary, for example, but DePasse traces the sources of his emphasis on the spiritual not only to the Native American heritage in which he took such pride, but perhaps unexpectedly to Mary Baker Eddy's *Science and Health with Key to the Scriptures*, and the Christian Science understanding that matter is but a mask for the reality and unity of spirit. The impact of his early years of itineracy with the circus, service abroad in the armed forces, experiences as a hobo on the railroads, ambivalent family relationships, complicated ethnicity—all this and so much more—gave shape not only to the subjects of his drawings, but to the way he approached them.

DePasse successfully captures the essential polarities of the artist's work in her astute interpretation of his drawings. On the one hand, they are grounded in place, "crackling monuments of rooted power," in the words of Randall Morris;[1] on the other, they are universal in nature, connected by a singular expressive voice, a visual lexicon of themes and variations wholly of Yoakum's invention. Placid and elegant, they seem to rumble with fiery undertones, like a distant earthquake. Deceptively simple and stylized, they reveal the artist's unerring mastery of spatial relationships, and suggest layers of deeply embedded meaning, keys to the varied expressions of an adventurous life.

DePasse affectingly recounts how Yoakum would travel by bus to see an exhibition of his work at Rockford College Art Gallery late in his career. Once there, he would sit for hours observing his drawings with obvious enjoyment. It is almost possible to imagine Derrel DePasse, like the artist an adventurer and bright spirit herself, sitting quietly beside him. The two never met, but their names will be inextricably linked through these pages. Tragically, Derrel DePasse's life was cut short five months before the publication of this book, before she could enjoy the fruits of her labor. Certainly she knew that she had enriched the literature of art and helped secure permanent recognition for the contributions of a gifted artist. I believe that was consoling to her. In the end, *Traveling the Rainbow* is a monument as much to Derrel DePasse as it is to Joseph Yoakum.

Gerard C. Wertkin

Preface

A decade ago I wandered into the Janet Fleisher Gallery (now the Fleisher/Ollman Gallery) in Philadelphia and, to my surprise, had one of the truly memorable art experiences of my life. On exhibition were the extraordinary visionary landscapes of a self-taught, twentieth-century master, Joseph Elmer Yoakum. Executed in pencil, ink, delicate watercolors, and pastels, his drawings seemed to capture what the artist Arthur Dove called the essential "force lines" of nature. Yoakum's remarkable use of curvilinear line and his rich vocabulary of forms reminded me of certain aspects of Native American art. My desire to know more about the man who produced these works was kindled in that brief moment. Little did I know that it marked the beginning of a fascinating journey of discovery into the life and work of a man who had inspired a group of distinguished academically trained artists much as the naïve painter Henri Rousseau had done in the early part of the twentieth century.

Like the world-traveled and sometimes eccentric American visionary painters of the nineteenth century, Yoakum had an exotic childhood that fed his artistic imagination. Of African American and Native American ancestry, he spent his early days with railroad circuses that took him to places seldom seen by others of his generation. In later life, he retold the fantastic stories of his youth as another visionary artist Elihu Vedder had done—with "just enough detail to convey the impression of their truth." For much of his adulthood, Yoakum lived a free life in the manner of William Blake, an eighteenth-century visionary artist to whose work his has sometimes been compared. Not following society's norms, this genius of visionary landscape remained free to wander the world of reality and that of his dreams.

My research on Joseph Yoakum presented several challenges. When this project began, all but one of the artist's children had died, and official records were scant, in part because of Yoakum's frequently nomadic lifestyle. As curator Maurice Tuchman had found in preparing the 1993 exhibition *Parallel Visions: Modern Art and Outsider Art* (Los Angeles County Museum of Art), I discovered that another difficulty was the lack of attention which has been paid to the work of self-taught artists generally. In large measure, this oversight seems to stem from the fact that for many years the mainstream art community viewed such art as being (in the words of art historian Roger Cardinal) "without precedent or tradition." In fact, sometimes the work of self-taught artists was perceived not only to be outside the conventional traditions of art history but also largely unrelated to the creator's life experiences. For instance, Whitney Halstead, the inspirational teacher who collected and promoted Yoakum's art in the late 1960s and early 1970s, believed that, with a few exceptions, the artist's "varied experiences are not represented in . . . [his] drawings."

My objective in writing this book was to begin to provide the in-depth attention to the work of Joseph Yoakum that it deserves. Yoakum is an important figure in the American visionary art tradition—what art historian Abraham Davidson calls "a small stream meandering slowly beside the two great torrents of nineteenth century painting," the realistic and the ideal. Like the work of his fellow visionary artists, Yoakum's art, contrary to popular belief, was greatly influenced by his early life experiences. For example, the twin passions for geography and traveling that find expression in his work were rooted in his midwestern boyhood and in his experiences with the circus advance department and the railroad during their golden epochs, as well as in his diverse ethnic and cultural heritage. His Native American background, in particular, is evident in his use of North American Indian design elements and his representation of tribal myths and mythological characters.

This book explores these and other heretofore little-known influences on Yoakum's oeuvre and discusses his materials and methods, as well as his stylistic development. It also seeks to satisfy Yoakum's once-stated desire for the art world to "get right" the story of his life by bringing to light for the first time facts that have been obscured by legend. In many ways, my journey of discovery that resulted in this book has paralleled the experience of students of African American art who, according to museum director Kinshasha Holman Conwill, must be like self-taught visionary artists—"able to see the unseeable, think the unthought, imagine the unimagined."

Acknowledgments

This book would not have been possible without the support and encouragement of many remarkable people. First, I am highly indebted to the late Whitney Halstead. While an instructor at the School of the Art Institute of Chicago, Halstead gathered extensive primary and secondary material on Joseph Yoakum, wrote an unpublished manuscript on the artist, and assembled a comprehensive study collection of his work that now is part of the Art Institute of Chicago's permanent collection. Also providing invaluable insights and inspiration were Halstead's former students and colleagues Gladys Nilsson and James Nutt, Ray Yoshida, Philip Hanson, and the late Roger Brown—all of whom assembled fine collections of the artist's work that they generously made available for study during this project. Other friends, acquaintances, and patrons of the artist who contributed useful information include Dennis Adrian, Jane Allen, Thomas Brand, Cynthia Carlson, Evonne Durham, Camilla Eichelberger, Philip Dedrick, Derek Guthrie, John Hopgood, Timothy Mather, Reverend Harvey Pranian, and Roger Vail.

I am also indebted to the members of the artist's family who gave useful and pertinent information. In particular, Yoakum's son Peter Yolkum, daughters-in-law Marian and Ida Mae Yolkum, and cousins Lora and Sara Brewer all responded generously to inquiries about the artist.

Deserving of special thanks is John Ollman of the Fleisher/Ollman Gallery, who first intro-duced me to the artist's work and provided much help and encouragement throughout this project. Other gallery directors who gave assistance were Carl Hammer, Phyllis Kind, Bonnie Grossman, and Adeliza McHugh.

A number of museum professionals have contributed in different ways to this project. In particular I would like to thank Gerard Wertkin and Lee Kogan of the Museum of American Folk Art, New York, and Mark Pascale of the Art Institute of Chicago. Also assisting in the project were Price Amerson of the Richard L. Nelson Gallery and the Fine Arts Collection, University of California at Davis; Paul Apodaca of the Bowers Museum of Cultural Arts, Santa Ana, California; Philip Linhares of the Oakland Museum of Art; Virginia Mecklenburg of the National Museum of American Art, Smithsonian Institution, Washington, D.C.; Marcia Tucker, formerly of the Whitney Museum of American Art, New York; and Barton Wright, formerly of the Museum of Northern Arizona, Tucson.

Many knowledgeable archivists and librarians aided my research. For their extensive assistance in the field of circus history, I particularly wish to thank Frederick Dahlinger and Tim Spindler of the Robert L. Parkinson Library and Research Center, Circus World Museum, Baraboo, Wisconsin. Others who generously gave of their time and resources were Paula Carr, San Luis Obispo Historical Society, San Luis Obispo, California; Louise Cooke of the Oklahoma Historical

Society, Oklahoma City; JoEllen Dickey of the Newberry Library, Chicago; Janice Diller of the Museum of Contemporary Art, Chicago; Ellen Halteman of the California State Railroad Museum, Sacramento; David Keough of the U.S. Army Military History Institute, Carlisle, Pennsylvania; Penny Lusater of the Nevada State Archives, Carson City, Nevada; Judy Melby of the Whitney Museum of American Art Library, New York; Connie Menninger of the Kansas State Historical Society, Topeka; Robert Newman of the Springfield-Greene County Library, Springfield, Missouri; Jennifer Restagno of the Pullman Archives, the Newberry Library, Chicago; Edna Rosenbaum of the John and Mable Ringling Museum of Art Library and Archives, Sarasota, Florida; Brian Shovers of the Montana State Historical Society, Missoula; and Judy Throm of the Archives of American Art, Smithsonian Institution, Washington, D.C.

Other scholars who gave useful insights on Native American art and culture were Dr. Nancy Parezo of the University of Arizona, Tucson, and Dr. Bruce Bernstein of the Laboratory of Anthropology and Archeology, Santa Fe, New Mexico. Dr. Ruth Neidleman of Indiana University, Gary, also contributed helpful information on certain aspects of African American history.

Many individuals provided invaluable assistance in locating photographs for this project. In this regard, I would especially like to thank Bernice Zimmer of the Robert L. Parkinson Library and Research Center; Hsiu-ling Huang, Leigh Gates, and Cari Schweiger of the Art Institute of Chicago; Ann Adams of the Kimball Museum of Art, Fort Worth, Texas; Rebecca Andrews of the Burke Museum of Natural History and Culture, University of Washington, Seattle; Richard Borne of the David and Alfred Smart Museum of the University of Chicago; Annie Browes of the National Museum of American Art; Jacklyn Burns of the J. Paul Getty Museum, Los Angeles, California; Keith Cummings of the British Columbia Archives, Victoria, B.C., Canada; Carol deFord of the Cranbrook Institute of Science, Bloomfield

Hills, Michigan; Donna Dickerson of the Peabody Museum of Archeology and Ethnology, Harvard University, Cambridge, Massachusetts; Linda Fisk of the San Diego Museum of Man, San Diego, California; Pattie Franklin and Anne Morand of the Thomas Gilcrease Museum of American History and Art, Tulsa, Oklahoma; Beth Garfield of the Detroit Institute of Arts, Detroit, Michigan; Ken Hildebrand of the University of British Columbia Library, Vancouver, Canada; Wendy Hurlock of the Archives of American Art; Harmon and Harriet Kelley; Daniel Leen; Karen Lenox of the Karen Lenox Gallery, Chicago, Illinois; Lisa Ann Libby of the Huntington Library, San Marino, California; Rebecca Lintz of the Colorado Historical Society, Denver; Thomas Maxwell; Joseph McGregor of the U.S. Department of the Interior, Geological Survey Photographic Library, Denver, Colorado; Karen Otis of the Museum of Fine Arts, Boston; Susan Ott of the Milwaukee Public Museum, Milwaukee, Wisconsin; Carol Rosset of the Richard L. Nelson Gallery and the Fine Arts Collection, University of California at Davis; Lisa Stone of the Roger Brown Study Collection of the School of the Art Institute of Chicago; Daisy Stroud of the Albright-Knox Art Gallery, Buffalo, New York; Jennifer Webb of the Museum of Anthropology at the University of British Columbia, Vancouver, Canada; John R. Wilson; and Lisa Zarrow of the Phillips Collection, Washington, D.C.

At the University Press of Mississippi, my editor, Craig Gill, provided tremendous support and diligent supervision throughout the process. I would also like to thank editor Anne Stascavage and copy editor Carol Cox. Without their help, and that of the rest of the staff at the press, this book would not have become a reality.

For their general enthusiasm and support in my research and writing, the following people deserve recognition: Morag Fullilove, Kevin Irot, Judge Paul Michel, Mark Stechbart, Curtis Strong, and my cousin Jean White. Finally, I am especially grateful to Jack Harris and to my parents, Al and Jo DePasse. Without their support and love, this project would not have been possible.

Traveling the Rainbow

Fig. 1. Joseph Yoakum in his Chicago home and studio, late 1960s. Collection of the Archives of American Art, Smithsonian Institution. Whitney B. Halstead Papers.

The Artist and the Journey

[T]here's nothing I haven't suffered to see things first hand.
—*Joseph Yoakum*

Joseph Elmer Yoakum (1890–1972) was one of the most original interpreters of landscape in the twentieth century. Although entirely self-taught, Yoakum developed a unique style that has been compared to that of some of the greatest artists who worked outside the mainstream art movements of their day. His work also inspired a surprising number of academically trained painters.

According to his fellow Chicago artist Roger Brown, the discovery of Joseph Yoakum "was like finding [Henri] Rousseau in our own back yard."[1] Just as mainstream Modernists like Paul Gauguin and Pablo Picasso had drawn inspiration from the work of the self-taught French painter Rousseau, a group of young artists who studied at the School of the Art Institute of Chicago in the late 1960s found a kindred spirit in Yoakum.[2]

Whitney Halstead, the teacher at the Art Institute of Chicago school who did the most to promote Yoakum's work during the artist's lifetime, believed that Yoakum's life story was "more invention than reality."[3] As Halstead observed, "I often had the feeling that what I saw and heard were in part myth, Yoakum's life as he would have wished to have lived it—larger and grander than reality."[4]

Given the artist's nomadic lifestyle during a portion of his boyhood and early manhood, it is unlikely that all of Yoakum's stories about his life experiences will ever be corroborated. However, the same could be said of him that was said of his former employer, Buffalo Bill Cody: "He seldom told any tale without some basis of fact."[5] As a child of the circus, the artist intuitively understood what Cody and circus impresarios like John Ringling realized: "The public likes and demands exaggeration." For example, if the circus had fifty elephants but advertised a hundred, it would please rather than offend, Ringling said.[6]

If Yoakum perhaps exaggerated certain details about his past life to captivate his admirers in the mainstream art community, the life he actually lived was truly extraordinary. His formative years spanned the golden epochs of the American railroad and the American circus, and he was an eyewitness to both. He came of age at the dawn of the twentieth century, at a time when tourism was in its infancy and few Americans ventured far beyond the towns they were born in. With almost no formal education and only meager financial resources, Yoakum nevertheless successfully traveled throughout North America and in other parts of the world. This feat was particularly remark-

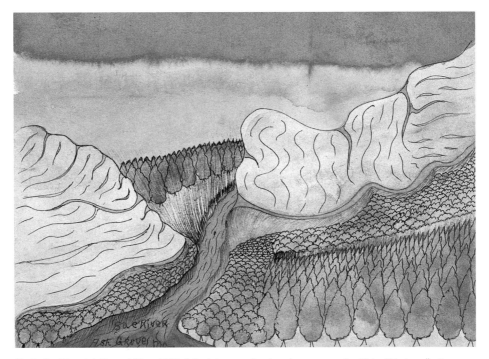

Fig. 2. *Sac River Ash Grove MO*, c. 1964. Ballpoint pen and watercolor on paper. 9 x 12 in. Private collection. Photo courtesy of Fleisher/Ollman Gallery, Philadelphia.

able for a person of color in an era when prejudice created barriers, and even hazards, to movement. As he told his fellow artist, Christina Ramberg, "Girl, there's nothing I haven't suffered to see things first hand."[7]

In his old age, without any formal art training, Yoakum created exquisite landscapes that were "memories he had of traveling in his younger days."[8] His sharp memory is evident when names, dates, and imagery found in his work are compared with people and places that he actually knew in his youth. The quality of his prodigious output—about two thousand drawings—is uniformly high. As his friend and fellow artist Ray Yoshida asserted, "I have never seen a mediocre Yoakum."[9] Jane Allen and Derek Guthrie, the founders and publishers of the *New Art Examiner*, share a similar enthusiasm for the artist's work. In an article written shortly before his death, they declared, "The best Yoakums convey a passion and linear urgency which has not been seen in landscape painting since Van Gogh."[10]

Youth

I surprised my mother and father. I was born knowing how to draw.
—*Joseph Yoakum*

Joseph Yoakum's life began in southwestern Missouri at the end of the nineteenth century. His birth date is listed as February 20, 1890, on his Social Security record, his army records, and on his son Peter's birth certificate. Less reliable sources, the federal censuses of 1900 and 1910, state that the artist was born in Missouri in February 1891.

Yoakum's parents were married in Cave Springs, a town in Greene County, Missouri, on August 4, 1874, and they appear in the federal censuses of Greene County for the years 1880 and 1900 (the 1890 census was destroyed by fire).[11] It is very likely that Joseph Yoakum was also born in this county, although as was typical of that time, his birth was never recorded with the state. Ash Grove, Missouri, is listed as the artist's place of

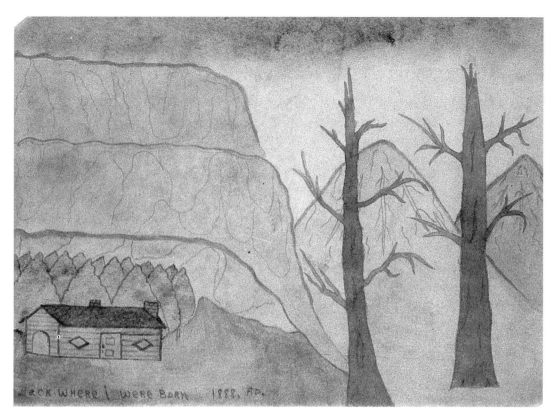

Fig. 3. *Back where i were born 1888, A D.*, c. 1964. Ballpoint pen and watercolor on paper. 9 x 12 in. Private collection. Photo courtesy of Fleisher/Ollman Gallery, Philadelphia.

birth on his death certificate and on his son Peter's birth certificate. The town is located in the southwestern part of the state, in the vicinity of Cave Springs, where he was later married and where his first three children were born (fig. 2).

While probably a native of Greene County, Missouri, Yoakum claimed to have been born in 1888 "near the village of Window Rock, Arizona, in the southwest territory before it were [*sic*] made the Navajo and Apache Indian reservation."[12] No record exists of his birth near Window Rock, the present-day capital of the Navajo nation. Moreover, the artist's drawing of his birthplace, *Back where i were born 1888, A D.*, contains a log cabin and two large, leafless deciduous trees that are strongly reminiscent of early photographs of midwestern farms of that period (fig. 3).

Family members report that Yoakum's Native American ancestry was predominantly Cherokee,

with some Creek, but not Navajo. Of mixed African American and Native American parentage, his father, John Yokum (an earlier spelling of the family name), was born in the Cherokee nation in 1850.[13] These lands were ceded to the Cherokee people following the "Trail of Tears," the federal government's forced relocation of the tribe from their lands in the southeastern United States. Originally, the Yokums had resided in the Cherokee nation of Tennessee. John Yokum's Cherokee heritage was apparent in his light complexion and fine, straight hair.[14]

Frances "Fannie" Wadlow, Joseph Yoakum's mother, was of French-American, Cherokee, and African American descent.[15] She was born a slave in 1857 on a farm in Greene County, Missouri.[16] Like her husband, Frances Wadlow was light complexioned.[17] She produced ten children, seven of whom survived to adulthood—Charles, Della,

Martha, Joseph, Frank, Alpha, and Virgil (nick-named Jack).[18] Her eldest son apparently was named after her owner, Charles Wadlow.

Yoakum's search for his Native American roots was a lifelong preoccupation. As a young man in 1916, after his father's death, he wrote to his Aunt Susan, "I want you to answer this letter at once and tell me how much Indian blood papa John Yokum had in him. Was he three quaiters [sic] Creek Indian or was his mother or father full blood Indian. Please let me know at once if you know how much Indian blood he had in him."[19]

Many years later, after Yoakum had gained recognition as an artist, his aunt Della learned of his public claim about Navajo origin and exclaimed, "He's no such thing! He's full-blooded Cherokee." When asked to explain himself to his family, the artist told a yarn about being traded to the Navajo for a horse by his parents during the Trail of Tears, an event that actually occurred more than fifty years before his birth. According to Yokum family lore, however, the real heroine of this story was one of John Yokum's elder sisters. As the artist's aunt Susan later retold the incident, the little girl remained among the Navajo and was lost to her family forever.[20]

Susan's own Native American heritage was obvious in her straight, coal-black hair, which fell below her waist. She eventually married an Indian with whom she lived in Montana for a time. Their son, Son De Witt Talmadge Rice Yokukhama Yellow Horse, was Joseph Yoakum's first cousin and his close companion during their younger days.[21] In a late sketch, the artist alludes to a trip he made to Montana to see them around 1900.[22]

Yoakum undoubtedly felt a kinship with the Navajo because of his aunt Susan's colorful stories about his father's family. His affinity for this culture may also have been linked to the Navajo people's love of beauty and their reverence for the artist. The Navajo believe that the highest goal and ulti-mate destiny of human beings is to create beauty and to be surrounded by beauty.[23] Essential to the Navajo's health and happiness, beauty is experi-enced in their culture primarily through the cre-ative process.[24] Thus, nearly all Navajos are artists at some time in their lives.

While he may have wanted to be associated with a culture that reveres the artist, Yoakum was also known for his love of telling elaborate jokes. However, according to his friends Jim Nutt and Gladys Nilsson, his audience of mainstream artists did not always understand his humor.[25] Perhaps this was the case when Yoakum identified himself as a Navajo, with the "jo" pronounced so that it rhymed with his nickname, Joe. In a 1969 letter to Nutt, the artist confided, "I am a full Blood Navajo Indian not a Navaho. I hope you won't advertise my work as being done by the Negro Joseph E. Yoakum s-m-i-l-e. Ha Ha."[26] Nevertheless, on other occasions the artist referred to himself as a black man, and his African American heritage similarly finds eloquent expression in his work.

Yoakum's mother also helped instill in him an intense interest in his Native American her-itage. The artist once described her to Whitney Halstead as a "strong woman" and "a doctor [who] knew about herbs in healing."[27] In Native Ameri-can societies (as in the African American one) women, as well as men, could enter the select group of healers or medicine men. Medicine was not used simply to cure disease, but to counsel, protect, and ensure success in the life of the indi-vidual, the family, and the community.

From his father, Yoakum undoubtedly inher-ited his love of freedom, travel, and the railroad. In part, his wanderlust was sparked by his father's tales of his early days on the railroad. While a farmer for much of his life, in his youth John Yokum served as a hunting guide for the president of one of the large railroads and worked briefly in the railroad yards of Kansas City, Missouri.[28] His formative years coincided with an enormous expansion of the railroads in the Midwest. In 1852,

when John Yokum was two years old, the railroad later known as the St. Louis & San Francisco ("Frisco") became the first to span the state of Missouri. By 1870, new roads were completed that connected the tremendous markets of the North and East with the great agricultural regions of eastern Kansas and western Missouri, as well as with the cattle-raising sections of Texas. To fulfill their expansionist dreams, the railroads had to obtain the consent of the Cherokee nation to enter tribal lands. Eventually, the Missouri-Kansas-Texas Railway ("Katy") was the first to earn that right. Both the Frisco and the Katy figure prominently in Joseph Yoakum's art.

John Yokum's decision to start a family likely precipitated his change of careers from railroading to farming. Many laborers employed by the railroads at that time left their jobs and bought farmland when they had saved enough money. After the birth of his first child in 1876, he moved his family to a farm in the town of Walnut Grove in southeastern Missouri.[29] There, as a youth, Joseph Yoakum took his first job driving a delivery wagon for a grocer.[30] One of the few drawings he gave to a member of his extended family is called *Poverty Hollar Walnut Grove Missouri*. In presenting it as a gift to the wife of his cousin Son Rice, Yoakum said, "This is a drawing like ones in the art museum. Keep it for the rest of your life to remember me by."[31]

Life for the Yokum family during the artist's boyhood was not easy. Yoakum had only four months of formal schooling. At the time of his birth, midwestern farmers like his father were suffering a severe economic depression. The boom of the early and mid-1880s, spurred by excessive rainfall and a surplus of capital from the East, had fueled an overdevelopment of farmland. When a decade-long drought hit in 1887, crops failed, mortgage credit dried up, thousands of farmers foreclosed on their land, and railroad construction largely stopped.

The lasting impression of this period on the artist and his family is hinted at in his late sketch *This is our Remembrance of Old Ex President William Jennings Bryan our 1st Democratic president* (plate 1). It is one of only two drawings Yoakum made that deal with a political subject. Bryan, who ran for president and lost three times, championed the cause of the midwestern farmers against the big eastern bankers and industrialists. As a prescription for economic recovery, he advocated an easy money policy based upon the free and unlimited coinage of silver. Bryan's politics may also have appealed to the Yokum family because he spoke out forcefully on issues concerning the African American's role in society. When lynching reached epidemic proportions in the last decade of the nineteenth century, Bryan condemned these "atrocities" as "inexcusable."[32]

In that era one of the few joys of small-town life in the Midwest was the circus. Many young boys looked for part-time jobs with the traveling show in exchange for free tickets. Yoakum left home for the first time when he was around nine years old to join the Great Wallace Circus. He recalled that at the beginning he "didn't do a thing but curry horses and polish saddles between the hours of 9 and 12."[33] Eventually he traveled all over North America with a number of the leading railroad circuses—Adam Forepaugh and Sells Brothers, Buffalo Bill Cody's Wild West Show, Ringling Brothers, and Al G. Barnes.[34] He rose to the position of billposter with the advance department, the part of the circus that is known for its expertise in geography.[35] The artist also stated that he served for a time as a groom to circus impresario John Ringling, but no record has been found to substantiate this claim.

Whatever their position in the traveling show, circus people were, in John Ringling's view, "a clan apart from all others." He could have been speaking of Joseph Yoakum: "[T]hey are broader, more liberal, and freer than the average American. This is

partly due to the rough outdoor life, the hard work, and the absence of temptations to a softer life. Partly this is due to the broadening effect of meeting and seeing hundreds of thousands of people, unconsciously studying life in many localities."[36]

It has not been possible to pinpoint precisely the years in which Yoakum was affiliated with each of the five circuses. A significant body of his work, however, deals with places they traveled, as well as with performers of the center ring, aftershows, and the spellbinding circus spectacles that celebrated events in the Bible, world history, and oriental mythology.[37]

As a member of the advance department, Yoakum would have had time to explore many of the locales he visited with the circus. His drawing *The Cyclone that Struck Susanville California in year of 1903* tends to support the artist's contention that he traveled with the Ringling Brothers Circus in that year (fig. 4). The only cyclone to hit northern California in that decade occurred in August of 1903 in Marysville, another town in northern California that the artist probably confused with Susanville.[38] Ringling Brothers played Marysville several weeks after the destructive storm.

Yoakum reported that he went overseas with Buffalo Bill Cody's Wild West. Cody's show toured Europe from 1903 to 1906. Its various routes included locations that are among the most frequent subjects of Yoakum landscapes, such as British Wales, northern Italy, southern Germany, Austria, the Balkans (especially Montenegro), and Russia. China, however, was never included on Cody's itinerary, although Yoakum spoke of visiting that country with the Wild West Show.

Philip Dedrick, the former chairman of the art department of Rockford College, recalled that Yoakum told stories about working as a horse handler in Cody's show in Great Britain and other parts of Europe.[39] Yoakum seemed particularly impressed with England, where he received a "very kind reception."[40] Europeans had great curiosity

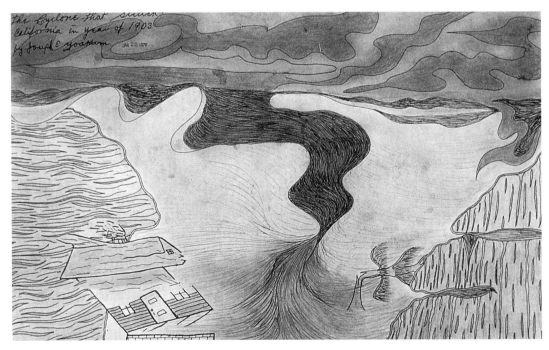

Fig. 4. *The Cyclone that Struck Susanville California in year of 1903*, 1970. Ballpoint pen, fiber-tip pen, and colored pencil on paper. 12 1/8 x 19 1/16 in. Collection of Gladys Nilsson and Jim Nutt.

about the Indians in Cody's Wild West and generally treated Americans of color with greater respect than they were accustomed to at home.

Family Man

All my days
Climbing up a great big mountain
Of yes, sirs!
—*Langston Hughes, "Porter"*
Standin' here lookin' one thousand miles away.
—*Blues song*

Circus life continued for Yoakum until 1908 when he returned to his family home in Ash Grove. There he met his future wife, Myrtle Julian, a native of Fort Scott, Kansas, who was two years his senior and the daughter of a local farmer[41] (fig. 5). They were married in Ash Grove on August 25, 1910.[42] The young groom was remembered as a handsome man with a sharp mind and a quick temper.[43] At the time he was employed as a fireman in a limekiln. His drawings *Ash Grove Lime Stone Querry Ash Grove Mo* and *Ash Grove Lime Stone A.G.W.C. & P.C. Co* recall this experience.

The couple's first child, Louis, was born on February 28, 1909, about a year and a half before their marriage. In July of that year, a raging flood devastated the region, resulting in extensive property damage and heavy loss of life, especially among the African American population. The *Springfield Missouri Republican* reported that houses were swept away, and "many men and women were rescued when they seemed to be past helping. . . ."[44] This tragic event was memorialized in the artist's late sketch *This is the flooding of Sock River through Ash Grove Mo on July 4th 1914 in that drove many persons from Homes I were with the Groupe leiving their homes for safety* (plate 2).

In the first four years of their married life, the Yoakums welcomed a second son, Peter, and a daughter, Margaret. A growing family imposed greater financial pressures on the artist, but, in that era, employment opportunities for African

Fig. 5. Myrtle Julian Yoakum, n.d. Collection of Peter Yolkum.

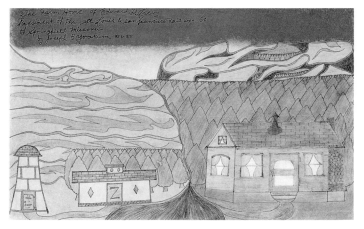

Fig. 6. *The Farm Home of Edward D. Leevy President of the St. Louis & San Francisco Railway Co of Springfield Missouri,* 1970. Ballpoint pen, fiber-tip pen, and colored chalk on paper. 12 x 19 in. Private collection. Photo courtesy of author.

American men were severely limited. In industry they were confined mostly to menial jobs with no upward mobility, such as digging ditches, building roads, stoking furnaces, quarrying rocks, and mining coal. At various times Yoakum pursued most of these occupations, some of which are depicted in his drawings. For a while, he and his wife worked for Edward Levy, the superintendent of the St. Louis & San Francisco Railway.[45] Yoakum accompanied him on road inspections, while Myrtle served as the family housekeeper. Their association is recalled in the drawing *The Farm Home of Edward D. Leevy President of the St. Louis & San Francisco Railway Co of Springfield Missouri* [46] (fig. 6).

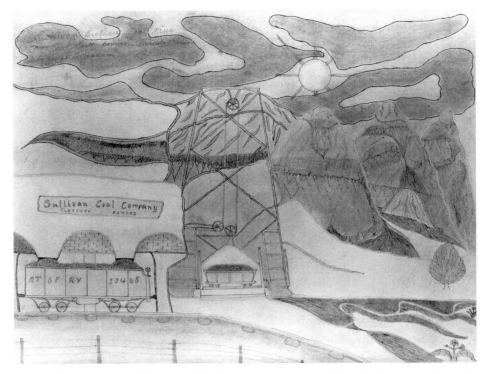

Fig. 7. *Sullivan Brothers Coal Mine near Fort Scott Bourbon County Kansas*, 1966. Ballpoint pen, graphite pencil, pastel, and ink on paper. 17 7/8 x 23 5/8 in. Collection of the National Musuem of American Art, Smithsonian Institution. Gift of Herbert Waide Hemphill, Jr., and museum purchase made possible by Ralph Cross Johnson, 1986. 65.225.

The 1913–14 depression cast the St. Louis & San Francisco Railway into receivership. Soon afterwards, Yoakum followed his eldest brother, Charles, to eastern Kansas and sought employment as a coal miner. At that time, the state was a major mining center, supplying railroads that were the heaviest users of coal. Yoakum later completed a drawing of the James Sullivan Company's mine in Cherokee, where Charles was employed (fig.7). A white man later murdered the artist's brother for allegedly killing his dog.

Yoakum settled with his family in Fort Scott, Kansas—his wife's birthplace—where he found employment with the Hale Coal and Mining Company.[47] His twin boys, John and William, were born there in October 1916. At that time Yoakum spelled his last name "Yokum" as his father had done, although two years later it was misspelled "Yoakum" in his army records.

Soldier

The spirit of St. Nazaire is the spirit of the South.

—African American officer, World War I

Well, captain, my captain, how can it be?

Whistles keep a-blowin', you keep a-workin' me.

Well, if I had my weight in lime,

I'd whip my captain till I went stone blind.

—African American work song

There are no men in this command Skilled in . . .

Freehand drawing. . . .

—Col. C. B. Humphrey, Commanding Officer, 805th Pioneer Infantry

With the entry of the United States into World War I, Yoakum was one of some 2,000 young African Americans from Kansas and 740,000 nationwide who were drafted into the U.S. Army in the summer of 1918. In his *Essay toward a History of the Black Man in the Great War*, W. E. B. Du Bois wrote, "Throughout American history the

black American viewed his military service in the nation's conflicts as proof of his loyalty and as a brief for his claim for his full citizenship. White Americans appear to have realized this, and they have continually sought to restrict or downgrade the black soldier's military service."[48] As an old man, remembering his war service, Yoakum said proudly, "I was with the bunch that drove von Hindenburg back out of France."[49] However, the untold story of the war for him and for many thousands of other black troops was the one Du Bois alluded to—a story of humiliation, mistreatment, and even outright brutality.

Over 70 percent of the African Americans in service were assigned to special stevedore and labor battalions, as well as to the pioneer infantry. These black service units were the day laborers of the army, acting as ditch diggers, road builders, freight handlers, hostlers, drivers, and cooks.[50] The general staff believed that since most African American draftees had performed manual labor in civilian life, they were best suited for this type of work in the army.[51]

Of the several types of noncombatant African American units, the pioneer infantries were considered the elite regiments. Yoakum was assigned to the Headquarters Company of the 805th Pioneer Infantry[52] (fig.8). The typical pioneer regiment was composed of white officers and a core of African American noncommissioned personnel supported by various specialists, such as mechanics, horse handlers, and carpenters.[53] The pioneer troops were trained for army work of a more technical nature, like road, bridge, and railroad construction and repair, performed just behind the front lines. Some also received standard infantry training so that, if necessary, they could be used in combat. As an example of their activities, Yoakum's 805th Pioneer Infantry once was rushed to repair a road that had been so badly damaged by German shelling that no ammunition could be moved forward and no wounded evacuated. Singing as they worked and with shells falling

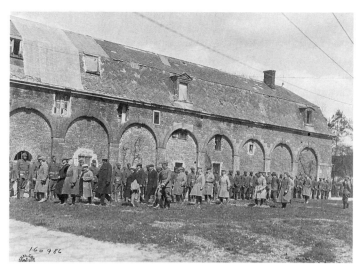

Fig. 8. Congressional Committee on Military Affairs, Maj. Gen. James W. McAndrew, Chief of Staff, and Col. C. B. Humphrey of 805th Pioneer Infantry reviewing Headquarters Co. 805th Pioneer Infantry. Capt. W. Bragan, Comdg. Chateau de Chahery, Chatel Chehery, Ardennes, France, 1919. Photograph by Cpl. W. J. Beach. National Archives, Washington, D.C. 160986-E.

around them, the pioneers labored through the night to make the road passable by morning. As one white officer exclaimed, "We cannot understand their makeup, for under the hardest conditions they hold themselves together and are able to raise a song."[54]

In the summer of 1918, following the draft, a flood of complaints reached the U.S. War Department about the mistreatment of the black American troops by white officers. These ranged from allegations of verbal abuse and physical assault to brutal work conditions. If the soldiers in any way resisted this harsh treatment, they faced long imprisonment and other kinds of punishment.[55] A private in Yoakum's 805th Pioneer Infantry was sentenced to three months of hard labor for shouting at his superior officer, "You fellows treat us like dogs!" Yoakum faced a somewhat similar ordeal.

On November 10, 1918, while serving in Clermont-en-Argonne, France, Pvt. Yoakum was court-martialed, confined to six months at hard labor, and given a two-thirds pay cut for addressing two noncoms in "an insubordinate and

disrespectful manner."[56] While carrying water to the kitchen, he reportedly shouted to one officer, "You lying son-of-a-bitch, I've done more than my share already; I'll go up to the Guard House before I'll carry more water. I'll get you as soon as I get out of the Army." To the other he threatened, "As for you, you dirty son-of-a-bitch, I'll go to your home when the war is over and get you!" The court-martial held that, "although . . . deserved," the full sentence should be commuted to a pay cut "owing to the impracticability of enforcing it under . . . [wartime] conditions."[57]

For Yoakum's exemplary conduct after the trial, Capt. George Bragan recommended him for clemency on January 24, 1919.[58] His full pay was retroactively restored on the first of that year. Bragan's sensitivity to the need for humane treatment of African American troops is also evident in his memo on the subject that was sent four months later to Col. C. B. Humphrey, Commanding Officer of the 805th Pioneer Infantry. Bragan admonished Humphrey for an incident in which a white noncom under his command sneered at a black soldier, "A nigger ought to know his place and keep it." His memo firmly states that "such an attitude and the public expression of it is out of place in the United States Army."[59]

The 805th Pioneer Infantry was formed in July 1918, and its Headquarters Company was assigned to Camp Funston near Manhattan, Kansas.[60] In late August, the unit of 236 men was moved to Camp Upton in upstate New York. Six days later they left for Quebec, from where they sailed to Europe on the *Saxonia*, a Cunard liner. In mid-September the company landed at Liverpool, England, and departed immediately for Southampton. Two days later they arrived in Le Havre, France, and then traveled to Rolampont, Haute-Marne. They camped for ten days, while being outfitted for service at the front. In early October, the unit boarded a train for Clermont-en-Argonne, a little village located a few miles back from the front line. The town served as a

training center, as well as the quartermaster depot and ordnance repair complex. After the armistice in November, the pioneers left Clermont and took up quarters at Chateau de Chehery. Yoakum and two other enlisted men were placed on special duty at an electric light plant at Courcelles in early February 1919.[61] Almost five months later, the company was ordered to Brest and reached the seaport in early May. They sailed for home in mid-June on the USS *Zeppelin* and were decommissioned at Camp Shelby in Mississippi that July.[62]

To occupy the troops during the six-month period after the armistice and before their return home, the American Expeditionary Forces held Inter-Allied Games throughout Europe. Nearly 29 million men competed in events including football, basketball, baseball, boxing, wrestling, track and field, tennis, swimming, fencing, and horse riding. Of all the events, horse riding was most important from a military standpoint.[63] After his assignment in Courcelles, Yoakum was chosen to accompany the U.S. equestrian team.

As he had done in his circus days and on the pioneers' ocean voyage to Europe, Yoakum cared for the horses—"fed them, cleaned them, and kept them calm."[64] Following a series of interviews with the artist in 1972, journalist Derek Guthrie recalled that Yoakum's "real passion was that he had gone places with horses, often under difficult circumstances."[65]

Through his art, Yoakum later returned to many of the places visited by the Headquarters Company of the 805th Pioneer Infantry. The location of their initial encampment is recorded in the sketch *This is Blue Mound Ridge Runs from Manhattan Kansas to Blue Mound Village near Village of Twin Oaks Kansas*. Their port of embarkation from Canada is commemorated in the drawing *Hudson Bay and Mt Elbi near Quebec Canada*. The ship they sailed to Europe is remembered in *Saxonia a Passenger Ship to Europe and Phillipine Islands from New York*. Upon their arrival in Europe, the company crossed the

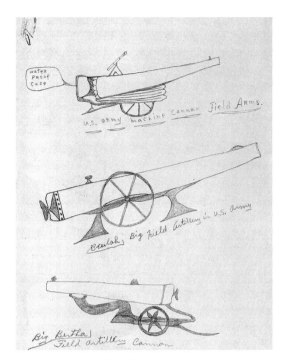

Fig. 9. *U.S. Army Machine Cannan Field Arms. Beulah Big Field Artillery in U.S. Army Big Bertha Field Artilliry Cannan*, 1972. Graphite pencil and colored pencil on paper. 14 1/4 x 11 in. Sketchbook. Private collection. Photo courtesy of author.

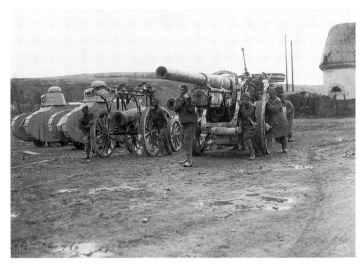

Fig. 10. Big German guns and dummy tanks brought into Dun-sur-Meuse for shipment by 805th Pioneer Infantry. Dun-sur-Meuse, France, 1919. Photograph by Cpl. W. J. Beach. Collection of the National Archives, Washington, D.C., 160980-E.

English Channel to the French port of Le Havre, a trip alluded to in several works. The artist also completed various landscapes of the mountainous region surrounding Clermont, the site of one of the unit's lengthy encampments. In *Mt Puyed Dome near Clermont France W.E. (some where in France theres a lily)*, a white soldier is shown with one of the big German guns that the troops affectionately called "Big Bertha" (plate 3). In addition, there are several sketchbook studies of these guns (figs. 9, 10). In the drawing *Courrelles Mtn Range Veraincourtti Valley somewhere in France theres a Lilly*, Yoakum recalls the town where he was on special assignment in an electric light factory. Finally, Brest, the port of troop debarkation from France, and St. Nazaire, the main freight port and center for animal care, are both the subjects of several other works.

In light of Yoakum's artistic achievement, it is somewhat ironic now to read a note from the commanding officer of his 805th Pioneer Infantry, dated May 8, 1919. Writing to the commander at Camp Ponanezen in Brest, the officer reported, "There are no men in this command Skilled in Drafting or Freehand drawing as requested in your memorandum."

Wanderer

I'm got a mind to ramble,
A mind fo' to leave dis town.
—*Blues song*

Despite the indignities that Yoakum suffered in the U.S. Army, his experience in Europe rekindled his wanderlust. His exposure to the cultural and geographic diversity of Europe nurtured his dream of exploring the world beyond his isolated midwestern milieu. In this regard he was not unlike other young American soldiers of his generation. For many of them the war experience had been their first opportunity to leave the rural communities of their birth. Their state of mind upon their return home was captured in the words of a popular song of the 1920s: "How ya gonna keep 'em down on the farm (after they've seen Paree)?"[66]

Yoakum may also have viewed travel, especially to foreign countries, as a means of escaping racial prejudice at home. For example, as an old man he reportedly recalled that "it was much easier for blacks in Europe."[67] Other African Americans of his generation echoed this sentiment. Among them was the great comedian Bert Walker, whose minstrel show was memorialized in several Yoakum portraits. In a 1918 article for *The American Magazine*, Walker confided: "I [go] to Europe frequently" in part to "practice my trade," but also "because I [find] kinder treatment there. . . . Every time I come back to America this thing they call race prejudice follows me wherever I go."[68]

Possessed by a passion to wander and fundamentally always a loner, Yoakum never returned to his family after the war. Sadly, he lost touch with his children for eighteen years.[69] His leaving understandably traumatized his children. Eventually when their mother remarried, they took the last name of her new husband. Following his death, however, they reverted to their original family name of Yokum, but spelled it "Yolkum," adding the "l" to signify the loss of their birth father.[70] Many years later, all but one of the children reconciled with the artist. His son John perhaps best understood his father's nomadic lifestyle, concluding, "Daddy is an Indian. He won't stay under another man's roof."[71]

In the early 1920s Yoakum traveled around the United States and overseas, performing a variety of odd jobs. He worked as a railroad porter, apple picker, and merchant seaman; he stoked furnaces on ships and in railroad roundhouses, quarried rock, and hoboed on freight trains. He rose to the position of service inspector on the railroad, but eventually was fired because he would not turn in "delinquents" (porters).[72] Yoakum was atypical of this class of railroad employees, who collectively posed the biggest hardship facing porters at that time. The inspector's main responsibility was to report to railroad management any failure of the porters to properly perform their duties. However,

the system led to abuses, with many service inspectors simply making up stories about alleged passenger complaints.[73]

By the mid-1920s Yoakum's wanderings finally led him to Ohio, around the Cincinnati area where, his son John believed, he had been employed with one of the many large lithography companies that produced circus posters.[74] By the end of the decade the artist had settled in Chicago.

Recalling his years as a wanderer, Yoakum said, "I had it in my mind that I wanted to go different places at different times. Wherever my mind led me, I would go. I've been all over this world four times."[75] While it is difficult to pinpoint his whereabouts on precise dates, his art provides tantalizing clues to the routes that he traveled during this period. For example, Yoakum did a series of landscapes of San Luis Obispo County, California, where he claimed to have once lived and owned property.[76] Initially, the artist may have been drawn to this region for a couple of reasons. Two of the circuses he traveled with actually visited San Luis Obispo in 1903, 1904, and 1906. Furthermore, thanks to the clever promotional efforts of some land developers, in the 1920s San Luis Obispo County became a mecca for midwesterners in search of the perfect climate.[77]

Baywood Park, a town in San Luis Obispo County that appears in at least four Yoakum drawings, offers one clue to the artist's whereabouts. The town of El Moro on the south end of Morro Bay was renamed Baywood Park in 1921, because the original name sounded too much like Moro Rock off Atascadero Beach. As it was developed, the town was laid out in a grid system with 3,000 lots of 25 by 125 feet.[78] Local artists' renderings of the San Luis Obispo area during that period often incorporated a grid of Baywood Park. Similarly, Yoakum later superimposes Baywood Park's grid pattern on several landscapes of the region (fig. 11). The town of Baywood Park is situated at the entrance of what was referred to in the 1920s and 1930s as Los Osos Valley, a location identified in

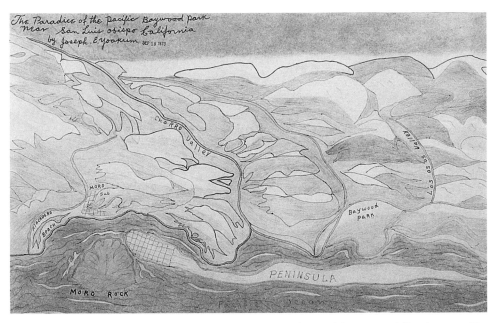

Fig. 11. *The Paradise of the Pacific and Baywood Park near San Luis Obispo California,* 1970. Ballpoint pen, graphite pencil, and colored pencil on paper. 12 x 19 in. Private collection. Photo courtesy of Phyllis Kind Gallery, Chicago and New York.

another Yoakum drawing, *Baywood Park Subdivision of Los Osos Valley Cal. Baywood Park San Luis Obispo County.*

To the north of Baywood Park is Morro Bay State Park Estuary, flanked on the east by nine volcanic sister peaks, the smallest of which is Moro Rock, and an eight-mile-long peninsula of sand dunes to the west. This sandy peninsula and Moro Rock, Baywood Park, Atascadero Beach, and Los Osos Valley are all identified by name in Yoakum's landscape *The Paradise of the Pacific and Baywood Park near San Luis Obispo California* (fig. 11). Another drawing, *This is of Moro Bay in San Luis Obispo County San Luis Obispo California,* shows Moro Rock with a pointed crown, as it looked before U.S. Army personnel blew off its top with dynamite shortly after World War II (plate 4).

While on the West Coast, following his stint with a roundhouse in San Francisco, Yoakum reportedly "stowed away on a ship not knowing where it was headed."[79] As he later related the story to Christina Ramberg, when the crew discovered him "they bound his hands and feet and were about to throw him overboard when the captain came out and saved him. He was put to work in the boiler room wheeling coal and tending the fire."[80] Probably after a stopover in Hawaii, the ship finally docked in Perth on Australia's western coast. Yoakum next journeyed to Sydney on the southeastern coast and Darwin on the northern coast. While heading back to Perth on another ship, he worked as a stevedore in return for his passage. Since meals were not included in his arrangement with the ship's captain, he was forced to go three days without food.

Perth, Sydney, and Darwin, the cities Yoakum saw on his first trip to Australia, are identified in a series of landscapes and sketches. Other major coastal cities that are named in the artist's drawings include Canberra and Brisbane. Yoakum refers to his second trip to Australia in a late sketch, *The attraction of all wanderers which is located in central Australia I have seen them twice myself.* His experience as a ship stowaway is captured in an amusing untitled drawing of a freighter with a man's face peeking out of a porthole.

From Australia, Yoakum's travels apparently continued to the "Asiatic side of the world," a region that he claimed to have visited four times. At that time, American cargo ships typically journeyed from the Australian continent to major port cities in India, Burma, Singapore, China, and Japan. Their trip home sometimes took them through the Panama Canal to New York City. Alternate routes went along the southern coast of India and northern coast of Africa, past Gibraltar to Great Britain. All of these ports of call, but particularly India and China, are favorite subjects of Yoakum's landscapes. It is unlikely that the artist actually visited all of the places that he depicted. However, his preference for certain geographical subjects (sites in his home state and along circus and cargo shipping routes) suggests that he did travel more extensively than has previously been thought to be the case.

During this period Yoakum also spoke of hoboing on a freight train through Canada. On his journeys he undoubtedly gained inspiration not only from the passing landscape but from the adventurous stories told by his fellow travelers as well. Frederick Mills, an investigator for the U.S. Immigration Commission, described the "floating army" of hobos in that era: "[T]hey have lived in a large world. They have seen life in many garbs and death in many disguises in the ends of all the earth. Perhaps it is a soldier who . . . braved the shots of Santiago [in the Spanish-American War]. . . . Or a sailor who ploughed the seven seas . . . with tales of coral isles, of icy Alaskan waters . . . and Ceylon. . . . Or a yegg who has pulled off taps from Florida to Vancouver Island, mentioning incidentally jails he has served in and bulls he has met. All of these I have met and seen, and many others."[81] Likewise, the artist probably encountered such characters during his travels and swapped stories with them. As his friend Evonne Durham remembered, Yoakum "met no strangers."[82]

Artist

My drawings are a spiritual unfoldment.
—Joseph Yoakum
My imagination it would seem has its own geography.
—Mark Tobey

Yoakum's wandering years ended sometime in the late 1920s. He eventually got remarried, to a woman named Floy, who had been born in Pensacola, Florida.[83] In 1936, following a chance meeting with his son John on a train, the artist was reunited with his children. At that time he was living in Chicago, where he had been variously employed as a janitor, mechanic, carpenter, and foundry worker, before operating an ice cream parlor on the city's South Side. During the 1940s, while working in a steel mill, he began making ceramics from molds in his spare time. He hoped to turn his hobby into a moneymaking enterprise, but the city of Chicago reportedly refused to grant him a business license. As his daughter-in-law Ida Mae recalled, he "was hard working, always talked business, and his hands were busy all the time."[84]

During this period, Yoakum also began to exhibit what his physicians called "chronic brain syndrome." His wife had him admitted to the Hines Veterans Hospital as a psychiatric patient in October 1946, and he was not released until September of the following year.[85] After that, Yoakum was unable to resume his former employment and essentially retired, although he continued to supplement his meager veteran's pension and Social Security with various odd jobs.[86] His wife died soon afterwards. He subsequently joined a number of Native American community groups, developed an interest in the environmental movement, and traveled occasionally to visit his children in Kansas, Missouri, Florida, and Washington, D.C.[87]

In a conversation with the journalists Derek Guthrie and Jane Allen just before his death, Yoakum confided, "I've been drawing all my life, but didn't know the value of it until recently."[88] He

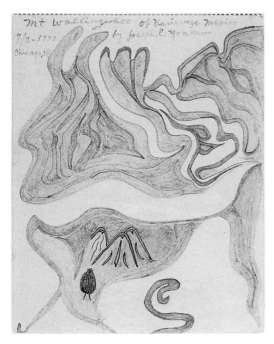

Fig. 12. *Mt Wallingwhoo of Varicruzs Mexico*, 1972. Crayon and fiber-tip pen on paper. 14 1/4 x 11 in. Private collection. Photo courtesy of author.

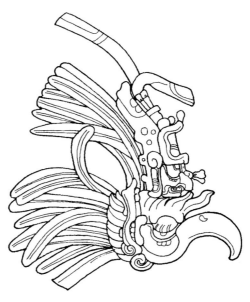

Fig. 13. Linda Schele, *Headdress with a quetzal representing the name of the person depicted, Lady Zac-Kuk, from the sarcophagus from the Temple of the Inscriptions at Palenque, Mexico*. Ink on paper. Collection of the Kimball Art Museum, Fort Worth, Texas. Photo courtesy of author.

spoke of doing murals on the canteen wall of a steel factory in Chicago.[89] It is likely that these works were completed in the mid-1940s after many plants had replaced their large employee restaurants with small canteens scattered throughout the factories.[90] According to some of his family and friends, by the 1950s Yoakum was drawing on a regular basis. Lowry Bryant, his longtime neighbor, reported that he typically made pictures "all day and half the night."[91] During a 1954 visit to his son Peter, the artist claimed to have finished some drawings that would "make big money some day."[92]

The common belief among Chicago's art establishment was that Yoakum began to draw in the early 1960s after a dream. As he related the story to some of his artist friends, a picture of Lebanon appeared in his dream, and he awoke to put it on paper.[93] In an interview at the time of his first exhibition, the artist reported that he had taken up drawing because he "had to do something or [he'd] go crazy."[94] He described his creative process as "spiritual unfoldment," a term

originated by Mary Baker Eddy, the founder of Christian Science.[95] The artist came to embrace Eddy's religious philosophy following his recovery from an illness during his days with Buffalo Bill's Wild West. For artistic purposes, he defined her spiritual term to mean that after he worked on a drawing he had a "spiritual remembrance" and the subject was finally revealed to him. This view of the creative process is similar to that expressed by African American artists in other disciplines like music and dance—namely that the preferred shape of a specific work will only be known when it is completed.[96]

The mainstream art community's discovery of Yoakum did not occur until 1967. In the summer of that year, John Hopgood, an instructor at Chicago State College, happened to walk by the artist's storefront studio and noticed some drawings hanging in the window. "The way the hills and plants were drawn actually stopped me in my tracks," he remembered.[97] Trained as an anthropologist, Hopgood saw striking similar-

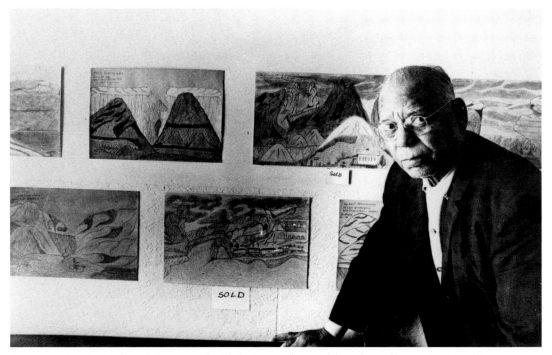

Fig. 14. Joseph Yoakum in front of drawings at The Whole, 1967. Collection of the Archives of American Art, Smithsonian Institution. Whitney B. Halstead Papers.

ities between Yoakum's work (fig. 12) and pre-Columbian art (fig. 13). He purchased twenty-two drawings on the spot.

Soon afterward, Hopgood took Yoakum to see the Reverend Harvey Pranian at St. Bartholemew's Church on the edge of the college campus. The artist brought a folio of about a hundred drawings, and Hopgood proposed an exhibition of these "outstanding and singular works" in the lounge of the church coffeehouse, The Whole. Pranian recalled that Yoakum was "an imposing man, rather shy, but very proud of his work."[98] Evonne Durham, Pranian's assistant at the time, was captivated by Yoakum's wonderful stories that made them both laugh.[99]

Following Yoakum's visit, Pranian exhibited about forty of the artist's drawings in the coffeehouse (fig. 14). In the first four weeks of the show, more than thirty pieces were sold. Eventually a total of about a hundred twenty-five were exhibited. Yoakum gave his friend Evonne Durham five drawings as a gift for her help with the sale of his work.

Thanks to Tom Brand, the owner of Galaxy Press and a visitor to the exhibition, Yoakum's career was launched in Chicago's mainstream art community. A painter himself, Brand was "bowled over" by Yoakum's work—"its peculiar imagery, masterful repetitive design, and illusion of perspective."[100] After seeing the show at The Whole, he quickly shared the news of his find with many friends in the city's art world. These included fellow painters Leon Golub and Theodore Halkin, gallery owner Edward Sherbeyn, and *Chicago Daily News* reporter Norman Mark, who later wrote a story on the artist. Mark quoted the abstract painter Jordan Davies, a visitor to the Yoakum exhibition: "As far as I'm concerned he is much better than Grandma Moses." In particular, Jordan was struck by the artist's "very beautiful linear stylization."[101]

After the exhibition closed, Brand persuaded Edward Sherbeyn Gallery, located on Chicago's Near North Side, to give Yoakum a one-man show of about fifty pieces. The exhibition ran from

March 28 through May 5, 1968, and brought the artist to the attention of a much larger audience (fig. 15). A local television anchorwoman who had purchased one of the artist's drawings featured the show in a news report. Don Anderson's review in *Chicago's American* found the exhibition to be "such a success that he [Yoakum] has become one of the permanent stable of artists at the Edward Sherbeyn Gallery."[102]

Perhaps the greatest enthusiasm for the artist's work was generated within Chicago's mainstream art community, especially among the group of young artists who were teachers or students at the School of the Art Institute of Chicago. Ray Yoshida, an instructor at the school, later recalled that they "found in Yoakum's work the qualities of fantasy and obsession that they were attempting to develop in their own art."[103] Moreover, Yoakum "validated and revalidated the idea of being able to create . . . visual phenomenon—unique, powerful, rich—without going through traditional art school."[104] Ultimately, Yoshida and his fellow artists became Yoakum's most avid patrons.

Soon after the Sherbeyn show, these enthusiastic young artists began to visit Yoakum in his 82nd Street studio on Chicago's South Side. At this time, he was working out of his one-bedroom, brick-front home, which had once served as part of a small commercial establishment. It was located in a block-long collection of little stores that included a television repair shop, cleaners, and beauty parlor. A curtained doorway separated Yoakum's tiny bedroom and kitchen from his cramped and dimly lit living room-studio area. The latter was furnished with two sofas and an easy chair upholstered in a faded turquoise fabric with silver flecks, an old television, a metal worktable and shelves that held his books, stacks of drawings, and an assortment of other objects.[105]

Gladys Nilsson, one of Whitney Halstead's art students, remembered that, typically upon their arrival at Yoakum's studio, they "would immedi-

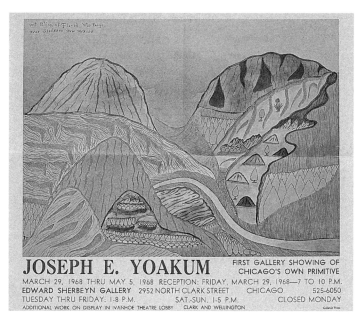

Fig. 15. *Joseph E. Yoakum, First Gallery Showing of Chicago's Own Primitive, Edward Sherbeyn Gallery,* 1968. Poster. Collection of the Roger Brown Study Collection of the School of the Art Institute of Chicago. Photograph by Jim Prinz.

ately get into the drawings and gasp with amazement and pleasure after seeing each one. If one of us expressed an interest in a particular work and wanted to put it aside to buy he wouldn't let you do it a second time so that we tried to hold off as long as possible before selecting one."[106]

Those who knew Yoakum at the time described him as a tall, vigorous man, standing "remarkably straight for his age."[107] Roger Vail, one of Nilsson's fellow students, was impressed by the artist's "striking presence."[108] His Cherokee heritage was evident not only in his stature, but also in his oval-shaped head and olive-colored complexion.[109] Nilsson noted that the artist's "large bearish hands" had "fingers like sausages, a sharp contrast to his delicate drawings."[110] However, his enormous dark eyes were his most distinguishing feature. As his daughter-in-law Marian observed, the intensity of his gaze made it seem as if "he looked right through you."[111]

With his young patrons, Yoakum's manner of speech tended to be somewhat slow and formal. He would greet them: "How are you today?"

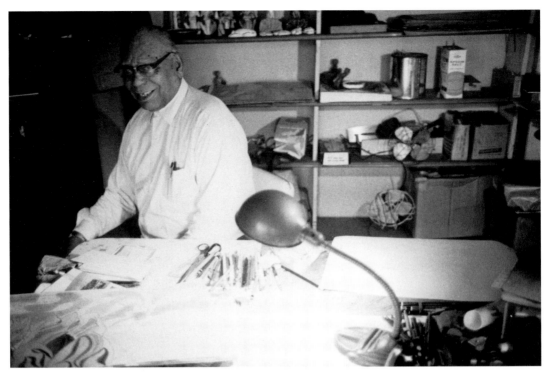

Fig. 16. Joseph Yoakum in his 82nd Street studio on Chicago's South Side, 1967. Collection of the Archives of American Art, Smithsonian Institution. Whitney B. Halstead Papers. Photograph by Roger Vail.

Sometimes his conversation and his correspondence were laced with biblical references. For example, in an interview with Norman Mark, the artist declared, "What I don't get God didn't intend me to have, and what I get is God's blessing. They say God is dead. Well, what man saw Him in a casket and put in the ground? Why can't people realize that we're all God-made and sustained and become more considerable toward each other?"[112]

Yoakum firmly held the belief that God had protected him throughout his life.[113] As an example, the artist told a story about the time he killed his cousin (Son Rice) in a fight after being attacked with a knife. His family recounted the incident somewhat differently, however. In their version, Rice, who had a violent temper, was angry with the artist, then a widower, for visiting his former wife. A fight ensued, and Rice was badly hurt, but was taken to the hospital and eventually recovered from his wounds.[114]

Despite his religious faith, Yoakum had a certain skepticism about the world, especially the big institutional power centers. Philip Hanson recalled, for example, that the artist characterized the Hong Kong flu as the fabrication of drug manufacturers—a story they invented to increase sales. The moon probe, which was often in the news at that time, was seen as "a hoax to get money out of the federal treasury." The artist explained that "it [was] impossible to go to the moon" since this would require astronauts also to approach the sun, thereby making their "apparatus" so hot that they would die.[115]

Other fantastic stories that Yoakum told reflected his wonderful sense of humor. His friend Evonne Durham remembered once seeing him on a bus entertaining a group of strangers with his marvelous yarns. One of his tall tales concerned his first and only airplane flight, which was aborted after a flying saucer "buzzed" the plane.[116] He completed several works incorporating flying saucer

imagery during the late 1960s; these were likely influenced by the constant stream of popular journal articles on the subject during this period.

Yoakum's humor was also reflected in the gentle way he sometimes teased his young patrons. For example, Roger Vail recalled that the artist told him a certain landscape he wanted to purchase was more expensive because it had "a sun, moon, and stars." In a visit to his studio, Vail captured Yoakum's playfulness in a series of photographs that show the artist at his worktable with his head cocked and a sly little grin on his face, as if he were "playing cat and mouse" with the photographer[117] (fig. 16). On another occasion, when Whitney Halstead asked Yoakum whether he would mind being photographed, the artist joked, "I knew sooner or later I'd be shot."[118] Although he was a man who enjoyed the company of women and treated them with great dignity, Yoakum liked to joke with his men friends about "sporting girls," a 1920s expression for flappers who had become prostitutes.[119] One of these seductive damsels is portrayed in his drawing *Enter in Man Onty Play House and at State and Polk Sts. Sept/1924* (fig. 17).

Not long after Yoakum's show at Sherbeyn, his relationship with the gallery began to sour. The dealer objected to the artist selling directly to collectors, and Yoakum, in turn, was dissatisfied with his exclusive agreement with the gallery, which did not allow him to deal directly with his patrons. At the suggestion of Whitney Halstead, Yoakum retained a law firm to terminate his contract with Sherbeyn. Through the artist's lawyer, the dealer was advised that the exclusive, lifetime nature of the contract had been inserted without Yoakum's knowledge or consent.[120] As the artist humorously explained it later, "I didn't have my glasses on when I signed the contract!"[121] The gallery was formally notified of its failure to pay the artist for all the works it had sold and asked to return the remaining drawings in its possession. However, some two hundred drawings apparently were never returned.

During Yoakum's ongoing negotiations with Sherbeyn, the gallery held a second one-man show for the artist in February 1969. It received a very favorable review in a Chicago magazine, *Skyline*, from Robert Glauber, who characterized Yoakum's drawings as "intriguing, witty, subtly colored, [and] highly original." Glauber praised the work as "an accomplishment of considerable stature." He remarked upon the almost obsessive quality of the artist's images, which were repeated over and over again, but "always with subtle changes of emphasis and color that, in turn, change the mood and intent of the drawings." This obsessive quality was likened to the style of Vincent van Gogh, another largely self-taught artist who did not conform to the mainstream art movements of his day.[122]

Eventually, Whitney Halstead replaced the Sherbeyn Gallery as Yoakum's exclusive agent. Over the next several years, Halstead assembled a study collection of the artist's work that he later bequeathed to the Art Institute of Chicago. In

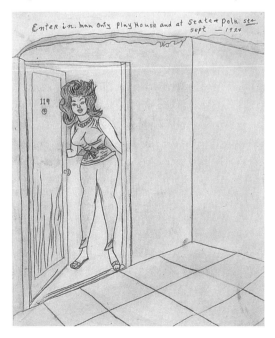

Fig. 17. *Enter in Man Onty Play House and at State and Polk Sts. Sept/1924*, c. 1968. Ballpoint pen and colored pencil on paper. 30.1 x 48.4 cm. Collection of the Art Institute of Chicago. Bequest of Whitney Halstead, 1979.176.

addition, he and several of his colleagues and former students provided the artist with new exhibition opportunities. For instance, Yoakum was included in the first major museum exhibition of local realist painters known as the Chicago Imagists. The show at the Chicago Museum of Contemporary Art was entitled *Don Baum Sez "Chicago Needs More Famous Artists."* It ran from March 8 through April 13, 1969.[123]

Later that year, Halstead arranged for Yoakum's work to be exhibited in *The Faculty Collects* at Illinois State University in Normal. Meanwhile, his former students Gladys Nilsson and Jim Nutt had moved to California, where they negotiated an exhibition at the Candy Store Gallery in Folsom. The owner/director Adeliza McHugh later recounted her fantastic experience during that show. One evening she walked into her gallery to find the anthropomorphic figures in Yoakum's landscapes "dancing around the room with their arms raised in the air. They were having a joyous celebration." However, the moment she entered the room "it was as if they suddenly jumped back up on the wall and, in a split second, were gone." To her, Yoakum's drawings were "pure feelings." She added, "Like all great works of art, they have a life of their own."[124]

In the ensuing months Yoakum began to have misgivings about how Halstead was representing his interests. In a letter sent to his artist friends Nilsson and Nutt in California, he wrote, "I learn that Mr. Halstead is putting my work in pocession [*sic*] of people out there to sell for him. I am asking you please don't accept from him as long as you are selling work for me." He asked them to serve as his West Coast representatives. However, as he had with others, he also demanded that they provide a monthly inventory of all the works that either had been sold or remained in their possession.[125]

Nevertheless, Whitney Halstead continued to pursue other exhibition venues for the artist. With the help of Ray Yoshida, he negotiated a one-man show, *The World of Joseph E. Yoakum*, at Pennsylvania State University. Richard Fraenkel, with the College of Arts and Architecture, was curator of the fifty-work exhibition that ran from March 31 to April 22, 1970.[126] Halstead also arranged for the artist to receive a small honorarium from the college. At first, Yoakum was concerned because he thought the payment was for the purchase of his work. However, they reassured him that it was only for the "rental" of the drawings.[127]

Other exhibitions followed later that year. Yoakum was included in a group show, *A Decade of Accomplishment—Prints and Drawings of the 1960s*, that was held at the Illinois Bell Telephone Company Gallery in Chicago. In the early summer, Philip Linhares, the curator at the San Francisco Art Institute, presented the artist's work in a show entitled *American Primitive and Naive Art*. Held in SFA's Emanuel Walter Gallery, the exhibition of six artists ran from June 25 through July 25.[128]

The following year, through Halstead's efforts, the School of the Art Institute of Chicago featured Yoakum's work in a show at its Wabash Transit Gallery. Entitled *Two Artists—Pauline Simon and Joseph E. Yoakum,* the exhibition ran February 4–18, 1971, and was later extended through February 27.[129] It included thirty-nine Yoakum drawings and received a favorable review from Harold Haydon in the *Chicago Guide*. Thirty-five of the drawings from the Wabash Transit Gallery show traveled to Rockford College Art Gallery for an exhibit that ran March 1–26.

During the Rockford show, Yoakum visited the college three times. He came from Chicago by bus, and friends at the college met him at the bus station. As the art department chairman, Philip Dedrick, recalled, "Nothing seemed to be an impediment to his going somewhere that it seemed right for him to go."[130] On each visit, the artist sat in the gallery for most of the day and enjoyed his drawings. The exhibition afforded him a rare opportunity to see them all together since his studio was too small to display more than

a few at one time. At the gallery opening he gave some brief remarks focusing on the beauty of the places he had seen that were depicted in his landscapes.

In early May 1971, through Cynthia Carlson, one of Whitney Halstead's former students, Yoakum was invited to exhibit some drawings at the Museum of Modern Art in New York.[131] Halstead selected six works for display in MoMA's Penthouse Gallery and consignment to its Art Lending Service.

By mid-July two of the drawings had sold. However, the artist, whose health had begun to fail, became greatly concerned that the museum had not kept him adequately informed about the progress on sales.[132] In a letter to MoMA dated July 14, Halstead described Yoakum's state of mind as "inordinately suspicious to the point of paranoia."[133] The museum subsequently provided written assurances to Halstead that the artist would be notified as soon as payment had been received from the buyers. In the same letter MoMA also asked to keep Yoakum's unsold drawings on consignment for another nine months, a request that was granted.[134]

The misunderstanding with MoMA was characteristic of Yoakum's dealings with museums and dealers throughout his career. As Nilsson and Nutt observed, Yoakum "had a hard time understanding something on consignment."[135] Thus, when arranging gallery exhibitions of his work, the couple would write up elaborate receipts for each drawing indicating the percentage Yoakum would receive if it sold.

At the time of the MoMA controversy, Yoakum was suffering from terminal prostate cancer, and his output declined dramatically. By July his health had deteriorated to the point that his daughter came from Topeka, Kansas, to have him admitted to the Hines Veterans Hospital in Chicago. Four days after his admission and against medical advice, he returned to his storefront studio. In early October his first wife's brother, John

Julian, who lived in Chicago, persuaded him to return to the hospital after Julian's wife, Ernestine, found the artist lying unconscious on his studio floor. Camilla Eichelberger, Yoakum's neighbor and barber, recalled, "We thought he wouldn't make it that day."[136]

Yoakum survived, but lost what he valued most—his independence. After being treated at a private community hospital and discharged, he soon reentered Hines. The hospital authorities found him to be too feeble to care for himself, and the Julians were appointed as his guardians. For the remainder of his life, the artist no longer handled his own financial affairs. After leaving the hospital in mid-December, he was moved to the Shoreview Manor nursing home on 75th Street, and finally to Ogden Park Convalescent Home on South Racine Avenue, where he remained until shortly before his death.

During his hospital stays, Yoakum ceased to draw, although his medical record stated that he "sketched for his own amusement" (figs. 18, 19, 20). By the spring of 1972, with his cancer in remission, he once again took up his pens and chalks. In a brief period of four or five months, he completed five sketchbooks. Many of these works are autobiographical in nature, mostly recounting events early in his life. At this time, Whitney Halstead continued to visit the artist and bring him art supplies.

In early February, before closing Yoakum's storefront studio, the Julians arranged for Halstead to store the 269 works that remained there.[137] By the summer, at their request, he began to sell the drawings. Eventually the couple received slightly over five thousand dollars for the entire collection. Their intent was to establish a trust fund for Yoakum with the money. This was never done, however, as the artist died later that year.

Shortly before Yoakum's death in December, the Julians became concerned that Halstead might not have fairly represented their interests. A *Chicago Tribune* article alleged that Halstead and

Fig. 18. Joseph Yoakum at the Ogden Park Convalescent Home, 1972. Photograph by Charles Osgood. Courtesy of the *Chicago Tribune*.

Fig. 19. Joseph Yoakum's hand with box of pastels and Medicare leaflet tucked into lid, 1972. Photograph by Charles Osgood. Courtesy of the *Chicago Tribune*.

Fig. 20. *Untitled (bowl of soup)*, 1972. Colored pencil and fiber-tip pen on paper. 14 1/4 x 11 in. Collection of the Richard L. Nelson Gallery and the Fine Arts Collection, University of California at Davis. Gift of Robert and Lou Ann Aichele, 88.87.20D. Copyright U.C. Regents and Nelson Gallery. Photograph by Sam Woo.

others in the city's art establishment had exploited Yoakum by acquiring drawings from him at below-market prices. In response to these allegations, Halstead wrote the couple to explain that he and several of Yoakum's artist friends had purchased some of the remaining works, while others had been purchased for resale by two well-known Chicago galleries.[138] It is not clear whether he struck the best possible deal for his clients, but, as one of his former students observed, Halstead was "not a businessman."[139]

During the last months of his life, Yoakum was featured in two one-man shows. In early October, the Chicago-based Douglas Kenyon Gallery presented an exhibition of about forty works. Dennis Adrian, an art critic and museum curator, wrote a glowing review for *Panorama-Chicago Daily News.* He described Yoakum's vision as "incredibly moving" and praised his landscapes for their "extraordinary use of scale." The artist's mountains and rock forms reminded him of "enlargements of cross-sections of cellular tissue, seamed and veined with curious stratifications like those in blown-up anatomical diagrams." Although self-taught, Yoakum was not viewed as a "naïve" or untutored artist. Adrian found his work to possess "a spiritual authority, an absolute rightness, which is encountered only in certain masterpieces of Chinese landscape painting."[140]

About that time, Yoakum was similarly honored with a one-man show at the Whitney Museum of American Art in New York. The museum's assistant curator, Marsha Tucker, became aware of the artist's work through her friends and acquaintances in the Chicago art community. Like Dennis Adrian, she did not regard Yoakum as a "naïve" artist at all, but simply as an artist of exceptional ability who deserved wider recognition.[141]

The Whitney exhibition ran from October 23 through November 26, 1972. It was one of a small number of solo exhibitions featuring the work of African American artists presented by the Whitney Museum in its "projects" gallery from 1968 to 1975. Up until that time no mainstream art museum (except for MoMA in the 1930s) had given a solo exhibition to an African American artist.[142]

In a monograph prepared for the Whitney Museum's exhibition of Yoakum's work, Whitney Halstead described the artist's landscapes as "[m]emories of places he had seen blended imperceptibly with fantasy." He characterized the artist's "repetition of motif and the echoing contours" as "a consciously developed leitmotif in music or . . . the repeated patterns in myth." This quality, he found, imparted to the work "a resonance remarkable for its small size and delicate medium."[143]

The Whitney Museum show received a number of favorable reviews. John Perreault with *The Village Voice* drew parallels between Yoakum's visionary art and that of William Blake, another man outside the artistic mainstream of his time. Both artists emphasized the primacy of art created from the imagination over that produced from the observation of nature. Speaking of this quality in Yoakum's work, Perreault remarked that "[m]ost of Joseph Yoakum's drawings are inscribed with the places they are meant to portray but geography is only where he begins." It was the artist's powerful inner vision, the critic observed, that made this work exceptional.[144]

Yoakum's drawings reminded Perreault of Blake's style in yet another sense. The critic observed that both of these visionary artists invented highly original forms distinguished by undulating contours and dramatic stylization. In the creation of form they tended to emphasize line over color, although they were unusually subtle colorists as well.

In his review of the Whitney exhibition for the *Christian Science Monitor*, Louis Chapin found "Yoakum's particular world" to be suffused with "inward springs of character and distinc-

tion." Like his fellow critic John Perreault, Chapin noted parallels between the art of Yoakum and William Blake. Chapin believed Yoakum to possess such "perception and authority" as an artist that "he might well send the directors of art schools back to their drawing boards (so to speak) to rethink their current curricula." In Chapin's view, this self-taught artistic genius could serve as a powerful source of inspiration to many academically trained artists and art students who had not yet discovered their own style.[145]

Barely three months before he died, Yoakum wrote a letter to his eldest son, Louis, in Florida. The artist confided, "I don't think I have much longer to stay here; well, if I don't have much longer to live I do have a home in Heavenly Glory, so I will live happy right on. . . . I am not suffering for nothing but GOD and I am receiving him Every day. Well sonny boy answere [sic] soon, from old Missouri Joe Yoakum."[146] The artist died on Christmas morning, 1972, and was buried five days later in the veterans' cemetery in Rockland, Illinois.[147]

Since Yoakum's death, his art has come to be enjoyed by larger and larger audiences. Major museums around the world have featured his drawings in important exhibitions and acquired the works for their permanent collections. Curiously, while his art has become better known, Yoakum has remained as much of a paradox as the coyote of Navajo mythology. In life, he embodied contradictions, being at various times formal and informal, serious and whimsical, quick tempered and easy to know, roguish and courtly. He was a skeptic and a believer, an intuitive person who loved learning, a man with massive hands who made delicate drawings. As one friend recalled, the artist might appear on the street looking very dignified in a dark suit with a boutonniere while eating a bag of peanuts in their shells.[148] Similarly, Yoakum's art, as will be discussed in later chapters, emphasized contrasts—between line and color, verticality and horizontality, monumentality and intimacy, simplicity and complexity. Most significantly, however, in his life, as in his art, reality and dreams were conjoined.

The Artist and the Circus

The circus . . . is the only spectacle I know, that while you watch it, gives the quality of a truly happy dream.
—Ernest Hemingway

From the time the 'advance man' flung his highly colored posters over the fence till the coming of the glorious day [when the circus came to town] we thought of little else. It was India and Arabia and the jungle to us. . . . To rob me of my memories of the circus would leave me as poor as those to whom life was a drab and hopeless round of toil.
—Hamlin Garland, A Son of the Middle Border

Mark Twain's Huckleberry Finn called the circus "the splendidest sight that ever was."[1] He could have been speaking for Joseph Yoakum and all the other midwestern boys in the early twentieth century, who were bewitched by the glitter, pageantry, and exoticism of the traveling circus during its Golden Age (1880–1910). As an old man reminiscing about the circus during this period, the novelist Ed Howe "listed a performance . . . of Miles Orton's circus at Bethany, Missouri, first among the wonderful things that happened to him in his life."[2] This sentiment was echoed by W. D. Howells, who chronicled a boy's life in a small town in America of the 1880s: "The only perfect joy on earth in the way of entertainment . . . was the circus. . . ."[3]

When the circus came to town, the local boys would assemble to watch the workers unload their trains and set up their large tents. "Many were there looking for most any job so they could earn free admission and passes to the show."[4] A lot of boys dreamed of running away with the circus, but only a few of them actually did. Among those were future artists like Joseph Yoakum, Byron Burford, H. C. Westermann, and Walt Kuhn, who temporarily signed on with traveling circuses and performed a wide variety of tasks—roustabout, ticket taker, announcer, clown, and advance man.[5]

Whether as performer or spectator, American artists with visions as diverse as those of George Luks, Marsden Hartley, Alexander Calder, Robert Motherwell, and Joseph Yoakum have been drawn to the circus and incorporated its imagery and themes into their art.[6] The influence of the circus on Yoakum's art is not as readily apparent as it is on that of other artists, however. Indeed, Whitney Halstead, the individual who most actively promoted Yoakum's work during his lifetime, asserted that "there are no drawings of which I am aware that show any aspect of the circus,"

except his portraits of the Wonder of Assirea. Halstead believed that this character was derived from a circus sideshow.[7]

In fact, Yoakum's experiences as a circus hostler and advance man, and possibly as a valet to circus impresario John Ringling, are evident in many of his drawings. Abstract images of menageries and clowns—stars of the center ring—populate his landscapes, as do images and themes drawn from circus spectacles. Some of his portraits, like those of the Wonder of Assirea, also seem to have been inspired by such spectacles, as well as by circus aftershows, such as the Wild Wests, minstrel shows, and sporting events. Not surprisingly, however, geography is the circus's most profound influence on the art of this former advance man. In this regard, Yoakum may be unique among his fellow artists.

The Advance Man: An Encyclopedia of Geographical Facts

Most circus people in Yoakum's day traveled widely, but actually saw very little of the world. Although the railroad circuses crisscrossed America and even toured abroad, they generally moved by night.[8] Thus, circus people rarely got glimpses of more than the show grounds in any town they visited, except for the occasional Sunday excursion into the local countryside when the circus was not performing or rushing to its next destination.

Circus advance men like Yoakum were the exception when it came to knowledge of geography. According to circus historians Charles Fox and Tom Parkinson, the advance department knows more about geography than all the others put together. Many advance men are "walking encyclopedias of geographical statistics," because they decide about routes and make the travel arrangements. Of all those who performed the role, John Ringling was reputed to know more geographical facts and figures than anyone before or since.[9] As Ringling himself recalled, "My training was largely in routing, and in the old opposition days, when shows fought for territory, and when the big fellows tried to starve us out, knowledge of railroads and routes were a big help. I learned my geography that way; and Charles [his brother] still insists that I am able to name the counties of any state in the United States and, if a county is named, to name the county seat, and the road leading to it."[10]

During the Golden Age of the railroad circus, the advance department traveled ahead of the performers by about two weeks, and the entire team came to know a lot about the places where the circus performed.[11] In addition to leasing the show lot, securing city licenses, and contracting for food and supplies, the advance department plastered the town and surrounding areas with posters, handbills, and other circus advertisements.[12] It was not uncommon for billposters to distribute as many as one million sheets of advertising paper in some two hundred towns during a single season.

Yoakum's fascination with geography, developed during his circus days, is apparent in his preference for landscape. Each of his landscape drawings is carefully labeled with the name of the place depicted, in the manner of early picture postcards. Examining the routes of the five circuses with which Yoakum claimed to have been associated reveals a startling fact. Hundreds of his landscapes make reference to cities in the United States, Canada, Mexico, and Europe where these circuses actually performed or other locations along the routes they traveled. Some are well-known cities, such as the capitals of U.S. states and Canadian provinces.

Many lesser-known circus stops are also the subjects of Yoakum drawings. They include Rockland, Maine; Pittsfield, Massachusetts; St. Johnsbury, Vermont; Marion, Virginia; Havanna, Arkansas; Beardstown, Illinois; McCook, Nebraska; Clarksville, Tennessee; Fergus Falls, Minnesota;

Tishimingo, Oklahoma; Iola, Kansas; Paris, Texas; Deming, New Mexico; Gerlach, Nevada; Susanville, California; and Pasco, Washington.

Another large group of Yoakum landscapes depicts sites within fifteen to fifty miles of a town in which one of the five circuses performed. These are scenic areas, mostly in national parks, that were accessible by railroad shortlines. During a season on the road, the circuses sometimes organized excursions for their employees to visit these tourist attractions on their days off. Such points of interest that are the subject of Yoakum drawings include California's Mt. Shasta and Colorado's Mountain of the Holy Cross.

What about the many foreign lands represented in Yoakum's landscapes that no American circus ever visited? A circus's geography has never been limited only to those places where it performs. As a 1920s Ringling Bros. and Barnum & Bailey Combined Shows poster boasted: "The greatest acts from every country in the world assembled for this year." Circus agents scoured the globe to recruit the most spellbinding attractions. As a result, the circus has always been a highly international entertainment, which is one reason it has held a continuing fascination for artists. In Yoakum's day, there were Japanese swordsmen and wrestlers, Chinese acrobats, Italian jugglers, Arabian tumblers, Hungarian aerialists, French trapeze flyers, German contortionists, Indian dancers, Syrian and Mexican equestrians, Russian cossacks, British lancers, and Moorish warriors, to name a few. Yoakum shows one such performer in a rare portrait, *Ophelia Billingsley imperfect in form of body danser from Hindu Kush India East Asia.*

An interesting Yoakum drawing, *Ankaratra Range Antsirabe Malagasy Africa Island*, features an impressionistic rendering of two exotic sideshow attractions from the 1930s—Africa's "Ubangi savages" and Burma's "giraffe women" (plate 5). Ringling Bros. and Barnum & Bailey Circus posters heralded these oddities as "the

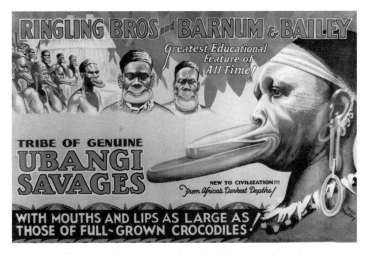

Fig. 21. Ringling Bros. and Barnum & Bailey, *Tribe of Genuine Ubangi Savages*, 1931. Poster. Collection of the Circus World Musuem, RBBB-NL37-31-1F-3. Image reproduced courtesy of Ringling Bros. and Barnum & Bailey Combined Shows, Inc. (Ringling Bros. and Barnum & Bailey and The Greatest Shows on Earth are federally registered trademarks and service marks of Ringling Bros. and Barnum & Bailey Combined Shows, Inc.)

Fig. 22. Ringling Bros. and Barnum & Bailey, *Giraffe Neck Women from Burma*, 1933. Poster. Collection of the Circus World Musuem, RBBB-NL37-33-1F-3. Image reproduced courtesy of Ringling Bros. and Barnum & Bailey Combined Shows, Inc.

greatest educational features of all time" (figs. 21, 22). The large mountain in the right half of Yoakum's landscape somewhat suggests a person's head and neck. It appears to represent the composite image of a Ubangi tribesman's head (distinguished by the grossly distended lips stretched by round wooden plates), which sits on a Burmese woman's elongated neck stretched by multiple rings. An ovoid form in the lower part of Yoakum's mountain resembles the Ubangi's mouth and lips, which were advertised to be "as large as those of full-grown crocodiles." The neck-like appendage decorated with three rings at the base of the artist's mountain form recalls the deformed neck of the human giraffe.

The Circus Spectacle: Mythology, World History, and the Bible

Circus spectacles undoubtedly provided another stimulus to Yoakum's interest in world geography. These little plays or musical dramas had elaborate stage effects and scenery that sometimes took up the entire rear wall of the big circus tent. They commemorated a wide range of events in mythology, world history, and the Bible. The most common spectacles were those portraying mythical events. Generally set in oriental countries like India and China—favorite subjects for Yoakum landscapes—these spectacles had exotically named characters, such as the Princess Bo Phrit-Phra and Calif Adjurbaniphral. They recounted the stories of Aladdin and His Wonderful Lamp, Princess Lallah Rookah from Delhi, the Pilgrimage to Mecca, and Tribute of Balkis, among others. A circus program of the early 1900s rhapsodized about Tribute of Balkis:

> Teeming with life and color and animation and abundantly replete with valuable, instructive and gorgeous sights purporting to be an exact reproduction of the splendid journey of an an-

cient powerful Queen to a mighty sovereign, with all the superb accessories and concomitants accurately represented, according to the best authorities just as it took place twenty-five centuries ago. Truthfully depicted in costumes more comprehensive in arrangement and far beyond more elegant in motion than was ever expressed in history. With all the royal pomp and splendor, magnificence and lavish prodigality characterizing a period of the world's history unexampled for extravagance and riches. Four hundred historical characters correctly costumed representing Philistines, Phoenicians, Egyptians, Sabaenians, Africans, Arabians, Abyssinians, and others together with mounted guards, trumpeters, heralds, charioteers, knights, nobles, high priests, foot soldiers, archers, warriors, idol men, banner bearers, dancing girls, fan girls, swaying houris, pages, household servants, slaves, servitors, horses, sacred beasts, trained animals, triumphal cars, floats, paeons, choruses, etc. The whole forming a brilliant kaleidoscopic vision of animated and iridescent splendor, with every known human and animal accompaniment in vogue with people of that age and clime[13] (fig. 23).

The fan girls and dancers in Tribute of Balkis and other oriental spectacles appear to be a source for the imagery in a series of Yoakum's portraits, *The Only Woman Ruler of Assirea*, also referred to as *The Wonder of Assirea 310 B.C.* (fig. 24). Her headdress, hairstyle, pose, and accouterments somewhat recall those of the exotic dancers in circus posters advertising such spectacles. Like the typical circus figure, the Wonder of Assirea stands with one arm held aloft, the hand clasping a fan-like scepter or torch. Her other arm is bent down, with the hand resting on her waist. Yoakum's mythical ruler's other attributes common to some circus spectacle performers include her single-strand necklace, long, dark, wavy hair, and elaborate headdress complete with a crown

Fig. 23. Barnum & Bailey, *Spectacle of Balkis*, 1903. Poster. Collection of the Circus World Museum, B&B-NL39-03-1F-1. Image reproduced courtesy of Ringling Bros. and Barnum & Bailey Combined Shows, Inc.

Fig. 24. *The Wonder of Assirea 310 B.C.*, 1967. Ballpoint pen, graphite pencil, and colored pencil on paper. 19 x 12 in. Private collection. Photo courtesy of Carl Hammer Gallery, Chicago.

Fig. 25. Ringling Brothers, *Three Famous Aerial Artists*, 1897. Poster. Collection of the Circus World Museum, RB-NL5-97-1U-1. Image reproduced courtesy of Ringling Bros. and Barnum & Bailey Combined Shows, Inc.

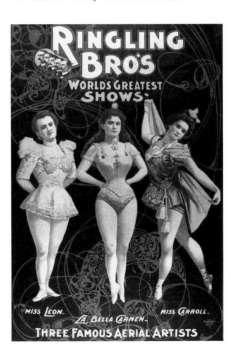

that suggests the cross-shaped fan on the Balkis girls or the swans with outstretched wings on some other circus headdresses. However, the Wonder of Assirea's costume does not resemble the harem pants and veil of circus dancers but rather the leotards worn by the lady aerialists and lion tamers in the show (fig. 25).

Some of Yoakum's landscapes also contain imagery that seems to derive from circus posters advertising oriental spectacles. For instance, a number of his drawings include a fan-shaped tree with five candelabra-like branches that is somewhat reminiscent of the fans held by the dancing girls in the Tribute of Balkis. A good illustration is found in the lower left corner of the artist's landscape *Arakan Mtn Range near Minabu Burma* (fig. 26). Similarly, posters or stage sets for oriental spectacles may be sources for the pagoda-style house that appears in other landscapes, such as *Tower and Mountain Range View of Jehol Proviance in Central Asia* and *Moovie Show Building at Sidney Australia.*

In addition to stories from mythology, another category of spectacles featured actual figures from world history, although "colored up for circus purposes."[14] Historical pageants included Caesar's Triumphal Entry into Rome, Columbus' Discovery of America, the 1776 American Revolution, Custer's Last Battle, the Battle of Wounded Knee, and the Battle of San Juan Hill, to name a few. Yoakum's drawing *this Gunboat were stationed at Santiago de Cuba on Guantanamo Bay until beginning of worlds war one* contains imagery found in several circus posters of the spectacle celebrating the U.S. naval victory at Santiago, Cuba, and the destruction of the Spanish fleet during the Spanish-American War (figs. 27, 28). The artist's gunboat, with its two-gun turrets, waving American flag, and billowing stream of black smoke, is a miniature replica of the poster battleships performing "maneuvers, drill and strategic evolutions . . . just before the fight at Santiago."

Biblical spectacles told the stories of Noah and the ark, David and Goliath, Anthony and Cleopatra, and King Solomon and the Queen of Sheba—perhaps the most famous circus spectacle of all time. Yoakum completed over two dozen landscapes of biblical locations, mostly in Egypt and Palestine. While biblical spectacles may have influenced his choice of subject, the artist also referred to the Bible as his "greatest story book."[15] The biblical references in his drawings seem to have a strong basis in African American culture, a source that is explored in chapter five.

The Center Ring: Menageries and Clowns

For all those artists drawn to the circus, the center ring performers have provided the greatest inspiration. Yoakum was somewhat unusual in this regard, however. Unlike his fellow artists, he was not particularly drawn to the high-wire artists, trapeze flyers, and other circus athletes. He preferred instead the circus menageries, known in colorful circus parlance as the "astounding assemblages of animal aristocracy," and the clowns. Not surprisingly, therefore, a number of Yoakum's landscapes contain abstract forms that suggest circus animals and clowns as they frequently appear in circus posters and other circus advertising art.

The *Illustrated Encyclopedia of Animal Life* found among Yoakum's studio papers at the time of his death may also have sharpened his memories of these circus menageries. This volume includes colored photographs of the elephant, lion, tiger, rhinoceros, and seal that recall images popularized in circus art.

In several Yoakum landscapes the elephant appears in his typical circus pose—with his head and outstretched trunk shown in profile. This pose is captured in many circus posters, such as Sells Floto's announcement of its "quarter million pound act of performing elephants—the most

Fig. 26. *Arakan Mtn Range near Minabu Burma*, 1964. Ballpoint pen and graphite pencil on paper. 30.5 x 45.6 cm. Collection of the Art Institute of Chicago. Bequest of Whitney Halstead, 1979.147.

Fig. 27. *this Gunboat were stationed at Santiago de Cuba on Guantanamo Bay until beginning of worlds war one*, 1969. Ballpoint pen, fiber-tip pen, colored pencil, and chalks on paper. 30.7 x 48.3 cm. Collection of the Art Institute of Chicago. Bequest of Whitney Halstead, 1979.253.

Fig. 28. Barnum & Bailey, *Maneuvers, Drills and Strategic Evolutions of the Splendid American Fleet of Battleships just before the Great Fight at Santiago*, 1899. Poster. Collection of the Circus World Museum, B7B-NL200-99-1F-2. Image reproduced courtesy of Ringling Bros. and Barnum & Bailey Combined Shows, Inc.

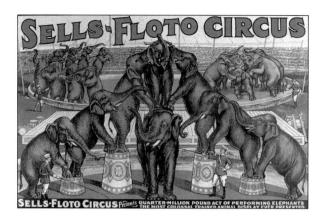

Fig. 29. Sells–Floto, *Sells–Floto Circus Presents Quarter Million Pound Act of Performing Elephants*, 1930. Poster. Collection of the Circus World Museum, SF-NL11-30-1/2F-1. Image reproduced courtesy of Ringling Bros. and Barnum & Bailey Combined Shows, Inc.

Fig. 30. *Zain Grays Ranch in Siskayou County near Susanville California*, 1968. Ballpoint pen, graphite pencil, and colored pencil on paper. 12 x 19 1/16 in. Collection of Gladys Nilsson and Jim Nutt.

Fig. 31. *Crater Head mtns of Honolula Hawaiia*, c.1965. Carbon transfer reinforced with ballpoint pen and colored chalks on paper. 22.8 x 29.9 cm. Collection of the Art Institute of Chicago. Bequest of Whitney Halstead, 1979.205b.

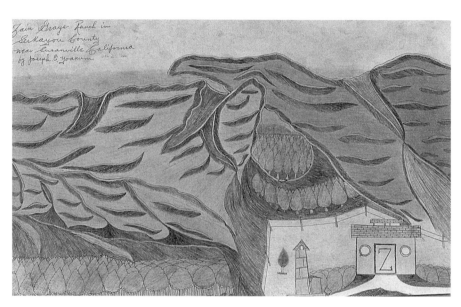

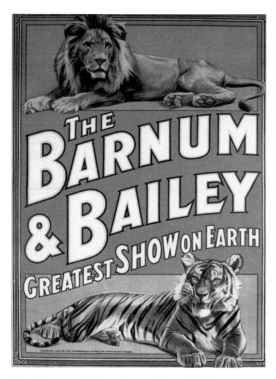

Fig. 32. Barnum & Bailey, *Lion and Tiger*, 1915. Poster. Collection of the Circus World Musuem, B&B-NL44-15-1U-2. Image reproduced courtesy of Ringling Bros. and Barnum & Bailey Combined Shows, Inc.

Fig. 33. Barnum & Bailey, *Giant Rhinoceros*, 1909. Poster. Collection of the Circus World Museum, B&B-NL44-09-1U-2. Image reproduced courtesy of Ringling Bros. and Barnum & Bailey Combined Shows, Inc.

colossal trained animal display ever presented" (fig. 29). Such posters appear to be sources for drawings like *Zain Grays Ranch in Siskayou County near Susanville California* (fig. 30) and *Crater Head Mtns in Andes Mtn Range near Santiaf Chile South America* (plate 6). These landscapes include a central mountain form that somewhat resembles the side view of an elephant's head, facing left, with its trunk raised in the air. An interesting element of the *Crater Head Mtns* composition is that the gray elephant's trunk seems to be curled around a honey-colored striped zebra-like form.

At some time virtually every animal species has been with the circus, and Yoakum's landscapes include an extensive representation. In addition to elephants, there are lions, tigers, rhinoceros, seals, snakes, camels, and monkeys. In his drawing *Crater Head mtns of Honolula Hawaiia*, the

large volcano in the foreground of the composition looks somewhat like the frontal view of an abstract lion head (fig. 31). The large dark area of this volcano may be read as the lion's mane, while the long ovoid-shaped lighter area at the center of the crater suggests his face. At the top of this ovoid-shaped area, the crater's scalloped-edged cone may be read as the lion's forehead. Yoakum indicates the lion's nose with his inclusion of a small tear-shaped form within another, larger, tear-shaped form at the base of the crater. The artist's imaginary lion is portrayed with jaws tightly shut—a pose commonly found in circus posters such as Barnum & Bailey's advertisement that pairs a lion with a tiger (fig. 32).

The profiled head of an impressionistic cocoa-brown rhinoceros seems to thrust out of a rock form in the right half of Yoakum's composition *Mt Shasta of Coast Range near McCloud*

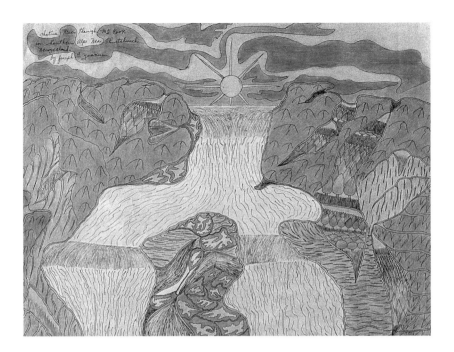

Fig. 34. *Cheta River through Mt Coole in Southern Alps near Christchurch New Zealand*, c. 1969. Ballpoint pen, graphite pencil, and colored pencil on paper. 19 1/16 x 24 1/8 in. Collection of Gladys Nilsson and Jim Nutt.

Fig. 35. Adam Forepaugh and Sells Brothers, *Captain Woodward and Performing Seals*, 1898. Poster. Collection of the Circus World Museum, A4P-NL33-98-1F-4. Image reproduced courtesy of Ringling Bros. and Barnum & Bailey Combined Shows, Inc.

Fig. 36. Sells–Floto, *Monster Sea Elephant*, 1932. Poster. Collection of the Circus World Museum, SF-NL11-32-1/2F-1. Image reproduced courtesy of Ringling Bros. and Barnum & Bailey Combined Shows, Inc.

California (plate 7). The animal's horn, facing left, forms a promontory. His upturned head and slightly open mouth recall a typical pose found in many circus posters, like the galloping rhino depicted in Barnum & Bailey's advertisement from the 1930s (fig. 33). Yoakum's abstract rhinoceros image is repeated in other drawings like *Mt Pikes Peak the Mtn of Pleasure near Colorado Springs Colorado Highest foot Bridge in U.S.A.* In this beautiful landscape the rhino's "head" is painted pale gray (plate 8).

Seals were other center ring performers whose popularity rivaled the elephant's. Two gray mountain forms that somewhat suggest two abstract seal heads dominate Yoakum's landscape *Cheta River through Mt Coole in Southern Alps near Christchurch New Zealand* (fig. 34). A source for this composition may be circus posters, such as an Adam Forepaugh and Sells Brothers portrait of "marvelously educated sea lions and seals" (fig. 35). In this poster, a large seal on the left tilts back his profiled head and opens his mouth to catch a baton from his trainer. The large mountain form on the right half of Yoakum's composition somewhat recalls the pose of the circus poster's open-mouthed seal head. Similarly, the mountain on the left half of his landscape suggests the profiled, upturned head of another seal in the circus poster who keeps his mouth tightly shut while puffing on a cigar. Like circus seal performers that bounce objects on their upturned noses, Yoakum's "seal" mountains almost seem to be taking turns balancing the tiny, ball-like sun above their heads.

The famous Sells–Floto Circus attraction, the "monster sea elephant captured live in the Antarctic," appears to be the source for an abstract seal form in Yoakum's drawing *Turtle Dove Slew in Suwanee River Wilcox Florida* (plate 9). A large, black rock that arches over the river recalls this strange beast with its distinctive hooked proboscis. The seal's wrinkled skin is suggested by a pattern of S and V forms covering the surface

of the rock. His pose is somewhat reminiscent of Sells–Floto's rendering of this "tremendous, living, breathing giant of the sea" (fig. 36).

In circus sideshows, the snake charmer always had a trunk of large snakes, usually pythons and boa constrictors that attained enormous sizes. While rarely depicted as a circus attraction, snakes occasionally are represented in posters, heralds, and other forms of circus advertising art. These appear to be sources for snake images in several Yoakum landscapes. One interesting drawing, *The Apalachicola River near Bluntstown Florida*, contains a full-length view of an abstract snake (plate 10). The reptile seems to slither through the water, its scaly skin indicated by a row of pale green trees. Menacing reptile heads and dancing miniature snakes emerge in other Yoakum drawings as well.

Camels have been fixtures in the circus ever since the mid-nineteenth century when the U.S. cavalry imported them for desert duty in the American West. They also populate a number of Yoakum landscapes. Two abstract, yellow camel heads, pressed together so that their noses and lips are touching, seem to float over the water in the upper right corner of the composition *Nile River near Cairo Egypt and Gulf of Suez* (plate 11). Full-length imaginary camel portraits, including the animal's distinctive hump, may be found in other drawings, such as *Mt Hugnaquilla in Wiklow Mtn Range near Dublin Ireland W. Europe* (fig. 37) and *Brenner Pass of Itley and Auastrian frontier* (fig. 38). In *Brenner Pass,* the mountain on the right half of the composition suggests an abstract camel's head, neck, and oddly shaped humped back—all shown in profile. The "camel" form appears to be nuzzling a large anthropomorphic rock in the left half of the landscape. As if he is savoring this pleasant encounter, the "camel" has closed his "eye," thus revealing his lovely long dark lashes, which the artist indicates with a tiny triangular form filled with hatching. In other

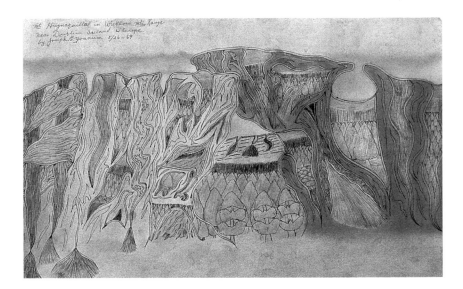

Fig. 37. *Mt Hugnaquilla in Wiklow Mtn range near Dublin Ireland W. Europe*, 1969. Ballpoint pen, graphite pencil, and colored pencil on paper. 12 1/16 x 19 1/16 in. Collection of Gladys Nilsson and Jim Nutt.

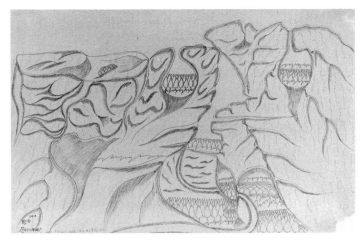

Fig. 38. *Brenner Pass of Itley and Auastrian frontier*, 1965. Ballpoint pen and fiber-tip pen on paper. 30.2 x 45.4 cm. Collection of the Art Institute of Chicago. Bequest of Whitney Halstead, 1979.168.

Fig. 39. Russell Brothers, *Camels*, 1930. Poster. Collection of the Circus World Museum, RUSS-NL46-30-1U-2. Image reproduced courtesy of Ringling Bros. and Barnum & Bailey Combined Shows, Inc.

versions of this composition, Yoakum colors the "camel" mountain either yellow or gold. Golden camels in similar poses are depicted in numerous circus posters, such as advertisements for spectacles like the "orientally splendid and weirdly romantic spectacular Pilgrimage to Mecca" and other camel attractions (fig. 39).

Circus impresario P. T. Barnum referred to the clowns as one of the two pegs on which to hang a circus. In addition to his secret menageries, Yoakum included abstract clown portraits in at least two of his landscapes. Like Ringling Brothers, the artist combines the two essential clown characters of the American circus—whiteface and auguste. The elegant whiteface circus clown covers his neck and face entirely with white and then adds a little touch of color, such as a black eyebrow. Auguste, his bumbling, flamboyant sidekick, uses more grotesque, colorful makeup— black lips, red face, and white only around the mouth and eyes. However, Ringling Brothers blurs these distinctions by adding a lot of color to the makeup of whiteface clowns and a lot of white to the makeup of auguste clowns[16] (figs. 40, 41). Tiny hats complete the costumes of both clown types.

The impressionistic clown in Yoakum's drawing *Coupelow Peak of Rocky Mtn Range near Edson of Alberta Canada* stares directly at the viewer

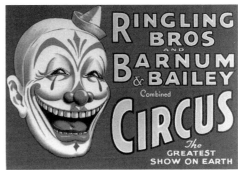

Fig. 40. Ringling Bros. and Barnum & Bailey, *Auguste Clown*, 1944. Poster. Collection of the Circus World Museum, RBBB-NL22-44-1/2U-3. Image reproduced courtesy of Ringling Bros. and Barnum & Bailey Combined Shows, Inc.

Fig. 41. Ringling Bros. and Barnum & Bailey, *Whiteface Clown*, 1937. Poster. Collection of the Circus World Museum, RBBB-NL12-37-1/2F-2. Image reproduced courtesy of Ringling Bros. and Barnum & Bailey Combined Shows, Inc.

Fig. 42. *Coupelow Peak of Rocky Mtn Range near Edson of Alberta Canada*, 1969. Ballpoint pen and colored pencil on paper, 12 x 19 in. Photo courtesy of Fleisher/Ollman Gallery, Philadelphia.

from the center of the drawing (fig. 42). His auguste-like bulbous nose is suggested by a square-shaped clump of large green trees, and his wide smiling mouth reveals a row of teeth delineated by the trunks of the bottom row of trees. His little triangular-shaped hat, more characteristic of whiteface clowns, is perched on top of his head and forms the pinnacle of the pale yellow Coupelow Peak. By contrast, a sad-faced clown peers out from the drawing *The Hills of Old Wyoming in the Valley of the Moon near Casper Wyoming* (plate 12). A tear in the form of a soli-

tary green tree appears to fall from his left eye, recalling the dots of makeup under the eyes of whiteface clowns. However, Yoakum's clown has a bulbous nose and the heavy black semicircles arching high above his eyebrows that are more typical of auguste clowns.

The Aftershow: Wild Wests, Minstrels, and Prizefighters

The tradition of the aftershow was established in the early years of the American circus. Following

Fig. 43. *Chieff Gray Eagle Squaw Wife of Ogalla of Jicarilla Tribe Reservation northe of Concord Newhampshire*, c. 1970. Fiber-tip pen, graphite pencil, and colored pencil on paper. 12 x 18 in. Private collection. Photo courtesy of Carl Hammer Gallery, Chicago.

the center ring performances, for an additional fee, spectators were entertained with concerts, minstrel shows, and even sporting events. Minstrel performers who appeared in circus aftershows are the subjects of several Yoakum portraits.

Originally minstrel shows featured only white performers in blackface. However, after the creation of the Original Georgia Minstrels in 1865, black actors and bands were finally also permitted to perform.[17] Over the next thirty years, dozens of other African American minstrel troupes, such as William McCabe's, added the words "Georgia Minstrels" to their stage names. Yoakum's minstrel portraits use only these black comedians as subjects—from Chick Beaman in William Mc-Cabe's Famous Georgia Minstrels to Lucille Hegamin in Williams and Walker. The latter group, which included Bert Williams, one of America's finest character comedians, is generally regarded as the greatest of all the troupes.

Toward the end of the nineteenth century, minstrelsy was eclipsed by Wild West shows as the most popular form of aftershow entertainment.

Modeled after the first Wild West show introduced by Buffalo Bill Cody in 1883, these circus aftershows were "fast-moving and action-packed, a miniature rodeo of rope-spinning, trick-riding, and bronco-busting."[18] Many Wild West shows also featured exhibitions of shooting skills, reenactments of stagecoach attacks and buffalo hunts with real cowboys and Indians, and even demonstrations of the Pony Express. Among their fans was Paul Gauguin, who wrote to a friend, "I have been to Buffalo [Wild West]. . . . It is of enormous interest."[19]

Historian Joseph Campbell wrote that he "fell in love with American Indians because Buffalo Bill used to come to Madison Square Garden every year with his Wild West Show."[20] Yoakum, who claimed to have worked for a time with Cody's show, must have been equally captivated by the Indians, because he returned to the subject a number of times—most notably in *Chieff Gray Eagle Squaw Wife of Ogalla of Jicarilla Tribe Reservation northe of Concord Newhampshire* (fig. 43). Dressed like the Sioux Indians who performed in Buffalo Bill's Wild West, the artist's squaw and

chief may have been inspired by two of the show's early-twentieth-century posters (figs. 44, 45). *"Arrow-Head" the Belle of the Tribe* depicts an Indian woman with a single feather in her headband, while *Indian Chief* portrays a noble warrior in a feathered war bonnet. However, the Jicarilla tribe, referred to in the title of Yoakum's drawing, was not Sioux, as the artist indicates, but rather Apache, and its reservation was located in northern Arizona, not New Hampshire.

Wild West shows influenced another aspect of Yoakum's oeuvre. Several landscapes depict the homes of the famous Wild West stars Buffalo Bill and Cole Younger, as well as the ranch of the Miller Brothers & Arlington 101 Ranch Real Wild West made famous by the great African American cowboy Bill Pickett. Younger—the former outlaw who rode with Jesse James—was the senior member of the Great Cole Younger and Frank James Historical Wild West and Congress of the Rough Riders of the World, which performed in 1902 and 1903.[21] Yoakum drew two different versions of the Younger home. His landscape *Ranch #101 Red Cloud Nebraska* contains a weathervane with the initials JMA for the Wild West show, Joe Miller & Arlington.

Other aftershow performers represented in Yoakum's oeuvre are former heavyweight boxing champions of the world. One of them, Jess Willard, appeared with the Miller Brothers & Arlington 101 Ranch Real Wild West in 1915 and acquired the show two years later, changing the name to Buffalo Bill Wild West & Jess Willard Show. A Yoakum portrait memorializes Willard, a white man who defeated Jack Johnson, the first African American to hold the world heavyweight title.

The Circus Poster: Composite Formats, Lithographs, and Copyrights

Another element of circus poster art that appears to have influenced Yoakum's oeuvre is the com-

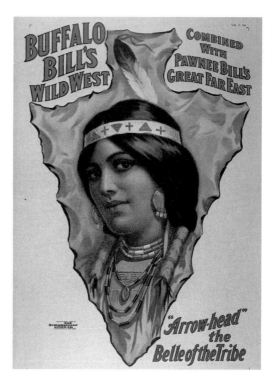

Fig. 44. Buffalo Bill's Wild West, *"Arrow-Head" the Belle of the Tribe*, 1901. Poster. Collection of Circus World Museum, BBWW-NL22-01-1/2U-2. Image reproduced courtesy of Ringling Bros. and Barnum & Bailey Combined Shows, Inc.

Fig. 45. Buffalo Bill's Wild West, *Indian Chief*, 1903. Poster. Collection of Circus World Museum, BBWW-NL30-03-1/2U-2. Image reproduced courtesy of Ringling Bros. and Barnum & Bailey Combined Shows, Inc.

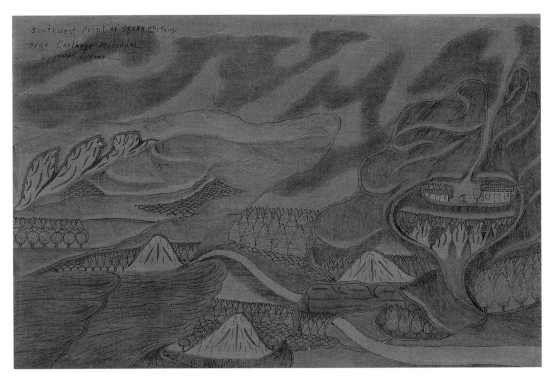

Fig. 46. *Southwest Point of Ozark Mtn Range near Carthage Missouri*, c. 1965. Ballpoint pen, watercolor, and colored pencil on paper. 12 x 18 in. Private collection. Photo courtesy of Fleisher/Ollman Gallery, Philadelphia.

positional technique known as the "picture within a picture." This technique mixes different forms—circle, oval, fan shape, rectangle, and square—one within the other. Once European artists appropriated this compositional style from Japan at the end of the nineteenth century, it eventually found its way into more popular art forms of the period, such as circus advertising art.

In circus posters, an oval, circle, or diamond shape typically was used inside a rectangular surface. The smaller form often contained portraits—either a bust or full-length view—of a single performer or a group of performers. People and animals alike were represented.

This "picture within a picture" technique was also employed to present multiple circus acts by the same performers within a single poster. An example of both applications of this compositional style may be seen in the 1898 Adam Forepaugh and Sells Brothers poster illustrating "the great and only troupe of marvelously edu-

cated sea lions and seals trained by Captain Woodward and performed by his talented sons" (fig. 35). Yoakum also used the technique in many landscapes. For instance, in *Southwest Point of Ozark Mtn Range near Carthage Missouri,* the artist places a tear-shaped form inside a rectangle (fig. 46). The tear-like form encloses a miniature scene with two buildings, a well, and trees—all of which appear to be floating on top of an abstract sectional view of the earth's interior. The drawing *Eastern Alps of Itely* provides an example of the oval format inside a rectangle, where the oval contains a little view of a log cabin beside a woodpile and ax (plate 13).

While no actual proof has been found of Yoakum's employment with a circus lithography company, a striking parallel exists between his earliest known works and the lithographer's art. His style of flat, line drawing, mostly in graphite pencil or ink with occasional splashes of watercolor, and his technique of tracing original designs both

Fig. 47. *Catskill Range near New Hampshire*, c. 1965. Ballpoint pen and watercolor on paper. 9 x 12 in. Collection of Gladys Nilsson and Jim Nutt.

recall the first stages of the lithography process used to make circus posters. That process began with an original design done in graphite pencil, followed by a watercolor proof. The design was then enlarged by means of a photographic slide, projected onto a wall, and traced in black crayon either onto paper, or directly onto the lithograph stone for printing.[22]

Somewhat similar to original lithographic poster designs and lithographic cartoons, Yoakum's early landscapes are predominantly line drawings executed in graphite pencil or ink on paper. Watercolor, another lithographer's medium, is occasionally added. Usually his colors are thinly applied, like washes, which allows the line to show through. An example of this approach is found in *Catskill Range near New Hampshire*, a landscape that approximates the lithographer's study drawing (fig. 47). In addition, Yoakum sometimes copied his favorite original designs by covering them with sheets of carbon paper. This process was reminiscent of making lithographic cartoons.

A departure from the lithographic process was the artist's tendency to use a different palette in his copies, thereby transforming them into essentially new drawings. A beautiful illustration occurs in two versions of *Jehol Mtn in Kuntsing Mtn Range near Tsingkin proviance of China Asia* (plates 14, 15). While the drawings are identical in

design, the predominant hue is a golden apricot in one and turquoise blue in the other. Scenes of Hawaiian volcanoes and the Brenner Pass in northern Italy, an area visited by Buffalo Bill's Wild West, were favorite subjects for copying as well.

From his experiences as a circus billposter, and possibly also as an employee with a lithography company, Yoakum developed "an obsession with copyright."[23] In 1900 a federal court decision denied U.S. copyright protection to circus posters as advertising.[24] As a result, competing firms routinely copied unprotected designs. The real monetary value, therefore, flowed not from the designs themselves, but from the thousands, sometimes millions, of copies. Indeed, Yoakum later expressed the view that reproductions were the only way an artist could really make money on his work.

Before U.S. copyright laws were amended to protect advertising art, lithography companies sometimes copyrighted circus posters, although the circuses really owned the artwork. Generally, the lithography companies affixed their copyright label in the lower right or left corner of their poster designs. Sensitive to the need to protect his own work, Yoakum similarly labeled a number of his drawings "copyrighted," using the copyright symbol. However, he actually copyrighted only one drawing, *Brenner Pass.* Since the copyright fee of four dollars greatly exceeded the fifty cents or a dollar he commanded for a single work in 1965, it is understandable that he did not copyright others. Whitney Halstead recalled that the artist sometimes sold drawings with a copyright label, but only if he were assured that the buyer would not resell or copy them for resale.[25] Nevertheless, throughout his career as an artist, Yoakum was continually plagued by the fear that his drawings would be reproduced as prints, thus enabling others to reap all the financial rewards from his artistic endeavors.[26]

The Artist and the Railroad

Every time de trains pass
I wants to go somewhere.
—Langston Hughes, "Homesick Blues"

When a woman gets the blues
She hangs her head and cries.
When a man gets the blues,
He catches a train and rides.
—Ballad

The [train] window was a frame, and I was able to get my full share of visuals. . . . I cherished
looking out of the window at all those small-town backsides—the angle of vision gave me
some sense of power and freedom—newfound values.
—John Baeder, Diners

Thomas Hart Benton—one of America's finest history painters and Yoakum's contemporary—described the railroad's importance to the Midwest of their youth: "For the nomadic urges of our western people, the prime symbol of the adventurous life for years has been the railroad train. . . . [A]ll during my boyhood it was the prime space cutter and therefore the great symbol of change. . . . For all bitten with the urge to pull up stakes and be done with familiar boredoms . . . the steam train bearing down on a station or roaring out of a curve of the hills, or disappearing over a distant ridge, was a thing replete with suggestive motion."[1]

When trains passed through small midwest-

ern towns, young boys often waited to greet them. Traveling to faraway places seemed glamorous and filled with opportunities for a more exciting life. Benton and Yoakum, like other boys who watched wistfully as the trains sped by, eventually became inveterate travelers. As artists they also liked to use railroad imagery in their work.

When Yoakum's youthful travels began, circuses were growing as fast as the railroads allowed. Circus trains often raced hundreds of miles in a single night to reach their next destination. Special excursion trains brought even bigger audiences to the performance location from the surrounding towns. At the time of Yoakum's birth, only seven of the one hundred or so circuses were

Fig. 48. Adam Forepaugh, *Cheap Excursions to the Great 4-Paw Wild West Shows*, 1887. Poster. Collection of Circus World Musuem, A4P-NL22-87-1/2U-1. Image reproduced courtesy of Ringling Bros. and Barnum & Bailey Combined Shows, Inc.

Fig. 49. *Tishimingo Tunnel near Tishimingo Oklahoma*, 1964. Ballpoint pencil, graphite pencil, and watercolor on paper. 12 x 18 in. Collection of Gladys Nilsson and Jim Nutt.

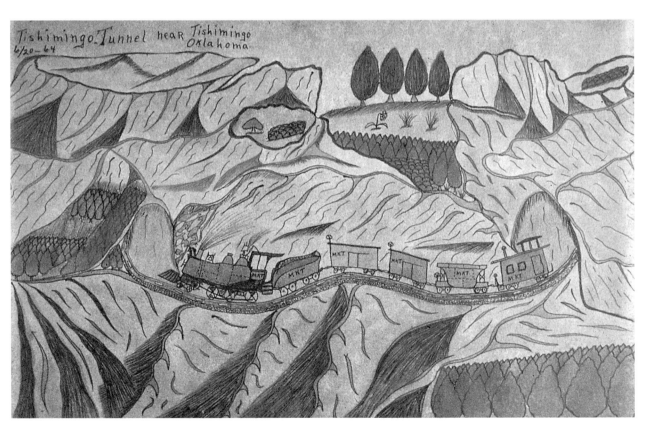

large railroad shows. However, there were nearly five times as many railroad shows by 1911 when the artist retired from circus life.[2]

Railroad circus posters appear to be sources for a number of Yoakum landscapes with train imagery. For example, the grouping of engine, coal car, and passenger car from the Adam Forepaugh and Sells Brothers poster *Cheap Excursions to the Great 4-Paw Wild West Shows* (fig. 48) is repeated in such works as *Tishimingo Tunnel near Tishimingo Oklahoma* (fig. 49). Many such Yoakum drawings include in their titles the names of the Atchison, Topeka and Santa Fe Railway, which was the primary carrier in the Southwest. All but one of the great circuses with which Yoakum was associated traveled its routes. The line passed through some of the most spectacular scenery in the region, including the sacred lands of the Navajo.

Other Yoakum landscapes with railroad imagery identify the main lines serving the Midwest—the Missouri, Kansas and Texas (M.K.T.) and St. Louis & San Francisco Railways (Frisco). The M.K.T. ran through many cities and towns depicted by the artist, including Ft. Scott, Kansas, Yoakum's home during his early manhood. Likewise, the Frisco reached numerous locales represented in Yoakum landscapes, such as Fulton, Missouri, a town in which he once claimed to have worked.

The Railroad and the Fine Arts

From their infancy, the railroads fostered tourism as a way to increase ridership and revenues. By the 1850s, they had begun to hire celebrated photographers and painters to help advertise the scenic wonders along their routes.[3] At the end of the nineteenth century, the American landscape painter Thomas Moran and the photographer William Henry Jackson were among the best known of these railroad artists. Just as they influenced each other's work, so Yoakum appears to have been inspired by the reproductions of their art in the advertising material distributed free by the western railroads on which he traveled. He also believed that his landscapes, like theirs, were suitable for reproduction in calendars, postcards, and other tourist literature.

At the time of Yoakum's birth, competition for passenger and railroad traffic in the West had become so intense that regional guidebooks were often given away free to the public.[4] In the period coinciding with Yoakum's circus travels, the most popular giveaways had lengthy titles reminiscent of those the artist later wrote on his landscapes, such as *What may be seen Crossing the Rockies en route between Ogden, Salt Lake City and Denver.*

To further boost tourism, the railroads actively campaigned to create and protect the national parks that eventually became the major tourist attractions along their routes.[5] They and the U.S. Geological Service commissioned landscapes of these scenic areas that helped persuade the U.S. Congress to establish the first national parks in the region, including Yellowstone, Grand Canyon, Rocky Mountain, Zion, and Bryce Canyon. These western parks are among Yoakum's most frequent landscape subjects, after his home state of Missouri.

One of Yoakum's few direct references to the influence of railroad art on his oeuvre is found in the drawing entitled *Missouri-Kansas-Texas Railway Route from Parsons Kansas to Paris Texas on 10th month and 8th day 1955 by request of MKT Advertising Department.* However, the debt Yoakum's art owes to these sources may be seen in the similarities of subject matter, composition, palette, and various design elements, such as the leafless tree, perched rock, arch, rainbow, road, and small foreground animals, in addition to the train. The influence of railroad art may also be observed in the artist's use of elaborate titles in his landscapes and his preference for composite formats similar to those used in circus advertising art.

Fig. 50. *Devil's Gate on the Sweetwater*, n.d. Wood engraving from *The Pacific Tourist*, New York, 1882–1883. Collection of the Huntington Library, San Marino, California. RB337.

Fig. 51. Castle Gate, D&RG RY, Colorado, n.d. Postcard. Collection of the California State Railroad Museum, Sacramento.

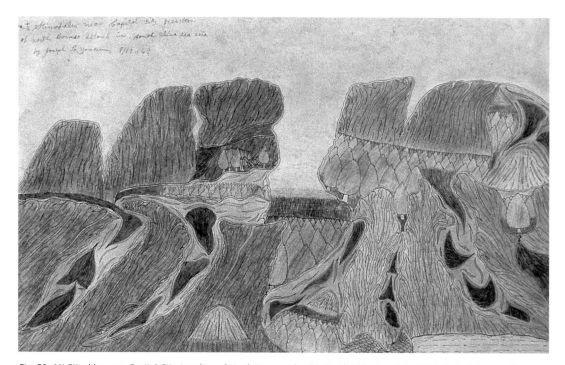

Fig. 52. *Mt Stinoblan near Capital City Jesselton of North Borneo Island in South China Sea Asia*, 1969. Ballpoint pen and colored pencil on paper. 12 x 19 in. Collection of Gladys Nilsson and Jim Nutt.

Fig. 53. *Cambrian Mtn Range near Denbiga (British Wales)*, c. 1965. Ballpoint pen and graphite pencil on paper. 12 x 18 in. Collection of Philip Hanson.

Composition and Railroad Art

Like others of his generation, Yoakum developed an appreciation of American landscape that was partly shaped by exposure to railroad advertising art. In the 1890s, significant advances in the publishing industry permitted widespread use of mass-reproduction techniques that marked an important milestone in Americans' exposure to landscape. Photographic images became as easy and cheap to reproduce as wood engravings. While this technological breakthrough enabled wider dissemination of views to the public, it also resulted in the use of more standardized scenes from a smaller number of photographers, like Jackson, who were successful in adapting to the new age of mass marketing. Popular understanding of landscape underwent a further transformation as the images produced by Jackson and other commercial photographers were reduced in size, cropped, and had text added for their conversion into picture postcards.

While Yoakum never copied these mass-marketed scenes, he was clearly influenced by their compositions. For example, in various landscapes he employs a format with a teapot or mitten-shaped mountain that is found in multiple western views, including *Gateway to the Garden of the Gods* and *Devil's Gate on the Sweetwater* (fig. 50). These scenes were reproduced in many guidebooks, as well as in numerous postcards (fig. 51). The composition features two distinctive rock forms, one shaped like a teapot or mitten, which are separated by a railroad, distant mountains, or a lake. Usually, the top of the second rock is rounded, but in some views it has three distinct contours, creating a scalloped effect. This format may be seen in Yoakum landscapes like *Mt Stinoblan near Capital City Jesselton of North Borneo Island in South China Sea Asia* (fig. 52) and *Cambrian Mtn Range near Denbiga (British Wales)* (fig. 53).

In another, slightly different composition, the teapot-shaped mountain is replaced with a rock form cropped to resemble a triangle with one of its points tilted to the left towards its partner. An early example of this format occurs in Thomas Moran's engraving *The Cliffs of Echo Canyon, Utah*, from *The Pacific Tourist* and numerous post-

Fig. 54. Thomas Moran, *The Cliffs of Echo Canyon, Utah*, c. 1882. Wood engraving from *The Pacific Tourist*, New York, 1882–1883. Collection of the Huntington Library, San Marino, California. RB337.

Fig. 55. *Mt Blanc Grainan Alps near Chemoix France*, c. 1965. Ballpoint pen and graphite pencil on paper. 12 x 18 in. Collection of Philip Hanson.

Fig. 56. *View of the Arctic Ocean at Sydnia Australia*, 1970. Ballpoint pen and colored pencil on paper. 12 x 18 in. Collection of Ellen and Leslie Kreisler. Photo courtesy of Fleisher/Ollman Gallery, Philadelphia.

card views (fig. 54). Yoakum re-creates it in such works as *Mt Blanc Grainan Alps near Chemoix France* (fig. 55) and *View of the Arctic Ocean at Sydnia Australia* (fig. 56).

Perhaps the most frequently mass-produced view is of two rounded mountains, usually separated by a river, road, railroad tracks, or some combination thereof. The conjunction of these peaks produces a V or U shape that often is filled with smaller hills or trees. This composition is repeated in another Moran engraving, *American Fork Canyon* (fig. 57) from *The Pacific Tourist*, as

well as in many later postcard and album views (fig. 58). It also appears frequently in Yoakum's oeuvre, in such drawings as *Gascanade River in Ozark Mtn Range at Newburg Missouri on Frisco Railroad* (fig. 59), *Pine Mountain near Middleboro Kentucky* (fig. 60), and *Spectacular Royal Gorge of Colorado Rockey Mtn Range* (fig. 61). In *Spectacular Royal Gorge,* a river runs parallel to railroad tracks between two mountains shaped like teapots. The composition appears to derive from a postcard view, *Highest Bridge in the World from the Bottom of Royal Gorge, Colorado* (fig.62). The

Fig. 57. Thomas Moran, *American Fork Canyon*, c. 1880. Wood engraving from *The Pacific Tourist*, 1882–1883. Collection of the Huntington Library, San Marino, California. RB337.

Fig. 58. *Georgetown Loop and Gray's Peak Road*. Hand-colored photograph from Denver & Rio Grande Railroad album Crest and Chasm, 1914. Collection of the Colorado Historical Society, Denver. MSS 513, Box 63, Folder 2531.

Fig. 59. *Gascanade River in Ozark Mtn Range at Newburg Missouri on Frisco Railroad*, c. 1967. Ballpoint pen and colored pencil on paper. 12 x 19 in. Collection of Mr. and Mrs. D. R. Milton. Photo courtesy of Fleisher/Ollman Gallery, Philadelphia.

Fig. 60. *Pine Mountain near Middleboro Kentucky*, 1964. Ballpoint pen and graphite pencil on paper. 9 x 12 in. Collection of Philip Hanson.

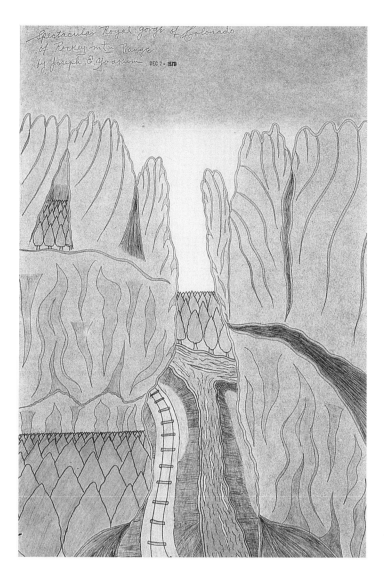

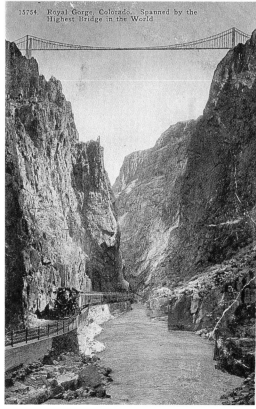

Fig. 61. *Spectacular Royal Gorge of Colorado Rockey Mtn Range*, 1970. Ballpoint pen, fiber-tip pen, and colored pencil on paper. 19 x 12 in. Collection of Harmon and Harriet Kelley.

Fig. 62. *Highest Bridge in the World from the Bottom of Royal Gorge, Colorado*, n.d. Postcard. Collection of the California State Railroad Museum, Sacramento.

Fig. 63. William Henry Jackson, *The Black Cañon of the Gunnison*, 1881. Collection of the Colorado Historical Society, Denver. Album No. 57, Jackson 1052.

WALLS OF THE CAÑON, GRAND RIVER

Fig. 64. *Walls of the Canyon, Grand River*. Handcolored photograph from album *Rocky Mountain Views on the Denver & Rio Grande—the Scenic Line of the World*, 1914. Collection of the Colorado Historical Society. MSS 513, Box 63, Folder 3187.

postcard's dappled gray and brown mountains receive an impressionistic treatment in the artist's rendering, however.

In another variation of this composition, a lake is included in the foreground. An early use of this format is found in an 1881 Jackson photograph, *The Black Cañon of the Gunnison*—a possible source for a Thomas Moran engraving and many later postcard and album views distributed by the Denver & Rio Grande and other western railroads (figs. 63, 64). Yoakum employs a similar composition in numerous landscapes, including *Persimmon Valley Chillacothie Missouri* (fig. 65)

and *Mt. Tohakum Park 8170 ft near Pyramid and Lake Oslo Nevada* (plate 16).

An early Jackson photograph, *The Devil's Gate, Weber Cañon*, contains yet another variation of the composition with two large mountains or rocks that is repeated in many railroad views and Yoakum landscapes (fig. 66). In this format, the mountains or rocks are placed side by side with a space in between. The artist employs this format in drawings like *Mt Sheridan in Gallation Mtn Range and Yellow Stone National Park near Canyon Wyoming* (plate 17). In some of these works, the artist creates a space between the two mountains

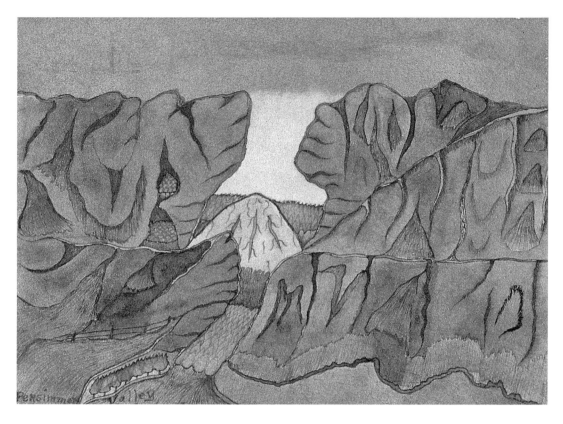

Fig. 65. *Persimmon Valley Chillacothie Missouri*, c. 1965. Ballpoint pen and watercolor on paper. 9 x 12 in. Collection of Gladys Nilsson and Jim Nutt.

Fig. 66. William Henry Jackson, *The Devil's Gate, Weber Cañon*, 1869. Collection of the U.S. Geological Survey Photographic Library, Denver, Colorado. Jackson 35.

Fig. 67. *"Agassiz" Column, Yosemite*, n.d. Lithograph from cover of "Yosemite and the Big Trees of California" (travel brochure), 1881. Collection of the California State Railroad Museum, Sacramento.

Fig. 68. Carleton E. Watkins, *"Agassiz" Column, Yosemite*, 1878. Albumen print. 14 5/16 x 4 15/16 in. Collection of J. Paul Getty Museum, Los Angeles. Accession no. 92. XM.81.4.

that is sufficiently wide to accommodate another large mountain or rock or several smaller ones. A large kidney-shaped rock placed between two mountains in the drawing *Mt Sheridan* somewhat resembles a boulder known as the Agassiz column that is pictured in an 1881 railroad travel brochure, "Yosemite and the Big Trees of California," as well as in period photographs commissioned by the Union Pacific Railroad (figs. 67, 68).

A large mountain placed on a central axis is a format used in a number of Yoakum's horizontal compositions, such as *Syrian Desert Namrath Syria of Saudi Arabia S.E.Q.* (fig. 69). This composition is typical of many mountain views distributed by the railroads, including the photograph of the Mountain of the Holy Cross that was reproduced in a popular 1910 guidebook from the Denver & Rio Grande Railroad (fig. 70). Like the artist's drawing, this album photograph shows a large mountain, cropped at the base, which fills the entire composition.

In the 1870s, Jackson and Thomas Moran immortalized the Mountain of the Holy Cross, known for the distinctive cross, formed by fallen snow, on its eroded face.[6] Yoakum's version, *Mt of the Holy Cross near Basalt NW Red Clay Mounds* (plate 18), contains elements of an 1874 Moran drawing (fig. 71) and of a 1914 album view distributed by the Denver & Rio Grande Railroad (plate 19). Like the album view, the artist's reddish-brown mountain assumes a triangular shape, but is missing the snowy cross on its face. By contrast, Moran's mountain contains the cross, but is partially obscured by clouds and other dark mountain forms. Moran's rendering also includes a small rocky mound that projects into the swirling clouds just below the cross. In Yoakum's drawing, this secondary cone-shaped mound occurs as well, but is painted olive green and is much larger than in the Moran work. Yoakum's mound seems to transform into the snout of an impressionistic totem-like coyote head. Two tree-filled cutaway sections of the larger reddish-

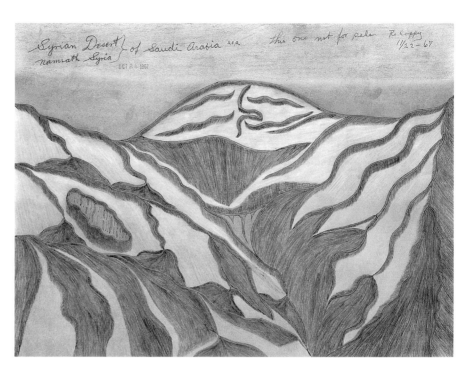

Fig. 69. *Syrian Desert Namrath Syria of Saudia Arabia S.E.Q.*, 1967. Ballpoint pen, colored pencil, and watercolor on paper. 12 x 14 1/2 in. Collection of Langford Wilson. Photo courtesy of Fleisher/Ollman Gallery, Philadelphia.

Fig. 70. *Mountain of the Holy Cross*. Photograph from album *Among the Rockies, Photographic Views of Magnificent Scenery in the Rocky Mountains As seen between Denver, Colorado, and Salt Lake City, Utah, Along the Line of the Denver & Rio Grande Railroad*, 1910. Author's collection.

Fig. 71. Thomas Moran, *Mountain of the Holy Cross*, 1874. Wash drawing (unlocated). From photograph. Photo courtesy of the Gilcrease Museum, Tulsa, Oklahoma. 1616.625.

brown mountain behind this conical mound in Yoakum's version may be read as the coyote's eyes, while upper portions of that mountain may be read as his pointed ears.

Railroad advertising art of the late nineteenth and early twentieth centuries also employed the compositional technique known as the "picture within a picture" that is found in circus advertising art. Yoakum's extensive use of this compositional style is discussed in chapter 2.

Palette and Railroad Art

Describing Yoakum's powers as a colorist, Whitney Halstead wrote, "Although rarely stronger than a tint, his sense of color was as singular, as individual as any Fauve or Expressionist."[7] The artist's soft pastel tones suggest the delicate hand-painted photographs and postcards distributed by the railroads. Likewise, his innovative use of color—creating mountains of pale pink, lavender, orange, and bright turquoise, for example—seems to draw inspiration from this source. However, Yoakum's colored images are uniquely his own.

Before the 1930s, when no practical means existed to commercially produce color photographs, hand-coloring monochrome images satisfied the public's demand for color. Known as the father of the picture postcard, William Henry Jackson—the most influential railroad photographer of the period—loved color. During the first two decades of the twentieth century, millions of his hand-colored images were reproduced as photographs and postcards, often colored by other artists or by coloring firms. The railroads used these color images to entice Americans to visit the natural wonders along their routes.

Reminiscent of Fauvism and Expressionism, which flowered during this period, hand-colored postcards showed natural objects, such as rocks and trees, not as they appear in nature but bathed in startling colors, like chartreuse, lavender, and orange. Like the Expressionists, the photographic colorists did not mix their colors, but laid them side by side, so that each tone was intensified.[8] The unusual colors applied to landscape photographs enhanced the beauty of the natural forms, and the results often rival the best modern color photography.[9]

Yoakum never copied hand-colored photographic images, but his palette sometimes seems to have found inspiration in their unusual juxtaposition of colors. As an illustration, his drawing entitled *Island of Sardinia in Mediterranean Sea Close to Italy* (plate 20) recalls an early postcard of Crater Lake, near Ashland, Oregon (plate 21). The drawing's palette of colors—lemon yellow, cobalt blue, and beige—mirror those of the postcard (as does its composition), although the subject matter, of course, is different. In both works, an oval-shaped body of water fills the center of the composition. Surrounded by beige mountains accented with bright yellow, the dark blue water is punctuated by a small island at its center that is tinted like the mountains. A pale blue sky that fades to pink engulfs the land and water.

A palette of soft orange and gray commonly used in early postcards and hand-colored photographs is found in several Yoakum landscapes, such as *Mt Baykal of Yablonvy Mtn Range near Ulan-ude near Lake Baykal of Lower Siberia Russia E. Asia* (plate 22). In this vertical composition, two gray mountain forms are separated by a sky that bleeds from light blue to orange. A similar postcard view from the 1920s depicts a scene of Davidson Glacier, Alaska, with two gray mountains silhouetted against a sky tinted like Yoakum's (plate 23).

Design Elements and Railroad Art

Various design elements found in railroad art, such as the so-called perched rocks, recur in Yoakum's landscapes. Large boulders have always featured prominently in western landscape. In the 1860s and 1870s, artists and photographers began to make rock portraits, particularly of boulders

precariously balanced on protruding ledges.[10] Such portraits often were meant to symbolize industrialized society's transformation of the western wilderness. Later on, such rock images were reproduced in picture postcards and album views. Similar examples are found in Yoakum's art. For instance, a centrally placed perched rock is the focal point of Jackson's photograph *Balanced Rock, Garden of the Gods* (fig. 72) and of Yoakum's drawing *Weeping Pebble of Sira Range on Lake Shasta in Nevada State* (fig. 73).

Thomas Moran and Yoakum treat the perched rock as a secondary element in several other beautiful landscapes. For example, in Yoakum's *Weeping Pebble of Sirrea Range* (plate 24) and *Weeping Pebble of Sirrea Range in Virginia Park Nevada* (plate 25), larger mountains and vegetation engulf a tiny rock placed off center in the composition. Similar formats are used in such Moran works as *Shin-Au-Av-Tu-Weep, or "God Land," Cañon of the Colorado, Utah Territory* (fig. 74).

Fig. 72. William Henry Jackson, *Balanced Rock, Garden of the Gods*, after 1890. Collection of the Colorado Historical Society, Denver. Jackson 2163.

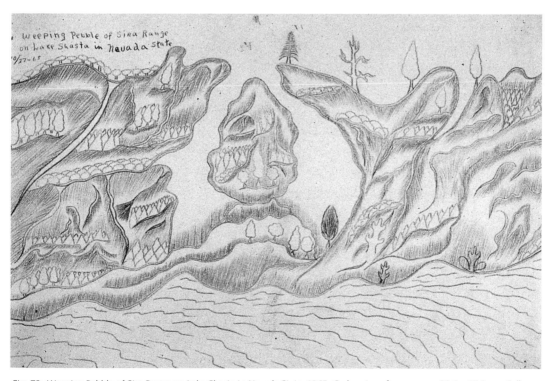

Fig. 73. *Weeping Pebble of Sira Range on Lake Shasta in Nevada State*, 1965. Carbon transfer on paper. 30.6 x 45.8 cm. Collection of the Art Institute of Chicago. Bequest of Whitney Halstead, 1979.225.

Fig. 74. Thomas Moran, *Shin-Au-Av-Tu-Weep, or "God Land," Cañon of the Colorado, Utah Territory*, 1873. Watercolor and graphite on paper. 12.2 x 36.9 cm. Collection of the National Museum of American Art, Smithsonian Institution. Gift of Dr. William Henry Holmes, 1930.12.42.

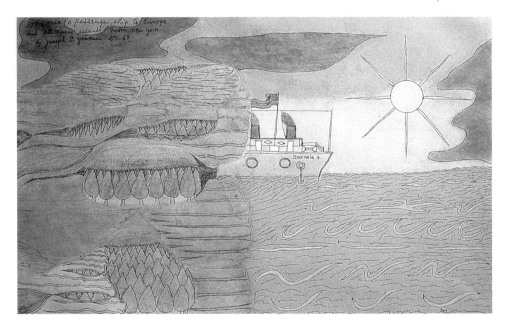

Fig. 75. *Saxonia A Passenger Ship to Europe and Philippines Islands*, 1969. Ballpoint pen, graphite pencil, and colored pencil on paper. 12 x 18 in. Collection of Gladys Nilsson and Jim Nutt.

Fig. 76. Dale Creek, Wyoming, n.d. Postcard. Collection of the California State Railroad Museum, Sacramento.

Other Yoakum rock forms seem to derive from such nineteenth-century sources that were later used in postcard views. For example, in his landscape *Saxonia A Passenger Ship to Europe and Philippines Islands* (fig. 75), a large rock form resembles many images found in postcard views distributed by the western railroads (fig. 76).

Like the perched rock, the tower was a common motif in nineteenth-century landscapes, being used as a metaphor for God.[11] Some biblical texts specifically refer to God as the "high tower."[12] Moran and Jackson recorded many tower-like rock views that found their way into railroad literature and later into Yoakum landscapes. For instance, the cone-shaped rock in Moran's watercolor drawing *The Liberty Cap and Clematis Gulch* (fig. 77) and in Jackson's photograph of the same subject (fig. 78) is also represented in Yoakum's drawing *Mt Liotian in Greater Khiangian Mtn Range near Tritsihar Deep Southern China East Asia* (plate 26). The cone-shaped rock in the center of Yoakum's composition has a mouth-like form filled with green trees. This form mirrors the horizontal indentation across the middle of the Liberty Cap tower in Jackson's photograph and in Moran's drawing.

The natural arch, another favorite motif of western landscape artists, also figures in Yoakum's landscapes. Often sacred to Native Americans, these arches served as earthly metaphors for stability and harmony in nineteenth-century American paintings.[13] Similar ovoid-shaped arches appear in the artist's oeuvre, such as in his drawing *Rain Bow Bridge in Bryce Canyon National Park near Henriville Utah* (plate 27). This composition appears to be based on many views of natural arches from picture postcards and tourist guides distributed by western railroads.

Another favorite nineteenth-century motif was the rainbow.[14] Like the curved rock arch, the rainbow signified stability and harmony. In Yoakum's drawing *Mt Atzmon on Border of Lebanon and Palestine SEA*, a large rainbow

Fig. 77. Thomas Moran, *The Liberty Cap and Clematis Gulch*, 1871. Watercolor and graphite pencil on paper. 17.5 x 25.4 cm. U.S. Department of the Interior, Yellowstone National Park, Wyoming.

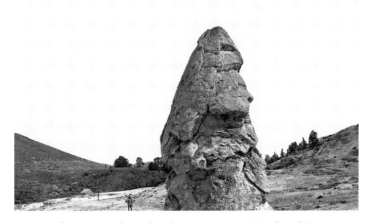

Fig. 78. William Henry Jackson, *The Liberty Cap*, 1871. U.S. Geological Survey Photographic Library, Denver. Jackson 204.

arches over the rocky terrain, similar to those in nineteenth-century landscape paintings later popularized by the major railroads (plate 28).

The leafless, dying tree is another pictorial element commonly found in nineteenth-century paintings and railroad art, as well as in Yoakum's drawings. Often inserted as a memorial object in these earlier landscapes, this tree form does not seem to have the same iconographical significance in the artist's work, however. The tree is repeated in numerous landscapes, such as *Mt Monte Rosa in Graino Alps near Little St Bernardo Pass and Aosta*

Fig. 79. *Mt Monte Rosa in Graino Alps near Little St Bernardo Pass and Aosta Italy W. Europe*, 1967.
Ballpoint pen and colored pencil on paper. 12 x 19 in. Collection of Gladys Nilsson and Jim Nutt.

Fig. 80. Thomas Moran, *Solitude*, 1869. Lithograph.
52.1 x 40.6 cm. Collection of the Gilcrease Museum, Tulsa,
Oklahoma. 1426.635.

Italy W. Europe (fig. 79). Typically, Yoakum pairs a dying tree with a living one, in the manner of many nineteenth-century landscapes, like Moran's lithograph *Solitude*, in which the two trees serve as a metaphor for a man's life and death (fig. 80).

The diagonally oriented road in the immediate foreground was a device used in nineteenth-century landscapes to create perspective.[15] Likewise, in many Yoakum landscapes, curvilinear roads disappear over or behind mountains and trees, leading the viewer's eye back into the picture. His roads are drawn mostly in isometric perspective—a method for suggesting an object's extension into space where there is no diminution of one-point perspective, as illustrated in *The Hills of Old Wyoming* (plate 12). Simply put, the lines of the road remain parallel, rather than becoming closer, as they seem to extend into depth. Other characteristics of the artist's roads are their diagonal orientation and colors that range from white and ivory to buff.

Yoakum appears to borrow yet another motif, small foreground animals, from nineteenth-century landscapes. Favorite animals include the squirrel, bird, turtle, and snake. For example, he groups a tiny squirrel with a cactus and flowering plants in the right foreground of his landscape *Weeping Pebble of Sirrea Range in Virginia Park Nevada* (plate 25). Miniaturized portraits of a squirrel, porcupine, and bird similarly appear in *Northern Tip of Rockey Mtn Range near Juneau*

Alaska. A tiny dancing snake and squirrel cavort together in *Fertel Loabs of Grand Prairie Nebraska*.

As in railroad art, many Yoakum landscapes feature the train winding through spectacular mountain scenery. In many nineteenth-century railroad views, the train becomes a metaphor for the nation's journey from a rural to an industrial society. David Strother, one of the first artists hired by a railroad, expressed this idea: "The iron horse and Pegasus have trotted side by side, puffing in unison, like a well-trained pair. We believe it marks the commencement of an era of human progress."[16] By contrast, Yoakum's trains often seem to symbolize his yearning to live a free life.

As nineteenth-century paintings and prints were transformed into twentieth-century picture postcards, titles were added as a design element. They occur in almost all Yoakum drawings as well. Borrowing from postcard titles, the artist names mountains and mountain ranges and sometimes includes their heights, as well as giving the names of nearby cities, towns, or national parks. Occasionally, he even identifies the country of origin and the continent. His phraseology also often mimics that of postcards. Some examples are *Mt Pikes Peak the Mtn of Pleasure near Colorado Springs Colorado Highest foot Bridge in U.S.A.* (plate 8) and *What I saw in Alberta B.C. Pacific Coastal Range*.

Yoakum typically did not determine in advance the location he wanted to draw. The title usually was selected after the work was completed, but there were a few exceptions. In fact, some landscapes derive not only their titles and subject matter but also their overall composition from picture postcards. For example, a postcard view entitled WE GOT OUR KICKS ON ROUTE 66 appears to have been a source for Yoakum's landscape *Route 66 via Albuquerque New Mexico* (figs. 81, 82). Each composition shows a vehicle following another one along the highway. In the artist's version, a truck and mountainous terrain replace the second car and the map of the United

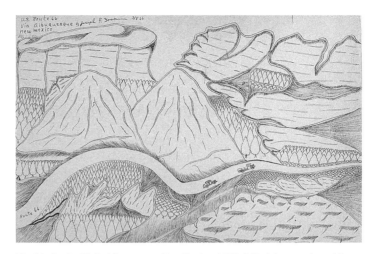

Fig. 81. *Route 66 via Albuquerque New Mexico*, 1965. Ballpoint pen and graphite pencil on paper. 12 x 18 in. Collection of Gladys Nilsson and Jim Nutt.

Fig. 82. WE GOT OUR KICKS ON ROUTE 66, n.d. Postcard. Author's collection.

States. In both views, Route 66 runs in curvilinear fashion across the composition. Of the thirteen cities identified in the postcard, only Albuquerque is mentioned in Yoakum's drawing, however.

The Saltair Pavilion and bathing resort at the Great Salt Lake is the subject of two Yoakum drawings that also relate to postcard views. Easily accessible by train, the Saltair was first opened in 1893. The *Deseret News* captured its spellbinding effect on the public: "The magnificent pavilion, rising, Venice-like, out of the waves in stupendous and graceful beauty, deepened in its semi-Moorish architectural lines the suspicion that what one saw was not firm structural reality but rather a delightful oriental dream."[17]

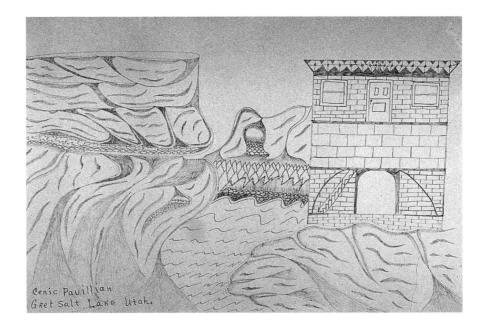

Fig. 83. *Cenic Pavillian Gret Salt Lake Utah*, c. 1964. Ballpoint pen and fiber-tip pen on paper. 30.2 x 45.3 cm. Collection of the Art Institute of Chicago. Bequest of Whitney Halstead, 1979.169.

Fig. 84. Saltair Pavilion and Bathers, Great Salt Lake, Utah. n.d. Postcard. Author's collection.

Yoakum's drawing *Cenic Pavillian Gret Salt Lake Utah* (fig. 83) somewhat recalls a postcard view entitled Saltair Pavilion and Bathers, Great Salt Lake, Utah (fig. 84). In the postcard, a curvilinear covered walkway running along the water creates an illusion of depth as it moves back toward the pavilion, which is located slightly to the right of center. This crescent-shaped angle is replicated in the artist drawing by the contour of an anthropomorphic rock form that delineates the water. The pavilion is positioned slightly more to the right of center than in the postcard, and the bathers are omitted altogether. The artist's treat-

ment of the pavilion's door combines U and V shapes that are similar to secondary design elements found in the postcard's pavilion. However, the overall structure of his building is rectilinear, resembling the base of the actual Saltair Pavilion. Yoakum gives it a flat roof, while the postcard shows a large dome surrounded by smaller Moorish-style onion-shaped domes.

Postcard views undoubtedly inspired several of Yoakum's vertical compositions in which a footbridge spans the width of a canyon enclosed by two rocky peaks. Canyons and bridges occurred frequently in scenes of Colorado popularized in railroad advertising art and were undoubtedly a source for several of the artist's Colorado landscapes, including *Mt Pikes Peak the Mtn of Pleasure near Colorado Springs Colorado the Highest foot Bridge in U.S.A.* (plate 8). The artist mentions the Union Pacific Railroad in the title of another Colorado bridge view, although the Denver and Rio Grande was the principal Colorado line. The Union Pacific heavily promoted other natural wonders along its major routes, such as Yellowstone, Zion, and the Grand Canyon—all of which were favorite Yoakum subjects.

The Artist and Native American Culture

Beauty is before me
And beauty is behind me,
Above and below me hovers the beautiful.
I am surrounded by it.
I am immersed in it.
In my youth I am aware of it,
And in my old age
I shall walk quietly
The beautiful trail.
—Navajo benedictory chant

Yoakum's lifelong interest in Native American culture strongly influenced his art. His earliest exposure to this culture was during childhood, but it continued in adulthood through his train travels over North America. His most extensive journeys coincided with the height of railroad tourism, from the 1880s through the 1920s, when the transcontinental railroad finally brought tourists directly to the doorsteps of the Native American cultures of the Southwest and Pacific Northwest.[1] Indian wares, some especially crafted for the tourist trade, were sold at the railroad stops and at nearby curio shops. Native American arts and artifacts were displayed in railroad stations and tribal designs incorporated into the station decor by railroad companies eager to stimulate the tourist trade. Tribal dances were performed for tourist entertainment along various railroad routes, and reservations became tourist attractions (fig. 85).

Even as an old man, after his traveling days were over, Yoakum continued to come into contact with Native American art and culture. His membership in the American Indian Center on Chicago's Near North Side provided access to large, annual powwows featuring tribal dances, as well as to arts and crafts fairs including demonstrations by tribal craftsmen. His portrait *Luella Ocondo Secretary of the American Indian Center 758 Sheridan Road* also suggests that the artist may have been more than a sometime visitor to the center. He perhaps attended some of the organization's lectures on Native American history, culture, and art, although no record exists of his activities there.

Yoakum expanded his knowledge of Native

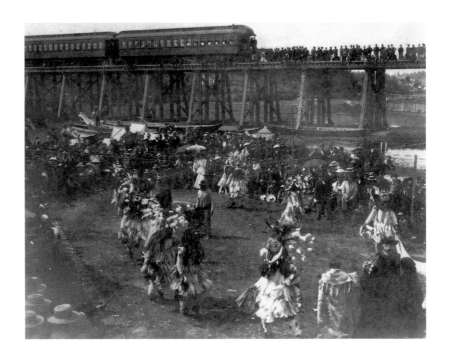

Fig. 85. Swaihwe dancers performing at a coast Salish potlatch at the Songhees Reserve in Victoria, 1895. Collection of the British Columbia Archives, Vancouver, Canada. Cat. no. G-210.

American culture by reading travel and other popular magazines of the 1950s and 1960s that he kept in a bookcase in his studio. *National Geographic, Life, Saturday Evening Post, Ebony, Hobbies,* and *Popular Mechanics* were just a few of the journals that featured articles about Native American art and culture as well as running advertisements of products with Indian names and imagery.[2] These publications explored a wide range of topics that seem to have had some influence on the artist's choice of subject matter, though not necessarily on his imagery; there were articles on, for example, archeological discoveries of prehistoric Indian mounds, reservations as tourist attractions, the common ancestry of many African and Native Americans, and Native American art and artifacts.

Ultimately, such sources, in addition to his life experiences, helped shape Yoakum's oeuvre. Of course, the artist's understanding of Native American art forms and design elements was not based upon any formal academic training. However, his landscapes incorporate numerous North American Indian motifs and mythological characters, such as the trickster hero in various guises—the raven of the Pacific Northwest coast

tribes and the coyote of the pueblo and plains Indians. His travels, conversations with other Native Americans, and reading of popular magazines all seem to have stimulated his interest in Native American subjects.

The most profound Native American influence on Yoakum's art was the respect and reverence for the earth that was manifested in the artist's preoccupation with landscape. The Native American worldview—a power underlying tribal art generally—extends moral considerations to the natural world. Elements of the natural world, such as trees, mountains, and rocks, are believed to possess spirits, just as people do. Furthermore, in tribal mythologies, animals are sometimes transformed into people and vice versa.

From these beliefs flows the Native American ideal that humans must have an ethical relationship with all nature. This concept is translated into tribal designs that are closely patterned after nature's own designs. What may appear to the untrained eye to be merely ornamentation on a tribal object may actually be an expression of tribal beliefs. To illustrate, in Zuni art, the decorative element of crooks joined together symbolizes

clouds or prayers for rain.[3] When such designs occur in Yoakum's art, however, they do not necessarily convey Native American beliefs or concepts. For instance, the artist frequently uses the Zuni cloud symbol to indicate waves, in such drawings as *West Coast Mtn Range on Pacific Ocean near Vancouver British Columbia* (fig. 86).

The anthropologist Claude Lévi-Strauss likened the first encounter with Native American culture to "a magic place where dreams of childhood hold a rendezvous, where century-old tree trunks sing and speak, where indefinable objects watch out for the visitor with the anxious stare of human faces."[4]

Similarly, the anthropomorphic figures that peer out from trees, rocks, and mountains in Yoakum's landscapes reflect the artist's familiarity with this culture and its mythological concept that the natural world is the abode of spirits. For example, in drawings like *Mt Olympus of Cumberland Mtn Range near Winchester Kentucky,* there are trees with faces that seem to be possessed by tree spirits (fig. 87). In *Cedar Valley Range Utah* a ghost-like white rock with black markings resembling eyes almost seems like the disembodied head of a ghost that is resting on the rim of a large sandstone-colored rock at the left of the composition (plate 29). This odd image recalls a ghost story told in almost every North American tribe about heads with no bodies, called Rolling Heads.[5]

Such representations of natural spirits are not typical of traditional Native American art. However, they are sometimes seen in woodcarvings, like nineteenth-century Sioux figures of tree dwellers (fig. 88) and in tribal masks, like the whimsical Iroquois "false face" masks of forest spirits with crooked mouths.[6] Though Yoakum may never have observed such tribal art forms, he certainly witnessed the unusual rock formations on Navajo sacred lands sculpted over the centuries by wind and rain erosion to resemble various mammals, reptiles, birds, humans, and supernatural beings. The Navajo named these rock formations

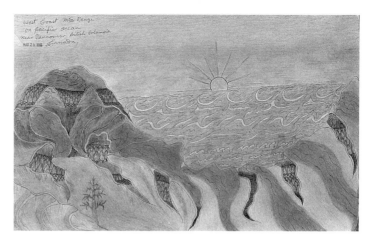

Fig. 86. *West Coast Mtn Range on Pacific Ocean near Vancouver British Columbia,* 1968. Ballpoint pen and colored pencil on paper. 12 1/16 x 19 1/16 in. Collection of Gladys Nilsson and Jim Nutt.

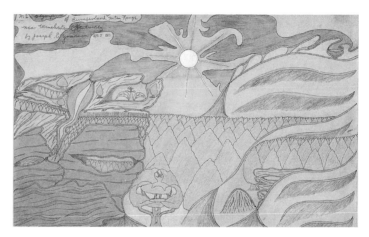

Fig. 87. *Mt Olympus of Cumberland Mtn Range near Winchester Kentucky,* 1971. Ballpoint pen and colored pencil on paper. 12 x 19 in. Private collection. Photo courtesy of Fleisher/Ollman Gallery, Philadelphia.

Fig. 88. Yankton Sioux tree dweller effigy, c. 1850. Carved wood stained with pigment. 9 1/2 x 1 2/3 in. Collection of the Detroit Institute of Arts. Founders Society purchase with funds from Flint Ink Corp., DIA 1988.35.

after the animate and inanimate objects suggested by the rocks' weathered contours; examples are Window Rock, Camel Rock, and Big Sheep Mountain.

Burial Mounds, Reservations, and Rock Art

During the 1960s, when Yoakum's artistic career flourished, popular magazines were filled with articles about several Native American subjects that are also treated in his work—ancient burial mounds, reservations, and rock art. For example, his landscapes feature many prehistoric mounds from the Mississippi River Valley, midwestern prairies, and river valleys of the Pacific Northwest. These mounds were found near places where the artist had either lived (including Ash Grove and Willard) or had visited with the circus.[7] These mysterious formations were first discovered in the Ohio River Valley during the eighteenth century and became the subject of one of the great debates in American archeology well into the next century. While President Thomas Jefferson correctly ascribed their origin as Native American, his conclusion flew in the face of scientific prejudice of his day. The more accepted view at that time was that exotic foreign races, perhaps from European or Mediterranean civilizations, had built these structures as they fought and settled across the Midwest and the South many centuries before the first Native Americans arrived. One Yoakum drawing, *This Picture of a Valley Mound in Akron Ohio*, depicts an early Ohio mound. While Akron is outside the region of the main archeological excavation sites, this rendering is reminiscent of nineteenth-century lithographs of mounds from southeastern Ohio.[8]

Ancient tribal burial mounds vary in form, from cone- and serpent-shaped mounds to flat-topped pyramids. The historic conical Blue Mound near the Kansas-Missouri border is the subject of Yoakum's drawing *View of Blue Mounds Kansas* (plate 30). Executed in graphite pencil with touches of green and orange watercolor and black crayon on manila paper, the work has something of the quality of a nineteenth-century plains Indian pictograph. Blue Mound is shown between two cone-shaped mounds of almost equal size, with four smaller mounds and little green trees nestled between them. An 1874 government geological survey recorded that Blue Mound was the burial place of "a very noted chief named Pawhusta, or called by the early French 'Cheveux Blanche,' who was said to have been killed during a skirmish with whites." The report found that the "occasional occurrence of these mounds [on the prairie] gives a charming variety to the landscape. Many of these can be seen at a long distance, and from their summits the views are often very fine."[9]

A series of Yoakum landscapes depicts Indian reservations or the towns where such reservations are located. During the 1960s, tourism on reservations was actively promoted in popular magazines and government publications. In 1965, for example, the Bureau of Indian Affairs published a guide to campgrounds on forty-two reservations and a calendar of events held on reservations throughout the year, including ceremonials, rodeos, fairs, feasts, celebrations, and art exhibitions. The artist may have had access to such publications, which were widely advertised in travel magazines and other popular journals. Whatever the source of his knowledge about reservations, Yoakum represents nearly two dozen sites in the western states of Arizona, Colorado, Idaho, Montana, Nevada, California, Oregon, and Washington. The names of the reservations are rarely indicated in the titles of his drawings, however. In addition to reservations, the artist captures various Native American religious sites, such as Rainbow Natural Bridge in Utah, a sandstone arch sacred to the Paiute, Navajo, and other southwestern tribes. Rock forms in some Yoakum landscapes display decorated faces that recall Native American rock art. Poetically named "dreaming rocks" by the elders of the Great Lakes

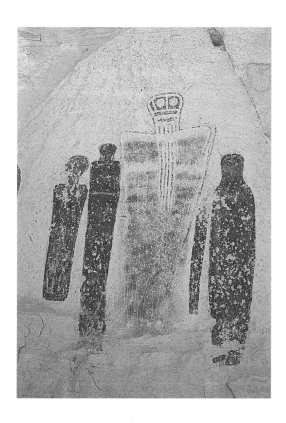

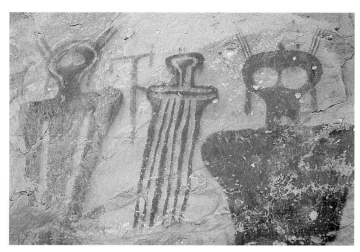

Fig. 89. Thomas Maxwell, *"Holy Ghost and Attendants,"* Great Gallery of Barrier Canyon, Utah, n.d. Collection of photographer.

Fig. 90. Daniel Leen, Shamans or spirits with ceremonial items, Sego Canyon, Utah, n.d. Collection of photographer.

tribes, prehistoric rock images are believed to interpret the dreams and visions of shaman-artists.[10] Rock art encompasses an infinite variety of figures and abstract patterns, from supernatural beings and heavenly bodies to the animistic spirits of wind, air, and other natural phenomena. Major concentrations of rock art are found in the American West and Southwest, both regions that are heavily represented in Yoakum's oeuvre. Some of the most beautiful and complex examples are by the Chumash tribe near San Luis Obispo, where Yoakum claimed to have lived for a brief period.[11]

The most famous southwestern rock art site is on the Colorado Plateau. Known as the Four Corners, this area comprises southeastern Utah, southwestern Colorado, northeastern Arizona, and northwestern New Mexico. The impressionistic images of shamans and specters on the walls of Sego and Barrier canyons in southeastern Utah bear an uncanny resemblance to the abstract anthropomorphic figure that adorns a small rock in Yoakum's drawing *Mt Thousand Lakes in Bryce*

Canyon National Park near Hanksville Utah[12] (plate 31). The mummy-like shape of the artist's curious anthropomorphic form with tapered torso recalls Barrier Canyon–style figures (fig. 89). Also similar to some Sego Canyon figures, Yoakum's form has a hooded ovoid head with a large round space for eyes and two short lines emerging from the top of its head like antennae (fig. 90). A T-shaped form to the left of Yoakum's figure suggests the ceremonial object pictured to the right of one hooded Sego Canyon specter.

In landscapes of other western sites known for their ancient rock art, Yoakum incorporates designs reminiscent of petroglyphs as well. For instance, his portraits of Moro Rock in San Luis Obispo show the rock's left face decorated with a white bird-like form. The bird's tail and outstretched wings that terminate in triangularly shaped tassels bring to mind impressionistic eagle designs found in a lot of western rock art (plate 4). Other examples of petroglyph-like forms may be seen in Yoakum's drawing *Mt Tohakum Park*

Fig. 91. Petroglyph figures at Horseshoe Rock Shelter, Barrier Canyon, Utah. Detail of figure 72 from Polly Schaafsma, *The Rock Art of Utah*, papers of the Peabody Museum of Archeology and Ethnology, vol. 65. Copyright 1971 by the President and Fellows of Harvard College.

8170 ft near Pyramid and Lake Oslo Nevada (plate 16). On a yellow, cone-shaped mountain, the artist draws a large trapezoidal shape heavily outlined in black that encloses a small green tree—a form approximating Barrier Canyon petroglyph depictions of humanoid torsos, missing arms and legs, with a single large hole punched through their breast area (fig. 91). On a smaller cone-shaped gray mountain, Yoakum repeats a T-shaped design that recalls some ancient rock artists' interpretations of birds or legless specters with outstretched arms.

Northwest Coast Tribal Art: Mythic Creatures and Family Crests

During his extensive travels in western Canada and Alaska, Yoakum undoubtedly came into contact with Pacific Northwest tribal art, which appears to have later influenced his own. Five major tribal groups of the Pacific Northwest coast inhabit a region bounded by Alaska in the north, the Coast Mountains in the east, the Columbia River in the south, and the Pacific Ocean in the west. Yoakum represents the entire area in a series of landscapes.

Over the centuries, each of the five Pacific Northwest coast tribes has developed its own artistic style and mythology, although they have many elements in common. For example, all but one carve totem poles—monuments declaring the crests and lineage of leading families. While some poles favor animals over human forms, others emphasize the spirit world over the secular. Similarly, all the tribes create complex masks for rituals and ceremonies as a means of giving visible form to the spiritual world. Some masks represent powerful supernatural beings, while others portray the tribe's ancestors.[13]

Many manifestations of the spirit world, such as birds, beasts, wild men, giants, and fools, are found in Pacific Northwest coast tribal paintings, textiles, masks, totems, and other carvings. These same forms, perhaps with different meanings, also emerge from the rocks, trees, and mountains of Yoakum's landscapes. One group of images includes supernatural birds, like the raven, eagle, and owl, which figure prominently in tribal mythology.

Believed to benefit mankind through his greed and curiosity, the raven is also an important totem figure of prestige.[14] In tribal art his most

distinguishing feature is a long, clear-cut beak that is curved above but straight on its underside (fig. 92). Yoakum captures this raven, with his distinctive beak, ovoid eye, and flared nostril in the drawing *Hills of Old Wyoming in the Valley of the Moon near Casper Wyoming* (plate 12). The bird, shown in profile, forms the upper right half of the brown hills. A small row of soft green trees indicates the pupil of his eye.

Another bird that figures prominently in Pacific Northwest coast tribal art is the eagle, a symbol of peace and friendship. His heavy beak, which is considerably shorter than the raven's, terminates in a strong downward curve (fig. 93). In the past, eagle masks from the Kwakiutl tribe were fitted with mats sewn with white eagle feathers to completely cover the head.[15] A somewhat realistic representation of the eagle is hidden in Yoakum's landscape *Green Valley Ashville Kentucky* (plate 32). The bird's white, feathered back forms a mountain peak that ends with his blue beak and green tongue. His large ovoid eye with its enormous black pupil has a menacing aspect that does not suggest an emblem of peace and friendship, however.

Perhaps because of its nocturnal habits and eerie call, the owl often is associated with death in Pacific Northwest coast tribal mythology. In tribal art the owl is characterized by large, round eye sockets and a short, sharp beak.[16] Yoakum portrays the owl with different degrees of abstraction in various landscapes. For instance, in the drawing *Mt Mowbullan in Dividing Range near Brisbane Australia*, the artist depicts a frontal view of a disembodied owl's head that appears to be resting on the top of a large mountain (plate 33). The most prominent feature of the bird's beige ovoid face is a short, sharp beak suggested by a black triangular form. Two large green trees are used to indicate his round eye sockets. The decorative pattern of T-shaped forms outlined in red fiber-tip pen that covers the mountain is reminiscent of the tertiary split U forms used by tribal artists to indicate

Fig. 92. Kwakwaka'wakw Hamat'sa raven mask from Kingcome Inlet, n.d. Painted wood and leather. Length 34 in. Collection of the Museum of Anthropology, Vancouver, Canada. MacMillan Purchase, 1953. A6317.

Fig. 93. Kwakwaka'wakw eagle mask from Blunden Harbor, collected in 1927. Painted wood. Length 17 in. Collection of the Museum of Anthropology, Vancouver, Canada. MacMillan Purchase, 1953. A4324.

bird feathers. Coincidentally, in tribal paintings, the split U form is often outlined in red, as in Yoakum's drawing. At the bottom of a second large mountain in the composition, another disembodied head seems to float out of the rocky terrain. It is the head of an Indian man with long, flowing, black hair and a bushy eyebrow. Shown in profile, the man seems to be staring up at the owl.

The thunderbird, another mythological bird, was frequently carved on the top of the wooden ceremonial staffs carried by the chief's orator, the tribal official responsible for relaying the chief's sentiments to visitors (fig. 94). Tribal artists

Fig. 94. E. S. Curtis, *Kwakiutl chief with orator's staff*, c. 1900. Collection of the University of British Columbia Library, Vancouver, Canada.

Fig. 95. Kwakwaka'wakw wolf mask from Kingcome Inlet. Painted wood. Length 17 in. Collection of the Museum of Anthropology, Vancouver, Canada. MacMillan Purchase, 1952. A3810.

represent the thunderbird with supernatural horns curving from his head. A frontal view of this bird as he would appear on ceremonial staffs is suggested in several Yoakum drawings, especially *Mt Mauna Kea in Volcanoic Range in Central Hawaii County of Hawaii Islands* (plate 34). In this landscape, a tiny impressionistic thunderbird's head seems to float like an apparition in the center of the composition. The bird's eye sockets seem to be indicated by a row of trees, his prominent beak by a single mound in a contrasting color, and his forehead and horns by a band of color above the trees that curves up at each end.

In addition to supernatural birds, Yoakum also depicts animals and fish that often occur in Pacific Northwest coast tribal myths. Among these is the wolf, an animal commonly associated with the special spirit power man needs to hunt successfully. In tribal art, the wolf's key features are an elongated snout with flared nostrils, large teeth, and prominent ears (fig. 95). An impressionistic wolf head, usually shown in profile, dominates a number of Yoakum's landscapes. For example, in *Mt Monte Rosa of Pennion Alps near Chasco Italy S.W. Europe*, a pale yellow wolf head, facing to the right, is represented with its characteristic long snout and big, upturned ears (fig. 96). Another wolf's head, also shown in profile but without upturned ears, seems to emerge from a large mountain that dominates the right half of the landscape *Poverty Hollar in Ozark Mts near Luck Green County Missouri* (fig. 97). The beast's large snout, which points to the left, is covered with curlicues and striations that recall the white striping painted on tribal wolf masks. Another interesting element of this drawing is the cutaway section of the mountain, shaped somewhat like the wolf's drooping ear, which encloses a little scene with a church and grove of trees.

The gray killer whale is another Yoakum subject common to tribal legends and art. In tribal art, the whale's characteristic features are a round head with prominent snout, dorsal and pectoral

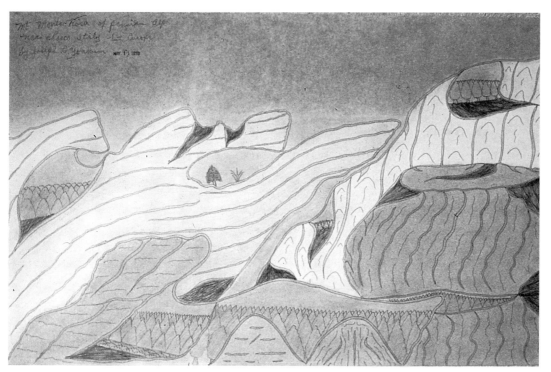

Fig. 96. *Mt Monte Rosa of Pennion Alps near Chasco Italy S.W. Europe*, 1970. Ballpoint pen, colored pencil, and ink on paper. 12 x 19 in. Collection of Gladys Nilsson and Jim Nutt.

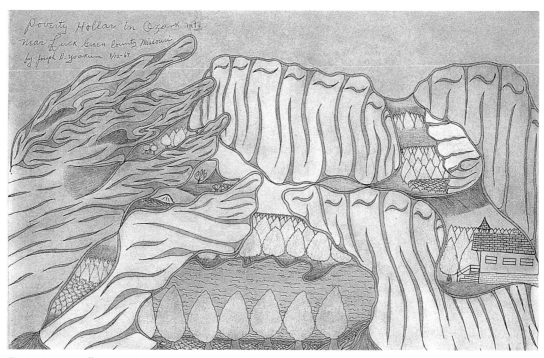

Fig. 97. *Poverty Hollar in Ozark Mts near Luck Green County Missouri*, c. 1966. Ballpoint pen and colored pencil on paper. 12 x 17 7/8 in. Collection of Gladys Nilsson and Jim Nutt.

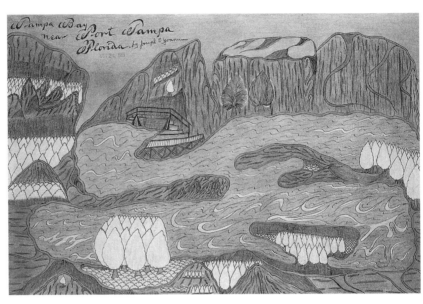

fins, and a tail with symmetrical flukes that can appear asymmetrical when the mammal is shown in profile[17] (fig. 98). Yoakum appears to portray an abstract whale, with his distinguishing snout and fluked tail, in the landscape *Tampa Bay near Port Tampa Florida* (fig. 99). The contour of the bay somewhat suggests the shape of a large whale, swimming from left to right. A small, narrow peninsula that extends out into the bay from the left shore defines the whale's fluked tail. Two rows of evergreen trees on a small peninsula in the lower right of the composition may be read as the large nostril of his distinctive snout. In the drawing *This is of Moro Bay in San Luis Obispo County San Luis Obispo California*, a tiny island takes the shape of a pale gray whale that seems to be swimming across the bay (plate 4). A central tower-like form in *Mt Liotian in Greater Khiangian Mtn Range near Tritsihar Deep Southern China East Asia* looks somewhat like an abstract whale surfacing for air (plate 26). A gash-like shape filled with green trees indicates the whale's open "mouth," while the trees may be read as his sharp teeth. In another drawing, *View of the Arctic Ocean at Sydnia Australia*, the head of an impressionistic whale, shown in a side view, is thrust upward as if surfacing for air (fig. 56). In this work, the "whale" is paired with what appears to be an abstract fish that resembles a giant marlin with an erect dorsal fin. This other "fish" form may also represent the spiny-backed Red Cod of tribal mythology, believed to be the slave of the killer whale.[18] A similar abstract portrait of this spiny fish is found in other Yoakum landscapes, such as *Granet Mts near Nome Alaska* (fig. 100).

In addition to birds, beasts, and fish, strange

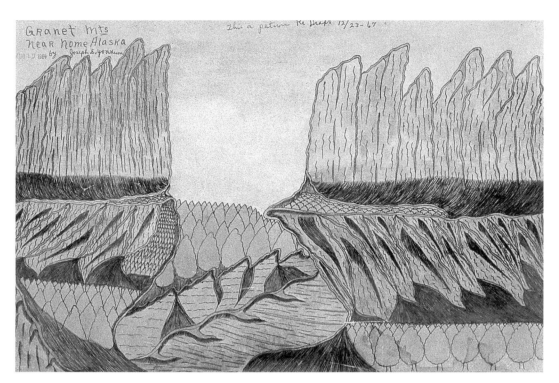

Fig. 100. *Granet Mts near Nome Alaska*, 1964. Ballpoint pen, watercolor, and chalk on paper. 30.4 x 45.5 cm. Collection of the Art Institute of Chicago. Bequest of Whitney Halstead, 1979.211.

and sometimes fierce human characters populate the legends and are represented in the art of Pacific Northwest coast tribes, as well as in Yoakum landscapes. One example is the fearsome giantess Tsonokwa, who, according to tribal legend, comes from a large family of giants living in the distant mountains and woods.[19] In tribal art, she is distinguished by black skin and a pursed mouth through which she utters the piercing cry, "Hu, hu!" (fig. 101). The top half of an abstract Tsonokwa head, with its large vacant eyes and heavy brow split by a white gash, is suggested by two dark mountain forms that fill the bottom half of the composition in Yoakum's landscape *Mt Kanchen in Himilaya Mtn Range near Shara China East Asia* (fig. 102). Yoakum indicates her pupil-less eyes by two tree-filled orbs and her long, bulbous nose by a larger teardrop-shaped space, also tree-filled, that is cropped at the base.

Yoakum captured the likeness of Bookus, another loathsome character of tribal legend

Fig. 101. Dzunk'wa mask, Kwakwaka'wakw. Painted wood. Height 35 in. Collection of the Museum of Anthropology, Vancouver, Canada. Gift of Walter C. Koerner, 1976. A2522.

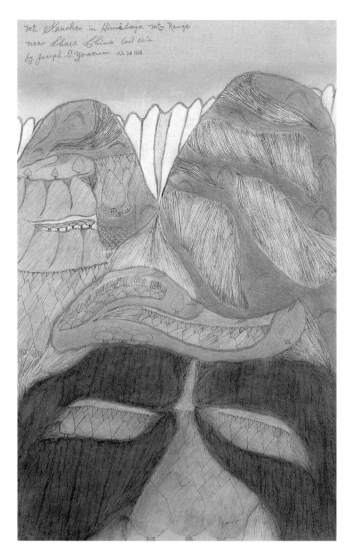

Fig. 102. *Mt Kanchen in Himilaya Mtn Range near Shara China East Asia*, 1970. Ballpoint pen, colored pencil, and watercolor on paper. 19 x 12 in. Collection of John and Ann Ollman. Photo courtesy of Fleisher/Ollman Gallery, Philadelphia.

Fig. 103. Wildman of the Woods mask (Cockle Hunter)—Kwakiutl. Wood, bear fur, and traces of red paint. Height 12 1/2 in. Collection of the Milwaukee Public Museum. Neg. no. 80944A.

known as the "Wildman of the Woods" who lives in a mythical forest.[20] His distinguishing features are heavily lined cheeks and forehead, hooked nose, and big mouth that is represented either open or closed (fig. 103). His lined face, as portrayed in numerous tribal masks, is suggested in such Yoakum landscapes as *Gulf of Mexico at Panama City Florida* (fig. 104) and *Gascanade River through Dixon Hills Mtns near Newburg Missouri* (fig. 105).

Komokwa, the king of the Undersea World, is another creature of tribal legend whose idealized portrait seems to emerge from at least one of Yoakum's landscapes. In tribal masks, his face is often depicted with curious round protuberances variously described as octopus tentacle suckers, air bubbles, or the sucking mouths of sea anemones (fig. 106). In Yoakum's landscape *A Seen between Carthage and Joplin Mo*, an abstract Komokwa-like figure is portrayed with his characteristic large round eyes, thick lips, and heavy forehead covered with round, sucker-like forms (fig. 107). The artist's Komokwa head–shaped mountain is bathed in a dark green ground, the color typically used by tribal artists to evoke this mythological creature's watery environment.

Northwest Coast Tribal Art: Form and Texture

In his landmark book *Northwest Coast Indian Art: An Analysis of Form*, Bill Holm introduced

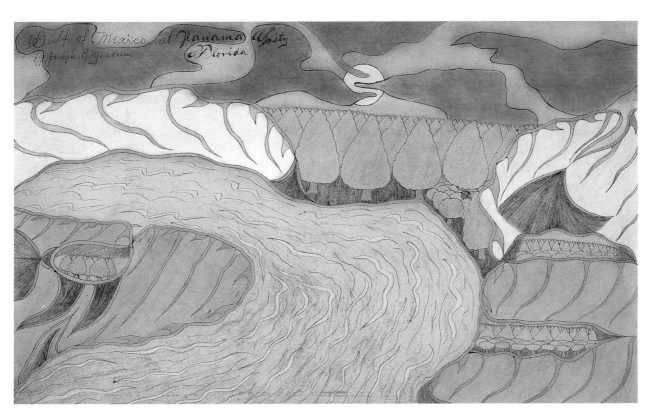

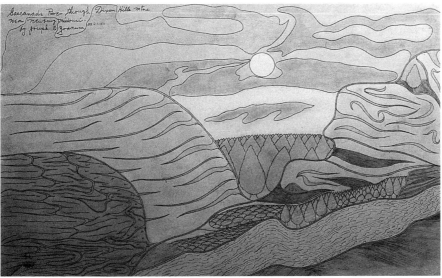

Fig. 104. *Gulf of Mexico at Panama City Florida*, c. 1967. Ballpoint pen, colored pencil, and watercolor on paper. 12 x 19 in. Private collection. Photo courtesy of Fleisher/Ollman Gallery, Philadelphia.

Fig. 105. *Gascanade River through Dixon Hills Mtns near Newburg Missouri*, 1970. Ballpoint pen, graphite pencil, and colored pencil on paper. 14 1/2 x 23 in. Private collection. Photo courtesy of Carl Hammer Gallery, Chicago.

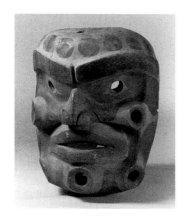

Fig. 106. Komokwa (Undersea Chief) mask from Quatsino, 1905. Painted wood. Height 13 1/2 in. Collection of the Museum of Anthropology, Vancouver, Canada. MacMillan Purchase, 1952. A8415.

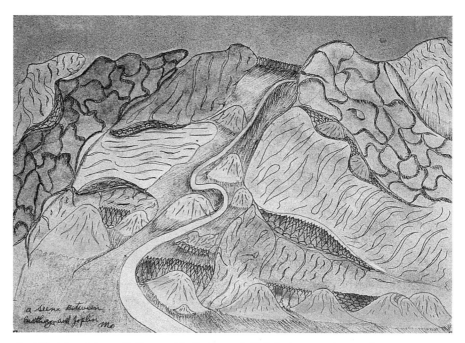

Fig. 107. *A Seen between Carthage and Joplin Mo.*, c. 1965. Ballpoint pen and watercolor on paper. 9 x 12 in. Collection of Gladys Nilsson and Jim Nutt.

Fig. 108. Ben Dick, *Kingcome Seal Eagle*, 1962. Watercolor on paper. Width 17 in. Collection of the Museum of Anthropology, Vancouver, Canada. A17102. Photograph by Bill McLennan.

Fig. 109. *Sand Dunes Arabian Desert*, c. 1965. Ballpoint pen and watercolor on paper. 9 x 12 in. Collection of Philip Hanson.

Fig. 110. *Fertil Mounds near Wyanoka Kansas*, c. 1965. Ballpoint pen on paper. 12 x 18 in. Collection of Philip Hanson.

terminology for defining the design elements of Pacific Northwest coast tribal art that has become the standard for art historians. This terminology is helpful in describing the apparent influence of such tribal art on the work of Joseph Yoakum.

Holm notes that two-dimensional design characterizes Pacific Northwest coast tribal art. Tribal designs range from near realism to abstraction and generate a feeling of constant movement. Other design principles include the use of a formline to delineate the main shapes and the repetition of the secondary and tertiary design elements like the ovoid, as well as U and S forms.

The major design element in tribal art is the curvilinear formline, or negative space between patterns, as illustrated in Ben Dick's watercolor of a seal eagle (fig. 108). Tribal artists' use of negative space to create a sinuous formline is suggested in such beautiful Yoakum drawings as *Sand Dunes Arabian Desert* (fig. 109) and *Fertil Mounds near Wyanoka Kansas* (fig. 110).

Yoakum also uses a variation of the tribal artists' curvilinear formline to enclose the major shapes that delineate his mountains, rocks, and

rivers. He creates the effect of the tribal artists' formline by outlining each of his large geological forms with two parallel lines. The space between these parallel lines is usually left empty, but is sometimes filled in with hatching or shading. A good example of the first approach is found in Yoakum's landscape *St Lawrence near Winnipeg Canada* (fig. 111). In this drawing, the landmasses and bodies of water are emphasized, if not defined, by the two parallel lines that encircle them. The artist employs the second approach, where the space between the lines is shaded, in *Mt Fitzroy Santa Cruz Argentina* (fig. 112).

According to Holm, the ovoid is the design element that most distinguishes Pacific Northwest Coast tribal art. It is used for such physical attributes as eyes and joints, as well as for space fillers.[21] Otherwise described as an "angular oval" or "bean shape," the ovoid pervades Yoakum's oeuvre as well. He employs it for eyes and mouths, and also for space fillers. Examples of landscapes in which the ovoid serves multiple purposes are *Mt Cloubelle of West India* (plate 35) and *Mt Baldy in Beaver Head Range near Humphery Idaho* (fig. 113). In each of these drawings there is a head-like

Fig. 111. *St Lawrence near Winnipeg Canada*, c. 1965. Ballpoint pen on paper. Private collection. Photo courtesy of Phyllis Kind Gallery, Chicago and New York.

Fig. 112. *Mt Fitzroy Santa Cruz Argentina*, c. 1965. Ballpoint pen on paper. Photo courtesy of Phyllis Kind Gallery, Chicago and New York.

mountain form with a cutaway ovoid section that may be read either as an eye or as a mouth. The ovoid spaces contain different miniature scenes— trees and a hill in *Mt Cloubelle* and a grotesque, brown Bookus-like head in *Mt Baldy*.

Another design element common to this tribal art and to Yoakum landscapes is the U form and its many variations. In tribal art, large U forms often help contour the body of a bird or animal, while smaller U forms are used as space fillers and to indicate bird feathers. The split U form, created by a "pointed double curve," is frequently seen in ears, feathers, tails, and many other open spaces.[22] Yoakum commonly employs the U or inverted U form to suggest abstract patterning of mountains, as well as the outlines of the mountains themselves. In his landscapes *St Lawrence near Winnipeg Canada* (fig. 111) and *Mt Fitzroy Santa Cruz Argentina* (fig. 112), the undulating U and inverted U forms—some filled with black dots—are reminiscent of stylized bird feathers characteristic of tribal art (fig. 114).

The S form is a small design element in Pacific Northwest coast tribal art used as a space filler. The halves of a U-form, connected in opposite directions, create the S. Typically the function of the S form is to connect part of a leg or arm or to outline other shapes.[23] In Yoakum's landscapes the S form is most often used to create patterns and textures on mountains. Illustrations may be found in drawings like *Mt Olympus of Cumberland Mtn Range near Winchester Kentucky* (fig. 87) and *Mt Mauna Kea in Volcanoic Range in Central Hawaii County of Hawaii Islands* (plate 34).

Hatching and dashing are other design elements common to this tribal art and to Yoakum landscapes.[24] Tribal artists employ these techniques for making textures and patterns, as well as for defining the shapes that make up an overall design. Hatching may serve as a filler for eye sockets, for example. A similar technique is used in Yoakum's landscape *Mt Sheridan in Gallation Mtn Range and Yellow Stone National Park near Canyon*

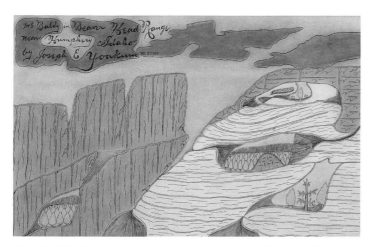

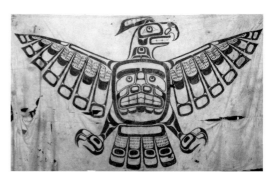

Fig. 113. *Mt Baldy in Beaver Head Range near Humphery Idaho*, 1969. Ballpoint pen, colored pencil, and watercolor on paper. 12 x 19 in. Private collection. Photo courtesy of Fleisher/Ollman Gallery, Philadelphia.

Fig. 114. Arthur Shaughnessy or Charlie George Walkus (attributed to), Kwakwaka'wakw ceremonial curtain from Village Island, n.d. Cotton with black thunderbird motif. Width 16 ft. 7 in. Collection of the Museum of Anthropology, Vancouver, Canada. MacMillan Purchase, 1952. A3773.

Wyoming (plate 17). Black hatching completely fills two ovoids that may be read as the eyes of a centrally placed mountain that is shaped like a large sweet potato. This orange mountain is squeezed between two other mountains, both brown, that also resemble disembodied heads. Areas of hatching on these head-like mountains could be read as mouths, teeth, and nostrils, which causes them to transform into buffoon-like characters. Other examples of Yoakum's use of hatching are found in such drawings as *Mt Cloubelle of West India* (plate 35) and *St Lawrence near Winnipeg Canada* (fig. 111).

Visual punning is another design feature of Pacific Northwest coast tribal art that appears to have influenced Yoakum's art. Often introduced for a humorous effect in tribal art, a pun may involve the placement of a whole animal in the body parts of another. For example, human faces often peer out of the ears of bears or the tails of beavers.[25] Yoakum's landscapes also sometimes contain human or animal faces that emerge from mountains or trees. As discussed earlier, cutaway views of mountains resemble the ears or noses of animals that are filled with grotesque faces, groves of trees, buildings, and other objects.

The Yoakum drawing that perhaps best cap-

tures the essence of Pacific Northwest coast tribal art is *Granit Center Mound in Rockey Mountain Range near Nome Alaska* (fig. 115). This landscape seems to contain all of the major design elements of this tribal art—the formline, ovoid, U and S forms, and hatching. In terms of composition, the work is reminiscent of a Chilkat woven robe of the Tlingit tribe[26] (fig. 116). A large split U form creates the outline of the robe's central design. On either side of this large U form, there are rows of S forms filled with black hatching that resemble the negative space defined by the robe's formline. In the lower left of the composition, the artist inserts a small square-shaped face with ovoid eyeballs, each encircled by an ovoid line for the eyelid. It closely resembles the many face-like structures that are repeated throughout the traditional Chilkat robe design.

Southwestern Pueblo Art: Sacred Sites, Spirits, and Symbols

As a circus advanceman, railroad worker, tourist, and armchair traveler, Yoakum visited the Southwest—the land of the Navajo, his adopted people—and gazed upon their four sacred mountains symbolizing the Four Corners of the world.

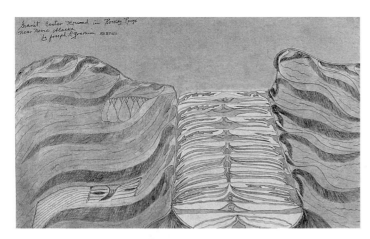

Fig. 115. *Granit Center Mound in Rockey Mountain Range near Nome Alaska*, 1970. Ballpoint pen, fiber-tip pen, colored pencil, and colored chalk on paper. 30.1 x 48.4 cm. Collection of the Art Institute of Chicago. Bequest of Whitney Halstead, 1979.183.

Fig. 116. Chilkat blanket. Tlingit. Collection of the Burke Museum of Natural History and Culture, Seattle. Cat. no. 1-1587.

The geographical area inhabited by the Navajo and other pueblo tribes is represented in a series of Yoakum landscapes depicting the region from Taos and Santa Fe in the east, Kayenta in the north, Cameron in the west, and Albuquerque in the south.

Yoakum shared the Navajo's twin passions for geography and traveling.[27] In Navajo mythology, the "heroes and supernaturals restlessly undertake long journeys during which many place names are mentioned, even spots merely passed by, and stopping at a spring for a drink of water is an occasion for giving a place a name."[28] For example, fifty-three place names are mentioned in the Navajo

Windway—a song ceremonial for curing the sick and celebrating mythical winds. Some, like Big Sheep Mountain in Colorado, are linked to actual locations, while others, like Turquoise Mountain near the home of the mythological Twin Gods of War, are not. Yoakum appears to represent some of these Navajo landmarks, such as the large turquoise mountain that dominates his landscape *Teppeniah Ridge in Yakama Valley near Wapata Washington* (plate 36).

A symbol of life's journey in Navajo mythology, the road is a topographical feature that occurs in many Yoakum landscapes. As each new child is presented to the sun on the fourth or eighth day of his or her life, the pueblos offer this prayer:

> *May your road be fulfilled*
> *Reaching the road of your sun father,*
> *When your road is fulfilled.*[29]

Yoakum's imagery also suggests the road as a journey. Cutting through complex rock and mountain forms, his roads seem to convey the struggles and challenges of life's journey, similar to those encountered by the mountain-dwelling deities of pueblo mythology. The artist's roads also impart a sense of the lonely and sometimes mystical quality of that journey. An excellent example of this road imagery occurs in *Mt Thousand Lakes in Bryce Canyon National Park near Hanksville Utah* (plate 31). A solitary white curvilinear road rises into the hills covered with a gray, taupe, and olive-green mosaic-like pattern and disappears over the ridge.

Certain symbols sacred to pueblo cultures—such as the coyote, eagle, badger, and the rainbow—sometimes appear in Yoakum landscapes. The artist's imagery reflects the influences of traditional as well as contemporary Native American designs. Both sources are evident in Yoakum's portrayal of the coyote as trickster hero. This multifaceted character in pueblo mythology and

religion has many different guises—animal and god, good and evil, creator and destroyer, hero and fool.[30] In his trickster role, the coyote plays cunning tricks that often backfire on him, thereby transforming himself into a buffoon, or clown. An impressionistic coyote becomes the central figure in Yoakum's landscape *Mt Negi in Transylvania Alps near Fagris Romania SE E* (plate 37). This whimsical portrait depicts the coyote's prominent snout with a yellow stripe and his long pale brown ears with black stripes. The image recalls pueblo clowns known as Kosharis, who wear coyote-like ears and paint their bodies and heads with black and white stripes (fig. 117).

In the Zuni and Hopi cultures, Kosharis serve important functions in addition to humor. These clowns are believed to represent spirits of divine origin who can control fertility, weather, war, and hunting.[31] Thus, it is not surprising to find Yoakum's Kosharis-like coyote portrayed with an arrow, the emblem of hunting. However, this arrow actually more closely resembles the great plumed arrows found in Navajo sandpaintings of Mountainway—the Navajo religious ceremony that literally means "chant towards a place within the mountains."[32] Significantly, Yoakum also encapsulates the arrow in a phallic-like form, perhaps to suggest the uncontrolled sexuality of the Kosharis in ceremonial dances symbolizing the creative power of the natural world. On the other hand, the form may simply signify the phallus—the trickster's (coyote's) alter ego.[33]

An abstract coyote head constitutes the central design element in yet another interesting Yoakum landscape, *Mt Everest of Himilaya Mtn Range in height 28027 ft in Nepal Distric of East India Asia* (plate 38). In this work, the impressionistic coyote head, identified by its olive-green face and erect brown ears, seems to float above a stand of five bluish-black evergreen trees. Two of these trees have faces, with mouths that appear to grin mischievously as if they had just outwitted the clever coyote. In this drawing, as well as in *Mt*

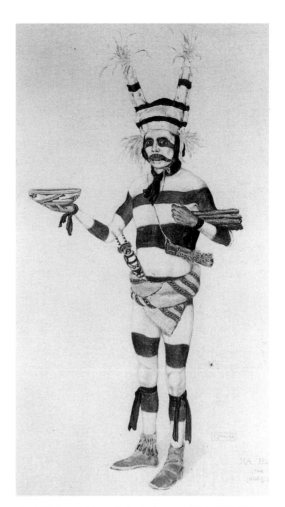

Fig. 117. Joseph Mora, *Koshari Clown*, c. 1904–1905. Watercolor on paper. 13 x 10 1/2 in. Photo courtesy of John R. Wilson.

Fig. 118. James Joe Shiprock, *Eagles and coyotes*, 1978. Sandpainting. Photo courtesy of Dr. Nancy Parezo.

Fig. 119. Barton Wright, *Pueblo Koyemsi or Mudhead clowns*, n.d. Watercolor on paper. Artist's collection.

Fig. 120. *Mt Tingra Khan of Run Lun Mtn Range near Alzosu in Sinkiang Sector of SE China*, 1970. Ballpoint pen, fiber-tip pen, colored chalk, and colored pencil on paper. 61.2 x 48.4 cm. Collection of the Art Institute of Chicago. Bequest of Whitney Halstead, 1979.227.

Negi, the coyote image somewhat parallels renderings of the animal found in ancient rock art and Navajo sandpaintings (fig. 118).

As discussed earlier, the eagle, another creature sacred to Native Americans, also occurs in Yoakum's landscapes. Among pueblo peoples, the eagle is believed to possess supernatural powers that protect humans and help them communicate with the spirit world. This bird is thought to receive inspiration from the life-giving powers of the sun that endow it with this special messenger status. Yoakum seems to convey this concept of the eagle in the landscape *Mt Phu-Las Leng in Plateau near Xieng Laos East Asia* (plate 39). One of the two central figures in the composition is an abstract, pale blue eagle head, with pointed beak, wedged between the bird's two outstretched wings. The eagle's head and wings seem to be suspended between the sun-filled sky and the earth below. A curious pale blue conical form suggestive of a disembodied head dominates the lower part of the composition. This head-like form appears to be a composite of several types of pueblo kachinas, dancers that represent supernaturals in major tribal ceremonials. For example, the three tiny circles Yoakum uses to define the eyes and nose-mouth orifice of his disembodied "head" are reminiscent of the sacred clowns of the Hopi and Zuni tribes known as Koyemsi, or Mudheads (fig. 119). Probably the most familiar figure in the

pueblo pantheon, Koyemsi perform a variety of roles, most commonly serving as a messenger between the gods and humans.[34] As in Yoakum's impressionistic rendering, the cheeks and foreheads of some Koyemsi clowns are decorated with curious "bean sprout" marks. The evergreen collars sometimes worn by these clowns are further suggested by the artist's inclusion of two small evergreen trees at the base of his "clown head." Another interesting element is the head's pale blue color. It is identical to the paint color that covers the faces and bodies of other pueblo kachinas with evergreen collars known as the Kaletaka kachinas, representing Hopi warrior gods. The artist Joseph Mora described the powerful impact of this color blue when he witnessed a Kaletaka dance in the early twentieth century: "They [Kaletaka kachinas] were all in blue phase, tho [sic] the masks . . . varied in blue over the naked torsos and lower legs. The moccasins were a different blue as were the rattles. Bits of blue accents asserted themselves from the woven decorations of the Kachina sashes hanging at their sides. . . . If ever I saw through a painter's eyes a symphony in blue there it was!"[35]

Evergreen collars on pueblo kachinas symbolize the sacred spruce tree. According to tribal belief, the breath of the underworld ascends through the trunks of these trees and forms clouds that contain life-giving rain.[36] In Yoakum's drawing *Mt Phu-Las Leng,* the spruce tree is also suggested by the unusual checkered pattern of dark green and light brown that decorates the two principal mountain forms. The concept of fertility is also conveyed by the repetition of tiny female genital-like forms in the light brown areas of this design.

A different eagle portrait is presented in the landscape *Mt Tingra Khan of Run Lun Mtn Range near Alzosu in Sinkiang Sector of SE China* (fig. 120). An abstract disembodied head of a man, shown in profile, forms the top of the mountain on the right. With his eye seeming to gaze upward towards the sky, the man's head appears to float

Fig. 121. Winnebago bag with eagle design, c. 1840–1860. Vegetal fiber, buffalo wool, and wool yarn. 15.5 x 21.0 cm. Collection of the Cranbrook Institute of Science, CIS 2311. Photograph by Robert Hensleigh.

over the outstretched right wing of a centrally placed impressionistic eagle. Hanging from the bird's "wings" are abstract tassel-like "feathers" reminiscent of Native American eagle designs. The two darker diamond shapes filled with hatching that decorate its "body" recall tribal representations of the eagle's heart and tail feathers (fig. 121). Yoakum's drawing may be an interpretation of a pueblo myth about a young man who falls in love with his captive eagle, who abandons him on a cliff after he tries to follow her to her home in the sky.[37]

The badger, another important animal in pueblo mythology and religion, seems to be portrayed in an intriguing Yoakum landscape, *E. P Everest in Himilaya Mtn Range near Gyangtse East Asia* (plate 40). In nature, the badger's face, reminiscent of the raccoon's, is a black mask broken by a white stripe that runs vertically over the top of its head. Yoakum suggests the badger's black face with its white stripe by a curvilinear white road edged in black that is interrupted by four rows of pine trees. The road becomes a point as it disappears to the left—a form that could be read as the

badger's prominent snout. The top of the badger's "head" may be read as the pale gray mountains above the black-edged white road and the animal's piercing "eyes" as the two black triangular forms inside these gray peaks. This drawing appears consonant with the Acoma tribe's creation myth, in which the badger facilitates man's ascent from the dark Underworld into the daylight. According to this myth, Two Sisters, the twin mothers of mankind, planted the seeds of four different pine trees in the Underworld. Each tree grew to successive levels of the Underworld, until the fourth pushed a small opening into the Upper World. While the hole let in light from the Upper World, it was too small for Two Sisters to crawl through until the badger climbed up the four pine trees and enlarged the hole with his teeth.[38] In Yoakum's drawing, the Underworld region is bathed in deep purple, its center split apart by four rows of pine trees. The badger's disembodied "head," which appears to be resting on these trees, is positioned between the dark Underworld and the light-filled Upper World, indicated by pale pink mountains and a large golden sun.

Other pueblo myths appear to be represented in Yoakum's landscapes as well. One such myth is about the sacred winds that are enclosed by the four sacred mountains serving as outposts of the Navajo universe. These winds figure prominently in the religious curing ceremonies of the Navajo known as the Windways. The Navajo believe that wind signifies the breath of life and that a person's life begins when the sacred wind enters the body and exits through the fingers. This Navajo belief is recalled in the unusual fist- or mitten-shaped mountains in Yoakum's drawing *Spectacular Royal Gorge of Colorado Rockey Mtn Range*[39] (fig. 61). In this landscape, the mountains terminate in multiple ridges that resemble the spread fingers of a hand. In such a pose, the hand is best able to carry the life-giving wind. The gray and brown dappled surface of the artist's mountains may also allude to the Spotted Winds of another Navajo myth.[40]

In Yoakum's beautiful drawing *Mt Atzmon on Border of Lebanon and Palestine SEA,* he presents the rainbow in its three traditional Navajo colors—red, white, and blue[41] (plate 28). The Navajo believe that the rainbow signifies earthly abundance and new life created through the three rainbow colors that permeate the heart of all seeds. Thus, when this symbol of nature's powerful creative force figures in a Navajo's dreams it is seen as a positive omen—a reward that often comes to those who walk the path of beauty.

The Artist and African American Culture

John Henry, with your hammer;
John Henry, with your steel driver's pride,
You taught us that a man could go down like a man,
Sticking to your hammer till you died.
Sticking to your hammer till you died.
—Sterling Brown, "Strange Legacies"

In his book *Art as Experience* John Dewey observes, "Every culture has its own collective individuality . . . which leaves its indelible imprint upon the art that is produced."[1] Dewey asserts that it is not necessary to actually experience a culture in order to appreciate the aesthetic qualities of its art, but that a deeper understanding of a culture may enhance enjoyment of its art. Such understanding may allow a person to reorient his or her own experience and thereby "enter the spirit of that art."[2] While Yoakum never discussed it, his African American cultural experience helped to shape the body of his work. By gaining a better understanding of this cultural context in which Yoakum worked, it is possible to find yet another way to enter the spirit of his art.

Archetypal Heroes: Tricksters, Strongmen, and Badmen

Heroes in every culture, whether real or fictional, reflect its values. As the historian Roger Abrahams

states, their heroic deeds communicate values by providing a guide to good behavior and a means by which to express hopes for the future.[3] Heroes who serve identical needs sometimes assume different guises, thus becoming what Joseph Campbell called "the hero with a thousand faces."[4]

According to historian Robert Levine, the archetypal African American hero has three distinct faces. The trickster, or clever hero, triumphs by means of his wits; the strongman, or contest hero, publicly defeats his rivals in contests of skill, strength, or virtue; and the badman—a special type of contest hero—overtly rebels against society's oppressive laws.[5] All three heroic models are celebrated in Yoakum's oeuvre.

The trickster hero is found in many different cultures. As discussed earlier, among Native Americans, he appears as a raven or coyote. By contrast, in the African American culture, he emerged during the slavery years as a fictional prankster, like Br'er Rabbit—a small animal that defeated his more powerful adversaries through guile and

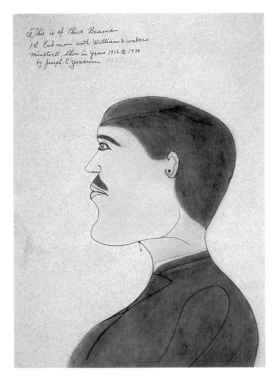

Fig. 122. *This is of Chick Beaman 1st End man with Williams & Walkers Minstrell Show in years 1916 to 1930*, 1968. Ballpoint pen, graphite pencil, and colored pencil on paper. 15 1/2 x 11 3/4 in. Collection of Gladys Nilsson and Jim Nutt.

cleverness. In the nineteenth-century black minstrel shows, this trickster role was performed by the end men—half-wit comics who always managed to get the better of the interlocutor, who was the only straight man in the show.[6] A well-dressed gentleman with impeccable manners and stilted speech, the interlocutor was a pompous intellectual who became an easy prey for the end men's buffoonery. To African American audiences, the end men's antics symbolized their own desires to poke fun of or get the better of those in white society who mistreated them or regarded them as inferior.

It is not surprising that Yoakum's drawings about minstrelsy memorialize the end men. One of the artist's most beautiful portraits is of end man Chick Beaman—a handsome mulatto man shown in profile with intense hazel eyes, black mustache, and pale pink lips (fig. 122). Beaman appears dignified in a dark suit, giving no hint of

his profession except perhaps in the slightly mischievous expression of his mouth.

Another face of the African American folk hero is the strongman, or contest hero, who, through his strength and courage, overcomes barriers to his progress imposed by white society.[7] His victories are won not by breaking the society's laws but by conforming to its rules. He triumphs by achieving success in careers from which blacks traditionally have been excluded.[8] Yoakum presents a pantheon of these contest heroes—both fictional and real—in his portraits and pays tribute to others in his landscapes. Among these are steel driver John Henry, boxers Jack Johnson and Joe Gans, cowboy Bill Pickett, and tennis champion Althea Gibson. Four others in Yoakum's heroic pantheon are white. Buffalo Bill Cody featured African American cowboys and other contest heroes in his Wild West Show. Zane Grey, the novelist, chronicled the contributions of these black cowboys to western settlement and glorified working men and Native Americans while criticizing their exploitation by government and business. The artist's portraits of two white politicians—William Jennings Bryan, discussed earlier, and President William McKinley—also celebrate champions of the underdog. McKinley initially won African American sympathy with his decision to commit U.S. armed forces to help the Cubans, a people of color, achieve their freedom from colonial rule. The Battle of San Juan Hill—the famous engagement of the war later reenacted in a popular circus spectacle—was noted for the distinguished contributions of black soldiers.[9]

Perhaps the greatest of the African American contest heroes that Yoakum depicted was the legendary John Henry. A steel driver employed by the Chesapeake and Ohio Railroad, Henry helped build a series of tunnels through the mountains of West Virginia. According to legend, Henry died of overexertion after winning a competition against a steam drill. His heroic feat epitomized man's refusal to bow to the power of the new in-

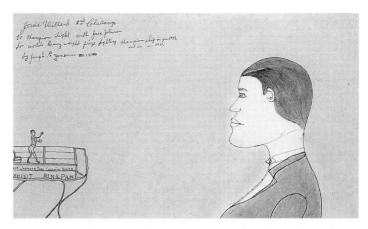

Fig. 124. *Jessie Willard 2nd Challenge to Champion Fight with Jack Johnson for Worlds Heavy Weight Prize fighting championship in year 1917 and 1920, Jack Johnson then Champion Boxer Exhibit Ring PAPF*, 1969. Ballpoint pen, graphite pencil, and colored pencil on paper. 12 x 18 in. Collection of Gladys Nilsson and Jim Nutt.

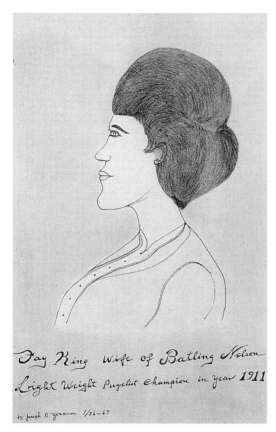

Fig. 123. *Fay King, wife of Batling Nelson Light Weight Pugelist Champion in year 1911*, 1967. Ballpoint pen, graphite pencil, and colored pencil on paper. 17 7/8 x 11 7/8 in. Collection of Gladys Nilsson and Jim Nutt.

dustrial society, which was perceived as being bent on replacing skilled workers with machines.

Over the years, railroad workers in different sections of the country have appropriated John Henry's story for their own regions and railroads. In keeping with this tradition, Yoakum memorialized Henry in several landscapes that identify the site of his martyrdom as Tishimingo, Oklahoma, a hub for the St. Louis & San Francisco Railroad, which once employed the artist.[10]

Other real-life contest heroes who captivated Yoakum were the boxing champions Jack Johnson, the first African American heavyweight champion of the world, and Joe Gans, the first African American to hold the lightweight championship title. Curiously, the artist does not represent these fighters at their moment of greatest professional

triumph, but rather focuses on the individuals associated with their biggest defeats.

Joe Gans lost his lightweight boxing crown in 1908 to a white man, "Battling" (Oscar) Nelson. Fay King, Nelson's wife, is the subject of two Yoakum portraits. In one version she is shown in profile (fig. 123). Her self-assured air is conveyed through a strong chin held high, lips pressed tightly together, and penetrating blue eyes set off by black hair swept up in an elegant pompadour style. In the second portrait, she appears with a regal long-necked swan that may serve as a metaphor for her grace and beauty (plate 41).

In the year of Gans's loss to "Battling" Nelson, Jack Johnson took the heavyweight crown from Tommy Burns at Sydney, Australia. His victories against Burns and a string of other white opponents had symbolic significance for the African American community, as fights against "Race Hatred, Prejudice, and Negro Persecution."[11] Ironically, Yoakum portrays Johnson at the moment when he finally loses his heavyweight crown to Jess Willard in a twenty-six-round fight (fig. 124). In this portrait, Johnson, dressed in boxer's shorts and alone in the center of the ring, strikes a curious pose. One gloved hand is raised to chest level, as if the champion wants to defend himself.

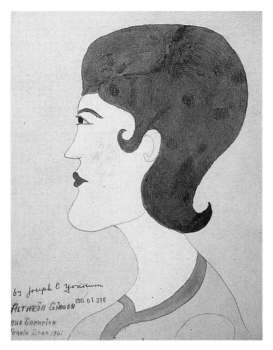

Fig. 125. *Altheia Gibson Our Champion Tennis star 1961*, 1963. Ballpoint pen, graphite pencil, and colored pencil on paper. 30.1 x 48.4 cm. Collection of the Art Institute of Chicago. Bequest of Whitney Halstead, RX18296/118.

With his other hand, gloveless and unprotected, Johnson appears to wave to the crowd. His posture conveys an ambivalent attitude. The artist may be alluding to the fact that many Johnson fans believed the boxer threw the fight to Willard in a deal that meant he could return to America without facing a prison term. The drawing, however, could also be read as an allusion to the fight's still controversial photo finish, when Johnson held one hand over his head to shield his eyes from the sun.

At a time when most African Americans were confined to jobs as laborers and farmers, the achievements of real-life contest heroes like Johnson and Gans symbolized the ability of their race to overcome stereotypes imposed by whites and to achieve success in nontraditional careers. Tennis star Althea Gibson, another African American hero who made it in the white world, is also the subject of a Yoakum portrait (fig. 125). Gibson was the first black woman to attain international fame

in tennis, a game of the social elite of her day. An intriguing aspect of Yoakum's portrait is that Gibson is represented as a white woman—perhaps a subtle statement by the artist about the athlete's ability to crack the color barrier in a tough competitive sport.

Another interesting Yoakum portrait that falls in the heroic genre is *Synthe Walwo the only Indian million air in U.S. derived from oil wells and refinery in Boley Oklahoma*. Walwo is depicted with pale copper-toned skin and a Christian cross around her neck. There is a distinct possibility that her racial and ethnic background, like Yoakum's, was both African American and Native American. Her hometown of Boley is noted for being the largest of the all-black communities established in Oklahoma during the late nineteenth and early twentieth centuries.[12] After a visit there, Booker T. Washington praised the town for being "another chapter in the long struggle of the Negro for moral, industrial and political freedom."[13]

In addition to his portraits, Yoakum produced landscapes to commemorate other contest heroes. Among those celebrated were African American cowboy Bill Pickett, the star of the Ranch 101 Wild West Show who invented the sport of bulldogging, Wild West impresario Buffalo Bill Cody, and novelist Zane Grey, who first chronicled the exploits of African American cowboys like Pickett. Grey, whose successful writing career spanned thirty years, was a popular writer of westerns. Many of his books were either serialized in magazines or turned into motion pictures.

Yoakum's affinity for Grey—whose ranch was pictured in at least three of the artist's landscapes—can be supposed from the themes of some of the writer's most memorable novels. *The Vanishing American*, for example, chronicles the life of a Navajo Indian who was picked up by a party of whites when he was seven years old, a story similar to the one Yoakum later told about himself. The novel presents a sympathetic view of Native Americans that was atypical of the period.

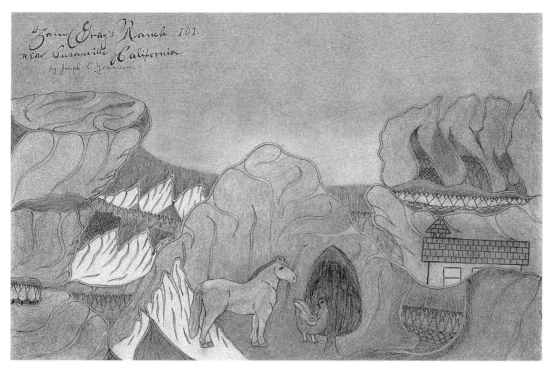

Fig. 126. *Zain Gray's Ranch 101 near Susanville California*, 1966. Ballpoint pen, graphite pencil, and colored pencil on paper. 12 x 18 in. Private collection. Photo courtesy of Fleisher/Ollman Gallery, Philadelphia.

Other Grey themes that must have resonated with Yoakum included antiracism, the gunman wronged by the law, loners who ran counter to prevailing trends, governmental indifference to the sufferings of World War I veterans, love of horses, and the beauty and restorative powers of the western landscape.[14]

In Yoakum's drawing *Zain Gray's Ranch 101 near Susanville California*, a silver-colored horse dominates the center foreground (fig. 126). This undoubtedly is a portrait of the novelist's first magnificent superhorse, Silvermane, which appeared in *Heritage of the Desert*, the book triggering Grey's rise to fame and fortune. A curious aspect of this landscape is the ranch house, which, with its bell tower, resembles a church—perhaps a reference to the theme of religious persecution and the Mormon Church that was developed in this and many other Grey novels.[15] The title of the drawing, which includes the words "Ranch 101," is another interesting element. While Grey was not

associated with the 101 Ranch Real Wild West Show made famous by Pickett, the title of Yoakum's work may be an oblique reference to the fact that the novelist was the first to record the unique contributions of black cowboys to the western frontier.

Another, very different, version of Zane Grey's ranch in terms of composition and palette is Yoakum's drawing *Zain Grays Ranch in Siskayou County near Susanville California* (fig. 30). In this landscape, the tiny ranch house suggests a horse-drawn circus wagon, with circular windows, pale yellow walls, and a pale pink door emblazoned with a large "Z." A fence encloses this structure and an adjacent tower, while a distant mountain takes the shape of a favorite circus performer—the elephant. In the early decades of the twentieth century, the town of Susanville, named in the title of this work, was on the routes of several railroad circuses, including Adam Forepaugh and Sells and Ringling Brothers. Grey's ranch, Winkle Bar, was

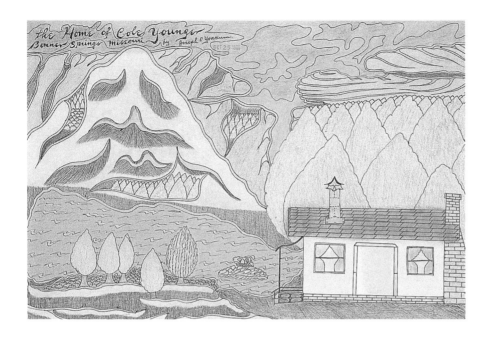

Fig. 127. *The Home of Cole Younger Bonner Springs Missouri*, c. 1965. Ballpoint pen, graphite pencil, and watercolor on paper. 11 13/16 x 17 13/16 in. Collection of Gladys Nilsson and Jim Nutt.

not located in Susanville, however, nor in Siskiyou County, but in the Siskiyou Mountains of southern Oregon.

The badman, or outlaw, is the third archetypal African American hero who captured Yoakum's imagination. As with the contest hero, the badman is victorious over all rivals, but his opponents include the weak as well as the strong.[16] In the European American heroic tradition, these outlaw heroes are usually driven to crime in order to avenge a societal wrong.[17] Examples of this heroic type are Jesse James and his accomplice, Cole Younger, who robbed banks to express their outrage over a Reconstruction period law that confiscated the horses, mules, and guns of former Confederate soldiers. Yoakum pays tribute to these two outlaw heroes in several landscapes of their homes. In such works the artist once again displays an affinity for those who challenge injustice in society and prevail against insurmountable odds.

Yoakum completed two very different drawings of the Younger home. One version, *The Home of Cole Younger Cousin to Jesse James near Bonner Springs Missouri*, painted in muted brown, gray,

gold, and rose tones shows a mulatto woman in a long, pale-pink dress standing in front of a log cabin (plate 42). Her hair is plaited in a single, long braid down her back, and her arms are outstretched as if in welcome. She is facing a little brown pony tied to a small empty sleigh. The pony seems to be traced from either a photograph or a drawing in a book or magazine. This curious assemblage suggests the long-awaited return of Cole Younger to his Missouri farm after his release from prison.

The second version of the Younger home is executed mostly in bright primary colors of yellow, green, and blue (fig. 127). A large lake and white, ghost-like mountain near the home dominate the left half of the composition. Covered with abstract black forms that may be read as eyes, nose, lips, and mustache, the mountain perhaps is the apparition of the departed Jesse James, who still haunts the Missouri hills. It also may be interpreted as the sorrowful image of Cole Younger. In the words of the ballad that bears his name, Younger lamented that "the crimes done by our bloody hands bring tears to my eyes," and for these terrible acts "I will be sorry until my dying day."[18]

Sacred Music: Biblical Heroes and the Children of Israel

In an interview with newspaper reporter Norman Mark, Yoakum confided that the "Bible is my biggest story book."[19] Indeed, the artist's landscapes of the Middle East mostly bear titles with ancient biblical names like Canaan, Palestine, Arabia, and Phoenicia. Some drawings even depict biblical sites, like the Wilderness of Sin and Mt. Horeb, whose locations have never been definitively established by archeologists or biblical scholars.

Significantly, Yoakum's oeuvre, like African American spirituals, deals principally with two biblical heroes—Moses and Jesus. Like the secular contest heroes who emerged following Emancipation, Moses was revered for directly challenging the established oppressive authority and securing freedom for the Hebrew slaves.[20] African American slaves closely identified with the Jews and honored their deliverer in songs like "Go Down, Moses." Similarly, Yoakum pays tribute to Moses in a series of landscapes depicting key events in the prophet's life.

The site where the daughter of Pharaoh discovered the infant Moses in a papyrus basket is commemorated in Yoakum's drawing *Nile River near Cairo Egypt and Gulf of Suez* (plate 11). Other landscapes depict Mt. Horeb, the mountain where God, in the guise of a burning bush, handed down the Ten Commandments and instructed Moses to liberate the Hebrews. In the drawing *Red Sea with Egypt and Arabia bordering on each side*, Yoakum recalls the Hebrews' deliverance from Pharaoh and the miraculous crossing of the Red Sea. This event, of course, marked merely the beginning of the forty-year Exodus from Egypt led by Moses. Before reaching the Promised Land, the Israelites walked through seven wilderness areas—deserts that are depicted in several Yoakum landscapes. Finally, in *Holly Hills of Canaan S.E. Asia*, Yoakum shows the Promised Land. His pale lavender hills

are a subtle reference to the Hebrew meaning of Canaan, "country of purple."

African American sacred music treats Jesus as a "second Moses," or deliverer. Similarly, in Yoakum's art, Jesus is on a par with Moses. In a series of landscapes the artist traces the key events in the life of Christ. These include his birth in Bethlehem, ministries in Nazareth and Jerusalem, baptism in the Sea of Galilee, Sermon on the Mount of Olives, forty-day fast in the wilderness, crucifixion on Mt. Calvary, and transfiguration after death on Mt. Tabor.

One of Yoakum's favorite subjects is Mt. Calvary. At least four versions exist, all with similar compositions but very different palettes. The earliest example is a small drawing, *Mt Calvary*, in somber hues of dark green, brown, blue, and rust orange. Its tone recalls more traditional crucifixion pictures in which blackened skies engulf the grief-stricken figures. A slightly later drawing, *Mt Calvalery near Jeruselam So. East asia*, is unusual because it contains a bright yellow sun, perhaps a reference to Christ's resurrection and the promise of eternal life for all those who "wait upon the Lord." A third version, *Mt Cavalary near Jerusalam and Bethelam palestine se Asia*, has a palette that ranges from black to pale tones of ivory, yellow, pink, blue, and gray (plate 43). The stark color contrasts in this drawing seem to convey the feeling of loneliness expressed in Arna Bontemps's poem "Golgotha is a Mountain":

> Then the people went away and left Golgotha
> Deserted.[21]

The Blues and Its High Priestesses

Music played an integral part in daily life for young African Americans of Yoakum's generation. From slavery times until well after World War I, black American laborers sang songs, metrically timed, as they loaded ships, dug ditches, built roads, quarried rocks, picked crops, and cooked

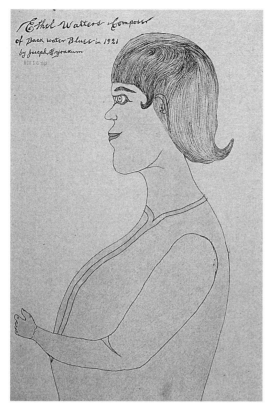

Fig. 128. *Ethel Watters Composer of Back Water Blues in 1921*, 1967. Ballpoint pen, graphite pencil, and colored pencil on paper. 17 x 11 in. Collection of Gladys Nilsson and Jim Nutt.

meals. In the 1920s, the blues transformed African American secular music and ultimately became a source of inspiration for Yoakum and many other black visual artists.

In his portraits, Yoakum honors the so-called high priestesses of the blues—Bessie Smith, Mamie Smith, Ethel Waters, Sippie Wallace, and Lucille Hegamin. His drawing *Bessie Smith Cousin to Mamie* celebrates one of the greatest blues singers of the 1920s. White clarinetist Mezz Mess-row remembered Bessie as "just this side of volup-tuous, buxom, massive, but stately too, shapely as an hourglass, with a high-voltage magnet for a personality."[22] Her fans were so devoted that if they heard a song they liked recorded by another singer, they would wait to buy Bessie's version.[23] Mamie Smith (no relation), referred to in the title

of this work, had an equally spellbinding voice and presence. Besides being the "best-looking woman in the business," according to fellow blues artist Willie "The Lion" Smith, this Mamie was noted for being the first African American to record the blues.[24] She pioneered the way for all those who followed in the field.[25] Yoakum alludes to Mamie's enormous influence on her fellow artists by often including her name in the titles of their portraits, as he does in his portrait of Bessie Smith.

Ethel Waters—at various times a singer of the blues, jazz, and big band music—is also featured in Yoakum's pantheon of hero-entertainers. With her lanky frame and large, dark, sparkling eyes, she was an African American sex symbol in her youth. This essence of Waters is conveyed in Yoakum's portrait of her. He emphasizes her eyes and brows with heavy makeup and puts a saucy, black curl over her ear (fig. 128).

There were many other African American female vocalists in the 1920s who shared the lime-light with Bessie Smith, Mamie Smith, and Ethel Waters. Two of the other trendsetters, Sippie Wallace and Lucille Hegamin, are the subjects of Yoakum portraits.[26] Wallace was the sister of the well-known Texas pianists George and Hersel Thomas, who were the first to play boogie-woogie. As one of the first regional blues singers to build a national reputation, Wallace "offered what amounted to sisterly advice in the form of coun-try homilies," in such songs as "Sister Be Wise."[27] The artist portrays her primly attired in a white blouse with a stiff high collar—a costume that seems to convey the essence of her musical admo-nitions (fig. 129).

Lucille Hegamin, known as "the light-skinned Georgia Peach," was the second African American woman to record the blues in the 1920s. Her song "He May Be Your Man But He Comes to See Me Sometimes" was one of the period's "most spirited romps and the godmother of a long line

of such songs about women competing for men."[28] In *Lucille Haggerman Mamie Smith's Competitor in 1927*, Yoakum portrays Hegamin as a white woman with heavily painted red lips and ebony-colored hair elaborately coifed with a bun on the top of her head. In another portrait, *Lucille Haggamon 1st End Lady with Williams and Walkers Minstrall Show in year 1901*, she appears as a pretty, smiling mulatto woman with delicate features. She is dressed in a pale brown skirt and a pale blue blouse that matches the color of her eyes.

Jazz great Ella Fitzgerald is also featured in Yoakum's pantheon of hero-entertainers. In his portrait *Ella Fitzgerald Moovie Star*, the singer is represented as a white woman with ivory skin and black hair drawn with a graphite pencil buffed to look gray. The portrait appears to be modeled after a Breck shampoo advertisement. A more interesting drawing is a dual portrait of Fitzgerald and Lucille Hegamin. It shows the singers facing each other, with their hands almost touching, as if they are at the moment of parting. This composition may allude to a Cole Porter tune, "Ev'ry Time We Say Goodbye," which became one of Fitzgerald's greatest hits.[29] It was released on her album of Porter songs that became the second-best-selling record in the nation.

In addition to his portraits of blues and jazz artists, Yoakum's landscape subjects sometimes reflect the themes of blues songs. These include floods, cyclones and other natural disasters, and the railroad, the favored symbol of escape from life's hardships. For instance, the floods of the Mississippi Valley, which the artist knew firsthand, inspired many blues songs, such as "Muddy Water," "Mississippi Flood Song," and "Mississippi Water Blues."[30] Yoakum recalled his experience in a Mississippi Valley flood in his drawing *This is the flooding of Sock River through Ash Grove Mo on July 4th 1914 in that drove many persons from Homes I were with the Groupe leiving their homes for safety* (plate 2).

Fig. 129. *Sippie Wallace 2nd to Ethel Watters*, n.d. Ballpoint pen, fiber-tip pen, and graphite pencil on paper. 15 x 12 in. Collection of Gladys Nilsson and Jim Nutt.

Other natural disturbances, such as cyclones and tornadoes, are subjects of blues songs and Yoakum landscapes. For example, one Missouri cyclone was lamented in the songs "St. Louis Cyclone Blues" and "St. Louis Tornado Blues":

The wind was howlin', buildin's begin to fall
I seen dat mean ol' twister comin' jes lak a cannon ball.[31]

By contrast, Yoakum's powerful, black twisters rip apart dwellings, leaving nothing in their wake. His compositions for *A Cyclone in Action at Iola Kansas in 1920* and *The Cyclone that Struck Susanville California in year of 1903* (fig. 4) recall photographic postcards of that era that typically captured all types of disasters—storms, floods, fires, train and ship wrecks, automobile accidents.

In view of Yoakum's long association with the railroad, it is not surprising that the train was a

favorite subject. A symbol of escape in the blues, it perhaps was for him as well. Blues songs like "Breakman's" express this sentiment.

Did you evah ride on de Mobile Central Line?
It's de road to ride to ease yo' troubling mind.[32]

Yoakum's art, however, also conveys the joy of train travel—a means of experiencing the breadth and the beauty of the American landscape. For example, in *Mt Bull Head of Adrondack Mtn Range near Glen Falls New York*, his engine almost appears to be smiling as it passes through a rainbow of colors—yellow-orange, pink, lilac, blue, olive, and buff (plate 44). Its bell may be read as an eyelid and its clapper a pupil of an eye. A line delineating the upper rim of its front fender suggests the engine's upturned mouth. Like his portraits of those who triumphed over adversity, this landscape conveys a sense of optimism that pervades much of Yoakum's art—a testament to his belief in the power of the human spirit.

Materials, Methods, and Motifs

In every artist's development the germ of the later work is always found in the earlier. The nucleus around which the artist's intellect builds his work is himself; the central ego, personality or whatever it may be called, and this changes little from birth to death. What he was once, he always is, with slight modification. Changing fashion in methods or subject matter alter him little at all.
—Edward Hopper

Marsden Hartley observed that "[a]s soon as a real artist finds out what art is, the more is he likely to feel the need of keeping silent about it, and about himself in connection with it."[1] Similarly, Yoakum was reluctant to discuss his art, even with members of the mainstream art community like Whitney Halstead, who befriended him and promoted his work. For instance, once when Halstead inquired whether a bird-like form hidden in a drawing of a New Mexico mountain was in fact meant to represent a bird, the artist replied simply, "If you say so."[2] Although reluctant to reveal his artistic intent, Yoakum nevertheless conveyed a strong sense of his own vision as an artist. When viewing Yoakum's landscape of hills in western Iowa, Halstead remarked that, although he had grown up in that area, he had never seen such mountains there. The artist responded matter-of-factly, "Well, that's because you never looked."[3]

Working Methods

Except for brief hospital stays at the end of his life, Yoakum produced his art in a modest storefront studio on Chicago's South Side that may have once served as a beauty parlor. During the artist's most productive period, he completed a single drawing in one or two days.[4] Generally, he preferred to work at night, undisturbed by the noise of neighborhood children playing in the street.[5] He sat at a large metal table lighted by a gooseneck table lamp and a floor lamp minus its shade. His worktable held a collection of cans and jars filled with an assortment of ballpoint pens, pencils, pastels, chalks, and, in later years, fiber-tip pens. He also kept rolls of toilet paper used for rubbing and blending his colors.

Yoakum had a lot of books neatly arranged in his bookcase (fig. 130). His collection included several "how to draw" books, an atlas, travel books, an encyclopedia of world geography, the *Encyclopaedia Britannica*, a Bible, and Mary Baker Eddy's *Science and Health*. As one visitor to his studio recalled, "He found his way easily around the books that he wanted to tell us about."[6] Several visitors remembered seeing one of these volumes opened to a picture that appeared to be the source for a particular landscape's title or composition.[7] In fact, Yoakum actually inscribed one

Fig. 130. Joseph Yoakum with books and drawing, c. late 1960s. Collection of the Archives of American Art, Smithsonian Institution. Whitney B. Halstead Papers.

drawing with the notation "Make more plain of upper New Zealand over the peak. See page 138 of Atlas New Zealand Mt Tolamar." He also clipped and saved photographs from various sources, including travel advertisements like the one for Kings Canyon National Park with evergreen trees found in his studio papers at his death. However, such photographs do not appear to have been major sources for the artist's imagery. It seems more likely that the captions on the photographs sparked ideas for landscape subjects and that the strata definitions of topographical maps in his atlases helped inspire the complex stratification in his rock forms.

A general understanding of Yoakum's methods of working may be gained from his contem-

poraries' observations, his own words, and his actual drawings. As evidenced by some discarded sketches on the backs of finished works, the artist sometimes began the picture-making process with a graphite pencil drawing.[8] His next step was to outline the forms and create textures in ink. A fountain pen was used for this purpose in the earliest known drawings of 1962 and 1963, but later he preferred the ballpoint pen. Yoakum developed such fluency with this medium that eventually he also used it to sketch his preliminary design. This method may be seen in the drawing *Mt Liotian in Greater Khiangian Mtn Range near Tritsihar Deep Southern China East Asia* (plate 26). It was purchased "unfinished" by the artist Ray Yoshida who thought it beautiful just as it was. Nevertheless, Yoakum told him, "Now, you can go and color it."[9]

By 1967, Yoakum had started to experiment with fiber-tip pens in red, blue, violet, and black. These were mostly used in combination with ballpoint pen, but did not feature prominently in his work until the 1969–72 period. The artist appears to have been fascinated by the wider, softer line produced by these pens.[10] Unfortunately, their colors are highly fugitive, and many have faded badly. Yoakum's use of fiber-tip pens to delineate mountain forms is beautifully illustrated in such landscapes as *Spectacular Royal Gorge of Colorado Rockey Mtn Range* (fig. 61) and *Mt Tingra Khan of Run Lun Mtn Range near Alzosu in Sinkiang Sector of SE China* (fig. 120).

Generally Yoakum drew freehand, except when he traced quarters to make suns or used a ruler to delineate houses, fences, and railroad tracks.[11] Larger houses often were outlined with ruled lines, while the smaller ones were executed freehand. Since drawing with a ruler slowed him down, he never represented the buildings of big cities like Chicago.[12] Examples of his ruled structures may be seen in *Zain Grays Ranch in Siskayou County near Susanville California* (fig. 30) and *The Home of Cole Younger Bonner Springs Missouri* (fig. 127). His fellow artist Roger Brown initially

Fig. 131. *Town of Fergus Falls Minnesotta in Stream Thrift River*, 1966. Ink and graphite pencil on paper. 12 x 18 in. Private collection. Photo courtesy of Phyllis Kind Gallery, Chicago and New York.

found Yoakum's ruled lines to be problematic, but later changed his view and even incorporated this design element into his own work.[13]

Whether he drew freehand or with a ruler, Yoakum had such a sensitivity to line that he almost never made corrections. Occasionally, in a landscape drawing, he would erase a line crossing a roadway, or remove a cloud covering a sun or moon. The rare exception in a portrait occurs in *Lucille Haggamon 1st End Lady with Williams and Walkers Minstrall Show in year 1901*. The line that defines Hegamin's back was erased and moved slightly to the left in the finished work.

After a drawing was completed, Yoakum added the title, usually in the upper left corner of the composition. In some of his early works, however, the titles were written in the lower left or right corner. A drawing was titled after it was finished. Upon completion, some drawings were also signed and dated. However, typically, this final step occurred at the time the works were sold.

Dates were either handwritten or affixed with rubber stamps. Unfortunately, the accuracy of the stamped dates is somewhat questionable, because children in the neighborhood often played with the stamps. Finished drawings were hung on a clothesline for viewing and later protected in plastic shirt bags.[14]

Yoakum sometimes made carbon copies of his drawings. Such reproductions typically were labeled "modles" or "patron" drawings, "not for sale." An example is *Town of Fergus Falls Minnesotta in Stream Thrift River* (fig. 131). The title of this drawing includes the artist's notation "This is a modle no paint." "Modle" drawings were stapled to second sheets upon which the artist laid carbon tracing paper. The image was transferred with ballpoint and fiber-tip pens and occasionally with graphite or colored pencil. Sometimes the image was traced in the same direction as the original design and at other times in the opposite direction.[15] As Yoakum's artist friend Gladys Nilsson

noted, "The tracing paper gave the drawings a soft, smoky, black, gray feeling."[16] The quality of his copies tends to be somewhat uneven, however.[17]

Occasionally, Yoakum employed a technique he called "embossing"—a method he favored when drawing on the harder surfaces provided by the covers of pads of drawing paper.[18] If he traced a design with heavy ballpoint on the printed side of the cover, the lines of the drawing were raised in relief when the cover was turned over. In this way, the artist said, he could "make the trees stand out."[19]

Palette

Around 1963, Yoakum began to add touches of watercolor to some of his drawings. In the beginning, he preferred a limited palette of mostly dark green, cobalt blue, orange, red, and black. In many of these compositions, large areas are left unpainted, and the watercolor tends to obscure the line. An example of this approach is seen in the landscape *View of Blue Mounds Kansas* (plate 30). In other drawings, such as *Back where i were born 1888, A D.* (fig. 3), dark patches of watercolor hide the contour lines that define the trees, mountains, man-made structures, and other major forms.

As Yoakum continued to gain fluency with watercolor, he began to use a softer palette, introducing pale golds, greens, and lilacs, as well as white. In these works, the artist typically envelops his forms with a delicate wash of jewel-like color that permits the line to show through. An example is *Lebanon Mts near Sidon Phoenicia Asia* (plate 45). White paint is sometimes added, especially to mountain forms.

During this early period, a few drawings were shellacked, which created a translucent patina like that of old leather or ivory. However, the artist soon abandoned this technique because a number of his friends in the mainstream art community advised him of the potential conservation problems associated with it.[20]

By 1965, Yoakum began to experiment with colored pencils, pastels, and chalks, but these were used sparingly. Over the next two years, he slowly abandoned watercolor in favor of these new media, perhaps because they were easier to control. The artist gradually built up his tones so that he could fully control their intensity. After being applied, the colors were buffed or burnished with toilet paper to make them "look like watercolor."[21] This technique produced what Whitney Halstead described as a "hazel-like smoothness that allowed the line . . . to stand out with greater clarity."[22] At this time, Yoakum's palette tended toward softer tones of blue, lilac, olive green, turquoise green, pearl gray, peach, gold, buff, cocoa, and deep brown. This change is illustrated in *Mt Pikes Peak the Mtn of Pleasure near Colorado Springs Colorado Highest foot Bridge in U.S.A.* (plate 8). Occasionally the artist departed from this delicate palette by introducing bright colors like yellow or black to emphasize the sun or rock and cloud forms.

Materials

From 1966 to the end of his artistic career, Yoakum colored almost every drawing. Halstead remarked that the artist applied color "with the same freedom that he brought to the invention of forms."[23] Yoakum preferred colored pencils when he wanted a finer line than could be achieved with either pastels or chalks. These other two media were favored over pencils when softer, less intense colors were desired.

According to Whitney Halstead, throughout Yoakum's career as an artist, he experimented with a variety of different surfaces.[24] His earliest drawings, from 1962 to 1963, are executed either in blue ballpoint pen on manila construction paper or in graphite pencil on white writing or typing paper. The works on white paper, mostly undated, are of two sizes—eight by ten inches and nine by twelve inches. By the 1964 to 1965 period, the majority of his drawings are done on manila construction

paper of a medium size—twelve by eighteen inches. Yoakum's friend Evonne Durham noted that Yoakum especially loved this surface, which he called "Egyptian paper," perhaps because it reminded him of papyrus.[25] Unfortunately, this paper darkens and becomes brittle soon after exposure to light so that the edges tend to break. Not surprisingly, therefore, a number of Yoakum's drawings on this paper have corners missing. Some of these works also were shellacked or varnished, a process that has further contributed to the paper's darkening and brittleness.

Such conservation problems eventually led Yoakum to abandon the use of manila construction paper. Around 1967 he switched to inexpensive drawing paper of a medium size, typically twelve by eighteen inches. This change in surface coincided with his almost total conversion from watercolor to colored pencil, pastel, and chalk. The artist also may have needed this harder, thicker surface for applying and buffing the colors, because manila paper does not take much of a beating.[26]

Until his final illness, Yoakum continued to prefer medium-sized drawing paper. Around 1969, however, he started to experiment with paper of larger dimensions—twenty-four by eighteen inches. During this period the artist also began to make vertical, as well as horizontal, compositions and to draw with fiber-tip pens, in addition to graphite pencil and ballpoint pen.

In the summer of 1971, after he was taken to the hospital, Yoakum ceased to draw. When he resumed working in the spring of 1972, he rapidly completed five sketchbooks. The largest is eleven by fourteen inches and the smallest eight by ten inches. Two are nine by twelve inches in dimension. Three media are used—ballpoint pen, fiber-tip pen, and pastel. Only 130 of the sketches reach some degree of completion, and the quality varies considerably. Some of his more abstract compositions are particularly beautiful.

Title and Signature Styles

Except for his early works, most of Yoakum's drawings were signed, and all were given titles. Generally, the artist signed his works "Joseph E. Yoakum." In a few cases, his initials "J.E.Y." preceded the signature. A rarely used stylistic variation is "J.E. Yoakum."

Particular Yoakum drawings may be dated in part by the style of lettering in the titles and signatures. The titles of the earliest known drawings were usually printed in large letters. Sometimes a printed date was included. By 1964, the artist often signed his drawings in ballpoint pen, typically with large script letters. Titles, on the other hand, were written in either large print or script letters. The dates were either handwritten or affixed with a rubber stamp. Occasionally part of the artist's address (city, state, and zip code) was also added.

By 1965, Yoakum was using a wider variety of title and signature styles. Most titles were written in ballpoint pen with either large print or large script letters. Yoakum's signature, when included, was also executed in large script, and part of his address occasionally was added. Sometimes his signature was preceded by the words "drawn by." Another stylistic variation introduced at this time was small print and script for titles and signatures. The artist continued to favor this style for the remainder of his career.

However, around 1966, Yoakum adopted yet another lettering style—large heavy script, which he used periodically through 1969.

Despite some variations, small script was the preferred style for titles and signatures from 1966 to mid-1971, the end of Yoakum's most productive years as an artist. During this period, blue ballpoint pen was generally the favored writing instrument. Occasionally, however, graphite pencil was substituted. Around 1970, the artist also introduced the red ballpoint pen. For example, he used it to write the words "Red Mtn" in the drawing entitled *Red Mtn Clay Pass in San Juan Range*

near Telluride Colorado. In other works, such as *Mt Kanchen in Himilaya Mtn Range near Shara China East Asia*, the title was executed entirely in red ballpoint pen (fig. 102). As Yoakum began to experiment with fiber-tip pens, especially between 1969 and 1971, his signatures and titles were written in this medium as well.

Stylistic Elements

Yoakum developed a rich vocabulary of forms, patterns, and other design elements to create visionary landscapes that Whitney Halstead described as both "panoramic" and "intimate."[27] Elements of the artist's visual language, drawn from such diverse sources as Native American art and railroad advertising, have been discussed in earlier chapters. These, as well as other design elements purely of his own invention, like overlapping rows of evergreen trees, were used by the artist in myriad combinations to create richly varied landscapes. Individual design and compositional elements occur in his landscapes throughout his artistic career. An examination of these various design elements shows a distinct evolution in the artist's style.

Representing roughly 95 percent of his output, Yoakum's landscape drawings may be categorized into five major stylistic periods.[28] In the earliest period, from 1962 to 1965, the artist's landscapes are the most naturalistic. Forms generally are modeled with graphite pencil and pen and typically are not elaborated with many complex abstract patterns. S and inverted U forms are common design motifs. Ovoids that reveal the interior view of mountains also appear, but not as frequently as in many later works that possess a more pronounced anthropomorphic content.

While a distinctive feature of his landscapes after 1965, the double lines or formline surrounding major landmasses are absent in many drawings of this earlier period. This is especially true of smaller works, such as *Back where i were born 1888,*

A D. (fig. 3) and *View of Blue Mounds Kansas* (plate 30). Hatching is used, but not as extensively as in later drawings. It most often occurs in larger works, sometimes as fillers of small triangular spaces but more frequently as shading along the bottom edge of the formline. Hatching also serves to indicate waterfalls and dashing to suggest ripples in water or contours of mountains. Both techniques are illustrated in the drawing *Monongahelia River Falls in West Virginia near Riverside* (plate 46). In other landscapes, like *View of Blue Mounds Kansas*, mountains are contoured not by hatching or dashing but rather by thick lines of watercolor, as well as by groves of overlapping trees.

In this early period, Yoakum's treatment of sky generally is distinguished by an absence of clouds or celestial bodies, such as the sun, moon, and stars. Typically, in his watercolors, a cloudless sky is in a single color or fades from various shades of pale blue to pink or orange (plates 47, 48). In a few drawings, the sky is rendered with cloud formations that are completely filled with color.

By 1964–65, Yoakum's "invention flowered, and a rich variety of forms was developing into a unique visual language."[29] His landscapes of this period are more fanciful, as a profusion of complex patterns play over the surfaces of his mountain forms. Design motifs previously seen in his oeuvre now reappear. These include S and U forms, ovoids, curvilinear lines, and rows of overlapping trees, as well as hatching and dashing for texture. However, these diverse design elements are now used with greater abandon. For example, in a transitional work, *Egyption Desert*, the three large cone-shaped hills are adorned with distinctly different designs—small U forms in two rows, small S forms in a Christmas tree design, and a hieroglyphic-like pattern with squiggly S forms and little dots (fig. 132). In some drawings, the artist creates a design with a continuous curvilinear line that covers the entire surface of the paper in a

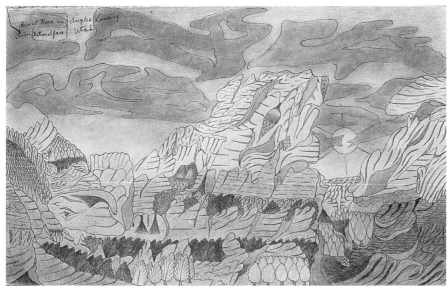

Fig. 132. *Egyption Desert*, c. 1965. Fiber-tip pen on paper. 30.2 x 45.2 cm. Collection of the Art Institute of Chicago. Bequest of Whitney Halstead, 1979.174.

Fig. 133. *Giant Rock Angles Landing Zion National Park Utah*, c. 1970. Ballpoint pen and pastel on paper. 12 x 19 in. Collection of Philip Hanson.

manner reminiscent of Pacific Northwest coast tribal art. Typically, brown or gray amoeba-like clouds create a complex pattern in the sky that appears to flow into the intricate, swirling designs on the mountainous terrain below. This technique is illustrated in *Giant Rock Angles Landing Zion National Park Utah* (fig. 133).

Yoakum's treatment of the formline delineating major shapes now also shows greater variation. While sometimes accented with hatching, the formline now is often filled with a contrasting color, perhaps graphite pencil buffed to look gray. To indicate mountain contouring, hatching now covers larger areas of the composition, as in the drawing *Syrian Desert Namrath Syria of Saudia Arabia S.E.Q.* (fig. 69). In many landscapes the anthropomorphic element also becomes more prominent.

The artist's growing proclivity for intricate, exuberant, and varied designs may be seen in an interesting transitional work, *Semi Granit Mtn Head Angles Landing near Forbs Valley Utah*

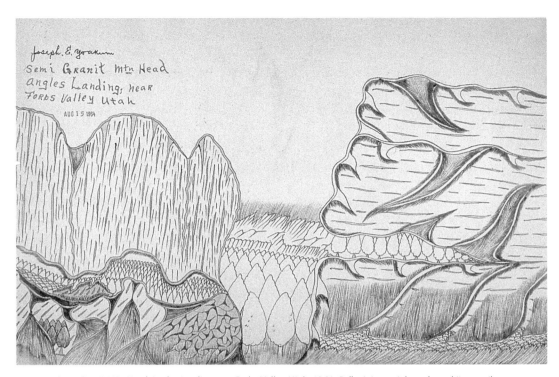

Fig. 134. *Semi Granit Mtn Head Angles Landing near Forbs Valley Utah*, 1964. Ballpoint pen, ink, and graphite pencil on paper. 30.5 x 45.5 cm. Collection of the Art Institute of Chicago. Bequest of Whitney Halstead, 1979.148.

(fig. 134). In this composition, two mountain forms stand side by side without converging. Hatching is used to emphasize the bottom edge of the formline that delineates the mountain on the right. By contrast, the formline defining the mountain on the left is filled with graphite pencil, buffed to create a soft tone that intensifies the line. The contours of both mountains are created by a variety of large triangular forms, as well as S and U shapes textured with hatching. The mountain on the right is decorated with a design of horizontal lines—occasionally broken by vertical U and S shapes—producing a tapestry-like effect. The large mountain on the left is patterned with heavy vertical lines. A small cone-shaped hill partially obscuring this mountain is covered with a contrasting curvilinear design that somewhat resembles intestines. The combination of vertical and horizontal designs with curvilinear and rectilinear designs produces an idealized landscape that conveys a feeling of continuous movement reminiscent of Native American art.

The last half of Yoakum's brief artistic career may be roughly divided into three stylistic periods. During the period from 1966 to 1968, his fascination with complex patterning grew as he invented increasingly abstract landscapes, often with animistic elements. Toward the end of his life, as the artist came to rely on the fiber-tip pen, his designs became bolder and more impressionistic, culminating in his final sketches of 1972, which often approach total abstraction (plates 1, 2).

From 1966 through 1968, Yoakum's treatment of the formline underwent further change. For instance, he began to gradually abandon the technique of hatching along the bottom edge of the formline. At the same time, his formline became more pronounced, especially when filled with a softer color that enhances the line. For example, his oddly shaped clouds, like pieces of a child's puzzle, may be outlined in heavy blue ballpoint pen but painted in soft gray or brown tones that make the line stand out (fig. 133).

Yoakum also experimented with a rich vari-

ety of new forms and patterns. He began to invent waves with dramatic abstract patterns of large, irregular curlicues and S forms, painted white and silhouetted against blue water. An illustration of this technique may be found in the drawing *Tampa Bay near Port Tampa Florida* (fig. 99). In earlier works, by contrast, waves are usually indicated with simple dashing or hatching in ballpoint pen. New forms are used in the treatment of sky as well. Sometimes Yoakum introduces a large yellow sun, or a crescent moon with a human face, and stars. It is curious that these design elements typically occur in skies that suggest sunset, colored in orange or pink and blue. If clouds are present, they usually tend to partially obscure the sun and are always rendered with distinctive long rays that imitate the spokes of a circus wagon's wheel.

The evolution of Yoakum's style is beautifully illustrated in two drawings of the same subject—a farm home in a suburb of Deming, New Mexico (plates 49, 50). The earlier version was completed in 1964, while the second was executed four years later. The works have similar compositions, but the details are handled very differently.

At the center of each composition is a large farmhouse with a covered porch. To the right is a shed or garage-type structure positioned near several large trees and a cactus. A road between them winds up to the hills. To the left of the farmhouse are a smaller house and signpost announcing "Deming Suburb." Gently rolling hills that run horizontally across the composition form a backdrop to this scene. Despite these similarities in format, the two drawings convey quite different visions of landscape.

In the earlier work, *Section #2*, the principal design elements are handled with restraint, producing a more naturalistic effect. The hills are bathed in a pale brown pastel pencil, occasionally accented with small groves of green trees. Hatching is used sparingly, simply to delineate the road, the front lawn of the farmhouse, and a shadow at the base of the hills. The colorless sky, which takes up about one-third of the composition, is devoid of clouds or any other decorative element. Also absent is a later favorite compositional technique, the picture-within-a-picture.

By contrast, *Deming Suburb,* the later work, is a study in decorative patterning. In this version of the subject, yellow, gray, and pink hills almost completely obscure the sky.

They are richly elaborated with myriad fanciful designs. The artist weaves a wonderful tapestry of ovoids, U and S forms, punctuated with hatching and dashing. Adding further complexity is his introduction of the picture-within-a-picture technique and his more expansive use of hatching. Cutaway views of the hills reveal groves of trees. Hatching fills large V and U shapes and surrounds ovoids that form part of the intricate patterning of the hills. In addition, structural elements, such as the farmhouse, are enlarged and made more decorative. Other points of interest are added, such as a small pond and row of trees to the left of the farmhouse. This more impressionistic landscape reveals how far the artist's vision of landscape had evolved.

During the next stylistic period, from 1969 to 1971, Yoakum's mastery of form is conveyed in a fashion that Whitney Halstead described as "often playful, and, at times, exaggerated."[30] Many landscapes from this period possess an anthropomorphic element. For instance, groves of overlapping pale green trees may transform into an animal's jaws and its watchful eye, or a man's teeth and his bulbous nose. There is increased use of the picture-within-a-picture compositional technique. In addition, Yoakum's geographical forms often exhibit gestalt. For example, in the drawing *Mt Kanchen in Himilaya Mtn Range near Shara China East Asia* (fig. 102), a mountain form may be read either as a human mask or as two hands clasped in prayer. Individual landscape elements not only seem to keep altering their identity, but particular forms may at some times appear to be near the viewer and at other times far away. This constantly chang-

ing perspective produces an almost hallucinatory sensation.

Up until this time, Yoakum's style had gradually incorporated more intricate and varied designs covering a broader surface. A subtle reversal in this trend now occurred as the artist began to rely increasingly on the fiber-tip pen as his principal drawing instrument, and he shifted to larger-sized paper (twenty-four by eighteen inches). Landscapes from the 1969–71 period are distinguished by bold yet simplified designs that are repeated over a larger area of the composition. The repetition of abstract forms often produces a sense of pulsating movement reminiscent of Navajo rug designs. A beautiful illustration is found in *Mt Tingra Khan of Run Lun Mtn Range near Alzosu in Sinkiang Sector of SE China*, a landscape in which two large mountains stand alongside each other (fig. 120). The vertical format of the composition is reinforced by the dominant design of vertical tassel-like forms in red fiber-tip pen that create a shimmering effect across both mountains. There are anthropomorphic elements in this work as well.

A variation of this design occurs in another monumental work, *Mt Mowbullan in Dividing Range near Brisbane Australia* (plate 33). In this composition, a slightly modified tassel-like design emphasizes the verticality of the mountain on the right. Alternating between the tassels are T forms that recall birds in flight. Their repetition across the mountain conveys a sense of continuous motion. A contrasting, mostly horizontal design dominates the mountain form on the left. The anthropomorphic elements in this drawing have already been noted.

Earlier works, such as *Semi Granit Mtn Head* (fig. 134), are characterized by a similar play between vertical and horizontal designs. However, in the landscapes of Yoakum's later period, like *Mt Mowbullan* (plate 33), the tapestry-like patterns are more dramatic because of their scale and simplicity. Moreover, the combination of fiber-tip pen

and delicate pastels imbues the mountain forms in these later drawings with a wonderful ethereal quality.

Four months in 1972 represented the final phase of Yoakum's career as an artist. This stylistic period was marked by a trend toward almost total abstraction. A beautiful illustration is the intriguing work *This is our Remembrance of Old Ex President William Jennings Bryan our 1st Democratic president* (plate 1). This purely abstract drawing is a study in raspberry, pale green, and gold. Known by his sobriquet "the Great Commoner," Bryan is perhaps best remembered for his famous "Cross of Gold" speech, a stinging indictment of the gold standard that succeeded in winning him his first presidential nomination from the Democratic party. The artist appears to make oblique reference to this influential speech and monetary policy with a small gold ovoid form that is engulfed by flowing curvilinear forms in raspberry and turquoise that resemble marbleized paper.

The autobiographical content of many of Yoakum's last works is conveyed by their long titles. An example is *This is the flooding of Sock River through Ash Grove Mo on July 4th 1914 in that drove many persons from Homes I were with the Groupe leiving their homes for safety* (plate 2). Like the sketch memorializing William Jennings Bryan, these works are almost pure abstraction. Exquisite combinations of hues show Yoakum's mastery as a colorist. In *This is the flooding*, for instance, ribbons of turquoise, chartreuse, yellow, and brown intertwine.

The finest of Yoakum's late sketches, like the *découpages* of the elderly Matisse, convey a purity of vision, with form reduced to its essential. Matisse might have been speaking of Yoakum's final work when he described his own *découpages*: "[They] do not break away from my former pictures. It is only that I have achieved more completely and abstractly a form reduced to the essential, and have retained the object no longer in the complexity of its space, but as the symbol

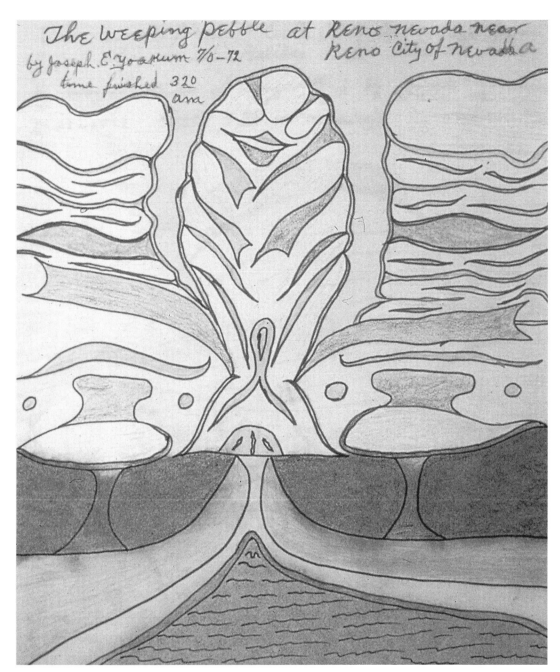

Fig. 135. *Weeping Pebble at Reno Nevada near Reno City Nevada*, 1972. Ballpoint pen, fiber-tip pen, and colored pencil on paper. 35.6 x 23 cm. Collection of the Art Institute of Chicago. Bequest of Whitney Halstead, RX12018/119.0. Sketchbook B.

which is both sufficient and necessary to make the object exist in its own right, as well as for the composition in which I have conceived it."[31] The Weeping Pebble, a subject that Yoakum returned to again and again throughout his career, illustrates Matisse's idea.

Yoakum's late sketch *Weeping Pebble at Reno Nevada near Reno City Nevada* depicts a perched rock (fig. 135). The artist completed at least four other portraits of this rock during his career. In the final version, an abstract rock form appears by itself—an "object no longer in the complexity of its space." Reminiscent of a Japanese woodcut, the flat two-dimensional pattern on the rock is produced with a heavy line in fiber-tip pen that is enhanced by soft pastel colors. His earlier depictions of Weeping Pebble, on the other hand, show the perched rock in its natural environment, or, as Matisse would say, "in the complexity of its space." In two such works from Yoakum's middle period, the rock is the major focal point of the composition, centrally placed between two larger mountain forms. By contrast, in two landscapes from his middle and later periods, the rock is a secondary element, with the massive mountain range behind it becoming the central theme of the composition. Executed over the length of Yoakum's career, the Weeping Pebble series also effectively shows the evolution of the artist's style, from less elaborate to more complex forms and finally to more simplified designs, culminating in the total abstraction of many of his last sketches.

The Artist in Context

Even the very great strong talent is more or less held back by the academy. . . . If a person who has not acquired any artistic schooling—and is thus free of objective artistic knowledge—paints some thing, the result will never be an empty pretense. Here we see an example of the inner force which is influenced only by the general knowledge of the practical-purposeful.
—Wassily Kandinsky, "On the Problem of Form"

Trust your own genius, listen to the voice within you, and sooner or later she will make herself understood not only to you, but she will enable you to translate her language to the world, and this it is which forms the only merit of any work of art.
—Washington Allston

The Self-Taught Art Tradition

The late 1960s and early 1970s witnessed a flowering of interest in art by people who were without formal artistic training that has continued to the present day.[1] Among these so-called self-taught artists, Joseph Yoakum has emerged as one of the most eminent and influential.

Since the 1940s, the definition of what constitutes self-taught art has moved away from what Jean Dubuffet first termed "work produced by people immune to artistic culture in which there is little or no trace of mimicry."[2] In today's technological society, everyone is constantly being bombarded with images transmitted by the mass media. While Yoakum came of age well before the technological revolution, he was exposed to images distributed by the circus and the railroads that were based on the work of academically trained artists. As was discussed earlier, he owes a debt to such sources for his compositional style, his use of various motifs, and, to some extent, his palette. Yoakum was inspired by Native American art as well as by advertising art. In recent decades, both of these sources have influenced the work of certain academically trained artists as well. Thus, it would seem that, over time, the distinctions between self-taught and academic art are gradually becoming blurred.

The challenge of defining the art of the self-taught is magnified by the fact that it is not a definitive style, any more than every form of academic art can be fit neatly into a single stylistic category. Unconcerned with academic art movements and theories, self-taught artists generally do not experiment with forms or styles borrowed from other artists to find a style of their own. As Herbert Waide Hemphill, Jr., and Julia Weissman have remarked, the style of these artists "quite

often comes forth full blown, and though there may be some development in it, there seldom is any genuine deviation or radical change."[3] Likewise, except perhaps for some of his late sketches that yield to total abstraction, Yoakum's early drawings do not depart significantly from his later works in terms of composition and content. As previously noted, a distinct stylistic development may be seen in terms of his use of form and color, but the changes here are not extreme in nature.

While working independently of art schools or movements, self-taught artists paradoxically "often achieve isolated results that parallel those of" academically trained artists.[4] For example, knowing nothing of Fauvism and Expressionism, Yoakum created a vibrant and decorative effect in his landscapes through the use of rich, unmixed colors and the free treatment of form that is reminiscent of these styles. He made drawings that, in the words of Henri Matisse, "do not depend on the exact copying of natural forms, . . . but on the profound feeling of the artist before the objects which he has chosen, on which his attention is focused, and the spirit of which he has penetrated." Like the Fauves and Expressionists, Yoakum sought to reveal what Matisse called the "inherent truth that must be disengaged from the outward appearance of the object to be represented."[5] Stated another way, his art "does not reproduce the visible; rather it makes visible" the reality behind things.[6]

Yoakum intuitively understood Matisse's approach to art. For example, when Whitney Halstead said that the mountains near his boyhood home were unlike the artist's expressionistic rendering of them, Yoakum explained that it was simply because his friend had "never looked" at them. In other words, Halstead had never experienced the artist's own unique emotions and responses to those mountains that allowed their hidden reality to be uncovered. While Yoakum's style is obviously not anything like "photographic realism," his depiction of nature is completely accurate and truthful on another level. Through a superb mastery of line, he captures the essential force lines of nature in a unique and powerful way.

The American Visionary Art Tradition

Unaware of an artistic tradition, self-taught artists have been said to possess only "an individual directness of purpose."[7] Thus, while parallels may exist between the work of self-taught and academically trained artists, the art of the self-taught "defies conventional art-historical contextualization," according to art historian Roger Cardinal.[8] To a degree, his statement also holds true for Yoakum, who was largely immune to formal artistic antecedents, except perhaps for reproductions of fine art commissioned by the major railroads for tourist consumption. On the other hand, his landscapes clearly fall within the tradition of American visionary painting. Indeed, the artist may be seen as one of the last great American visionaries—a group of highly original painters that includes Elihu Vedder, John La Farge, Albert Pinkham Ryder, Arthur Dove, Charles Burchfield, and Adolph Gottlieb, as well as certain self-taught artists.

American visionary painting is rooted in Romanticism, a leading intellectual movement of the late eighteenth and early nineteenth centuries. Romanticism embraced an "artistic philosophy of escape, fantasy, reverie, and revolt."[9] The Romantics believed that human beings' unhappiness with ordinary, everyday life could only be overcome through the "mysterious transforming powers of the artist's individual imagination."[10] Because of their special gift, it was thought that artists needed to live apart or remain isolated from mainstream society. Whether academically trained or self-taught, American visionary painters belong to this Romantic tradition. They, like Yoakum, have worked mostly in isolation and have not tried to emulate the work of other artists.

No one style or subject matter really defines

American visionary painting.[11] According to the art historian Abraham Davidson, the preeminent characteristic of such painting is the dream-like mood it conveys. The visionary's environment is not based on the world of the senses, but rather on the artist's private vision. According to Davidson, that world is "more deeply felt, more authentic, more integrated, more deeply moving" than the "merely fantastic, seemingly contrived environments" characteristic of some twentieth-century art.[12]

The American painter Washington Allston perhaps best articulated the visionary perspective on art. Allston advised the artist to "use his imagination as a springboard for his art rather than the world he perceives through his senses." Since each person's mind is unique, he asserted, "Originality lies in the individual's ability to produce images corresponding to the feelings that are his alone."[13] To stimulate artistic creativity, Allston advocated voracious reading for adults and vivid experiences for children. Joseph Yoakum's early life with the circus obviously provided such a spark to his own artistic invention, as did his later reading about geography and travel, not to mention his peripatetic wanderings over the globe.

Davidson observes that many American visionaries, like Yoakum, were eccentrics in action and thought, or isolates to some extent.[14] Some had exotic childhoods, or traveled extensively to far-off lands as adults. These experiences fed their artistic imaginations and produced an art suffused with the humorous, the bizarre, and the exaggerated. For instance, Elihu Vedder lived in Cuba and Jamaica as a child and mainly in Europe as an adult. He, like Yoakum, embellished the "quaint legends of his infancy" with "just enough detail to convey the impression of their truth."[15] An early life event in Cuba, for instance, inspired Vedder's strange landscape *Lair of the Sea Serpent* (fig. 136). As the artist recounted the tale, a fisherman killed a giant sea creature "of a rich velvet brown" by biting into its viscera. In this painting, a placid scene

Fig. 136. Elihu Vedder, *Lair of the Sea Serpent*, 1864. Oil on canvas. 54.6 x 93 cm. Collection of the Museum of Fine Arts, Boston. Bequest of Thomas G. Appleton.

with ocean and sand dunes appears normal at first glance. However, a second look reveals something odd and out of place—a dinosaur-sized serpent lurking in the sand. Similarly, in many of Yoakum's landscapes elements appear strange or out of place. Mountains and lakes may transform into circus animals and other exotic beasts, while rocks may take the shape of Indians and clowns. For example, a large, disembodied reptile head with pale green eyes seems to rest on the riverbank in the lower right corner of Yoakum's landscape *The Lebanon Mountain Range in Phoenicia on Leontes River* (fig. 137). As if preparing to strike an unseen prey, the reptile's jaws are open, revealing a row of teeth. In other drawings, such as *Mt Tingra Khan of Run Lun Mtn Range near Alzosu in Sinkiang Sector of SE China* (fig. 120), human heads appear to float in the recesses of the rocks, almost like the airborne head over the ocean in Vedder's seascape entitled *Memory*.

Another wandering American visionary artist, John La Farge, traveled extensively in Japan and the islands of the South Seas at a time when these distant places saw few westerners. His exotic journeys influenced dream-like landscapes that, like Vedder's, are obviously bizarre. For instance, in La Farge's painting *Strange Thing Little Kiosai Saw in the River*, a human head floats on the water. In other works, animals assume both humanoid

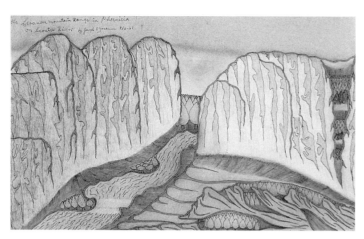

Fig. 137. *The Lebanon Mountain Range in Phoenicia on Leontes River*, 1967. Ballpoint pen, graphite pencil, and colored pencil on paper. 12 x 19 in. Private collection. Photo courtesy of Fleisher/Ollman Gallery, Philadelphia.

Fig. 138. Albert Pinkham Ryder, *Moonlit Cove*, c. 1880–1890. Oil on canvas. 35.9 x 43.5 cm. Acquired 1924. The Phillips Collection, Washington, D.C.

and bestial qualities, somewhat reminiscent of Yoakum's work. For example, in *The Uncanny Badger*, La Farge presents a badger as the trickster from Japanese myth. In this portrait, the animal appears in his twin guises of cuddly prankster and cunning predator, along with his emblem, the waterfall. To deceive wayfarers and take them out of their way, this mythological trickster was believed to call to them "at a distance by beating a tattoo on his swollen abdomen. The noise," La Farge reported, "is not unlike the muffled roar of the waterfall" in the badger's natural habitat.[16] As

seen earlier, Yoakum, too, portrays the trickster, but as the coyote of pueblo mythology and the raven of Northwest Coast tribal lore. In Yoakum's drawing *Mt Negi in Transylvania Alps near Fagris Romania SE E* (plate 37), the coyote is shown in two of his guises—creator and fool—beside his emblems, the arrow and the phallus, which connotes his creative power in the natural world.

While Vedder and La Farge populated their exotic landscapes with strange mythical beasts or other unusual sights, Albert Pinkham Ryder painted imaginary landscapes in which more commonplace animals and inanimate objects, like clouds, seem to possess human qualities. For instance, in his small painting *Moonlit Cove*, an abstract cloud form suggests the profiled head of a woman with long flowing hair; the luminescent moon may be read as her watchful eye (fig. 138). This celestial apparition appears to caress and lend comfort to a large black bear-like rock that delineates the cove. Many Yoakum landscapes exhibit a similar animistic quality. For example, in *Turtle Dove Slew in Suwanee River Wilcox Florida* (plate 9), an enormous black rock seems to transform into a bull-nose seal guarding his harem.

Professor Davidson has noted a dramatic change in American visionary painting after 1900.[17] Whereas nineteenth-century visionary artists displayed some stylistic similarities, their twentieth-century followers have pursued a wide diversity of styles. These include early Modernism (Dove), Expressionism (Burchfield), and early Abstract Expressionism (Gottlieb). While unaware of such trends, Yoakum nevertheless occasionally produced drawings that somewhat reflect these styles of painting.

Through his abstractions, Arthur Dove sought to paint the essential spirit of an object or situation.[18] For instance, when depicting a cyclone, he said, he "would show the repetition and convolutions of the rage of the tempest. I would paint the wind, not a landscape chastised by the cyclone."[19] As an illustration, in his painting

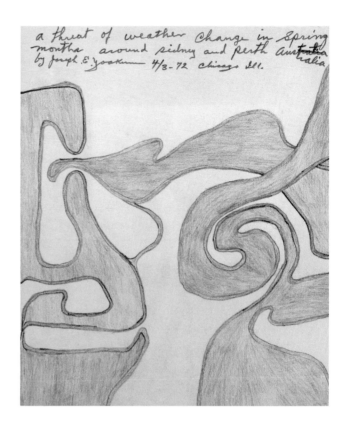

Fig 139. Arthur Dove, *Golden Storm*, 1925. Oil and metallic paint on plywood panel. 48.8 x 53.3 cm. Acquired 1926. The Phillips Collection, Washington, D.C.

Fig. 140. *A threat of weather change in spring months around Sidney and Perth Australia*, 1972. Colored pencil and fiber-tip pen on paper. 25.3 x 20.3 cm. Collection of the Art Institute of Chicago. Bequest of Whitney Halstead, RX12018/118. Sketchbook, p. 15, recto.

Golden Storm, curvilinear patterning in turquoise, brown, and gold suggest tumultuous cloud movements (fig. 139). This work recalls two late Yoakum sketches of abstract storm clouds, *A threat of weather change in spring months around Sidney and Perth Australia* (fig. 140) and *The Bowing Cliff of Burno Utah, cloud assembly for cyclone storm.*

Like the Fauves, Dove saw color, not outer form, as the primary means to "represent the essence or inner character of an object."[20] However, just as each object has its distinguishing color, or "condition of light," Dove believed that it also possesses a certain characteristic form that captures its inner spirit. This form he called the "force lines" or "growth lines," which indicate not the physical outlines of an object but rather "the forces or tensions alive within it."[21] For example, in his painting *Fields of Grain as Seen From Train*, the identifying form of the waving grain is a pattern of curvilinear and vertical "force lines" that

conveys the essence of its blurred image as viewed from a speeding train (fig. 141). Yoakum creates a somewhat similar effect with his gently undulating hills in the drawing *Imperial Valley near town of Blyth in Imperial County California* (fig. 142). He also makes landscapes in which inanimate objects, such as rocks and mountains, seem to pulsate with inner life. To capture their spirit, he reduces objects to a limited number of colors and form motifs that, like Dove's, are recombined in myriad ways as the mood and design requires.

Animism is another feature common to both artists' work. For instance, in Dove's painting *Lake Afternoon,* two amoeba-like forms suggest an American Indian man and his golden horse (fig. 143). These whimsical figures float in front of a pumpkin-colored teepee form that rises up into undulating bands of blue and green, punctuated by abstract white puffs of smoke. The artist created this work after a visit to Lake Seneca in upstate New York.[22] Perhaps the lake's tribal name

Fig. 141. Arthur Dove, *Fields of Grain as Seen From Train*, 1931. Oil on canvas. Collection of the Albright-Knox Art Gallery, Buffalo, New York. Gift of Seymour H. Knox, 1958.1.

Fig. 142. *Imperial Valley near town of Blyth in Imperial County California*, c. 1965. Ballpoint pen, graphite pencil, and colored pencil on paper. 9 x 12 in. Collection of Gladys Nilsson and Jim Nutt.

inspired his landscape's Native American imagery in much the same way that Yoakum's travel with the circus inspired the animal and clown imagery in many of his landscapes.

The Expressionist painter Charles Burchfield was another American visionary, like Dove and Yoakum, whose response to nature was deeply subjective and whose landscapes had an animistic quality. Especially during his early career, Burchfield produced small "fantastic watercolors that visualize the song of insects and recreate childhood moods, like the fear of the dark; in them flowers have faces, trees gesticulate and cornstalks dance."[23] Burchfield's moods and childhood

memories were visually communicated through his personal vocabulary of abstract shapes. For instance, in his lexicon, hump-like forms symbolize melancholy and sightless eyes insanity. Similarly, Yoakum invented a personal language of forms that were used to evoke emotion subtly but powerfully. Often delineated with a calligraphic line, his forms, like Burchfield's, create flat patterns that possess a decorative, dramatic quality.

Burchfield's symbolic language can be clearly seen in one of his finest early watercolors, *Church Bells Ringing, Rainy Winter Night* (fig. 144). A symbolic depiction of childhood memories and feelings, the "church steeple resembles a grotesque

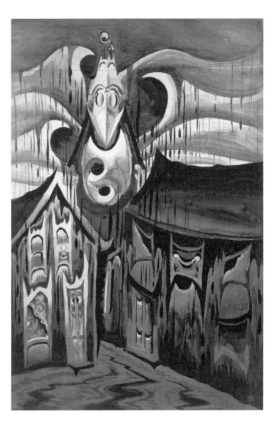

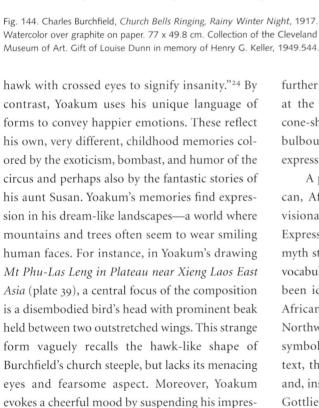

Fig. 143. Arthur Dove, *Lake Afternoon*, 1935. Wax emulsion on canvas. 63.5 x 88.9 cm. Acquired 1947. The Phillips Collection, Washington, D.C.

Fig. 144. Charles Burchfield, *Church Bells Ringing, Rainy Winter Night*, 1917. Watercolor over graphite on paper. 77 x 49.8 cm. Collection of the Cleveland Museum of Art. Gift of Louise Dunn in memory of Henry G. Keller, 1949.544.

hawk with crossed eyes to signify insanity."[24] By contrast, Yoakum uses his unique language of forms to convey happier emotions. These reflect his own, very different, childhood memories colored by the exoticism, bombast, and humor of the circus and perhaps also by the fantastic stories of his aunt Susan. Yoakum's memories find expression in his dream-like landscapes—a world where mountains and trees often seem to wear smiling human faces. For instance, in Yoakum's drawing *Mt Phu-Las Leng in Plateau near Xieng Laos East Asia* (plate 39), a central focus of the composition is a disembodied bird's head with prominent beak held between two outstretched wings. This strange form vaguely recalls the hawk-like shape of Burchfield's church steeple, but lacks its menacing eyes and fearsome aspect. Moreover, Yoakum evokes a cheerful mood by suspending his impressionistic bird between two large checkered mountains whose mouth-like cavities, filled with pale green trees, appear to be grinning broadly. He

further conveys this upbeat mood by introducing, at the base of the mountains, a disembodied cone-shaped head with tiny eyes and a clown-like bulbous nose that give it a wonderfully droll expression.

A preoccupation with myth—Native American, African, and Freudian—characterized the visionary painting of the American Abstract Expressionist Adolph Gottlieb.[25] Gottlieb's use of myth stimulated the invention of his own unique vocabulary of images.[26] At times these images have been identified with symbols from Surrealism, African and Oceanic art, petroglyphs, Pacific Northwest coast totem poles, and other forms of symbolism.[27] Removed from their cultural context, these symbols lose their original meaning and, instead, become merely abstract designs. For Gottlieb, however, they took on a universal significance. Woven into paintings he termed "pictographs," these images offered him a way to break out of the "academic straightjacket" and "be

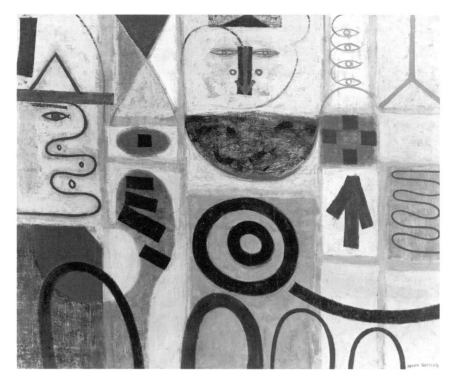

Fig. 145. Adolph Gottlieb, *The Seer*, 1950. Oil on canvas. 59 3/4 x 71 5/8 cm. The Phillips Collection, Washington, D.C.

free to express what was visually true" for him.[28] His pictographs usually are composed of abstract shapes and anatomical parts set within compartments. For example, in his painting *The Seer*, ovoid-shaped eyes and faces recall those on a Chilkat blanket of the Tlingit tribe[29] (fig. 145). Other paintings recall totem pole carvings and prehistoric rock engravings.

Similarly, Yoakum's admiration for Native American culture is evident in many direct and subtle ways as he incorporates its symbols into his visual vocabulary. He introduces various designs that are reminiscent of petroglyphs, pueblo pottery, and Navajo sandpaintings, as well as Northwest Coast tribal totem figures and mythological heroes. Much like Gottlieb, he borrows symbols that in a new context lack their original meaning, but become part of the artist's unique vision of a universal landscape. At other times, however, Yoakum uses such images to interpret the sacred myths of his Native American ancestors. As we have seen, this fascination with myth is also characteristic of the nineteenth-century visionary painters La Farge and Vedder, who transformed their landscapes with strange mythological characters.

Gottlieb has been described as "a maverick working on his own terms according to his own timing."[30] The same could be said of Joseph Yoakum and other American visionary artists. Like many of them, Yoakum was an adventurer and a loner. He did not conform to the art movements of his day. He invented a rich vocabulary of forms that was highly original, the product of a lifetime of acute observation. With his unique visual language and extraordinary powers as a colorist, Yoakum created an imaginary world that was inspired by memories of his traveling days. Infused with the humorous, the bizarre, and the exaggerated, his memory drawings reveal what Matisse called the "inherent truth" of the visible world. In this way, Yoakum's art transforms the world of the senses into pure poetry.

Plates

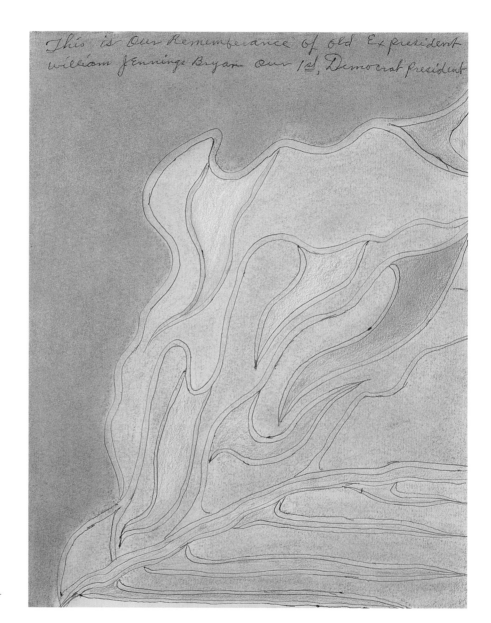

Plate 1. *This is our Remembrance of Old Ex President William Jennings Bryan our 1st Democratic president*, 1972. Ballpoint pen and colored chalk on paper. 35.6 x 23 cm. Collection of the Art Institute of Chicago. Bequest of Whitney Halstead, RX12018/119.1. Sketchbook B, p. 24.

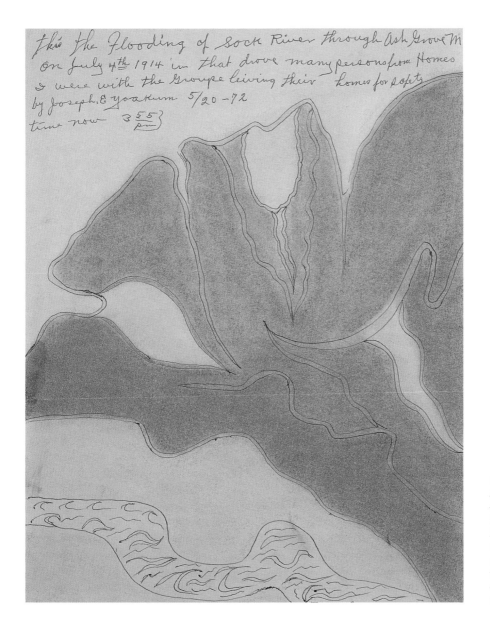

This the Flooding of Sock River through Ash Grove M
On July 4th 1914 'im that drove many persons from Homes
I were with the Groupe leiving their homes for safty
by Joseph. E Yoakum 5/20 -72
time now 3 55/pm

Plate 2. *This is the flooding of Sock River through Ash Grove Mo on July 4th 1914 in that drove many persons from Homes I were with the Groupe leiving their homes for safety*, 1972. Ballpoint pen and colored chalks on paper. 35.6 x 23 cm. Collection of the Art Institute of Chicago. Bequest of Whitney Halstead, RX2018/119.2. Sketchbook B, p. 28.

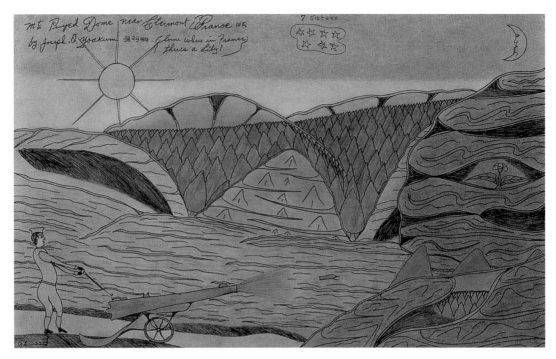

Plate 3. *Mt Puyed Dome near Clermont France W.E. (some where in France theres a lily)*, 1967. Ballpoint pen and colored pencil on paper. 12 x 18 in. Collection of Gladys Nilsson and Jim Nutt.

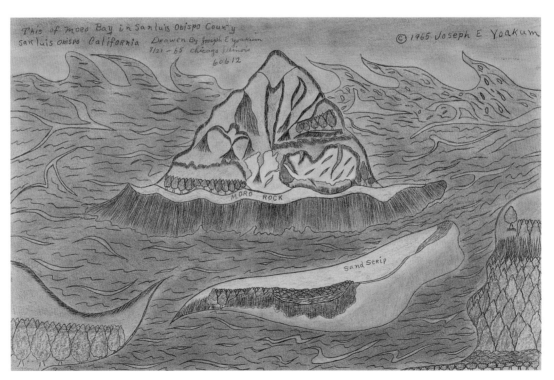

Plate 4. *This is of Moro Bay in San Luis Obispo County San Luis Obispo California*, 1965. Ballpoint pen, colored pencil, and watercolor on paper. 12 x 18 in. Photo courtesy of Fleisher/Ollman Gallery, Philadelphia.

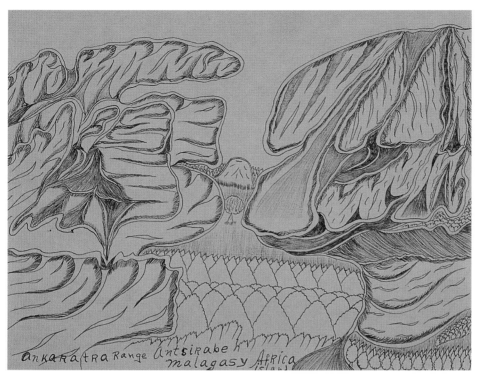

Plate 5. *Ankaratra Range Antsirabe Malagasy Africa Island*, c.1965. Ballpoint pen on paper. 9 x 12 in. Collection of Gladys Nilsson and Jim Nutt.

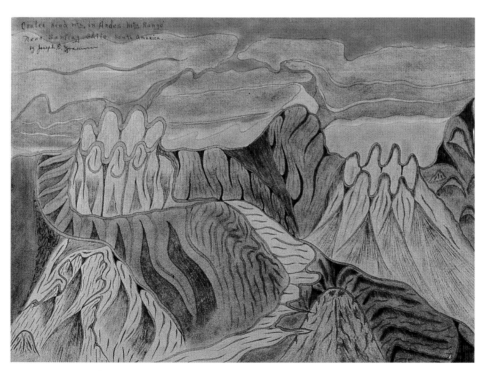

Plate 6. *Crater Head Mtns in Andes Mtn Range near Santiaf Chile South America*, 1969. Ballpoint pen, fiber-tip pen, and colored chalk on paper. 17 15/16 x 23 15/16 in. Collection of Gladys Nilsson and Jim Nutt.

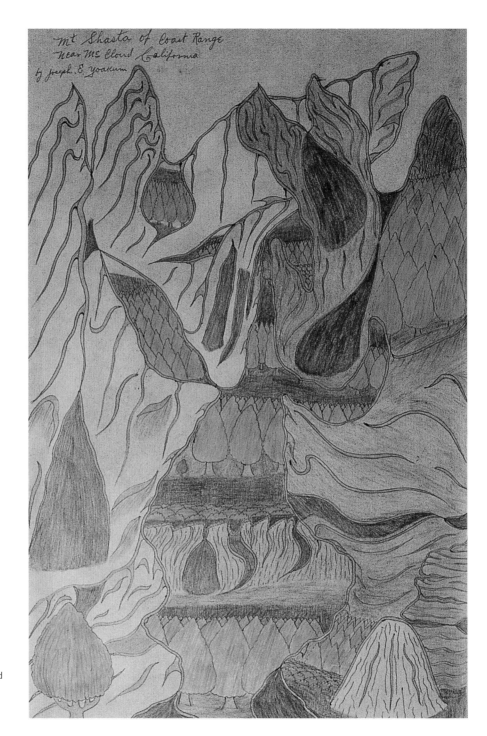

Plate 7. *Mt Shasta of Coast Range near McCloud California*, 1968. Ballpoint pen, graphite pencil, and colored pencil on paper. 18 7/8 x 11 7/8 in. Private collection. Photo courtesy of Carl Hammer Gallery, Chicago.

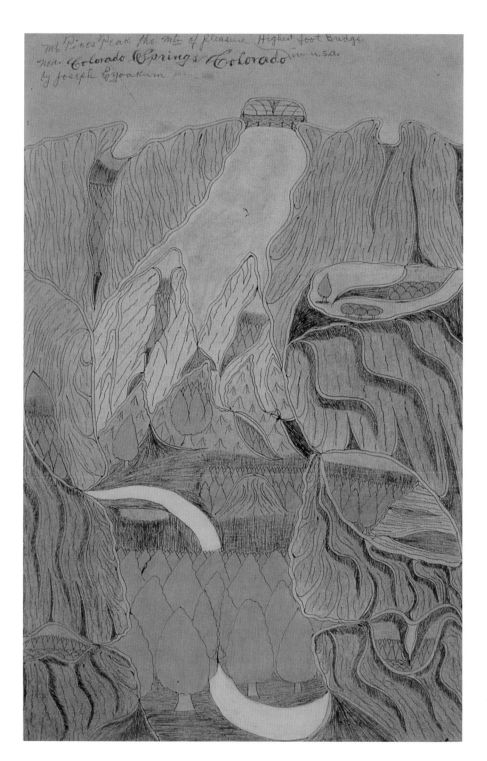

Plate 8. *Mt Pikes Peak the Mtn of Pleasure near Colorado Springs Colorado Highest foot bridge in U.S.A.*, 1968. Ballpoint pen, graphite pencil, and colored pencil on paper. 19 x 12 in. Collection of Ray Yoshida.

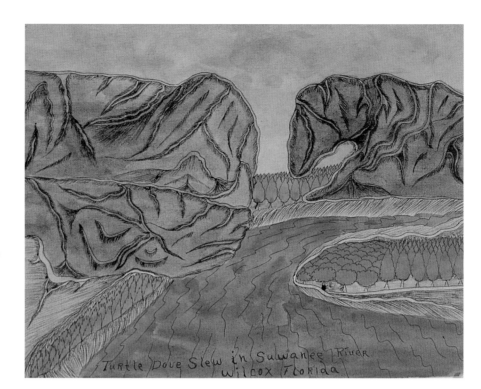

Plate 9. *Turtle Dove Slew in Suwanee River Wilcox Florida*, c. 1965. Ballpoint pen and watercolor on paper. 9 x 12 in. Collection of Ray Yoshida.

Plate 10. *The Apalachicola River near Bluntstown Florida*, 1967. Ballpoint pen and colored pencil on paper. 12 x 18 in. Collection of Ray Yoshida. Photo courtesy of Karen Lenox Gallery, Chicago.

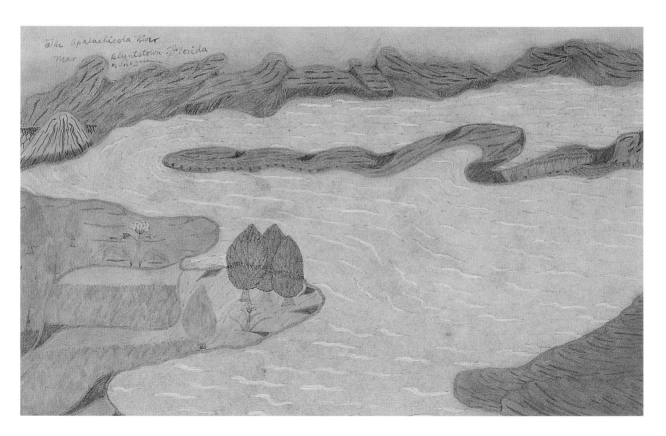

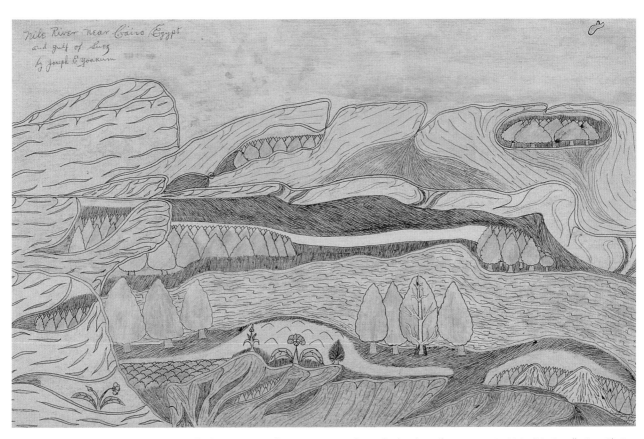

Plate 11. *Nile River near Cairo Egypt and Gulf of Suez*, 1968. Ballpoint pen, watercolor, and colored pencil on paper. 14 x 22 in. Private collection. Photo courtesy of Fleisher/Ollman Gallery, Philadelphia.

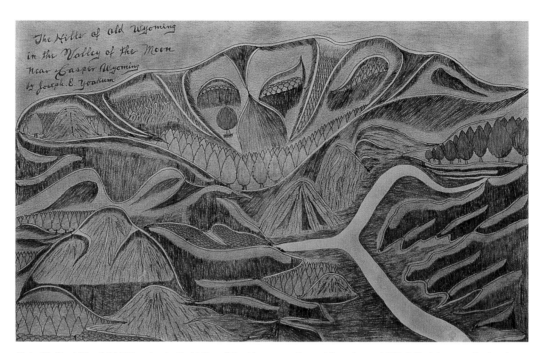

Plate 12. *The Hills of Old Wyoming in the Valley of the Moon near Casper Wyoming*, c. 1967. Ballpoint pen and colored pencil on paper. 12 x 19 in. Private collection. Photo courtesy of Carl Hammer Gallery, Chicago.

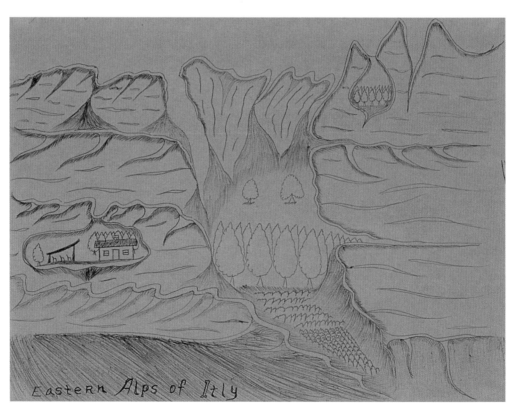

Plate 13. *Eastern Alps of Itely*, c. 1965. Ballpoint pen and graphite pencil on paper. 9 x 12 in. Collection of Gladys Nilsson and Jim Nutt.

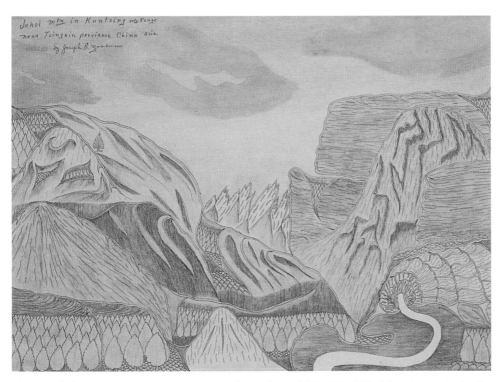

Plate 14. *Jehol Mtn in Kuntsing Mtn Range near Tsingkin proviance of China Asia*, 1969. Ballpoint pen and colored pencil on paper. 18 x 24 in. Collection of Gladys Nilsson and Jim Nutt.

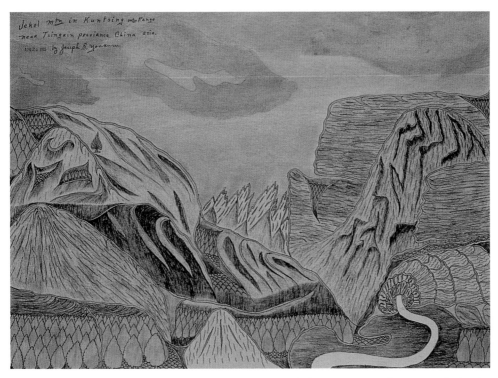

Plate 15. *Jehol Mtn in Kuntsing Mtn Range near Tsingkin proviance of China Asia*, 1969. Ballpoint pen and colored pencil on paper. 18 x 24 in. Collection of Gladys Nilsson and Jim Nutt.

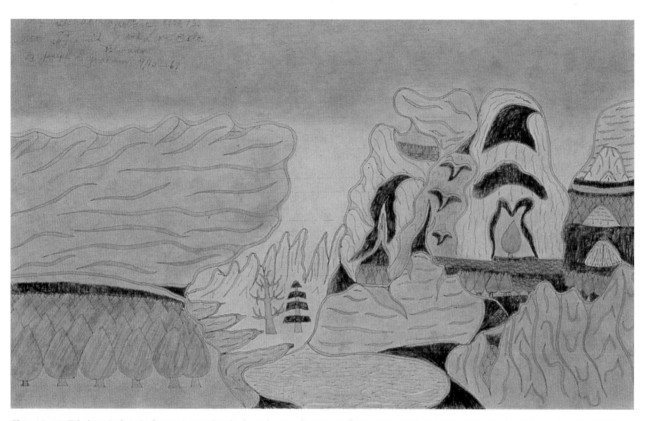

Plate 16. *Mt. Tohakum Park 8170 ft near Pyramid and Lake Oslo Nevada*, 1969. Ballpoint pen, graphite pencil, and colored pencil on paper. 12 x 18 in. Collection of Gladys Nilsson and Jim Nutt.

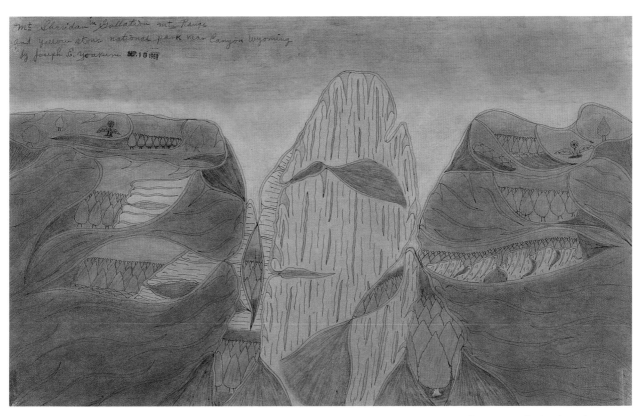

Plate 17. *Mt Sheridan in Gallation Mtn Range and Yellow Stone National Park near Canyon Wyoming*, 1969. Ballpoint pen and colored pencil on paper. 12 x 19 in. Photo courtesy of Fleisher/Ollman Gallery, Philadelphia.

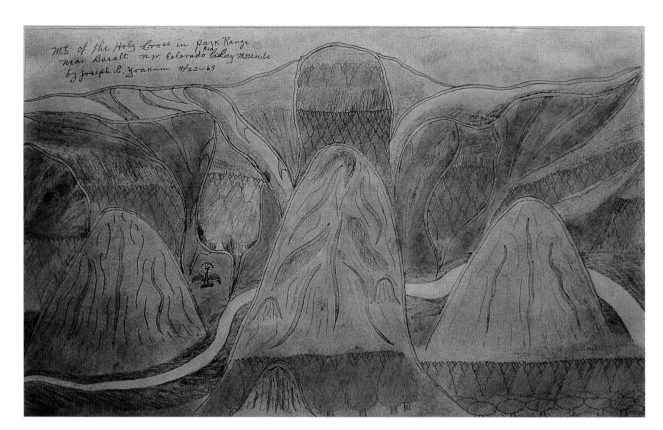

Plate 18. *Mt of the Holy Cross near Basalt NW Red Clay Mounds*, 1969. Ballpoint pen and colored pencil on paper. 12 x 19 in. Private collection. Photo courtesy of Carl Hammer Gallery, Chicago.

Plate 19. *Mount of the Holy Cross*. Handcolored photograph from album *Rocky Mountain Views on the Denver & Rio Grande—the Scenic Line of the World*, 1914. Collection of the Colorado Historical Society, Denver. MSS 515, Box 63, Folder 3187.

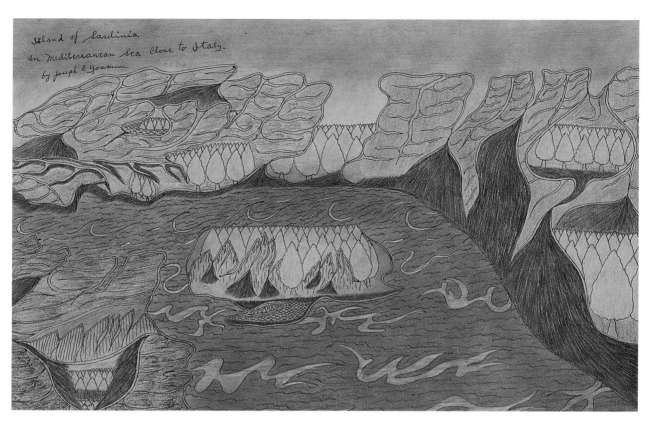

Plate 20. *Island of Sardinia in Mediterranean Sea Close to Italy*, 1966. Ball-point pen, graphite pencil, and colored pencil on paper. 12 x 19 in. Collection of Gladys Nilsson and Jim Nutt.

Plate 21. Crater Lake, near Ashland, Oregon, n.d. Postcard. Author's collection.

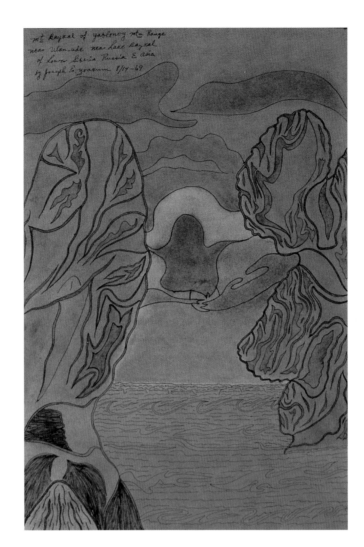

Plate 22. *Mt Baykal of Yablonvy Mtn Range near Ulan-ude near Lake Baykal of Lower Siberia Russia E. Asia*, 1969. Ballpoint pen, graphite pencil, and colored pencil on paper. 19 1/16 x 12 1/8 in. Collection of Gladys Nilsson and Jim Nutt.

Plate 23. Davidson Glacier, Alaska, n.d. Postcard. Author's collection.

1426 — DAVIDSON GLACIER, ALASKA.

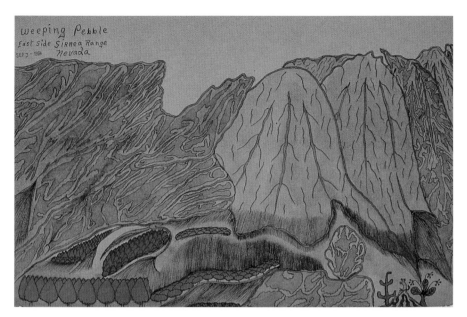

Plate 24. *Weeping Pebble of Sirrea Range*, c. 1965. Ballpoint pen and watercolor on paper. 12 x 18 in. Collection of Ray Yoshida.

Plate 25. *Weeping Pebble of Sirrea Range in Virginia Park Nevada*, 1967. Ballpoint pen, graphite pencil, and colored pencil on paper. 11 7/8 x 18 in. Collection of Gladys Nilsson and Jim Nutt.

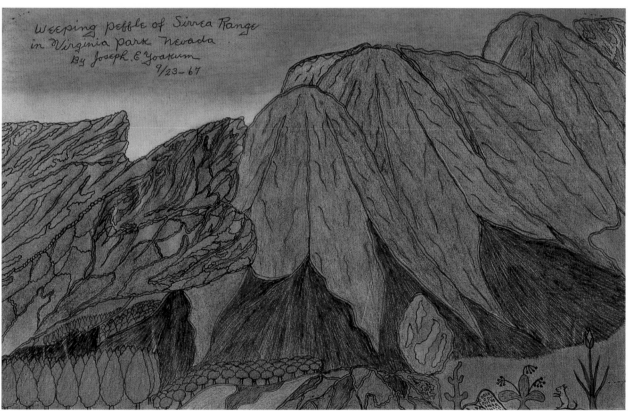

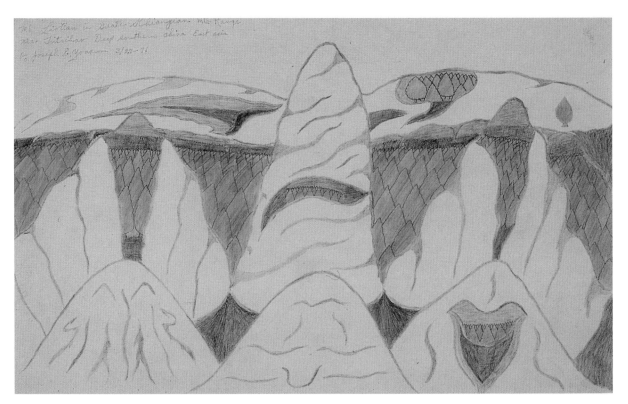

Plate 26. *Mt Liotian in Greater Khiangian Mtn Range near Tritsihar Deep Southern China East Asia*, 1971. Ballpoint pen, fiber-tip pen, and colored pencil on paper. 12 x 18 in. Collection of Ray Yoshida. Photo courtesy of Karen Lenox Gallery, Chicago.

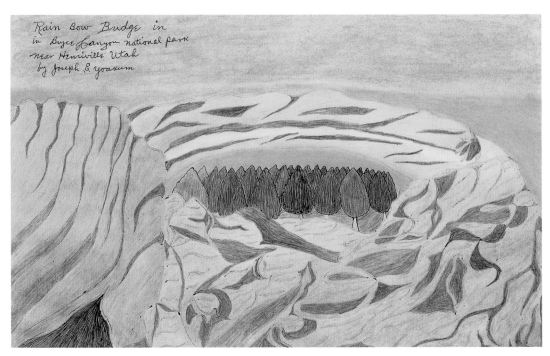

Plate 27. *Rain Bow Bridge in Bryce Canyon National Park near Henriville Utah*, 1968. Ballpoint pen, chalk, and colored pencil on paper. 13 1/8 x 19 in. Roger Brown Study Collection/School of the Art Institute of Chicago. Photograph by Jim Prinz.

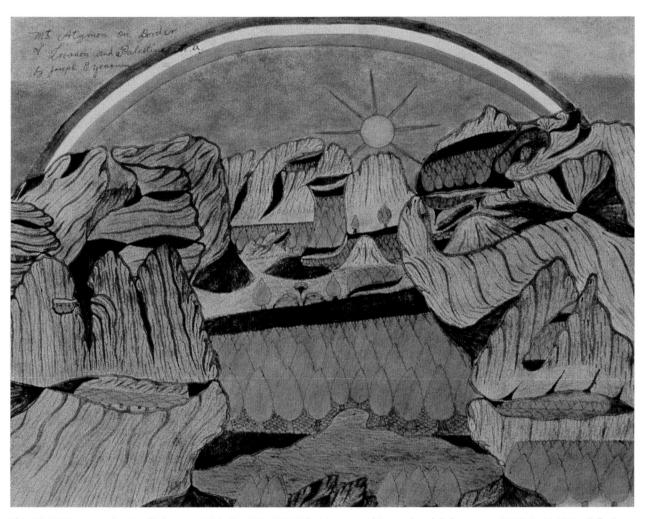

Plate 28. *Mt Atzmon on Border of Lebanon and Palestine SEA*, 1970. Ballpoint pen, graphite pencil, and chalk on paper. 19 1/16 x 24 1/8 in. Collection of Gladys Nilsson and Jim Nutt.

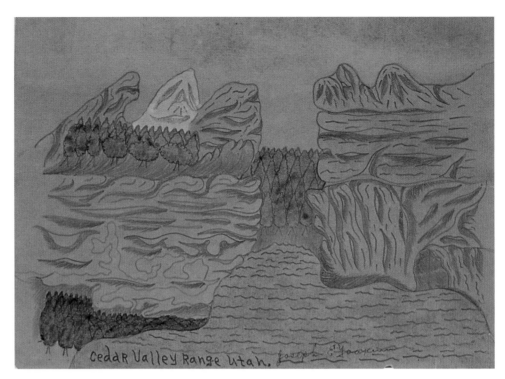

Plate 29. *Cedar Valley Range Utah*, c. 1964. Ballpoint pen, graphite pencil, and watercolor. 9 x 12 in. Private collection. Photo courtesy of Fleisher/Ollman Gallery, Philadelphia.

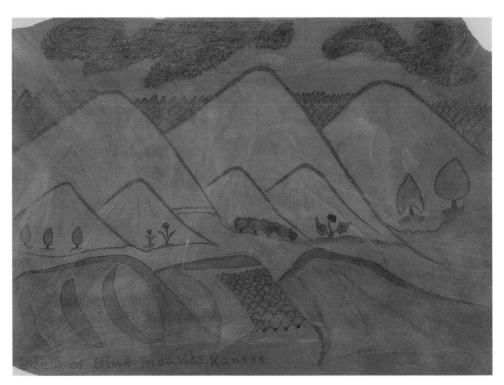

Plate 30. *View of Blue Mounds Kansas*, c. 1964. Ballpoint pen, graphite pencil, and watercolor on paper. 9 x 12 in. Private collection. Photo courtesy of Phyllis Kind Gallery, Chicago and New York.

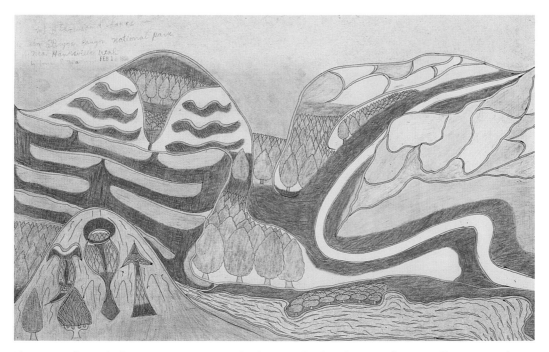

Plate 31. *Mt Thousand Lakes in Bryce Canyon National Park near Hanksville Utah*, 1968. Ballpoint pen, fiber-tip pen, and pastel on paper. 12 x 19 in. Collection of Philip Hanson.

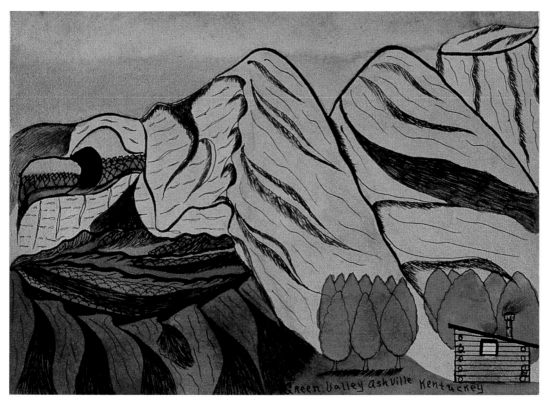

Plate 32. *Green Valley Ashville Kentucky*, 1965. Ballpoint pen and watercolor on paper. 9 x 12 in. Collection of Gladys Nilsson and Jim Nutt.

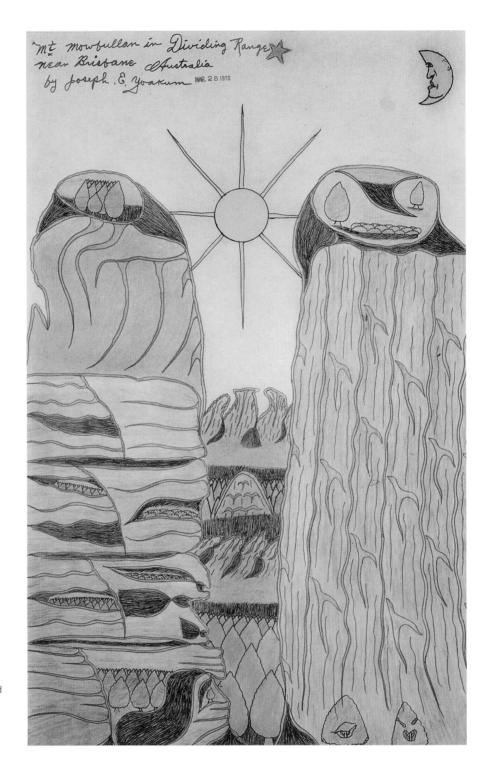

Plate 33. *Mt Mowbullan in Dividing Range near Brisbane Australia*, 1970. Ballpoint pen, fiber-tip pen, and colored pencil on paper. 48.3 x 30 cm. Collection of the Art Institute of Chicago. Bequest of Whitney Halstead, 1979.417.

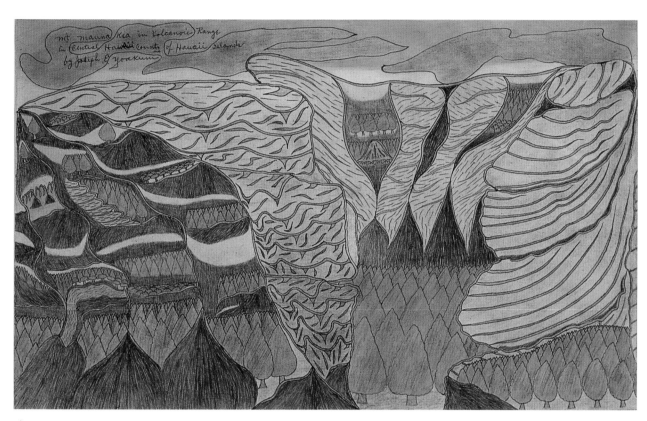

Plate 34. *Mt Mauna Kea in Volcanoic Range in Central Hawaii County of Hawaii Islands*, 1968. Ballpoint pen and colored pencil on paper. 14 x 19 in. Collection of Ray Yoshida.

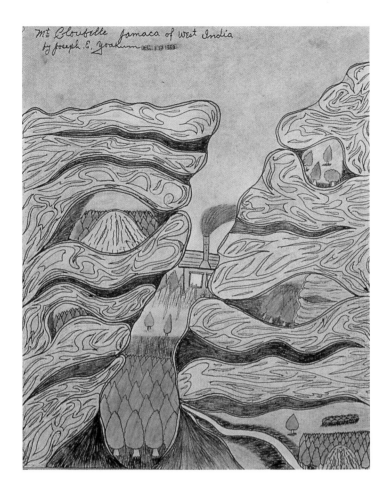

Plate 35. *Mt Cloubelle of West India*, 1969. Ballpoint pen, colored pencil, and ink on paper. 12 x 9 1/2 in. Collection of Gladys Nilsson and Jim Nutt.

Plate 36. *Teppeniah Ridge in Yakama Valley near Wapata Washington*, 1970. Ballpoint pen, colored pencil, and pastel on paper. 12 x 19 in. Private collection. Photo courtesy of author.

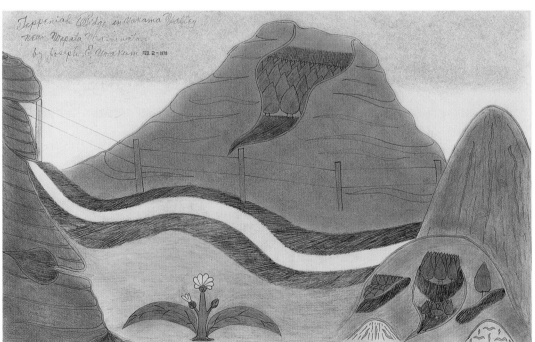

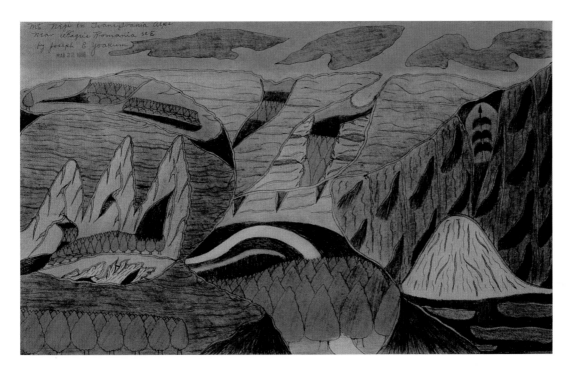

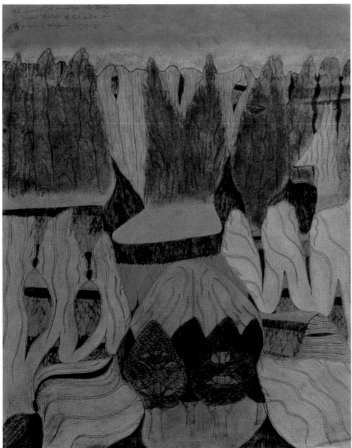

Plate 37. *Mt Negi in Transylvania Alps near Fagris Romania SE E*, 1968. Ball-point pen, graphite pencil, and colored pencil on paper. 12 x 19 in. Collection of Gladys Nilsson and Jim Nutt.

Plate 38. *Mt Everest of Himilaya Mtn Range in height 28027 ft in Nepal Distric of East India Asia*, 1969. Ball-point pen and colored pencil on paper. 24 x 18 in. Collection of Gladys Nilsson and Jim Nutt.

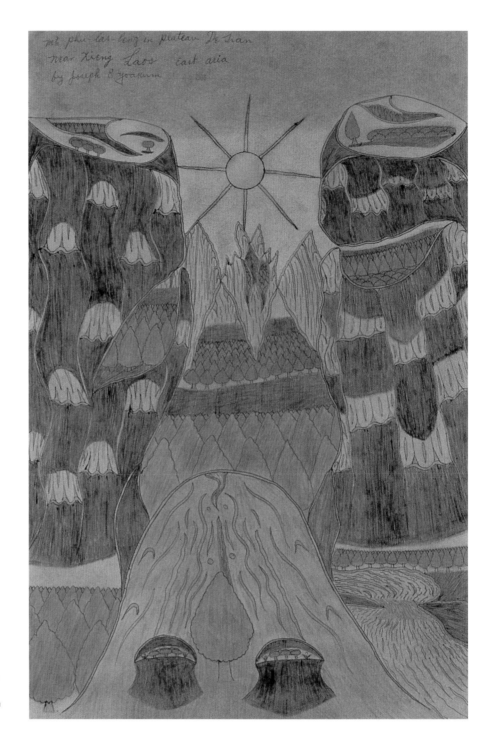

Plate 39. *Mt Phu-Las Leng in Plateau near Xieng Laos East Asia*, 1968. Ball-point pen, colored pencil, and ink on paper. 19 1/2 x 12 1/16 in. Collection of Gladys Nilsson and Jim Nutt.

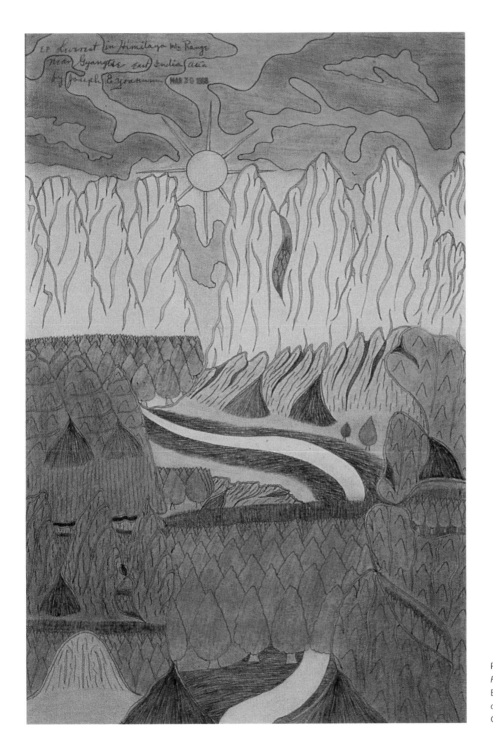

Plate 40. *E.P Everest in Himilaya Mtn Range near Gyangtse East Asia*, 1968. Ballpoint pen, colored pencil, and ink on paper. 19 x 12 in. Collection of Gladys Nilsson and Jim Nutt.

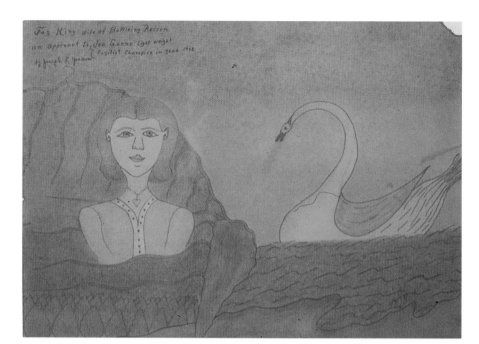

Plate 41. *Fay King, wife of Battleing Nelson Opponent to Joe Ganns Light Weight Pugilist Champion in year 1908*, n.d. Ballpoint pen, graphite pencil, and colored pencil on paper. 12 x 17 3/4 in. Collection of Philip Hanson.

Plate 42. *The Home of Cole Younger Cousin to Jesse James near Bonner Springs Missouri*, 1965. Ballpoint pen, graphite pencil, and watercolor on paper. 18 x 24 in. Private collection. Photo courtesy of Fleisher/Ollman Gallery, Philadelphia.

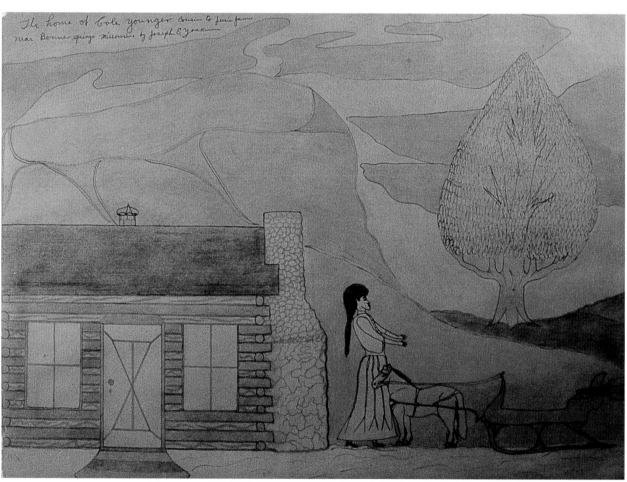

Plate 43. *Mt Cavalary near Jerusalam and Bethelam palestine se Asia*, 1968. Ballpoint pen and colored pencil on paper. 30.5 x 48.4 cm. Collection of the Art Institute of Chicago. Bequest of Whitney Halstead, 1979.203.

Plate 44. *Mt Bull Head of Adrondack Mtn Range near Glen Falls New York*, 1969. Ballpoint pen, colored pencil, colored chalk, and fiber-tip pen on paper. 30.7 x 48.4 cm. Collection of the Art Institute of Chicago, 1979.209.

Plate 45. *Lebanon Mts near Sidon Phoenicia Asia*, 1964. Ballpoint pen, graphite pencil, and watercolor on paper. 12 x 17 3/4 in. Roger Brown Study Collection of the School of the Art Institute of Chicago. Photograph by Jim Prinz.

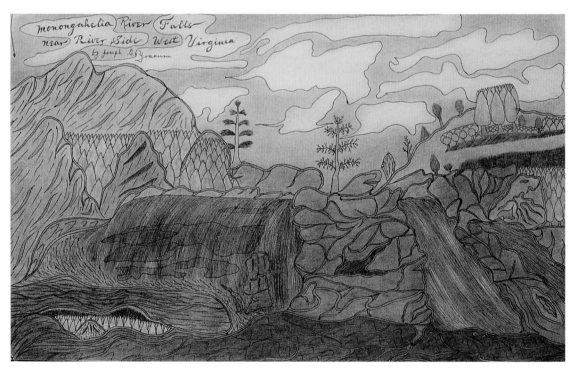

Plate 46. *Monongahelia River Falls in West Virginia near Riverside*, c. 1965. Ballpoint pen, graphite pencil, and watercolor on paper. 12 x 18 in. Collection of Philip Hanson.

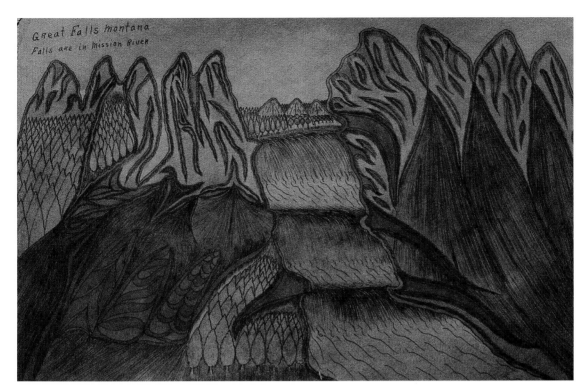

Plate 47. *Great Falls Montana are in Mission River*, c. 1964. Watercolor, graphite pencil, and ballpoint pen on paper. 9 x 12 in. Collection of Philip Hanson.

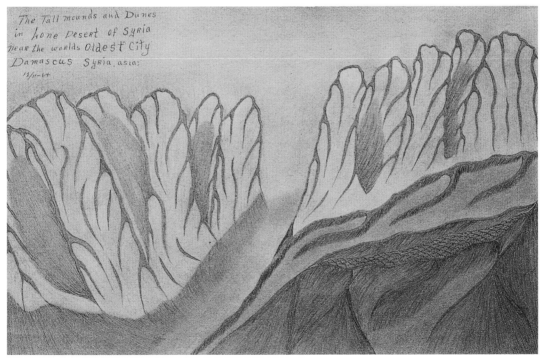

Plate 48. *The Tall Mounds and Dunes in Lone Desert of Syria near the Worlds Oldest City, Damascus, Syria*, 1964. Colored pencil, watercolor, and ballpoint pen on paper. 9 x 12 in. Collection of Philip Hanson.

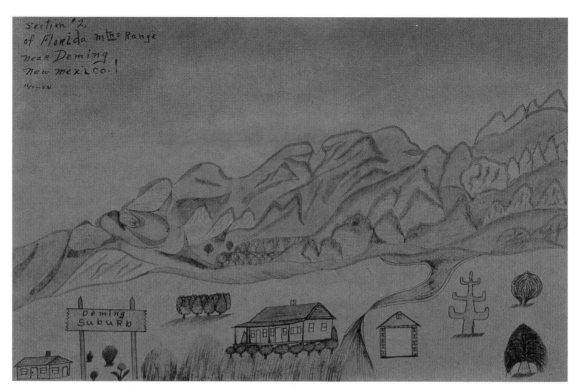

Plate 49. *Section #2, of Florida Mtns Range near Deming New Mexico*, 1964. Ballpoint pen and watercolor with varnish on paper. 30.5 x 45.6 cm. Collection of the Art Institute of Chicago. Bequest of Whitney Halstead, 1979.209.

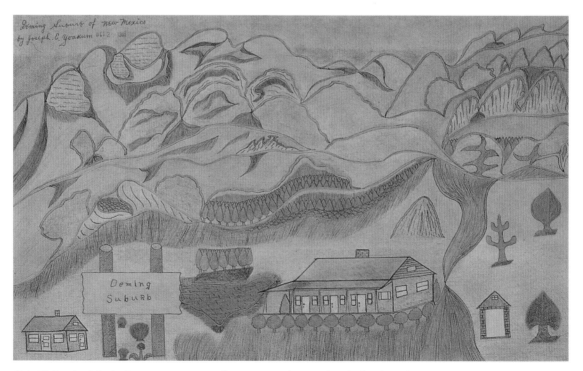

Plate 50. *Deming Suburb of New Mexico*, 1968. Ballpoint pen, graphite pencil, and colored pencil on paper. 12 x 19 in. Collection of Ray Yoshida.

Notes

* Randall Morris, "The Man Who Drew the Earth," in *Animistic Landscapes* [Philadelphia: Janet Fleisher Gallery, 1989], p. 7.

CHAPTER ONE

1. Quoted in Russell Bowman, "Chicago Imagism: The Movement and the Style" in *Who Chicago? An Exhibition of Contemporary Imagists* (Sutherland, England: Sutherland Arts Centre, 1980), 24.

2. Dennis Adrian, "Who Chicago?" in *Sight Out of Mind: Essays and Criticism on Art* (Ann Arbor: University of Michigan Press, 1985), 18.

3. Whitney Halstead, "Joseph Yoakum," unpublished manuscript, c. 1977, in Whitney Halstead Papers, Archives, Art Institute of Chicago, 3.

4. Ibid.

5. Don Russell, *The Lives of Buffalo Bill* (Norman: University of Oklahoma Press, 1960), 38.

6. John Ringling, "We Divided the Job—but Stuck Together," *The American Magazine*, September 1919, 184.

7. Christina Ramberg, diary entry, 29 May 1969, in Whitney B. Halstead Papers, Archives of American Art, Smithsonian Institution.

8. Camilla Eichelberger, interview by author, 4 May 1994.

9. Ray Yoshida, interview by author, 6 May 1994.

10. Jane Allen and Derek Guthrie, "Joseph Yoakum: Portrait of a Luckless Artist," *Chicago Tribune Magazine*, 10 December 1972, 32.

11. Greene County, Missouri, Marriage Abstracts, Book D, 68. The 1890 Federal Census was destroyed.

12. Joseph Yoakum, letter to Jim Nutt, 18 August 1969, in Whitney Halstead Papers, Archives, Art Institute of Chicago.

13. John Yokum was seven years his wife's senior, but there is some uncertainty as to their exact birth dates. The 1880 Federal Census of Greene County, Missouri (Cass Township) lists John Yocum, age thirty, born in the Cherokee Nation, and his wife Fanny, age twenty-three, born in Missouri. The 1900 Federal Census lists the dates of their births as March 1846 and December 1854, respectively. The later census also recorded that ten children had been born to the couple, nine of whom were still living. Given the date of their marriage (1874) and the birth date of their eldest son (1877) it is more likely that the later dates given for their births (1850 and 1857 respectively) are more accurate. John Yokum presumably died before 1910, because he does not appear in the 1910 Federal Census. Curiously, his children list Arkansas as the birthplace of their deceased father in the 1910 Federal Census. It is conceivable that John's family may originally have been part of the group known as the "Western Cherokees." From the 1790s, small bands of eastern Cherokees moved to the Arkansas Territory. By 1816 their population stood at almost two thousand. From about 1794 to 1828, they occupied a northwestern area of Arkansas designated as the "Arkansas band." A good discus-

sion of the Arkansas Cherokees can be found in William G. McLoughlin, *Cherokee Renascence in the New Republic* (Princeton, New Jersey: Princeton University Press, 1986), 162–64.

14. Lora Rice Brewer, interview by author, 10 May 1994.

15. Ibid.

16. 1870 Federal Census, Greene County, Missouri.

17. Ibid.; Lora Brewer, interview.

18. 1900 Federal Census, Greene County, Missouri.

19. Joseph Yoakum, letter to his aunt Susan Yokum Rice, 25 March 1916, in Brewer Family Archives.

20. Lora Brewer, interview.

21. Sara Brewer, interview by author, 10 September 1995.

22. The sketch is entitled *Mt Gracious of Montana in Year 1900 at close of summer it were cold there then not chilli. I were made fraid of cold weather while I were there we had a very large snow on it measured almost 3 feet on lavle, the trains were old locomotives and the Railroads were commone and took no chance against snow blocking the Railroads. I were 12 days from Montana to at that time Phenix MO this were my own trip* (1972). There were large snowstorms in Montana during the late summer months of the years 1900 and 1902. Adam Forepaugh and Sells Brothers Circus traveled twelve days between Montana and Missouri in 1906.

23. Gary Witherspoon, *Language and Art of the Navajo Universe* (Ann Arbor: University of Michigan Press, 1977), 151.

24. Ibid., 152.

25. Gladys Nilsson and Jim Nutt, interview by author, 5 April 1994.

26. Joseph Yoakum, letter to Jim Nutt, 18 August 1969.

27. Halstead, "Joseph Yoakum," 2.

28. Philip H. Hanson, "Joseph E. Yoakum," unpublished manuscript, 31 March 1969, in Whitney Halstead Papers, Archives, Art Insitute of Chicago, 4.

29. The 1880 Federal Census suggests that Charles Yokum was born in 1876, while the 1900 Federal Census indicates that he was born in September 1877.

30. Hanson, "Joseph E. Yoakum," 5.

31. Lora Brewer, interview.

32. Louis W. Koenig, *William Jennings Bryan: A Political Biography* (New York: Putnam's Sons, 1971), 357.

33. Allen and Guthrie, "Joseph Yoakum," 33.

34. Ibid., 32. This list of circuses does not correspond precisely to those named in Whitney Halstead's unpublished manuscript. Halstead omits any mention of either the Great Wallace Circus or Al G. Barnes circuses, but includes Sells- Floto. He indicates that Sells-Floto and Adam Forepaugh were combined shows, although this was never the case. Adam Forepaugh and Sells Brothers, an Indiana-based enterprise, was unrelated to Sells-Floto, a show based in Denver. The World Circus Museum archives contain an extensive listing of circus employees, but Joseph Yoakum is not included. Unfortunately, circus record keeping related to African American employees, especially those who were not performers, was minimal at best in the early years. According to World Circus Museum archivist Ted Ballinger, given the number of lesser-known railroad shows named by Yoakum, it is quite likely that he actually was associated with the circus at some point during his career.

35. Derek Guthrie, interview by author, 20 August 1994. A good discussion of the circus advance department appears in Charles Philip Fox and Tom Parkinson, *The Circus in America* (Waukesha, Wisconsin: Country Beautiful, 1969).

36. Ringling, "We Divided the Job," 182.

37. A review of the route books for 1900–1908 of the circuses Yoakum claimed to be employed by reveals a startling fact. A majority of the cities and locales that he depicted in North America and Europe were places that these circuses actually visited.

38. Thomas Grazulis, *Significant Tornadoes, 1680–1991* (St. Johnsbury, Vermont: Environmental Films, 1993).

39. Philip Dedrick, interview by author, 6 June 1995. Dedrick visited Yoakum's studio with Whitney Halstead on several occasions and hosted the artist during his three visits to Rockford College in 1971.

40. Ibid.

41. Peter Yolkum, interview by author, 15 October 1995.

42. Marriage Abstracts, 1910, Greene County, Missouri, 320.

43. Lora Brewer, interview; Marian (Mrs. John) Yolkum, interview by the author, 30 August 1993. Marian recalled that the artist had a "temper like an Indian."

44. *Springfield Missouri Republican*, 8 July 1909, 1. There were no other major floods in the Springfield area reported in July during the years 1910–19.

45. Peter Yolkum, interview.

46. Edward Levy held a series of posts with the St. Louis & San Francisco Railroad in Springfield from 1906 to 1917. He is listed in Harold Lane, ed., *The Biographical Directory of the Railway Officials of America* (New York: Simmons-Boardman Publishing Co., 1922), 372.

47. Joseph Yoakum, letter to his aunt Susan Yokum Rice.

48. W. E. B. Du Bois, "An Essay toward a History of the Black Man in the Great War," *The Crisis*, June 1919.

49. Norman Mark, "My drawings are a spiritual unfoldment," *Panorama-Chicago Daily News*, 11 November 1967, 2.

50. Arthur E. Barbeau and Florette Henri, *The Unknown Soldiers: Black American Troops in World War I* (Philadelphia: Temple University Press, 1974), 89.

51. Ibid., 92.

52. National Archives, World War I Organization Records, 805th Pioneer Infantry, Headquarters Company, R.G. 120.

53. Barbeau and Henri, *Unknown Soldiers*, 105.

54. Ibid.

55. Emmett Scott, *Scott's Official History of the American Negro in the World War* (reprint, New York: Arno Press and the *New York Times*, 1969), 101–02.

56. Special Court Martial Orders No. 2 by order of Col. C. B. Humphrey, 23 November 1918, in National Archives.

57. Ibid.

58. Capt. George M. Bragan to Commanding Officer of 805th Pioneer Infantry, "Recommendations for Clemency," 24 January 1919, in National Archives.

59. Capt. George M. Bragan to Col. C. B. Humphrey, "Treatment of Colored Troops," 28 May 1919, in National Archives.

60. *Order of Battle of the United States Land Forces in the World War, 1917–1919, Zone of the Interior, Vol. III, Part II, Directory of Troops* (Washington, D.C.: Government Printing Office, 1949), 1403.

61. Col. C. B. Humphrey, "Special Orders No. 35," 4 February 1919, in National Archives.

62. History of the Headquarters Company, 805th Pioneer Infantry, n.d., in National Archives.

63. Col. Wait C. Johnson and Elwood S. Brown, eds., *Official Athletic Almanac of the American Expeditionary Forces Championships and Inter-Allied Games, 1919* (New York: American Sports Publishing Co., 1919), 309.

64. Guthrie, interview.

65. Ibid.

66. Copyright: Warlock Corporation.

67. Guthrie, interview.

68. Bert Walker, "The Comic Side of Trouble," *The American Magazine*, 85, January 1918, 58.

69. Peter Yolkum, interview.

70. Ibid.

71. Allen and Guthrie, "Joseph Yoakum," 33.

72. Whitney Halstead, notes, in Whitney B. Halstead Papers, Archives of American Art, Smithsonian Institution.

73. Robert E. Turner, *Memories of a Retired Pull-*

man *Porter* (New York: Exposition Press, 1954), 122–23.

74. Allen and Guthrie, "Joseph Yoakum," 34.

75. Ibid., 33.

76. Nilsson and Nutt, interview.

77. Dorothy L. Gate and Jane H. Bailey, *Morro Bay's Yesterdays: Vignettes of Our City's Lives and Times* (Morro Bay, California: El Moro Publications, 1982), 45.

78. Walter Redfield obituary, *San Luis Obispo Telegram-Tribune*, 5 February 1987, 4B.

79. Ramberg, diary entry, 29 May 1969.

80. Ibid.

81. Gregory R. Woirol, *In the Floating Army: F. C. Mills on Itinerant Life in California, 1914* (Urbana: University of Illinois Press, 1972), 81.

82. Evonne Durham, interview by author, 12 November 1995.

83. Peter Yolkum, interview.

84. Ida Mae (Mrs. William) Yolkum, interview by author, 9 December 1995.

85. "Request for Number and Service Information" form, Veterans Administration, Hospital Unit, VA Hospital, Hines, Illinois, 14 October 1946. "Request for Change of Address" form, Veterans Administration, Vaughn Unit, VA Hospital, Hines, Illinois, signed by Joseph E. Yoakum, 1 January 1947. Veterans Administration, Adjudication Section form concerning continuation of pension benefits, signed by Joseph E. Yoakum, 6 February 1948.

86. Veterans Administration file concerning pension benefit of Joseph E. Yoakum, Adjudication Section, Chicago, Illinois, 6 February 1948.

87. According to his Veterans Administration records, before his hospitalization Yoakum lived at 6221 Vernon Avenue in Chicago. After his release he moved to 4947 Champlain Avenue, and seven years later resided at 4646 Prairie Avenue. He did not appear in the Chicago telephone directory until 1958 when he was listed as a carpenter at 5107 South Calumet Avenue. He did not show up again in the directory until 1965, when his address was given as 150 South Campbell Avenue, in the heart of one of Chicago's toughest neighborhoods. From 1966 to 1971 he was listed at 1545 East 82nd Street, a location on the city's South Side, where he moved for greater safety.

88. Allen and Guthrie, "Joseph Yoakum," 34.

89. Guthrie, interview.

90. Walter Maqueral, interview by author, 3 August 1994. Maqueral, a retired steelworker formerly with Local 1066, joined the U.S. Steel Works in 1927.

91. Allen and Guthrie, "Joseph Yoakum," 33.

92. Ibid.

93. Hanson, "Joseph E. Yoakum," 3.

94. Mark, "My drawings are a spiritual unfoldment," 2.

95. Hanson, "Joseph E. Yoakum," 13. Hanson discusses what the term "spiritual unfoldment" meant to Yoakum. The term is found in Mary Baker Eddy's *Science and Health with Key to the Scriptures* (Boston: Allison V. Stewart, 1912), 371. Eddy writes, "No impossible thing do I ask when urging the claim of Christian Science; but because this teaching is in advance of the age, we should not deny our need of its spiritual unfoldment." Philip Dedrick, in an interview by the author, spoke about the general circumstances surrounding Yoakum's conversion to Christian Science.

96. John Michael Vlach, "The Afro-American Aesthetic," in Charles Reagan Wilson and William Ferris, eds., *Encyclopedia of Southern Culture* (Chapel Hill and London: University of North Carolina Press in association with the Center for the Study of Southern Culture at the University of Mississippi, 1989), 457.

97. Allen and Guthrie, "Joseph Yoakum," 35.

98. The Reverend Harvey Pranian, interview by author, 7 May 1995.

99. Durham, interview.

100. Tom Brand, interview by author, 20 June 1995.

101. Mark, "My drawings are a spiritual unfoldment."

102. Don Anderson, *Chicago's American*, 26 May 1968, 7.

103. Allen and Guthrie, "Joseph Yoakum," 35.

104. Yoshida, interview.

105. Hanson, "Joseph E. Yoakum," 2.

106. Nilsson and Nutt, interview.

107. Halstead, "Joseph Yoakum," 8.

108. Roger Vail, interview by author, 9 July 1999.

109. Describing the Cherokees of 1700, historian William McLoughlin writes in *Cherokee Renascence* (9), "The Cherokees were a tall, athletic, and handsome people, whose posture, stamina, physique, and good looks were universally admired by the Europeans. They were taller than most Europeans, hardier, and better athletes. Oval-headed and olive-colored, they did not have the high cheekbones and Roman noses of the Plains Indians."

110. Nilsson and Nutt, interview.

111. Marian Yolkum, interview.

112. Mark, "My drawings are a spiritual unfoldment," 2.

113. Halstead, "Joseph Yoakum," 18.

114. Lora Brewer, interview.

115. Halstead, "Joseph Yoakum," 18–19.

116. Hanson, "Joseph E. Yoakum," 3.

117. Vail, interview.

118. Ramberg, diary entry, 23 November 1969.

119. Guthrie, interview. John Ringling also noted that "[t]he respect of the . . . [circus employee] for women was almost beyond belief. It is much the same spirit that is seen in the Western outdoor show, and probably is the result of knowing so few women intimately. If you were to take the finest lady in the land to the circus lot and introduce her, say to a boss hostler, in rough clothes, and perhaps dirty, he would greet her with a deference and a dignity that would impress her because of its realness." Quoted in *The American Magazine*, September 1919, 183.

120. Malcolm Kamin, Esq., letter to Edward Sherbeyn Gallery, 27 November 1968, in Whitney B. Halstead Papers, Archives of American Art, Smithsonian Institution.

121. Nilsson and Nutt, interview.

122. Robert Glauber, "True Primitive Exhibits His Work," *Skyline*, 19 February 1969, 32.

123. Curatorial Archives, Chicago Museum of Contemporary Art.

124. Adeliza McHugh, interview by author, 17 July 1994.

125. Joseph Yoakum, letter to Jim Nutt and Gladys Nilsson, 17 February 1970, in Whitney Halstead Papers, Archives, Art Institute of Chicago.

126. Richard Fraenkel letter to Joseph Yoakum, 14 April 1969, in Whitney B. Halstead Papers, Archives of American Art, Smithsonian Institution.

127. Nilsson and Nutt, interview.

128. Philip Linhares, interview by author, 25 June 1994.

129. June Soucek, letter to Joseph Yoakum, 2 November 1970, in Whitney B. Halstead Papers, Archives of American Art, Smithsonian Institution.

130. Dedrick, interview.

131. Cynthia Carlson, interview by author, 21 September 1994.

132. Whitney Halstead, letter to Aline Hill, Art Lending Service, Museum of Modern Art, 4 July 1971, in Whitney B. Halstead Papers, Archives of American Art, Smithsonian Institution.

133. Ibid.

134. Aline Hill, letter to Whitney Halstead, 12 July 1971.

135. Nilsson and Nutt, interview.

136. Allen and Guthrie, "Joseph Yoakum," 35.

137. Whitney Halstead, letter to Mr. and Mrs. John Julian, 16 February 1973, in Whitney B. Halstead Papers, Archives of American Art, Smithsonian Institution.

138. Ibid.

139. Vail, interview.

140. Dennis Adrian, "The strange and wondrous revelations of Joseph Yoakum," *Panorama-Chicago Daily News*, 14 October 1972, 29.

141. Marsha Tucker, interview by author, 20 October 1995.

142. Sharon F. Patton, *African-American Art* (Oxford and New York: Oxford University Press, 1998), 211.

143. Whitney Halstead, *Joseph E. Yoakum* (New

York: Whitney Museum of Art, 1972), 3.

144. John Perreault, "Art & . . . ," *The Village Voice*, 9 November 1972, 36.

145. Louis Chapin, "A 'Naive' Artist Views the World," *Christian Science Monitor*, 11 December 1972, 8.

146. Joseph Yoakum, letter to Mr. and Mrs. Louis H. Yolkum, 1 October 1972, in Whitney Halstead Papers, Archives, Art Institute of Chicago.

147. Joseph Elmer Yoakum, Medical Certificate of Death, State of Illinois.

148. Durham, interview.

CHAPTER TWO

1. Mark Twain, *The Adventures of Huckleberry Finn* (1882; reprint, New York: Modern Library, 1985), 196.

2. Ed Howe, *Plain People* (New York: Dodd, Mead, 1929), 44–45.

3. W. D. Howells, *A Boy's Town* (Reprint, Westport, Connecticut: Greenwood Press, 1970), 105.

4. Frank Lewis, "When the Circus Came to Town," *Siskayou Pioneer*, summer 1914, 37.

5. Dean Jensen, *The Center Ring: The Artist* (Milwaukee: Milwaukee Art Museum, 1981), 25.

6. Ibid.

7. Whitney Halstead, "Joseph Yoakum," unpublished manuscript, c. 1977, in Whitney Halstead Papers, Archives, Art Institute of Chicago, 27.

8. Charles Philip Fox and Tom Parkinson, *The American Circus* (Waukesha, Wisconsin: Country Beautiful, 1969), 53.

9. Ibid.

10. John Ringling, "We Divided the Job—but Stuck Together," *The American Magazine*, September 1919, 57.

11. Fox and Parkinson, *American Circus*, 53.

12. Don Russell, *The Lives and Legends of Buffalo Bill* (Norman: University of Oklahoma Press, 1960), 96.

13. The Spectacle of Balkis advertisement is in *Barnum and Bailey Greatest Show on Earth Official Program and Book of Wonders Combined*, 1903.

14. Robert Barbour Johnson, *The Old-Time Spec* (unpublished monograph, n.d.), 2.

15. Norman Mark, "My drawings are a spiritual unfoldment," *Panorama-Chicago Daily News*, 11 November 1967, 2.

16. John H. Towsen, *Clowns* (New York: Hawthorn Books, Inc., 1976), 274.

17. LaVahn G. Hoh and William Rough, *Step Right Up! The Adventure of the Circus in America* (White Hall, Virginia: Betterway Publications, 1990), 67.

18. R. H. Gollmar, *My Father Owned a Circus* (Caldwell, Ohio: Caxton Printers, 1965), 194.

19. Quoted in Hershell B. Chipp, ed., *Theories of Modern Art: A Source Book by Artists and Critics* (Berkeley and Los Angeles: University of California Press, 1968), 157.

20. Joseph Campbell with Bill Moyers, *The Power of Myth* (New York: Doubleday, 1988), 11.

21. "The Great Cole Younger and Frank James Historical Wild West and Congress of Rough Riders of the World," *Wheeling Daily Intelligencer*, 30 July 1903, 21.

22. Charles Philip Fox and Tom Parkinson, *Billers, Banners and Bombast: The Story of Circus Advertising* (Boulder, Colorado: Pruett, 1985), 26.

23. Derek Guthrie, interview by author, 20 August 1994.

24. James Rennert, *100 Years of Circus Posters* (New York: Darien House, 1974), 3.

25. Halstead, "Joseph Yoakum," 16.

26. Guthrie, interview.

CHAPTER THREE

1. Thomas Hart Benton, *An Artist in America* (Reprint, Columbia: University of Missouri Press, 1968), 70.

2. Tom Parkinson and Charles Philip Fox, *The Circus Moves by Rail* (Boulder, Colorado: Pruett Publishing Co., 1978), 25.

3. Susan Danly, introduction to *The Railroad in*

American Art: Representations of Technological Change, ed. Susan Danly and Leo Marx (Cambridge: MIT Press, 1988), 30.

4. J. Valerie Fifer, *American Progress: The Growth of the Transport, Tourist, and Information Industries in the Nineteenth Century as Seen through the Life and Times of George A. Crofutt, Pioneer and Publicist of the Transcontinental Age* (Chester, Connecticut: The Globe Pequot Press, 1988), 321–22.

5. Alfred Runte, *Trains of Discovery: Western Railroads and the National Parks* (Niwot, Colorado: Roberts Reinhart Publishers, 1990), 31.

6. Joni Louise Kinsay, *Thomas Moran and the Surveying of the American West* (Washington, D.C., and London: Smithsonian Institution Press, 1992), 141.

7. Whitney Halstead, "Joseph Yoakum," unpublished manuscript, c. 1977, in Whitney Halstead Papers, Archives, Art Institute of Chicago, 38.

8. See Herschell B. Chipp, ed., *Theories of Modern Art: A Source Book by Artists and Critics* (Berkeley and Los Angeles: University of California Press, 1968), 63.

9. T. C. McLuhan, *Dream Tracks: The Railroad and the American Indian, 1890–1930* (New York: Harry N. Abrams, 1985), 40.

10. Kinsay, *Thomas Moran*, 39.

11. Ibid., 35.

12. Samuel 22:2–3.

13. Kinsay, *Thomas Moran*, 26.

14. George P. Landow, "The Rainbow: A Problematic Image" in *Nature and the Victorian Imagination*, ed. U. C. Knoepflmacher and G. B. Tennyson (Berkeley: University of California Press, 1977), 341.

15. Bruce Weber and William H. Gerdts, *In Nature's Way: American Landscape Painting of the Late Nineteenth Century* (West Palm Beach, Florida: Norton Gallery of Art, 1987), 29.

16. David Hunter Strother, "Artists' Excursion over the Baltimore and Ohio Rail Road," *Harper's New Monthly Magazine* 19, June 1859, 2.

17. *Deseret News*, 9 June 1893, 1.

CHAPTER FOUR

1. Rick Dillingham with Melinda Elliott, *Acoma and Laguna Pottery* (Santa Fe, New Mexico: School of American Research Press, 1992), 156.

2. Found among Yoakum's studio papers at his death was a magazine advertisement for Pontiac automobiles that depicted the Natchez Indians from the southeastern United States.

3. Ruth L. Bunzel, *The Pueblo Potter: Study of Creative Imagination in Primitive Art* (New York: Dover Publications, 1928), 96.

4. Quoted in Allen Wardell, *Objects of Bright Pride: Northwest Coast Indian Art from the American Museum of Natural History* (Seattle and London: University of Washington Press and the American Federation of Arts, 1978), 32.

5. Cottie Burland, *North American Indian Mythology* (London and New York: Hamilyn Publishing Group, 1965), 114.

6. David W. Penney, *Art of the American Indian Frontier: The Chandler-Pohrt Collection* (Seattle and London: University of Washington Press in association with the Detroit Institute of Arts, 1992), 248.

7. A late sketch is inscribed *The temperature today is much cool. This picture is of healthy mounds at Ash Grove and Willard in Missouri, 6–18–72.*

8. Rev. Stephen D. Peet, *The Mound Builders: Their Works and Relics* (Chicago: Office of the American Antiquarian, 1892), 66.

9. J. F. Snyder, "Who Were the Osages Mound Builders?," *Smithsonian Institution Annual Report, 1888* (Washington, D.C.: Government Printing Office, 1888), 592.

10. Thor Conway, *Painted Dreams: Native American Rock Art* (Minocqua, Wisconsin: North Word Press, Inc., 1993), 17.

11. Campbell Grant, *The Rock Paintings of the Chumash* (Santa Barbara: Santa Barbara Museum of Natural History, 1993), 74.

12. Polly Schaafsma, *The Rock Art of Utah: A Study from the Donald Scott Collection* (Salt Lake City: University of Utah Press, 1971), 72.

13. Edward Malin, *Totem Poles of the Pacific Northwest Coast* (Portland, Oregon: Timber Press, 1986), 45.

14. Audrey Hawthorn, *Art of the Kwakiutl Indians and Other Northwest Coast Tribes* (Seattle and London: University of Washington Press, 1967), 271

15. Ibid., 270.

16. Hilary Stewart, *Looking at Indian Art of the Northwest Coast* (Seattle and London: University of Washington Press, 1979), 97.

17. Ibid., 42.

18. Claude Lévi-Strauss, *The Way of the Masks*, trans. Sylvia Modelski (Seattle and London: University of Washington Press, 1975), 214.

19. Hawthorn, *Art of the Kwakiutl Indians*, 152.

20. Edward Malin, *A World of Faces: Masks of the Northwest Coast Indians* (Portland, Oregon: Timber Press, 1978), 24.

21. Bill Holm, *Northwest Coast Indian Art: An Analysis of Form* (Seattle and London: University of Washington Press, 1965), 37.

22. Ibid., 42.

23. Stewart, *Looking at Indian Art*, 19.

24. Holm, *Northwest Coast Indian Art*, 64–65.

25. Marjorie M. Halpin, *Totem Poles: An Illustrated Guide* (Vancouver: University of British Columbia Press in association with the University of British Columbia Museum of Anthropology, 1983), 36.

26. Nora Marks Dauenhauer, "Tlingit Atoow: Traditions and Concepts," in *The Spirit Within: Northwest Coast Native Art from the John H. Hauberg Collection* (New York: Rizzoli International Publications, 1995), 60–63.

27. Hamilton A. Tyler, *Pueblo Gods and Myths* (Norman: University of Oklahoma Press, 1964), 141.

28. Leland Wyman, *The Windways of the Navajo* (Colorado Springs: Taylor Museum of the Colorado Springs Fine Arts Center, 1962), 78.

29. Tyler, *Pueblo Gods and Myths*, 139.

30. Karl W. Luckert, ed., *Navajo Coyote Tales: The Curly to Aheedliini Version* (Lincoln and London: University of Nebraska Press, 1984), 97.

31. Tyler, *Pueblo Gods and Myths*, 205.

32. Leland C. Wyman, *The Mountainway of the Navajo* (Tucson: University of Arizona Press, 1975), 1.

33. Tyler, *Pueblo Gods and Myths*, 197.

34. Barton Wright, *Clowns of the Hopi: Tradition Keepers and Delight Makers* (Flagstaff, Arizona: Northland Publishing, 1994), 77.

35. Quoted in *Year of the Hopi* (Washington, D.C.: Smithsonian Institution Traveling Exhibitions Service, 1982), 54.

36. Virginia More Roediger, *Ceremonial Costumes of the Pueblo Indians: Their Evolution, Fabrication, and Significance in Prayer Drama* (Berkeley and Los Angeles: University of California Press, 1941), 81.

37. Hamilton A. Tyler, *Pueblo Birds and Myths* (Flagstaff, Arizona: Northland Publishing, 1979), 55.

38. Virginia More Roediger, *Ceremonial Costumes of the Pueblo Indians: Their Evolution, Fabrication, and Significance in Prayer Drama* (Berkeley and Los Angeles: University of California Press, 1941), 107.

39. Gylbert Coker, "American Folk Art and the Black Folk Artist," in *The Harmon and Harriet Kelley Collection of African American Art* (San Antonio: San Antonio Museum of Art, 1994), 42.

40. Wyman, *Windways of the Navajo*, 74.

41. David V. Villasenor, *Tapestries in Sand: The Spirit of Indian Sandpainting* (Healdsburg, California: Naturegraph Co., 1963), 20.

CHAPTER FIVE

1. John Dewey, *Art as Experience* (New York: Minton, Blach and Co., 1934), 334.

2. Ibid.

3. Roger D. Abrahams, "Some Variations of Heroes in America," *Journal of the Folklore Institute* 3 (1967): 341.

4. Joseph Campbell, *The Hero with a Thousand Faces* (Princeton, New Jersey: Princeton University Press, 1972).

5. This analysis of African American folk heroes

is largely based upon the seminal work by Lawrence W. Levine, *Black Culture and Black Consciousness: African American Folk Thought from Slavery to Freedom* (New York: Oxford University Press, 1977).

6. Dailey Paskman, *"Gentlemen, Be Seated!" A Parade of American Minstrels* (New York: C. N. Potter, distributed by Crown Books, 1976), 24.

7. Levine, *Black Culture and Black Consciousness*, 420.

8. Ibid.

9. Yoakum's drawing *In Campagne Season of 1898 President William McKinley is Seen in this Drawing Speaking from Platform of his country home* (1970) is an unusual landscape-portrait. It depicts the solitary figure of the president standing on a platform, with a large American flag as a backdrop, engulfed by massive battleship-gray mountains. McKinley's firm stance, with one hand at his side holding a hat, recalls a photograph of him giving a campaign address from the porch of his home to a crowd that includes many African Americans. Yoakum's portrait conveys the "dominant will and energy" that one British journalist saw expressed in the president's facial features.

10. One of Yoakum's Tishimingo Tunnel drawings is entitled *The Tishimingo Tunnel Tishimingo, Oklahoma Where John Hener the steel driver died 4–16–1901*. No record was found of the death of any man named John Hener in Tishimingo on that date, however. Another version is entitled *Tishimingo Tunnel in Tishimingo Oklahoma on the St. Louis and San Francisco Railroad*.

11. Levine, *Black Culture and Black Consciousness*, 430–31.

12. Mozell C. Hill, "The All-Negro Communities in Oklahoma: The Natural History of a Social Movement," *Journal of Negro History* (July 1946), 264.

13. Quoted in William Loren Katz, *The Black West* (Garden City, New York: Doubleday and Co., 1971), 317.

14. Arthur G. Kimball, *Ace of Hearts: The Westerns of Zane Grey* (Fort Worth: Texas Christian University Press, 1993).

15. Carlton Jackson, *Zane Grey* (New York: Twayne Publishers, 1973), 57.

16. John W. Roberts, *From Trickster to Badman: The Black Folk Hero in Slavery and Freedom* (Philadelphia: University of Pennsylvania Press, 1989), 173.

17. Levine, *Black Culture and Black Consciousness*, 415.

18. Richard E. Lingenfelter, Richard A. Dwyer, and David Cohen, eds., *Songs of the American West* (Berkeley and Los Angeles: University of California Press, 1968), 322.

19. Norman Mark, "My drawings are a spiritual unfoldment," *Chicago Daily News-Panorama* (11 November 1967), 2.

20. Quoted in Peter Kolchin, *First Freedom: The Responses of Alabama Blacks to Emancipation and Reconstruction* (Westport, Connecticut: Greenwood Press, 1972), 118.

21. Arna Bontemps, "Golgotha is a Mountain" in *The Poetry of the Negro, 1746–1949*, ed. Langston Hughes and Arna Bontemps (Garden City, New York: Doubleday and Co., 1949), 117.

22. Quoted in Francis Davis, *The History of the Blues* (New York: Hyperion, 1995), 77.

23. Ibid., 34.

24. Willie "The Lion" Smith, *Music on My Mind: The Memories of an American Pianist* (Garden City, New York: Doubleday and Co., 1964), 97.

25. Derrick Stewart-Baxter, *Ma Rainey and the Classic Blues Singers* (New York: Stein and Day, 1970), 8.

26. Ibid., 7.

27. Davis, *History of the Blues*, 82.

28. Ibid.

29. Ian Carr, Digby Fairweather, and Brian Priestley, *Jazz: The Essential Companion* (New York and London: Prentice Hall Press, 1987), 169.

30. Sterling A. Brown, "The Blues as Folk Poetry," *Folk-Say* 2 (1930), 330.

31. Ibid.

32. Ibid., 334.

CHAPTER SIX

1. Marsden Hartley, "Art and the Personal Life," *Creative Art* (6 June 1928), xxxi–vii.

2. Whitney Halstead, "Joseph Yoakum," unpublished manuscript, c. 1977, in Whitney Halstead Papers, Archives, Art Institute of Chicago, 51.

3. Ibid., 33.

4. Ibid., 27.

5. Ray Yoshida, interview by author, 6 May 1994.

6. Philip Dedrick, interview by author, 6 June 1995.

7. Gladys Nilsson and Jim Nutt, interview by author, 5 April 1994; Roger Vail, interview by author, 9 July 1999.

8. Philip H. Hanson, "Joseph E. Yoakum," unpublished manuscript, 31 March 1969, in Whitney Halstead Papers, Archives, Art Institute of Chicago, 3.

9. Yoshida, interview.

10. Halstead, "Joseph Yoakum," 41.

11. Philip Linhares, interview by author, 25 June 1994. Linhares visited Yoakum's studio in 1968 with Gladys Nilsson and Jim Nutt.

12. Hanson, "Joseph E. Yoakum," 6.

13. Roger Brown, interview by author, 13 August 1994.

14. John Hopgood, interview by author, 10 June 1995.

15. Nilsson and Nutt, interview.

16. Ibid.

17. Christina Ramberg, diary entry, 29 May 1969, in Whitney B. Halstead Papers, Archives of American Art, Smithsonian Institution.

18. Evonne Durham, interview by author, 12 November 1995.

19. Ibid.

20. Nilsson and Nutt, interview.

21. Mark, "My drawings are a spiritual unfoldment," 2.

22. Halstead, "Joseph Yoakum," 39.

23. Ibid., 28.

24. This discussion of surfaces is drawn primarily from Whitney Halstead's unpublished manuscript "Joseph Yoakum."

25. Dedrick, interview.

26. Nilsson and Nutt, interview.

27. Halstead, "Joseph Yoakum," 26.

28. This discussion of stylistic periods is partially based upon Whitney Halstead's unpublished manuscript "Joseph Yoakum."

29. Halstead, "Joseph Yoakum," 28.

30. Ibid., 39.

31. Quoted in Hershell B. Chipp, ed., *Theories of Modern Art: A Source Book by Artists and Critics* (Berkeley and Los Angeles: University of California Press, 1968), 143.

CHAPTER SEVEN

1. Joanne Cubbs, "The Romantic Artist Outsider, " in *The Artist Outsider: Creativity and the Boundaries of Culture* (Washington and London: Smithsonian Institution Press, 1994), 86.

2. Quoted in Roger Cardinal, "Toward an Outsider Aesthetic," in *The Artist Outsider*, 23.

3. Herbert Waide Hemphill, Jr., and Julia Weissman, *Twentieth-Century American Folk Art and Artists* (New York: E. P. Dutton, 1984), 18.

4. Sidney Janis, *They Taught Themselves: American Primitive Painters of the 20th Century* (Port Washington, New York: Kennikat Press, 1942), 10.

5. Quoted in *Henri Matisse: Retrospective Exhibition of Paintings, Drawings and Sculpture Organized in Collaboration with the Artist* (Philadelphia: Philadelphia Museum of Art, 1948), 33–34.

6. Quoted in Norbert Guterman, *The Inward Vision: Watercolors, Drawings and Writings by Paul Klee* (New York: Harry N. Abrams, 1959), 5.

7. Janis, *They Taught Themselves*, 11.

8. Cardinal, "Toward an Outsider Aesthetic," 30.

9. Cubbs, "Romantic Artist Outsider," 77.

10. Ibid.

11. This discussion of American visionary painting is largely based upon Abraham A. Davidson's pi-

oneering book *The Eccentrics and Other American Visionary Painters* (New York: E. P. Dutton, 1978).

12. Ibid., xvii.

13. Quoted in Jared B. Flagg, *Washington Allston: Life and Letters* (Charles Scribner's Sons: New York, 1892), 198–99.

14. Davidson, *The Eccentrics*, 68.

15. Elihu Vedder, *The Digressions of V. Written for His Own Fun and That of His Friends* (Boston and New York: Houghton Mifflin, 1910), 312.

16. Quoted in Henry La Farge, *John La Farge: Oils and Watercolors* (New York: Kennedy Galleries, 1968), pages unnumbered.

17. Davidson, *The Eccentrics*, 158.

18. Barbara Haskell, *Arthur Dove* (Boston: New York Graphic Society in association with San Francisco Museum of Art, 1974), 7.

19. Ibid.

20. Ibid.

21. Ibid.

22. Elizabeth Hutton Turner, *In the American Grain: Arthur Dove, Marsden Hartley, John Marin, Georgia O'Keeffe, and Alfred Stieglitz: The Stieglitz Circle at the Phillips Collection* (Washington, D.C.: Counterpoint in association with the Phillips Collection, 1995), 28.

23. John Ireland Howe Baur, *Charles Burchfield* (New York: The MacMillan Co. in association with the Whitney Museum of American Art, 1956), 11.

24. Matthew Baigell, *Charles Burchfield* (New York: Watson-Guptill Publications, 1976), 76.

25. Davidson, *The Eccentrics*, 176.

26. Robert Doty and Diane Waldman, *Adolph Gottlieb* (New York: Frederick A. Praeger in association with the Whitney Museum of American Art and the Solomon R. Guggenheim Museum, 1968), 14.

27. Ibid.

28. Quoted in Doty and Waldman, *Adolph Gottlieb*, 9.

29. This interpretation of Gottlieb's painting is found in Evan M. Maurer, "Adolph Gottlieb: Pictographs and Primitivism," in *The Pictographs of Adolph Gottlieb* (New York: Hudson Hills Press in association with the Adolph and Ester Gottlieb Foundation, 1994), 37.

30. Charlotta Kotik, "The Legacy of Signs: Reflections on Adolph Gottlieb's Pictographs" in *The Pictographs of Adolph Gottlieb*, 66.

Chronology

1890

Born in Ash Grove, Missouri, on February 20, to John and Frances "Fannie" Wadlow Yokum (also spelled "Yocum"). One of ten children.

1890s

Moved to Kansas City, Missouri, where his father worked briefly in railroad yards. Relocated to Walnut Grove, where his father ran a farm. Attended school for only four months during this period.

1900

Joined the Great Wallace Circus; his work was grooming the horses.

1901–1908

Employed with various railroad circuses, including Adam Forepaugh and Sells Brothers, Buffalo Bill Cody's Wild West, Ringling Brothers, and Al G. Barnes. Major jobs were as a horse handler and billposter with the advance department.

1908

Left the circus and returned to his family home in Missouri when his father died. Worked as a fireman for a limekiln in the town of Ash Grove. Met his future wife, Myrtle Julian, the daughter of a local farmer.

1909

First child, a son, Louis, born to Joseph and Myrtle on February 28. Forced to leave home during major flood in early July.

1910

Married Myrtle Julian on August 25 in Ash Grove. Employed as an assistant to Edward Levy, the superintendent of the St. Louis and San Francisco Railroad.

1912

Second son, Peter, born on September 22.

1914

Daughter, Margaret, born on November 25.

1915

Relocated family to Fort Scott, Kansas, and worked in the coal mining industry.

1916

Last of five children, twins John and William, born on October 2.

1918

Inducted into the U.S. Army at Camp Funston, Kansas, on July 16. Sailed to Europe in September. Served in France with Headquarters Company of the 805th Pioneer Infantry.

1919

After the armistice, accompanied U.S. Army equestrian team to Inter-Allied Games in Paris. Decommissioned on July 8 at Camp Shelby, Mississippi. Divorced first wife and lost touch with his children for eighteen years.

1920s

Traveled widely in North America, Australia, and parts of Asia. Held a variety of odd jobs—railroad inspector, fireman, farm worker, miner, and seaman. Hoboed across Canada.

Late 1920s

Remarried and settled in Chicago. At various times employed as a janitor, mechanic, foundry worker, and carpenter.

1936

Reunited with his children after chance encounter with his son John on a train in Missouri.

1940s

Reportedly executed murals in a steel foundry where he worked. Made ceramics as a hobby which he tried unsuccessfully to turn into a business enterprise. Later ran an ice cream parlor.

1946

Entered Hines Veterans Hospital as psychiatric patient on October 9.

1947

Discharged from Hines on September 12.

1950s

Retired to live on veteran's pension. Supplemented income with odd jobs including carpentry and paper hanging. Periodically visited his children in Florida, Kansas, Missouri, and Washington, D.C.

1960s

Resided in a housing project for senior citizens.

1962

Motivated by a dream, began to draw on an almost full-time basis.

1966

Moved to a storefront studio. Began his most productive period as an artist.

1967

Discovered by John Hopgood, an instructor at Chicago State College. Had his first exhibition at St. Bartholomew's Church.

1968

Introduced by Tom Brand, a local artist and printer, to Edward Sherbeyn Gallery on Chicago's Near North Side. Sherbeyn began to represent artist and held one-man show of his work. Led to artist's discovery by Chicago's mainstream art community.

1969

Participated in exhibition at the Chicago Museum of Contemporary Art. Second one-man show held at the Sherbeyn Gallery. When that business relationship ended, Whitney Halstead, a teacher at the School of the Art Institute of Chicago, became his representative.

1970

One-man exhibition held at Pennsylvania State University. Participated in other group shows in Chicago and northern California, including one at the San Francisco Art Institute.

1971

Two-man show held at Wabash Transit Gallery of the School of the Art Institute of Chicago that later traveled to Rockford College in Illinois. Exhibited in Penthouse Gallery of Museum of Modern Art in New York. Entered Hines Veterans Hospital in the summer for a brief stay. Readmitted in the fall and discharged to convalescent home. Stopped drawing while hospitalized.

1972

Completed five sketchbooks. One-man shows held at the Whitney Museum of American Art in New York and the Douglas Kenyon Gallery in Chicago. Died on December 25; buried five days later in veterans' cemetery at Rockford, Illinois.

Permanent Collections

Akron Museum of Art

Art Institute of Chicago

Roger Brown Study Collection of the School of
the Art Institute of Chicago

Fine Arts Museums of San Francisco

Illinois Bell Telephone Company, Chicago

The Menil Collection, Houston

Milwaukee Museum of Art

Museum of American Folk Art, New York

Museum of Contemporary Art, Chicago

Museum of International Folk Art, Santa Fe

National Museum of American Art, Smithsonian
Institution, Washington, D.C.

Richard L. Nelson Gallery and the Fine Arts Collec-
tion, University of California, Davis

Philadelphia Museum of Art

David and Alfred Smart Museum of the University
of Chicago

University of Kansas Museum of Art, Lawrence

Exhibition History

SOLO EXHIBITIONS

1997

Grace Catches Fire: A Selection of Visionary Stones with the Drawings of Joseph Yoakum, Cavin-Morris/Project Gallery, New York

1995

Force of a Dream: The Drawings of Joseph E. Yoakum, Art Institute of Chicago

1989

Animistic Landscapes, Janet Fleisher Gallery, Philadelphia

Joseph E. Yoakum: Selected Drawings from the Collection, Richard L. Nelson Gallery and the Fine Arts Collection, University of California, Davis

Joseph Yoakum: A Comprehensive Exhibition of Works from Collections, Carl Hammer Gallery, Chicago

1988

Joseph E. Yoakum: A Survey of Drawings, Memorial Union Art Gallery, University of California, Davis

1985

Joseph E. Yoakum: Drawings, Hirschl & Adler Modern Gallery, New York

1982

Joseph E. Yoakum: Drawings, Hammer and Hammer Gallery, Chicago

1975

Joseph E. Yoakum: Drawings, 1886–1972, Gallery 200, Northern Illinois University, Dekalb

Joseph E. Yoakum: Drawings, Artist's House, New York

1973

Joseph E. Yoakum: Drawings, Fine Arts Center, University of Rhode Island, Kingston

1972

Joseph Yoakum: Drawings, Douglas Kenyon Gallery, Chicago

Joseph E. Yoakum: Drawings, Montgomery Ward Gallery, Chicago Circle Center, University of Illinois at Chicago Circle

Joseph E. Yoakum, The Whitney Museum of American Art, New York

1970

The World of Joseph E. Yoakum, Pennsylvania State University Art Museum, University Park

1969

Joseph Yoakum: Recent Paintings, Edward Sherbeyn Gallery, Chicago

1968

Joseph E. Yoakum, Edward Sherbeyn Gallery, Chicago

GROUP EXHIBITONS

1999

Art Outsider et Folk Art des Collections de Chicago, Halle Sainte Pierre, Paris; traveled to Terra Museum of Art, Chicago

Surreal Landscapes: Henry Darger, Joseph Parker, Eugene von Bruenchenhein, Joseph Yoakum, Carl Hammer Gallery, Chicago

Drawn from Artists' Collections, The Drawing Center, New York; traveled to Armand Hammer Museum, Los Angeles

Outsider Art: Tradition vs. Obsession, Carl Hammer Gallery, Chicago

Defining Their Times—Masterworks by Twentieth Century Self-Taught Artists, Fleisher/Ollman Gallery, Philadelphia

American Masters: A Study Collection, Intuit, Chicago

Humble Beginnings: Awesome Legacies, Afro-American Cultural Center, Charlotte, North Carolina

1998

Self-Taught Artists of the Twentieth Century: An American Anthology, Philadelphia Museum of Art; High Museum of Art, Atlanta; Amon Carter Museum and the Modern Art Museum of Fort Worth; Memorial Art Gallery of the University of Rochester; Wexner Center for the Arts, Ohio State University, Columbus; Museum of American Folk Art, New York

Self-Taught Artists of the 20th Century: Perspectives on Patterning, Museum of American Folk Art, New York

In and Out: Naïve Folk and Self-Taught Artists from the Collection, The Menil Collection, Houston

Hidden Aspects: A Selection of Works on Paper and Other Materials from the Roger Brown Study Collection of the School of the Art Institute of Chicago, Roger Brown Study Collection of the School of the Art Institute of Chicago

1997

Art in Chicago, 1945–1995, Museum of Contemporary Art, Chicago

Flying Free—Twentieth Century Self-Taught Art from the Collection of Ellin and Baron Gordon, Abby Aldrich Rockefeller Folk Art Center, Williamsburg, Virginia

Outsider Art: An Exploration of Chicago Collections, Chicago Cultural Center

1996

Off Center: Outsider Art in the Midwest, Minnesota Museum of American Art, St. Paul

Sacred Waters: Twentieth Century Outsiders and the Sea, South Street Seaport Museum, New York

Since the Harlem Renaissance: Sixty Years of African American Art, Art Institute of Chicago

In Pursuit of the Invisible: Selections from the Collection of Janice and Mickey Cartin, The Sue and Eugene Mercy, Jr., Gallery, Richmond Art Center, Loomis Chaffee School, Windsor, Connecticut

1995

A World of Their Own: Twentieth Century American Folk Art, Newark Museum

Chicago Connectors: Ten Self-Taught Visions Intersect the Mainstream, Carl Hammer Gallery, Chicago

Peace on Earth. Eddie Arning, Tony Fitzpatrick, Kamante Gatura, Marcy Hermansader, Joseph Yoakum, Janet Fleisher Gallery, Philadelphia

The Tree of Life, American Visionary Art Museum, Baltimore

1994

Free Within Ourselves: African American Artists in the Collection of the National Museum of Art, Wadsworth Atheneum, Hartford, Connecticut; IBM Gallery of Science and Art, New York;

Crocker Museum of Art, Sacramento; Memphis Brooks Museum; Columbus Museum, Columbus, Georgia

The Harmon and Harriet Kelley Collection of African American Art, San Antonio Museum of Art; El Paso Museum of Art; Michael C. Carlos Museum of Art, Atlanta; Butler Institute of American Art, Youngstown, Ohio; Hunter Museum of Art, Chattanooga, Tennessee; Museum of History and Science, Smithsonian Institution, Washington, D.C.

Heartland Visions: Nine Self-Taught Artists from Chicago and Vicinity, Carl Hammer Gallery, Chicago

Philadelphia Wireman and Joseph Yoakum, Janet Fleisher Gallery, Philadelphia

1993

Black History and Artistry: Work by Self-Taught Painters and Sculptors from the Blanchard-Hill Collection, Sidney Mishkin Gallery, Baruch College/CUNY, New York

Common Ground—Uncommon Vision: The Michael and Julie Hall Collection of American Folk Art, Milwaukee Museum of Art; Nelson-Atkins Museum of Art, Kansas City, Missouri; Albright-Knox Gallery of Art, Buffalo; Phoenix Museum of Art; Delaware Museum of Art, Wilmington; Abby Aldrich Rockefeller Folk Art Center, Williamsburg, Virginia

Driven to Create: The Anthony Petullo Collection of Self-Taught and Outsider Art, Museum of American Folk Art, New York; Milwaukee Museum of Art; Krannert Art Museum, University of Illinois at Urbana-Champaign; Akron Art Museum; Tampa Art Museum

Parallel Visions, Los Angeles County Museum of Art; Museo Nacional Reina Sofia, Madrid; Kunsthalle, Basel, Switzerland; Setagaya Art Museum, Tokyo

Visionaries, Outsiders and Spirtualists, David Winton Gallery, List Art Center, Brown University, Providence

1992

Contemporary American Folk Art: The Balsley Collection, Patrice and Beatrice Haggerty Museum of Art, Marquette University, Milwaukee

Dream Seekers, Story Tellers: An African-American Presence, Fukui Fine Arts Museum, Fukui, Japan; Tokushima Modern Art Museum, Tokushima, Japan; Otani Memorial Art Museum, Otani, Japan; New Jersey State Museum, Trenton

Without Parallel, Ricco-Maresca Gallery, New York

1991

Different Drummer: Works by American Self-Taught Artists, Metlife Gallery, New York

1990

American Outsiders and Visionaries, Davis McClaine Gallery, Houston

Image: Contemporary Drawing, Janet Fleisher Gallery, Philadelphia

Made with Passion: The Hemphill Folk Art Collection, National Museum of American Art, Smithsonian Institution, Washington, D.C.

Outsiders: Artists Outside the Mainstream, Octagon Center for the Arts, Ames, Iowa

The Cutting Edge: Contemporary American Folk Art, Museum of American Folk Art, New York

The Singular Imagination, Phyllis Kind Gallery, Chicago

Visions: Expressions Beyond the Mainstream from Chicago Collections, The Arts Club of Chicago

1989

A Density of Passions, New Jersey State Museum, Trenton

Viewpoints VII: 20th Century American Landscape Drawings, M. H. DeYoung Memorial Museum, Fine Arts Museums of San Francisco

African American Artists, 1880–1987: Selections from the Evans-Tibbs Collection, Smithsonian Institution Traveling Exhibition Service, Washington, D.C.

Gifted Visions: Black American Folk Art, Nashua Fine
 Arts Center, Nashua, New Hampshire
Self-Taught Masters of Twentieth Century Art, Cavin-
 Morris Gallery, New York

1988
Shape Shifting, Cavin-Morris Gallery, New York
Outsider Art: The Black Experience, Carl Hammer
 Gallery, Chicago
Drawings by Master Visionaries, Carl Hammer
 Gallery, Chicago
Worlds of Wonder, Memorial Gallery, Mills College,
 Oakland, California

1987
American Mysteries: The Rediscovery of Outsider Art,
 San Francisco Arts Commission Gallery
*American Outsider Art: A Few People Have Imagina-
 tion for Reality*, George Cicle Gallery, Baltimore
*In Another World: Outsider Art from Europe and
 America*, South Bank Centre, London; Ferens
 Gallery of Art, Hull, England; Milton Keynes
 Exhibition Gallery, Saxon Gate East, England;
 Wolverhampton Art Gallery, Wolverhampton,
 England; Graves Art Gallery, Sheffield, Eng-
 land; Stoke-on-Trent City Museum and Art
 Gallery, Stoke-on-Trent, England; Arnolfini,
 Bristol, England; Cornerhouse, Manchester,
 England; Aberystwyth Art Center, Aberyst-
 wyth, England
Paintings and Sculpture by Black Self-Taught Artists,
 Janet Fleisher Gallery, Philadelphia
*Visionary Landscapes: Works by Four Self-Taught
 Artists*, Cavin-Morris Gallery, New York

1986
*Muffled Voices: Folk Artists in Contemporary
 America*, Museum of American Folk Art at
 Paine Webber Art Gallery, New York
Naivety in Art, Setagaya Art Museum, Tokyo;
 Tochigi Prefectural Museum of Fine Arts,
 Tochigi, Japan

Outsiders: Art Beyond the Norms, Rosa Esman
 Gallery, New York
The Imagist Tradition: Chicago in the 70's, Janet
 Fleisher Gallery, Philadelphia
Visionary Works on Paper, Janet Fleisher Gallery,
 Philadelphia

1985
A Time to Reap: Late-Blooming Folk Artists, Seton
 Hall University, South Orange, New Jersey;
 Museum of American Folk Art, New York;
 Monmouth County Historical Association,
 Freehold, New Jersey; Allen House, Shrews-
 bury, New Jersey; Noyes Museum, Oceanville,
 New Jersey
Masterpieces of Folk Art, Janet Fleisher Gallery,
 Philadelphia

1984
Artists of the Black Experience, University of Illinois
 at Chicago Circle
*Joseph Yoakum: His Influence on Contemporary Art
 and Artists*, Carl Hammer Gallery, Chicago;
 Janet Fleisher Gallery, Philadelphia
Major Black Folk Artists, Janet Fleisher Gallery,
 Philadelphia

1983
*Masters of 20th Century American Naive and Vision-
 ary Art*, Janet Fleisher Gallery, Philadelphia

1982
Black Folk Art in America 1930–1980, Corcoran
 Gallery of Art, Washington, D.C.; J. B. Speed
 Art Museum, Louisville, Kentucky; Brooklyn
 Museum of Art; Craft and Folk Art Museum,
 Los Angeles; Institute of the Arts, Rice Uni-
 versity, Houston; Detroit Institute of Arts;
 Birmingham Museum of Art, Birmingham,
 Alabama; Field Museum of Natural History,
 Chicago
Self-Taught, Janet Fleisher Gallery, Philadelphia

Selections from the Dennis Adrian Collection, Museum of Contemporary Art, Chicago

1981

American Folk Art: The Herbert Waide Hemphill, Jr., Collection, Milwaukee Museum of Art; Everson Museum of Art, Syracuse; Allentown Art Museum, Allentown, Pennsylvania; Whitney Museum of American Art–Fairfield, Stamford, Connecticut; Akron Museum of Art; Santa Barbara Museum of Art; Georgia Museum of Art, Athens; Joslyn Museum of Art, Omaha

Transmitters: The Isolate Artist in America, Philadelphia College of Art

Welcome to the Candy Store! Crocker Art Museum, Sacramento

1980

Who Chicago? Camden Arts Centre, London; Sutherland Arts Centre, Sutherland, England; Third Eye Center, Glasgow, Scotland; Scottish National Gallery of Art, Edinburgh; Ulster Museum of Art, Belfast, Northern Ireland

Outsiders: An Art without Precedent or Tradition, Arts Council of Great Britain, London

1979

Outsider Art in Chicago, Museum of Contemporary Art, Chicago

Contemporary American Naive Works, Phyllis Kind Gallery, New York and Chicago

1978

Contemporary American Folk Art and Naive Art: The Personal Visions of Self-Taught Artists, School of the Art Institute of Chicago

Five Artists, Candy Store Gallery, Folsom, California

1977

Masterpieces of Recent Chicago Art, Chicago Public Library Cultural Center

Twentieth Century American Folk Art, Janet Fleisher Gallery, Philadelphia

1975

American Folk Art from the Ozarks to the Rockies, Philbrook Art Center, Tulsa, Oklahoma; Oklahoma Art Center, Oklahoma City; Springfield Art Museum, Springfield, Missouri; Arkansas Art Center, Little Rock

1972

The Artless Artist: Contemporary American "Naive" Works, Phyllis Kind Gallery, Chicago

1971

Two Artists—Pauline Simon and Joseph E. Yoakum, Wabash Transit Gallery, School of the Art Institute of Chicago; Rockford College, Rockford, Illinois

Penthouse Gallery, Museum of Modern Art, New York

1970

A Decade of Accomplishment: Prints and Drawings of the 1960s, Illinois Bell Telephone Company Lobby Gallery, Chicago

American Primitive and Naive Art, Emanuel Walter Gallery, San Francisco Art Institute

1969

Three Artists, Candy Store Gallery, Folsom, California

Don Baum Sez "Chicago Needs Famous Artists," Museum of Contemporary Art, Chicago

The Faculty Collects, Illinois State University, Normal

Bibliography

ARCHIVAL RESOURCES

Art Institute of Chicago (Whitney Halstead Papers and Collection)

Bernice P. Bishop Museum, Honolulu, Hawaii (Archives)

Bourbon County Office of the Clerk, Fort Scott, Kansas

Brooklyn Museum of Art, New York (American Indian Art Collection)

California State Railroad Museum, Sacramento

Carlisle Barracks, U.S. Army Military History Institute, Carlisle, Pennsylvania

Chicago Historical Society

Colorado Historical Society, Denver

Cook County Office of Vital Records, Chicago

Denver Museum of Art (American Indian Art Collection)

Fort Scott Historical Society, Fort Scott, Kansas

Thomas Gilcrease Institute of Art and History, Tulsa, Oklahoma

Greene County Archives and Vital Records Center, Springfield, Missouri

Johnson County Geneological and Historical Society, Tishimingo, Oklahoma

Kansas Office of Vital Statistics, Topeka

Kansas State Historical Society, Topeka

Library of Congress, Folklife Center, Washington, D.C.

Mills College, Oakland, California (Memorial Gallery Archives)

Montana State Historical Society, Missoula

Museum of American Folk Art, New York (Curatorial Archives)

Museum of Anthropology, Vancouver, Canada (Northwest Coast Tribal Art Collection)

Museum of Contemporary Art, Chicago (Curatorial Archives)

NAES College, Chicago (Community Archives)

National Archives, Washington, D.C. Federal Censuses of 1840–1920; World War I Organization Records, 805th Pioneer Infantry

Nevada State Library, Carson City (Governor Charles Russell Papers)

Oklahoma Historical Society, Indian Archives Division, Talequah (Records of the Cherokee Nation)

Robert L. Parkinson Library and Research Center, Circus World Museum, Baraboo, Wisconsin

Pittsburgh State University Library, Pittsburgh, Kansas

Ringling Brothers Circus, Sarasota, Florida (Archives)

San Francisco Art Institute (Curatorial Archives)

San Luis Obispo Historical Society, San Luis Obispo, California

Seattle Museum of Art (John H. Hauberg Collection of Northwest Coast Native American Art)

Smithsonian Institution, Washington, D.C., Archives of American Art (Whitney B. Halstead Papers)

Smithsonian Institution, Washington, D.C., National Museum of American Art (Curatorial Archives

and Herbert Waide Hemphill Collection)

Springfield-Greene County Library, Springfield, Missouri (The Shepard Room)

University of California at Davis (Richard L. Nelson Gallery and the Fine Arts Collection)

Utah State Archives, Salt Lake City

Whitney Museum of American Art, New York (Curatorial Archives)

INTERVIEW BY AUTHOR

Jane Allen, cofounder and publisher, *New Art Examiner*, 20 August 1994

Thomas Brand, artist and owner of Galaxy Press, 20 June 1995

Lora Rice Brewer, artist's second cousin, 10 May 1994

Sara Brewer, daughter of artist's second cousin, 10 September 1995

Roger Brown, artist and collector, 13 August 1994

Cynthia Carlson, artist and collector, 19 October 1995

Philip Dedrick, retired chairman of art department, Rockford College, 6 June 1995

Evonne Durham, artist's friend, 12 November 1995

Camilla Eichelberger, artist's neighbor, 4 May 1994

Derek Guthrie, cofounder and publisher, *New Art Examiner*, 20 August 1994

John Hopgood, former instructor, Chicago State College, 10 June 1995

Philip Linhares, former curator, San Francisco Art Institute, 25 June 1994

Walter Maqueral, retired steelworker, 3 August 1994

Adeliza McHugh, retired owner, Candy Store Gallery, 17 July 1994

Gladys Nilsson and Jim Nutt, artists and collectors, 5 April 1994

Reverend Harvey Pranian, 7 May 1995

Marsha Tucker, former curator, Whitney Museum of American Art, 20 October 1995

Roger Vail, photographer and collector, 9 July 1999

Ida Mae Yolkum, widow of artist's son William, 9 December 1995

Marian Yolkum, widow of artist's son John, 30 August 1993

Peter Yolkum, artist's son, 15 October 1995

Ray Yoshida, artist and collector, 6 May 1994

BOOKS AND DISSERTATIONS

Adrian, Dennis. *Sight Out of Mind: Essays and Criticism on Art.* Ann Arbor, Michigan: UMI Research Press, 1985.

Among the Rockies. Denver: H. H. Tammen Co., 1910.

Arthur, John. *Spirit of Place: Contemporary Landscape Painting and the American Tradition.* Boston: Bullfinch Press, 1989.

Athearn, Robert. *Rebel of the Rockies: A History of the Denver and Rio Grande Railroad.* New Haven: Yale University Press, 1962.

Atherton, Lewis. *Main Street on the Middle Border.* Bloomington: Indiana University Press, 1954.

Barbeau, Authur E., and Florette Henri. *The Unknown Soldiers: Black American Troops in World War I.* Philadelphia: Temple University Press, 1974.

Barnum, Darold T. *The Negro in the Bituminous Coal Mining Industry* (Report No. 14 of the Racial Policies of American Industries). Philadelphia: University of Pennsylvania Press, 1970.

Benton, Thomas Hart. *An Artist in America.* Columbia: University of Missouri Press, 1968.

Bihalji-Merin, Oto. *Modern Primitives: Masters of Naive Painting.* New York: Harry N. Abrams, Inc., 1959.

Bihalji-Merin, Oto, and Nebjosa Bato Tomasevic. *World Encyclopedia of Naive Art.*

Secaucus, New Jersey: Chartwell Books, 1984.

Boll, Heinrich. *The Clown.* New York: McGraw-Hill, 1971.

Bontemps, Arna. *Story of the Negro.* New York: Alfred A. Knopf, 1958.

Botkin, B. A., and Alvin F. Harlow. *A Treasury of Railroad Folklore.* New York: Crain Books, 1953.

Brewer, Mason. *American Negro Folklore*. Chicago: Quadrangle Books, 1968.

Bronner, Simon J. *American Folk Art: A Guide to Sources*. New York: Garland Publishing, Inc., 1984.

Brown, Joseph Epes. *The Spiritual Legacy of the North American Indian*. New York: The Crossroad Publishing Co., 1982.

Brown, Vinson. *Voices of Earth and Sky: The Vision Life of the Native Americans and Their Culture Heroes*. Harrisburg, Pennsylvania: Stackpole Books, 1974.

Bryant, Keith L., Jr. *History of the Atchison, Topeka, and Santa Fe Railway*. New York: The MacMillan Co., 1974.

Bunzel, Ruth L. *The Pueblo Potter: A Study of Creative Imagination in Primitive Art*. New York: Dover Publications, Inc., 1928.

Burdick, Jeff R. *The Handbook of Detroit Publishing Company Postcards: A Guide for Collectors*. Syracuse, New York: J. R. Burdick, 1955.

Burland, Cottie. *North American Indian Mythology*. London and New York: The Hamlyn Publishing Group Ltd., 1965.

Butcher, Margaret J. *The Negro in American Culture*. New York: Alfred A. Knopf, 1957.

Campbell, Joseph. *The Hero with a Thousand Faces*. Princeton: Princeton University Press in association with Bollingen Foundation, 1973.

Campbell, Joseph, with Bill Moyers. *The Power of Myth*. New York: Doubleday and Co., 1988.

Cardinal, Roger. *Outsider Art*. New York and Washington, D.C.: Praeger Publishers, 1972.

Chindahl, George. *History of the Circus in America*. Caldwell, Idaho: Caxton Printers, 1959.

Coffin, Tristram P., ed. *Our Living Traditions: An Introduction to American Folklore*. New York: Basic Books, 1968.

Collias, Joe G., and Raymond B. George, Jr. *Katy Power: Locomotives and Trains of the Missouri-Kansas-Texas Railroad, 1912–1985*. Crestwood, Missouri: MM Books, 1986.

Conron, John. *The American Landscape*. New York: Oxford University Press, 1974.

Conway, Thor. *Painted Dreams: Native American Rock Art*. Minocqua, Wisconsin: North Word Press, 1993.

Coup, William Camron. *Sawdust and Spangles: Stories and Secrets of the Circus*. Chicago: H. S. Stone and Co., 1901.

Culhane, John. *The American Circus: An Illustrated History*. New York: Henry Holt and Co., 1990.

Danly, Susan, and Leo Marx. *The Railroad in American Art: Representatives of Technological Change*. Cambridge, Massachusetts: MIT Press, 1988.

Davidson, Abraham A. *The Eccentrics and Other American Visionary Painters*. New York: E. P. Dutton, 1978.

Davis, Francis. *The History of the Blues*. New York: Hyperion, 1995.

Debo, Angie. *A History of the Indians in the United States*. Norman: University of Oklahoma Press, 1970.

Denver and Rio Grande Railway. *Health, Wealth, and Pleasure in Colorado and New Mexico*. Chicago: Bedford, Clarke and Co., 1881.

Dewey, John. *Art as Experience*. New York: Minton, Blach and Co., 1934.

Donodore, Dorothy Anne. *The Prairie and the Making of Middle America: Four Centuries of Description*. Cedar Rapids, Iowa: Torch Press, 1926.

Douglas, Frederic H., and Rene D'Haroncourt. *Indian Art of the United States*. New York: Museum of Modern Art, 1941.

Durant, John, and Alice Durant. *Pictorial History of the American Circus*. New York: A. S. Barnes, 1957.

Durham, Philip, and Everett L. Jones. *The Negro Cowboys*. New York: Dodd, Mead and Co., 1965.

Feder, Norman. *American Indian Art*. New York: Harry N. Abrams, Inc., 1965.

Ferris, William, et al. *Black Art: Ancestral Legacy*. New York: Harry N. Abrams, Inc., 1990.

Fifer, J. Valerie. *American Progress: The Growth of the*

Transport, Tourist and Information Industries in the Nineteenth-Century West, Seen Through the Life and Times of George A. Crofutt, Pioneer and Publicist of the Transcontinental Age. Chester, Connecticut: Globe Pequot Press, 1988.

Finch, Christopher. *American Watercolors.* New York: Abbeville Press, 1986.

Fishback, Price V. *Employment Conditions of Blacks in the Coal Industry, 1900–1930.* Ann Arbor, Michigan: University Microfilms International, 1983.

———. *Soft Coal, Hard Choices: The Economic Welfare of the Bituminous Coal Miners, 1890–1930.* New York: Oxford University Press, 1992.

Foster, Kenneth E. *Navajo Sandpaintings.* Window Rock, Arizona: Navajo Tribal Museum, 1964.

Fox, Charles Philip. *Circus Trains.* Milwaukee: Kalmbach Publishing, 1947.

———. *A Ticket to the Circus.* Seattle: Superior Publishing, 1960.

———, ed. *American Circus Posters.* New York: Dover Publications, Inc., 1978.

Fox, Charles Philip, and Tom Parkinson. *Billers, Banners and Bombast: The Story of Circus Advertising.* Boulder, Colorado: Pruett Publishing Co., 1985.

———. *The Circus in America.* Waukesha, Wisconsin: Country Beautiful, 1969.

———. *The Circus Moves by Rail.* Boulder, Colorado: Pruett Publishing Co., 1978.

Frazier, E. Franklin. *The Negro Family in the United States.* Chicago: University of Chicago Press, 1939.

Glanz, Dawn. *How the Great West Was Drawn: American Art and the Settling of the Frontier.* Ann Arbor: University of Michigan Press, 1982.

Gollmar, R. H. *My Father Owned a Circus.* Caldwell, Idaho: Caxton Printers, 1965.

Grant, Campbell. *The Rock Paintings of the Chumash.* Santa Barbara, California: Santa Barbara Museum of Natural History, 1993.

Grazulis, Thomas P. *Significant Tornadoes, 1680–1991.* St. Johnsbury, Vermont: Environmental Films, 1993.

Grissom, Mary Alice. *The Negro Sings a New Heaven.* Chapel Hill: University of North Carolina Press, 1930.

Gruber, Frank. *Zane Grey: A Biography.* New York and Cleveland: The World Publishing Co., 1970.

Haile, Berard. *Head and Face Masks in Navajo Ceremonialism.* St. Michael's, Arizona: The St. Michael's Press, 1947.

Hales, Peter B. *William Henry Jackson and the Transformation of the American Landscape.* Philadelphia: Temple University Press, 1988.

Hall, Michael D., and Eugene W. Metcalf, Jr., eds. *The Artist Outsider: Creativity and the Boundaries of Culture.* Washington, D.C. and London: Smithsonian Institution Press, 1994.

Halpin, Majorie M. *Totem Poles: An Illustrated Guide.* Vancouver: University of British Columbia Press in association with the University of British Columbia Museum of Anthropology, 1983.

Hammond, Leslie King. *We Wear the Mask: The Ethos of Spirituality in African American Art, 1750 to the Present.* New York: Abbeville Press, 1993.

Hardy, A. C. *Seaways and Sea Trade: Being a Maritime Geography of Routes, Ports, Rivers, Canals, and Cargoes.* New York: D. Van Nostrand Co., 1928.

Hawthorn, Audrey. *Art of the Kwakiutl Indians and Other Northwest Coast Tribes.* Seattle and London: University of Washington Press in association with University of British Columbia, 1967.

Hayden, Ferdinand Vandiveer. *Sun Pictures of Rocky Mountain Scenery, with a Description of the Geographical and Geological Features, and Some Account of the Resources of the Great West: Containing Thirty Photographic Views Along the Line of the Pacific Railroad, from Omaha to Sacramento.* New York: J. Bien, 1870.

———. *The Yellowstone National Park and the*

Mountain Regions of Portions of Idaho, Nevada, Colorado and Utah. Boston: L. Prang and Co., 1876.

———. *The Great West: Its Attractions and Resources.* Philadelphia: Franklin Publishing Co., 1880.

Hemphill, Herbert Waide, Jr., and Julia Weissman. *Twentieth-Century American Folk Art and Artists.* New York: E. P. Dutton, 1984.

Herskovits, Melville J. *The Myth of the Negro Past.* Reprint. Boston: Beacon Press, 1958.

Hodes, Scott. *Legal Rights in the Art and Collectors' World.* Dobbs Ferry, New York: Oceana Publications, 1986.

Hoh, LaVahn G., and William Rough. *Step Right Up! The Adventure of Circus in America.* White Hall, Virginia: Betterway Publications, 1990.

Holbrook, Stewart H. *The Story of American Railroads.* New York: American Legacy Press, 1957.

Holm, Bill. *Northwest Coast Indian Art: An Analysis of Form.* Seattle and London: University of Washington Press, 1965.

———. *The Box of Daylight: Northwest Coast Indian Art.* Seattle and London: University of Washington Press in association with Seattle Art Museum, 1983.

Howe, Edgar Watson. *Plain People.* New York: Dodd, Mead and Co., 1929.

Howells, William Dean. *A Boy's Town, Described for "Harper's Young People."* Reprint. West Port, Connecticut: Greenwood Press, 1970.

Hughes, Langston, and Arna Bontemps, eds. *The Book of Negro Folklore.* New York: Dodd, Mead and Co., 1958.

Hughes, Langston, Arna Bontemps, and Milton Meltzer. *A Pictorial History of the Negro in America.* New York: Crown Publishers, Inc. 1963.

Huth, Hans. *Nature and the American: Three Centuries of Changing Attitudes.* Berkeley and Los Angeles: University of California Press, 1957.

Hyde, Anne Farrar. *An American Vision: Far Western Landscape and National Culture, 1820–1920.* New York: New York University Press, 1990.

Igoe, Lynn Moody, with James Igoe. *Two Hundred Fifty Years of Afro-American Art: An Annotated Bibliography.* New York and London: R. R. Bower Co., 1981.

Jackson, Carlton. *Zane Grey.* New York: Twayne Publishers, 1973.

Janis, Sidney. *They Taught Themselves.* Port Washington, New York: Kennikat Press, 1942.

Joe, Eugene Baatsoslanii, and Mark Bahti. *Navajo Sandpainting Art.* Tucson, Arizona: Treasure Chest Publications, Inc., 1978.

Johnson, Guy B. *John Henry: Tracking Down a Negro Legend.* Chapel Hill: University of North Carolina Press, 1929.

Johnson, Jay, and William Ketchem, Jr. *American Folk Art of the Twentieth Century.* With a foreword by Dr. Robert Bishop. New York: Rizzoli Publications, 1983.

Johnson, Wait C., and Elwood S. Brown, eds. *Official Athletic Almanac of the American Expeditionary Forces Championships and Inter-Allied Games, 1919.* New York: American Sports Publishing Co., 1919.

Jones, William C., and Elizabeth B. Jones, comps. *William Henry Jackson's Colorado.* Boulder, Colorado: Pruett Publishing Co., 1975.

Josephy, Alvin M., Jr. *The Indian Heritage of America.* New York: Alfred A. Knopf, 1968.

Jussim, Estelle, and Elizabeth Lindquist-Cock. *Landscape as Photograph.* New Haven and London: Yale University Press, 1985.

Katz, William Loren. *Black Indians: A Hidden Heritage.* New York: Atheneum, 1986.

———. *The Black West.* Garden City, New York: Doubleday and Co., 1971.

Kimball, Arthur G. *Ace of Hearts: The Westerns of Zane Grey.* Fort Worth: Texas Christian University Press, 1993.

Kinsay, Joni Louise. *Thomas Moran and the Surveying of the American West.* Washington, D.C. and

London: Smithsonian Institution Press, 1992.

Levine, Lawrence W. *Black Culture and Black Consciousness: Afro-American Thought from Slavery to Freedom.* New York: Oxford University Press, 1977.

Lévi-Strauss, Claude. *The Way of the Masks.* Translated by Sylvia Modelski. Seattle and London: University of Washington Press, 1975.

Licht, Walter. *Working for the Railroad: The Organization of Work in the Nineteenth Century.* Princeton: Princeton University Press, 1983.

Lindquist-Cock, Elizabeth. *The Influence of American Photography on American Landscape Painting, 1839–1880.* New York: Garland Publishing, Inc., 1977.

Littlefield, Daniel F., Jr. *The Cherokee Freedmen from Emancipation to Citizenship.* Westport, Connecticut: Greenwood Press, 1978.

Locke, Raymond F. *Sweet Salt: Navajo Folktales and Mythology.* Santa Monica, California: Roundtable Publishing Co., 1990.

Lomax, John A., and Alan Lomax, eds. *Folk Songs U.S.A.* New York: Duell, Sloan and Pearce, 1947.

———. *Our Singing Country: A Second Volume of American Ballads and Folk Songs.* New York: The MacMillan Co., 1941.

Luckert, Karl W., ed. *Navajo Coyote Tales: The Curly to Aheedliini Version.* Lincoln and London: University of Nebraska Press, 1984.

MacFarlan, Allan A., ed. *American Indian Legends.* New York: The Heritage Press, 1968.

Maiken, Peter T. *Night Trains: The Pullman System in the Golden Years of American Rail Travel.* Chicago: Lakme Press, 1989.

Malin, Edward. *A World of Faces: Masks of the Northwest Coast Indians.* Portland, Oregon: Timber Press, 1978.

———. *Totem Poles of the Pacific Northwest Coast.* Portland, Oregon: Timber Press, 1986.

Mangan, Terry William. *Colorado on Glass: Colorado's First Half Century as Seen by the Camera.* Denver: Sundance, 1975.

Maresca, Frank, and Roger Ricco. *American Self-Taught: Paintings and Drawings by Outsider Artists.* New York: Alfred A. Knopf, 1993.

Marriott, Alice, and Carol K. Rachlin. *American Indian Mythology.* New York and Scarborough, Ontario: New American Library, 1968.

Marshall, James. *Santa Fe: The Railroad that Built an Empire.* New York: Random House, 1945.

Marx, Leo. *The Machine in the Garden.* New York: Oxford University Press, 1964.

Masterson, John A. *The Katy Railroad and the Last Frontier.* Norman: University of Oklahoma Press, 1952.

McLuhan, T. C. *Dream Tracks: The Railroad and the American Indian, 1890–1930.* New York: Harry N. Abrams, Inc., 1985.

McShine, Kynaston, ed. *The Natural Paradise: Painting in America, 1800–1950.* New York: Museum of Modern Art, 1976.

Meinig, D. W., ed. *The Interpretation of Ordinary Landscapes.* New York: Oxford University Press, 1979.

Menzel, Donald H., and Lyle G. Boyd. *The World of Flying Saucers: A Scientific Evaluation of a Major Myth of the Space Age.* Garden City, New York: Doubleday and Co., 1963.

Morgan, Hal, and Andreas Brown. *Prairie Fires and Paper Moons: The American Photographic Postcard, 1900–1920.* Boston: David R. Godine, 1981.

Murphy, Thomas D. *Seven Wonderlands of the American West.* Boston: L. C. Page and Co., 1925.

Naef, Weston, in collaboration with James N. Wood. *Era of Exploration: The Rise of Landscape Photography in the American West, 1860–1885.* Boston: New York Graphic Society, 1975.

Nash, Roderick. *Wilderness and the American Mind.* New Haven and London: Yale University Press, 1967.

Naylor, Maria, ed. *Authentic Indian Designs: 2500 Illustrations from Reports of the Bureau of American Ethnology.* New York: Dover Publications, Inc., 1975.

North, Henry Ringling, and Alden Hatch. *The Circus Kings.* Garden City, New York: Doubleday

and Co., 1960.

Ostroff, Eugene. *Photographing the Frontier.* Washington, D.C.: Smithsonian Institution Press, 1981.

Owens, J. Garfield. *All God's Chillun: Meditations on Negro Spirituals.* Nashville and New York: Abington Press, 1971.

Parezo, Nancy J. *Navajo Sandpainting from Religious Act to Commercial Art.* Tucson: University of Arizona Press, 1983.

Paskman, Dailey. *"Gentlemen, Be Seated!" A Parade of the American Minstrels.* New York: C. N. Potter, distributed by Crown Books, 1976.

Peet, Steven D. *The Mound Builders: Their Works and Their Relics.* Vol. 1. Chicago: Office of the American Antiquarian, 1892.

Penny, David W. *Art of the American Indian Frontier: The Chandler-Pohrt Collection.* Seattle and London: Detroit Institute of Arts in association with University of Washington Press, 1995.

Perdue, Theda. *Slavery and the Evolution of Cherokee Society, 1549–1866.* Knoxville: University of Tennessee Press, 1979.

Plowden, Gene. *Those Amazing Ringlings and Their Circus.* Caldwell, Idaho: The Caxton Printers, 1968.

Pomeroy, Earl Spencer. *In Search of the Golden West: The Tourist in Western America.* New York: Alfred A. Knopf, 1957.

Quimby, Ian M. G., and Scott T. Swank, eds. *Perspectives on American Folk Art.* New York: W. W. Norton and Co., 1980.

Reichard, Gladys A. *Navajo Medicine Man Sandpaintings.* New York: Dover Publications, Inc., 1977.

Rennert, Jack. *One Hundred Years of Circus Posters.* New York: Darien House, 1974.

Rhodes, Louis C. *The Inland Ground: An Evocation of the American Middle West.* New York: Atheneum, 1970.

Rhymes of the Rockies; Or What Poets Have Found to Say of the Beautiful Scenery on the Denver and Rio Grande Railroad. Pamphlet. Chicago: Poole Bros. Printers, 1887.

Rice, Edward LeRoy. *Monarchs of Minstrelsy from "Daddy" Rice to Date.* New York: Knesey, 1911.

Riegel, Robert Edgar. *The Story of the Western Railroads From 1852 Through the Reign of the Giants.* New York: The Macmillan Co., 1926.

Roediger, Virginia More. *Ceremonial Costumes of the Pueblo Indians.* Berkeley and Los Angeles: University of California Press, 1991.

Roberts, John W. *From Trickster to Badman: The Black Folk Hero in Slavery and Freedom.* Philadelphia: University of Pennsylvania Press, 1989.

Robeson, Dave. *Al G. Barnes, Master Showman.* Caldwell, Idaho: Caxton Printers, 1935.

Rosa, Joseph G. *Buffalo Bill and His Wild West: A Pictorial Biography.* Lawrence: University of Kansas Press, 1989.

Rosenak, Chuck, and Jan Rosenak. *Museum of American Folk Art Encyclopedia of Twentieth Century American Folk Art and Artists.* New York: Abbeville Press, 1990.

Rowland, Mabel, ed. *Bert Williams, Son of Laughter.* New York: Negro Universities Press, 1969.

Runte, Alfred. *Trains of Discovery: Western Railroads and the National Parks.* Niwot, Colorado: Roberts Rinehart Publishers, 1990.

Russell, Andrew Joseph. *The Great West Illustrated.* Omaha, Nebraska: Union Pacific Railroad, 1869.

Russell, Don. *The Lives and Legends of Buffalo Bill.* Norman: University of Oklahoma Press, 1960.

———. *The Wild West: A History of Wild West Shows.* Fort Worth, Texas: Amon Carter Museum, 1970.

Schaafsma, Polly. *The Rock Art of Utah: A Study from the Donald Scott Collection.* Salt Lake City: University of Utah Press, 1971.

Sell, H. B., and Victor Weybright. *Buffalo Bill and the Wild West.* New York: Oxford University Press, 1935.

Sellen, Betty-Carol, with Cynthia J. Johnson. *20th Century American Folk, Self-Taught and*

Outsider Art. New York: Neal-Shuman Publishers, 1993.

Shearer, Frederick E., ed. *The Pacific Tourist.* New York: Adams and Bishop Publishers, 1884.

Smith, Eric Ledell. *Bert Williams: A Biography of the Pioneer Black Comedian.* Jefferson, North Carolina: McFarland, 1992.

Smith, Henry Nash. *Virgin Land: The American West as Symbol and Myth.* Cambridge, Massachusetts: Harvard University Press, 1950.

Speaight, George. *A History of the Circus.* London: The Tantivy Press, 1980.

Standing Rainbows: The Railroad Promotion Art of the West and Its Native People. Wichita: Kansas State Historical Society, 1981.

Stewart, Hilary. *Looking at Indian Art of the Northwest Coast.* Seattle and London: University of Washington Press, 1979.

———. *Totem Poles.* Seattle: University of Washington Press, 1990.

Stewart-Baxter, Derrick. *Ma Rainey and the Classic Blues Singers.* New York: Stein and Day, 1970.

Stone, Eric. *Medicine Among the American Indians.* New York: AMS Press, 1978.

Suzuki, David, and Peter Knudson. *Wisdom of the Elders: Honoring Sacred Native Visions of Nature.* New York: Bantam Books, 1992.

Sweeney, William A. *History of the American Negro in the Great World War.* Chicago: Cuneo-Henneberry Co., 1919.

Swortzell, Lowell. *Here Come the Clowns.* New York: Viking Press, 1978.

Taft, Robert. *Artists and Illustrators of the Old West, 1850–1900.* New York: Charles Scribner's Sons, 1953.

———. *Photography and the American Scene: A Social History, 1839–1889.* Reprint, Minneola, New York: Dover Publications, 1964.

Taylor, Gordon. *Born to Be.* New York: Covici-Friede Publishers, 1929.

Thisted, Moses. *Pershing's Pioneer Infantry.* San Jacinto, California: Alphabet Printers, 1982.

Thomas, Cyrus. *Report of the Mound Explorations of the Bureau of Ethnology.* 1894. Reprint, Washington, D.C.: Smithsonian Institution Press, 1985.

Thompson, W. C. *On the Road With A Circus.* New York: Goldmann, 1903.

Toll, Robert C. *Blacking Up: The Minstrel Show in Nineteenth-Century America.* New York: Oxford University Press, 1974.

Towsen, John H. *Clowns.* New York: Hawthorn Books, 1976.

Turner, Robert E. *Memories of a Retired Pullman Porter.* New York: Exposition Press, 1954.

Tyler, Hamilton A. *Pueblo Animals and Myths.* Norman: University of Oklahoma Press, 1975.

———. *Pueblo Birds and Myths.* Flagstaff, Arizona: Northland Publishing, 1991.

Union Pacific Sketchbook: A Brief Description of Prominent Places of Interest Along the Line of the Union Pacific. Omaha, Nebraska: Union Pacific Railroad Passenger Department, 1887.

Villasenor, David V. *Tapestries in Sand: The Spirit of Indian Sandpainting.* Healdsburg, California: Naturegraph Co., 1963.

Vlach, John Michael, and Simon J. Bronner, eds. *Folk Art and Art Worlds: Essays Drawn from the Washington Meeting on Folk Art Organized by the American Folk Life Center at the Library of Congress.* Ann Arbor, Michigan: UMI Research Press, 1986.

Wade, Edwin L., and Carol Haralson, eds. *The Arts of the North American Indian: Native Traditions in Evolution.* New York: Hudson Hills Press in association with Philbrook Art Center, Tulsa, Oklahoma, 1986.

Wardell, Allen. *Objects of Bright Pride: Northwest Coast Indian Art from the American Museum of Natural History.* Seattle and London: University of Washington Press and the American Federation of Arts, 1978.

Waters, L. L. *Steel Rails to Santa Fe.* Lawrence: University of Kansas Press, 1950.

Weber, Bruce, and William H. Gerdts. *In Nature's Way: American Landscape Painting of the Late*

Nineteenth Century. West Palm Beach, Florida: Norton Gallery of Art, 1987.

Witherspoon, Gary. *Language and Art in the Navajo Universe.* Ann Arbor: University of Michigan Press, 1977.

Woirol, Gregory R. *In the Floating Army: F. C. Mills on Itinerant Life in California, 1914.* Urbana: University of Indiana Press, 1992.

Wyatt, Gary. *Spirit Faces: Contemporary Native American Masks from the Northwest.* San Francisco: Chronicle Books, 1995.

Wyman, Leland C. *The Mountainway of the Navajo.* Tucson: University of Arizona Press, 1975.

———. *The Windways of the Navajo.* Colorado Springs, Colorado: Taylor Museum of the Colorado Springs Fine Arts Center, 1962.

Zion National Park, Bryce Canyon, Cedar Breaks, Kaibab Forest and North Rim of Grand Canyon. Omaha, Nebraska: Union Pacific System, 1925.

PERIODICALS WITH YOAKUM REFERENCES

Adrian, Dennis. "The strange and wondrous world of Joseph Yoakum." *Panorama-Chicago Daily News* (14 October 1972): 11.

Allen, Jane, and Derek Guthrie. "Portrait of the Artist as a Luckless Old Man: The Hard Times and Artistic Genius of Joseph E. Yoakum." *Chicago Tribune Magazine* (10 December 1972): 32–37.

Allison, Diane. "Joseph Yoakum at the Beginning: The Show at 'The Whole.'" *Raw Vision* 16 (November 1996): 24–31.

Amenoff, Gregory. "Forum: Joseph Yoakum's 'mt. Kanchen in Himilaya mtn Range near Shara China East Asia.'" *Drawing* (September–October 1990): 58–59.

Anderson, Don J. "My drawings are a spiritual unfoldment." *Chicago's American* (26 May 1968): 2.

Atkins, Jacqueline M. "Joseph E. Yoakum, Visionary Traveler." *The Clarion* 15 (winter 1990): 50–57.

Auer, James. "Yoakum gives us the world transformed." *Milwaukee Journal* (26 March 1995): 1D.

Barrett, Didi. "A Time to Reap: Late-Blooming Folk Artists." *The Clarion* 10 (fall 1985): 39–47.

———. "Folk Art of the Twentieth Century." *The Clarion* 12 (spring-summer 1987): 32–35.

"Black Folk Art in America, 1930–1980." *Folk Art Finder* 2, no. 6 (January–February, 1982): 5–8.

Bonesteel, Michael. "Joseph E. Yoakum at Hammer & Hammer Folk Art Gallery." *Art in America* 70 (November 1985): 125–26.

———. "Chicago Originals." *Art in America* 73 (February 1985): 128–35.

———. "The Drawings of Joseph Yoakum," *Intuit* 4, no. 1 (summer 1995): 1, 16–18.

Chapin, Louis. "A 'Naive' Artist Views the World." *Christian Science Monitor* (11 December 1972): 8.

"Chicago Artists." *Art Scene* (April 1969): 12.

"Drawings on Exhibition." *Drawing* (May/June 1995): 14.

Duval, Quinton. "Joseph Yoakum at the Candy Store." *Inside Art* 2, no. 3 (June 1978): 3.

"Force of a Dream: The Drawings of Joseph E. Yoakum." *News and Events: A Magazine for Members of the Art Institute of Chicago* (May–June 1995): cover, 5.

Gaver, Eleanor E. "Inside the Outsiders." *Art and Antiques* 7 (summer 1990): 87.

Glauber, Robert. "True Primitive Exhibits His Work." *Skyline* (19 February 1969): 32.

Haydon, Harold. "Eighty-Year-Old Is New Kind of Primitive." *Chicago Sun-Times* (7 April 1968): 43.

———. "The Stunning Toll of Fire and Water." *Chicago Sun-Times Weekender* (12 February 1971): 39–40.

Hirsch, Faye. "The Fifth World." *New Observations* 110 (spring 1996): 24–25.

Holg, Garrett. "'Dream' Gains Clarity. Joseph Yoakum Exhibit Explores 'Hidden' Images." *Chicago Sun-Times* (19 February 1995): B5.

Johnson, Patricia C. "Art Created in Isolation; Out-

siders Set Apart by an Inner Spirit That Moves Them." *Houston Chronicle* (6 December 1990).

Kind, Phyllis. "Some Thoughts About Contemporary Folk Art." *American Antiques* (June 1976): 28–32, 44.

Mark, Norman. "My drawings are a spiritual unfoldment." *Chicago Daily News-Panorama* (11 November 1967): 2.

Perreault, John. "Art & . . ." *The Village Voice* (9 November 1972): 36.

Price, Vincent. "Way Out Art Found Way Out of the Way." *Barron's* (16 March 1988).

Pridmore, Jay. "Outsider artist, and his art, still a mystery." *Chicago Tribune* (3 February 1995): sec. 7, pp. 4, 20.

Raynor, Vivien. "Art Show in Brooklyn Mines Black Folk Vein." *New York Times* (2 July 1982): 29.

———. "Exercising the Mind as Well as the Eye." *New York Times* (13 August 1989): 16.

"Remembering China with the circus at age thirteen." *Chicago Magazine* (July–August 1972): 51.

Schwabsky, Barry. "Hirschl & Adler Modern Gallery New Exhibit." *Arts Magazine* 60 (October 1985): 140–41.

Tully, Judd. "Black Folk Art in America." *Flash Art*, no. 114 (November 1983): 32–35.

Wilson, Judith. "Black Folk Art: A Vision Endures." *Museum* (March–April 1982): 38–41.

"Yoakum, Joseph E." *The Clarion* 14 (winter 1989): 15.

"Yoakum, Joseph E. at Hammer & Hammer American Folk Art Gallery." *Art in America* (November 1982): 125.

"Yoakum, Joseph Elmer." *Folk Art Finder* 2, no. 6 (January/February 1982): 7.

GENERAL PERIODICALS

Abrahams, Roger D. "The Changing Concept of the Negro Hero." *The Golden Log: Publications of the Texas Folklore Society* 31 (1962): 119–34.

———. "Some Varieties of Heroes in America." *Journal of the Folklore Institute* 3 (1967): 341–62.

Anderson, John Q. "Another Texas Variant of 'Cole Younger,' Ballad of a Badman." *Western Folklore* 31, no. 2 (April 1972): 103–15.

Brown, Sterling A. "The Blues as Folk Poetry." *Folk-Say* 2 (1930): 324–39.

Chalmers, F. Graeme. "The Study of Art in a Cultural Context." *Journal of Aesthetics and Art Criticism* 32 (winter 1973): 249–55.

Conwill, Kinshasha Holman. "In Search of an 'Authentic' Vision." *American Art* 5 (fall 1991): 2–9.

DeCarlo, Tessa, and Susan Subtle Dintenfass. "'Outsider' Art Is Inside Now." *Wall Street Journal* (8 May 1992): 1.

Du Bois, W. E. B. "An Essay Toward a History of the Black Man in the Great War." *Crisis* (June 1919).

Hallowell, A. Irving. "American Indians, White and Black: The Phenomenon of Transculturalization." *Current Anthropology: A World Journal of the Science of Man* 4 (December 1963): 519–31.

Hill, Mozell C. "The All-Negro Communities of Oklahoma: The Natural History of a Social Movement." *Journal of Negro History* 31 (July 1946): 254–68.

Kuspit, Donald B. "American Folk Art: The Practical Vision." *Art in America* 68 (September 1980): 94–98.

McPhee, S. "Life Into Art: Phenomenon of the Folk Artist." *Art News* 85 (May 1986): 20.

Metcalf, Eugene. "Black Art, Folk Art and Social Control." *Wintherthur Portfolio* 18 (winter 1983): 271–89.

Miele, Frank J., moderator. "Folk, or Art? A Symposium." *The Magazine Antiques* 135 (January 1989): 272–82.

Mitchells, K. "The Work of Art in Its Social Setting and Its Aesthetic Isolation." *Journal of Aesthetics and Art Criticism* 25 (summer 1967): 369–74.

Odum, Howard W. "Folk-Song and Folk-Poetry as Found in the Secular Songs of Southern Negroes." *Journal of American Folklore* (1911).

Ringling, John. "We Divided the Job—but Stuck To-

gether." *The American Magazine* (September 1919): 182–85.

Williams, Bert. "The Comic Side of Trouble." *The American Magazine* 85 (January 1918): 33–35, 58–61.

CATALOGS WITH YOAKUM REFERENCES

A Density of Passions. Trenton: New Jersey State Museum, 1989.

Abell, Jeff, et al. *Art in Chicago 1945–1995.* Chicago: Thames and Hudson and Museum of Contemporary Art, 1996.

Adrian, Dennis. *Masterpieces of Recent Chicago Art.* Chicago: Chicago Public Library Cultural Center, 1977.

America Expresses Herself: 18th, 19th and 20th Century Folk Art from the Herbert W. Hemphill Collection. Indianapolis, Indiana: Children's Museum, 1976.

American Folk Art from the Collection of Herbert Waide Hemphill, Jr. Oceanville, New Jersey: Noyes Museum, 1988.

American Folk Art from the Ozarks to the Rockies. Tulsa, Oklahoma: Philbrook Art Center, 1975.

Art Outsider et Folk Art des Collections de Chicago. Paris: Halle Sainte Pierre, 1999.

Artists of the Black Experience. Chicago: University of Illinois at Chicago Circle, 1984.

Barrett, Didi. *Muffled Voices: Folk Artists in Contemporary America.* New York: Museum of American Folk Art, 1986.

Baum, Don. *Visions: Expressions Beyond the Mainstream from Chicago Collections.* Chicago: Fine Arts Club of Chicago, 1990.

Bowman, Russell, and Roger Cardinal. *Driven to Create: The Anthony Petullo Collection of Self-Taught and Outsider Art.* Milwaukee, Wisconsin: Milwaukee Museum of Art, 1993.

Brittan, Crystal A. *African American Art—The Long Struggle.* New York and London: Todtric Production, Ltd., 1996.

Burkhart, Kenneth C., curator. *Outsider Art: An Exploration of Chicago Collections.* Chicago: City of Chicago Department of Cultural Affairs and Intuit, 1997.

Carter, Curtis L., Roger Manley, and Didi Barrett. *Contemporary American Folk Art: The Balsley Collection.* Newark, New Jersey: Newark Museum of Art, 1992.

Coker, Glybert, and Corrine Jennings. *The Harmon and Harriet Kelley Collection of African American Art.* San Antonio: University of Texas Press for the San Antonio Museum of Art, 1994.

Contemporary American Folk and Naïve Art—The Personal Visions of Self-Taught Artists. Chicago: School of the Art Institute of Chicago Gallery, 1978.

Drawn from Artists' Collections. New York, New York: The Drawing Center, 1999.

Dream-Seekers, Story-Tellers: An African-American Presence. Tokyo, Japan: Yoshida Kinbundo Co., 1992.

Flanagan, Michael E. *Personal Intensity: Artists in Spite of the Mainstream.* Milwaukee: University of Wisconsin-Milwaukee Art Museum, University of Wisconsin-Milwaukee, 1991.

Gordon, Ellin, Barbara R. Luck, and Tom Patterson. *Flying Free—Twentieth Century Self-Taught Art from the Collection of Ellin and Baron Gordon.* Williamsburg, Virginia: Colonial Williamsburg Foundation in association with the University Press of Mississippi, 1977.

Halstead, Whitney. *Joseph E. Yoakum: Drawings.* Introduction by Marsha Tucker. New York: Whitney Museum of American Art, 1972.

Hartigan, Lynda. *Made with Passion: The Hemphill Folk Art Collection in the National Museum of Art.* Washington, D.C.: Smithsonian Institution Press, 1990.

Hobbs, J. Kline, Jr. *Introduction to Black Art: The Known and the New.* Battle Creek, Michigan: Battle Creek Civic Art Center, 1977.

Hodorowski, Ken. *Joseph Yoakum: His Influence on Contemporary Art and Artists.* Chicago: Carl

Hammer Gallery, 1984.

Hoffberger, Rebecca, et al. *The Tree of Life.* Baltimore: Baltimore Museum of Art, 1995.

In Another World: Outsider Art from Europe and America. London: South Bank Centre, 1987.

Jacobs, Joseph. *A World of Their Own: Twentieth Century American Folk Art.* Newark, New Jersey: Newark Museum of Art, 1995.

Kahn, Michael Douglas. *Roger Brown.* With contributions by Dennis Adrian and Russell Bowman. Montgomery, Alabama: Montgomery Museum of Fine Arts, 1980.

Kaufman, Barbara Wahl, and Didi Barrett. *A Time to Reap: Late-Blooming Folk Artists.* South Orange, New Jersey: Seton Hall University in association with Museum of American Folk Art, 1985.

Kelly, Kathy. *Joseph E. Yoakum: A Survey of Drawings.* Davis, California: Memorial Union Art Gallery, Memorial Union Programs and Campus Recreation, University of California, 1988.

Kraskin, Sandra. *Black History and Artistry: Work by Self-Taught Painters and Sculptors from the Blanchard-Hill Collection.* New York: Baruch College/CUNY, 1993.

Lawrence, Sidney. *Roger Brown.* With an essay by John Yau. New York: George Braziller in association with Hirshhorn Museum and Sculpture Garden, Smithsonian Institution, 1987.

Livingston, Jane, and John Beardsley. *Black Folk Art in America.* With a contribution by Regina Perry. Jackson: University Press of Mississippi, Center for the Study of Southern Culture for the Corcoran Gallery of Art, 1982.

Longhauser, Elsa, Harry Steem, et al. *Self-Taught Artists of the Twentieth Century: An American Anthology.* San Francisco, California: Chronicle Books for Museum of American Folk Art, 1998.

McElroy, Guy C., Richard Powell, and Sharon F. Patton. *African-American Artists, 1880–1987: Selections from the Evans-Tibbs Collection.* Introduction by David C. Driskell. Seattle: University of Washington Press in association with

the Smithsonian Institution Travel Exhibition Service, 1989.

Naivety in Art. Tokyo, Japan: Setagaya Art Museum, 1986.

Ollman, John. Introduction to *Animistic Landscapes: Joseph Yoakum Drawings.* Philadelphia: Janet Fleisher Gallery, 1989.

Outsiders: Art Without Precedent or Tradition. London: Arts Council of Great Britain, 1979.

Outsiders: Artists Outside the Mainstream. Ames, Iowa: Octagon Center for the Arts, 1990.

Parallel Visions: Modern Artists and Outsider Art. Princeton: Princeton University Press in association with the Los Angeles Museum of Art, 1992.

Perry, Regenia. *Free Within Ourselves: African American Artists in the Collection of the National Museum of American Art.* Washington, D.C., and Petaluma, California: National Museum of American Art, Smithsonian Institution and Pomegranate Press, 1992.

Rossen, Susan F., ed. *Selections from the Art Institute of Chicago.* Chicago: Art Institute of Chicago in association with the University of Washington Press, 1999.

Selections from the Dennis Adrian Collection. Chicago: Museum of Contemporary Art, 1982.

Since the Harlem Renaissance: Sixty Years of African American Art. Chicago: Art Institute of Chicago, 1996.

Transmitters: The Isolate Artist in America. Philadelphia: Philadelphia College of Art, 1981.

Uncommon Ground: American Folk Art from the Michael and Julie Hall Collection. Milwaukee, Wisconsin: Milwaukee Art Museum, 1993.

Visionaries, Outsiders, and Spiritualists. Providence, Rhode Island: David Winston Gallery at Brown University, 1993.

Visions: Expressions Beyond the Mainstream from Chicago Collections. Chicago: The Arts Club, 1990.

Walker, Kenneth. *Joseph Yoakum.* New York: Hirschl & Adler Modern, 1985.

Who Chicago? An Exhibition of Contemporary Imag-

ists. Sunderland, England: Sunderland Arts Centre Ltd., 1980.

Yoakum, Joseph E.: Selected Drawings from the Collection. Exhibition Checklist. Davis, California: Department of Art, University of California, Davis, 1989.

GENERAL CATALOGS

American Indian Art: Form and Tradition. New York: E. P. Dutton and Co., 1972.

Black Art—Ancestral Legacy: The African Impulse in African-American Art. Dallas: Dallas Museum of Art, 1989.

Conn, Richard. *Native American Art in the Denver Art Museum.* Seattle and London: University of Washington Press, 1979.

Fane, Diana, Ira Jacknis, and Lise M. Breen. *Objects of Myth and Memory: American Indian Art at the Brooklyn Museum.* Brooklyn, New York: Brooklyn Museum in association with the University of Washington Press, 1991.

Feder, Norman. *Two Hundred Years of North American Indian Art.* New York: Praeger Publishers in association with the Whitney Museum of American Art, 1971.

Jensen, Dean. *The Center Ring: The Artist—Two Centuries of Circus Art.* With a foreword by Robert H. Wills. Milwaukee, Wisconsin: Milwaukee Museum of Art, 1981.

Marzio, Peter. *The Democratic Art: Chromolithography, 1840–1900.* Boston: D. R. Godine in association with Amon Carter Museum of Western Art, 1970.

Sacred Circles: Two Thousand Years of American Indian Art. Kansas City, Missouri: Nelson-Atkins Museum of Fine Art, 1977.

The Spirit Within: Northwest Coast Native American Art from the John H. Hauberg Collection. New York: Rizzoli International Publications in association with Seattle Museum of Art, 1995.

Wade, Edwin L., Carol Haralson, and Rennard Strickland. *As in a Vision: Masterworks of American Indian Art.* Tulsa: University of Oklahoma Press and Philbrook Art Center, 1983.

Walther, Susan Danly. *The Railroad in the American Landscape.* Wellesley, Massachusetts: Wellesley College Museum, 1981.

Photo Credits

Albright-Knox Art Gallery: fig. 141

Archives of American Art, Smithsonian Institution: figs. 1, 14, 16, 130

Art Institute of Chicago: figs. 17, 26, 27, 31, 38, 73, 83, 99, 100, 115, 120, 125, 132, 134, 135, 140, plates 1, 2, 33, 43, 44, 49

Author: figs. 6, 9, 12, 13, 70, 82, 84, plates 21, 23, 36

British Columbia Archives: fig. 85

Roger Brown Study Collection of the School of the Art Institute of Chicago: fig. 15, plates 27, 45

Burke Museum of Natural History and Culture: fig. 116

California State Railroad Museum: figs. 51, 62, 67, 76

Chicago Tribune: figs. 18, 19

Circus World Museum: figs. 21, 22, 23, 25, 28, 29, 32, 33, 35, 36, 39, 40, 41, 44, 45, 48

Cleveland Museum of Art: fig. 144

Colorado Historical Society: figs. 58, 63, 64, 72, plate 19

Cranbrook Institute of Science: fig. 121

Detroit Institute of Arts: fig. 88

Fleisher/Ollman Gallery: figs. 2, 3, 42, 46, 56, 59, 69, 87, 102, 104, 113, 126, 137, plates 4, 11, 17, 29, 42

J. Paul Getty Museum: fig. 68

Thomas Gilcrease Museum: figs. 71, 80

Carl Hammer Gallery: figs. 43, 105, plates 7, 12, 18

Philip Hanson: figs. 24, 53, 55, 60, 109, 110, 133, plates 31, 41, 46, 47, 48

The Huntington Library: figs. 50, 54, 57

Harmon and Harriet Kelley: fig. 61

Phyllis Kind Gallery: figs. 11, 111, 112, 131, plate 30

Daniel Leen: fig. 90

Karen Lenox Gallery: plates 10, 26

Thomas Maxwell: fig. 89

Milwaukee Public Museum: fig. 103

Museum of Anthropology (Vancouver, Canada): figs. 92, 93, 95, 98, 101, 106, 108, 114

Museum of Fine Arts (Boston): fig. 136

National Archives: figs. 8, 10

National Museum of American Art, Smithsonian Institution: figs. 7, 74

Richard L. Nelson Gallery and the Fine Arts Collection (University of California, Davis): fig. 20

Gladys Nilsson and Jim Nutt: figs. 4, 30, 34, 37, 47, 49, 52, 65, 75, 79, 81, 86, 96, 97, 107, 122, 123, 124, 127, 128, 129, 142, plates 3, 5, 6, 13, 14, 15, 16, 20, 22, 25, 28, 32, 35, 37, 38, 39, 40

Dr. Nancy Parezo: fig. 118

Peabody Museum of Archeology and Ethnology (Harvard University): fig. 91

The Phillips Collection: figs. 138, 139, 143, 145

University of British Columbia Library: fig. 94

U.S. Department of the Interior (Yellowstone National Park): fig. 77

U.S. Geological Survey Photographic Library: fig. 66, 78

John R. Wilson: fig. 117

Barton Wright: fig. 119

Peter Yolkum: fig. 5

Ray Yoshida: plates 8, 9, 24, 34, 50

Index

References to figures appear in italics.

Abrahams, Roger, 87

Abstract Expressionism, 112, 115

Acoma tribe, 86

Adam Forepaugh and Sells Brothers, 7, 37, 42, 47, 91;
 Captain Woodward and Performing Seals, 36

Adam Forepaugh, *Cheap Excursions to the Great 4-
 Paw Wild West Shows, 46*

Adrian, Dennis, 25

African art, 115

"Agassiz" Column, Yosemite, 56

Allen, Jane, 4, 16

Allston, Washington, 111

Alpha (sibling), 6

American Expeditionary Forces, 12

American Indian Center, Chicago, Ill., 65

American Magazine, The, 14

Anderson, Don, 19

Apache Indians, 41

"Arrow-Head" the Belle of the Tribe, 41

Art Institute of Chicago, 21

Ash Grove, Mo., 4, 9

Atascadero Beach, Calif., 14, 15

Atchison, Topeka, and Santa Fe Railway, 47

Barnes, Al G., 7

Barnum & Bailey Circus, 29–30, 35, 37; *Giant Rhinoc-
 eros, 35; Lion and Tiger, 35; Maneuvers, Drills and
 Strategic Evolutions of the Splendid American Fleet
 of Battleships just before the Great Fight at
 Santiago, 33; The Spectacle of Balkis, 31*

Barnum, P. T., 38

Barrier Canyon, 69, 70

Bathers, Great Salt Lake, Utah, 64

Battle of San Juan Hill, The, 88

Baywood Park, Calif., 14–15

Beaman, Chick, 40, 88

Beardstown, Ill., 28

Benton, Thomas Hart, 45

Bethlehem, 93

Bible, 8, 30, 32, 93, 97

Big Sheep Mountain, Colo., 68, 82

Blake, William, 25, 26

Blue Mound, Kans., 68

Blues, the, 94–96

Boley, Okla., 90

Bookus ("Wildman of the Woods"), 75–76

Bragan, Capt. George, 12

Brand, Tom, 18–19

"Breakman's," 96

Brenner Pass, 44

Br'er Rabbit, 87–88

Brest, France, 13

Brisbane, Australia, 15

Brown, Roger, 3, 98–99

Bryan, William Jennings, 7, 88, 106

Bryant, Lowry, 17

Bryce Canyon National Park, 47

Buffalo Bill Cody's Wild West Show, 7, 8–9, 17, 40–41,

44, 88; *"Arrow-Head" the Belle of the Tribe*, 41; *Indian Chief*, 41
Buffalo Bill Wild West & Jess Willard Show, 41
Burchfield, Charles, 110, 112, 114–15; *Church Bells Ringing, Rainy Weather Night*, 114–15, *115*
Bureau of Indian Affairs, 68
Burford, Byron, 27
Burial mounds, 68
Burns, Tommy, 89

Calder, Alexander, 27
Camel Rock, 68
Camp Funston, Kans., 12
Camp Ponanezen, France, 13
Camp Shelby, Miss., 12
Camp Upton, N.Y., 12
Campbell, Joseph, 40, 87
Canberra, Australia, 15
Candy Store Gallery, 22
Cardinal, Roger, 110
Carlson, Cynthia, 23
Cave Springs, Mo., 4, 5
Chapin, Louis, 25
Charles (brother), 5–6, 10
Chateau de Chehery, France, 12
Cheap Excursions to the Great 4-Paw Wild West Shows, 47
Cherokee, Kans., 10
Cherokee nation, 5, 6, 7, 19
Chesapeake and Ohio Railroad, 88
Cheveux Blanche. *See* Pawhusta ("Cheveux Blanche")
Chicago Daily News, 18
Chicago Guide, 22
Chicago, Ill., 16–25, 97, 98
Chicago Imagists, 22
Chicago Museum of Contemporary Art, 22
Chicago State College, 17
Chicago Tribune, 23–25
Chicago's American, 19
Chilkat blanket, 81, *82*, 116
Christian Science, 17
Christian Science Monitor, 25–26

Chumash tribe, 69
Circus: acts, 29–30; advance men, 28; clowns, 38–39; Golden Age of, 27, 28; posters, 29–44, 47
Clarksville, Tenn., 28
Clermont-en-Argonne, France, 11, 12
Cody, Buffalo Bill, 3, 40, 41, 88, 90. *See also* Buffalo Bill Cody's Wild West Show
Courcelles, France, 12
Crater Lake, Oreg., 58
Creek Indians, 5, 6
Curtis, E. S., *Kwakiutl chief with orator's staff*, *72*

Dale Creek, Wyoming (postcard), *60*
Darwin, Australia, 15
Davidson, Abraham, 111, 112
Davidson Glacier, Alaska, 58
Davies, Jordan, 18
Dedrick, Philip, 8, 22–23
Della (aunt), 6
Della (sister), 5
Deming, N. Mex., 29, 105
Denver & Rio Grande Railroad, 54, 56, 64; Castle Gate postcard, *48*
Desert News, 63
Devil's Gate on the Sweetwater, *48*, 49
Dewey, John, *Art as Experience*, 87
Dick, Ben, 79; *Kingcome Seal Eagle*, *78*
Douglas Kenyon Gallery, 25
Dove, Arthur, 110, 112–14; *Fields of Grain as Seen From Train*, 113, *114*; *Golden Storm*, 113, *113*; *Lake Afternoon*, 113, *115*
Du Bois, W. E. B., *Essay toward a History of the Black Man in the Great War*, 10–11
Dubuffet, Jean, 109
Durham, Evonne, 16, 18, 20
Dzunk'wa mask, *75*

Ebony, 66
Eddy, Mary Baker, 17, 97; *Science and Health*, 97
Edward Sherbeyn Gallery, 18–19, 21
Eichelberger, Camilla, 23
805th Pioneer Infantry, 11, 12, 13
El Moro, Calif., 14

Emanuel Walter Gallery, 22

Encyclopaedia Britannica, 97

Expressionism, 58, 110, 112, 114

Fauvism, 58, 110, 113

Fergus Falls, Minn., 28

Fitzgerald, Ella, 95

Floy (second wife), 16

Fort Scott, Kans., 9, 10, 47

Four Corners, 69

Fox, Charles, 28

Fraenkel, Richard, 22

Frank (brother), 6

Fulton, Mo., 47

Galaxy Press, 18

Gans, Joe, 88, 89, 90

Gateway to the Garden of the Gods, 49

Gauguin, Paul, 3, 40

Georgetown Loop and Gray's Peak Road, 51

Gerlach, Nev., 29

Gibson, Althea, 88, 90

Glauber, Robert, 21

"Go Down, Moses," 93

"Golgotha is a Mountain," 93

Golub, Leon, 18

Gottlieb, Adolph, 110, 112, 115–16; *The Seer*, 116, *116*

Grand Canyon National Park, 47, 64

Grandma Moses, 18

Great Cole Younger and Frank James Historical Wild West and Congress of the Rough Riders of the World, 41

Great Salt Lake, Utah, 63–64

Great Wallace Circus, 7

Greene County, Mo., 4, 5

Grey, Zane, 88, 90–92; *Heritage of the Desert*, 91; *The Vanishing Americans*, 90–91

Guthrie, Derek, 4, 16

Hale Coal and Mining Company, 10

Halkin, Theodore, 18

Halstead, Whitney, 3, 6, 19, 21–22, 23–25, 27–28, 44, 58, 97, 100, 102, 105, 110

Hanson, Philip, 20

Hartley, Marsden, 27, 97

Havanna, Ark., 28

Haydon, Harold, 22

Hegamin, Lucille, 40, 94–95; "He May Be Your Man But He Comes To See Me Sometimes," 94

Hemphill, Herbert Waide, Jr., 109–10

Henry, John, 88–89

Highest Bridge in the World from the Bottom of Royal Gorge, Colorado, 51, *53*

Hindenburg, Paul von, 11

Hines Veterans Hospital, 16, 23

Hobbies, 66

Holm, Bill, *Northwest Coast Indian Art: An Analysis of Form*, 76–79

Hopgood, John, 17–18

Hopi culture, 84, 85

Howe, Ed, 27

Howells, W. D., 27

Humphrey, Col. C. B., 12

Ida Mae (daughter-in-law), 16

Illinois Bell Telephone Company Gallery, 22

Illinois State University, 22

Illustrated Encyclopedia of Animal Life, 32

Indian Chief, 41

Inter-Allied Games, 12

Iola, Kans., 29

Iroquois art, 67

Jackson, William Henry, 47, 49, 54, 56, 58, 59, 61; *Balanced Rock, Garden of the Gods*, 59, *59*; *The Black Cañon of the Gunnison*, 54, *54*; *The Devil's Gate, Weber Cañon*, 54, *55*; *The Liberty Cap*, 61

James, Jesse, 41, 92

James Sullivan Company, 10

Japanese woodcut, 108

Jefferson, Thomas, 68

Jerusalem, 93

Jesus, 93

Jicarilla tribe, 41

John (son), 10, 14, 16

Johnson, Jack, 88, 89–90

Jones, Jack, 41

Julian, Ernestine, 23–25

Julian, John, 23–25

Julian, Myrtle (first wife), 9, *9*

Kachinas, 84–85

Kaletaka kachinas, 85

Kansas City, Mo., 6

King, Fay, 89

Kings Canyon National Park, 98

Komokwa, 76; mask, *78*

Koyemsi ("Mudheads"), 84–85

Kuhn, Walt, 27

Kwakiutl tribe, 71

Kwakwaka'wakw eagle mask, *71*

Kwakwaka'wakw Hamat'sa raven mask, *71*

Kwakwaka'wakw wolf mask, *72*

La Farge, John, 110, 111–12, 116; *Strange Thing Little Kiosai Saw in the River*, 111; *The Uncanny Badger*, 112

Lake Seneca, N.Y., 113

Le Havre, France, 12, 13

Leen, Daniel, *Shamans or spirits with ceremonial items*, 69

Levi-Strauss, Claude, 67

Levine, Robert, 87

Levy, Edward, 9

Life, 66

Linhares, Philip, 22

Liverpool, England, 12

Los Osos Valley, Calif., 14–15

Louis (son), 9, 26

Luks, George, 27

Manhattan, Kans., 12

Margaret (daughter), 9

Marian (daughter-in-law), 19

Marion, Va., 28

Mark, Norman, 18, 20, 93

Martha (sister), 6

Marysville, Calif., 8

Matisse, Henri, 106–08, 110, 116

Maxwell, Thomas, *"Holy Ghost and Attendants,"* 69

McCook, Nebr., 28

McHugh, Adeliza, 22

McKinley, William, 88

Messrow, Mezz, 94

Miller Brothers & Arlington 101 Ranch Real Wild West Show, 41, 90, 91

Mills, Frederick, 16

"Mississippi Flood Song," 95

"Mississippi Water Blues," 95

Missouri-Kansas-Texas Railway ("Katy" or M.K.T.), 7, 47

Modernism, 112

Mora, Joseph, 85; *Koshari Clown*, *83*

Moran, Thomas, 47, 49–51, 54, 56, 59, 61; *American Fork Canyon*, 51, *51*; *The Cliffs of Echo Canyon, Utah*, 49, *50*; *The Liberty Cap and Clematis Gulch*, 61, *61*; *Mountain of the Holy Cross*, *57*; *Shin-Au-Av-Tu-Weep, or "God Land," Cañon of the Colorado, Utah Territory*, 59, *60*; *Solitude*, 62, *62*

Moro Rock, 14, 15, 69

Morro Bay, 14

Morro Bay State Park Estuary, 15

Moses, 93

Motherwell, Robert, 27

Mountain of the Holy Cross, 29, 56, *57*

Mountainway, 83

Mt. Calvary, 93

Mt. Horeb, 93

Mt. Shasta, 29

Mt. Tabor, 93

"Muddy Water," 95

Museum of Modern Art, New York, 23

National Geographic, 66

Navajo and Apache Indian Reservation, 5, 47

Navajo Indians, 6, 67–68, 82, 83, 86, 90, 116

Nazareth, 93

Nelson, "Battling" (Oscar), 89

New Art Examiner, 4

New York City, N.Y., 16

Nilsson, Gladys, 6, 19, 22, 23, 99–100

Nutt, Jim, 6, 22, 23

Oceanic art, 115

Ogden Park Convalescent Home, 23

101 Ranch Real Wild West Show. *See* Miller Brothers
 & Arlington 101 Ranch Real Wild West Show

Original Georgia Minstrels, 40

Pacific Tourist, The, 49

Paiute Indians, 68

Panama Canal, 16

Panorama-Chicago Daily News, 25

Paris, Tex., 29

Parkinson, Tom, 28

Pasco, Wash., 29

Pawhusta ("Cheveux Blanche"), 68

Pennsylvania State University, 22

Pensacola, Fla., 16

Perreault, John, 25, 26

Perth, Australia, 15

Peter (son), 4, 9, 17

Picasso, Pablo, 3

Pickett, Bill, 41, 88, 90, 91

Pittsfield, Mass., 28

Pony Express, 40

Popular Mechanics, 66

Porter, Cole, "Ev'ry Time We Say Goodbye," 95

Pranian, Rev. Harvey, 18

Pre-Columbian art, 17, 18

Quebec, Canada, 12

Rainbow Natural Bridge, Utah, 68

Ramberg, Christina, 4, 15

Ranch 101 Wild West Show. *See* Miller Brothers &
 Arlington 101 Ranch Real Wild West Show

Reconstruction, 92

Reservations, 68

Ringling Bros. and Barnum & Bailey: *Auguste Clown,*
 39; Giraffe Neck Women from Burma, 29; Tribe of
 Genuine Ubangi Savages, 29; Whiteface Clown, 39

Ringling Brothers Circus, 7, 8, 29–30, 38, 91; *Three*
 Famous Aerial Artists, 31

Ringling, John, 3, 7, 28

Rock art, 68–70, *70,* 115, 116

Rockford College, 8, 22–23; Art Gallery, 22–23

Rockland, Ill., 26

Rockland, Maine, 28

Rocky Mountain National Park, 47

Rolampont, Haute-Marne, France, 12

Romanticism, 110

Rousseau, Henri, 3

Russell Brothers Show, *Camels, 38*

Ryder, Albert Pinkham, 110, 112; *Moonlit Cove,* 112, *112*

Saltair Pavillion, Great Salt Lake, Utah, 63–64, *64*

San Francisco Art Institute, 22

San Francisco, Calif., 15

San Luis Obispo County, Calif., 14–15, 69

Santiago, Cuba, 32

Saturday Evening Post, 66

Schele, Linda, *Headdress with a quetzal representing*
 the name of the person depicted, Lady Zac-Kuk,
 from the sarcophagus from the Temple of the
 Inscriptions at Palenque, Mexico, 17

School of the Art Institute of Chicago, 3, 19, 22

Sea of Galilee, 93

Sego Canyon, 69

Sells-Floto Circus, 32–35, 37; *Monster Sea Elephant,*
 36; Sells-Floto Circus Presents Quarter Million
 Pound Act of Performing Elephants, 34

Sermon on the Mount of Olives, 93

Shaughnessy, Arthur (or Charlie George Walkus),
 Kwakwaka'wakw ceremonial curtain, *81*

Sherbeyn, Edward, 18

Shiprock, James Joe, *Eagles and coyotes, 83*

Shoreview Manor (nursing home), 23

Silvermane, 91

Sioux Indians, 40, 41, 67

Siskiyou County, Calif., 92

Siskiyou Mountains, Oreg., 92

Skyline, 21

Smith, Bessie, 94

Smith, Mamie, 94

Smith, Willie "The Lion," 94

Son Rice (cousin). *See* Yellow Horse, Son De Witt
 Talmadge Rice Yokukhama

Southampton, England, 12

Spanish-American War, 32

Spotted Winds, 86

Springfield Missouri Republican, 9

St. Bartholemew's Church, 18

St. Johnsbury, Vt., 28

St. Louis & San Francisco Railroad ("Frisco"), 7,
 9–10, 47, 89

"St. Louis Cyclone Blues," 95

"St. Louis Tornado Blues," 95

St. Nazaire, France, 13

Strother, David, 63

Surrealism, 115

Susan (aunt), 6, 115

Susanville, Calif., 29, 92

Swaihwe dancers, *66*

Sydney, Australia, 15, 89

Ten Commandments, 93

Thomas, George and Hersel, 94

Tishimingo, Okla., 29, 89

Tlingit tribe, 81, 116

Topeka, Kans., 23

Trail of Tears, 5, 6

Tsimshian killer whale mask, *74*

Tsonokwa, *75*

Tucker, Marsha, 25

Turquoise Mountain, 82

Twain, Mark, *Huckleberry Finn*, 27

Twin Gods of War, 82

Two Sisters, 86

Union Pacific Railroad, 56, 64

U.S. Geological Service, 47

U.S. Immigration Commission, 16

U.S. War Department, 11

U.S.S. *Saxonia*, 12

U.S.S. *Zeppelin*, 12

Vail, Roger, 19, 21

Van Gogh, Vincent, 4, 21

Vedder, Elihu, 110, 111, 112, 116; *Lair of the Sea Serpent*,
 111, *111*; *Memory*, 111

Village Voice, The, 25

Virgil ("Jack") (brother), 6

Wabash Transit Gallery, 22

Wadlow, Charles, 6

Wadlow, Frances "Fannie" (mother), 5–6

Walker, Bert, 14

Walkus, Charlie George. *See* Shaughnessy, Arthur

Wallace, Sippie, "Sister Be Wise," 94

Walls of the Canyon, Grand River, *54*

Walnut Grove, Mo., 7

Walwo, Synthe, 90

Washington, Booker T., 90

Waters, Ethel, 94

Watkins, Carleton E., *"Agassiz" Column, Yosemite*, *56*

WE GOT OUR KICKS ON ROUTE 66 (postcard),
 63, *63*

Weissman, Julia, 109–10

Westermann, H. C., 27

*What may be seen Crossing the Rockies en route
 between Ogden, Salt Lake City and Denver*
 (railroad poster), 47

Whitney Museum of American Art, 25

Whole, The, 18

Wilderness of Sin, 93

Wildman of the Woods mask, *76*

Willard, Jess, 41, 89, 90

William McCabe's Famous Georgia Minstrels, 40

William (son), 10

Williams and Walker, 40

Williams, Bert, 40

Window Rock, Ariz., 5, 68

Windways, 82, 86

Winkle Bar, 91

Winnebago bag, *85*

Wonder of Assirea, 28

Woodward, Captain, 42

World War I, 10–13, 91, 93

Wright, Barton, *Pueblo Koyemsi or Mudhead clowns*,
 84

Yankton Sioux tree dweller effigy, *67*

Yellow Horse, Son De Witt Talmadge Rice
 Yokukhama (cousin), 6, 7, 20

Yellowstone National Park, 47, 64

Yoakum, Joseph Elmer: African American roots, 5–6, 32, 87–96; and American Visionary art tradition, 110–16; and animal imagery, 28, 32–38, 62–63, 70–75, 82–86, 114; and anthropomorphic figures, 67–68, 69, 106, 107; art career, 16–19, 21–26; biographical and autobiographical myths about, 3–4, 5–6, 20, 115; children, relationship with, 14, 16; and the circus, 3, 7–9, 14, 27–44, 91–92, 109, 114; and clown imagery, 28, 114; composition in, 49–58, 79–81; and copyrights, 44; death of, 26; ethnicity of, 5–6; and exaggeration, 3, 6; exhibition poster for, 19; and fascination with geography, 28–30, 82; health, 16, 23; humor, 6, 20–21; jobs, 7–10, 14, 16, 81–82; materials, 100–02; media, 100–01; and minstrel shows, 28, 39–40, 88; and mythology, 30–32, 66, 70–76, 82–86, 112, 116; Native American roots, 5–6, 19, 65–86, 109, 116; palette, 58, 100; photographs of, 2, 18, 20, 24, 98; and postcards, 47, 49–54, 58, 63–64, 95; and the railroad, 3, 6–7, 45–64, 95–96, 109; and railroad art, 47–64; and reviewers, 18, 19, 21, 22, 25–26; and self-taught art tradition, 109–19; as soldier, 10–13; as storyteller, 18, 20–21; studio, 19, 97; stylistic elements in, 58–64, 102–08; stylistic periods, 102–08, 110; and titles, 47, 63, 99, 101; travels, 3, 6, 7–9, 14–16, 65, 70, 81–82, 114; and Wild West shows, 28, 40–41; working methods, 97–100; youth, 3, 4–9

Yokum, John (father), 5, 6–7

"Yosemite and the Big Trees of California" (railroad brochure), 56

Yoshida, Ray, 4, 19, 22, 98

Younger, Cole, 41, 92

Zion National Park, 47, 64

Zuni culture, 66–67, 83, 84–85

The Artwork of Joseph Yoakum

Altheia Gibson Our Champion Tennis star 1961, 90, 90

Ankaratra Range Antsirabe Malagasy Africa Island, 29–30

Apalachicola River near Bluntstown Florida, 37

Arakan Mtn Range near Minabu Burma, 32, 33

Ash Grove Lime Stone A.G.W.C.&P.C. Co, 9

Ash Grove Lime Stone Querry Ash Grove Mo, 9

Attraction of all wanderers which is located in central Australia I have seen them twice myself, The, 15

Back where i were born 1888, A D., 5, 5, 100, 102

Baywood Park Subdivision of Los Osos Valley Cal. Baywood Park San Luis Obispo County, 15

Bessie Smith Cousin to Mamie, 94

Bowing Cliff of Burno Utah, cloud assembly for cyclone storm, The, 113

Brenner Pass of Itley and Auastrian frontier, 37–38, 38, 44

Cambrian Mtn Range near Denbiga (British Wales), 49, 49

Catskill Range near New Hampshire, 43, 43

Cedar Valley Range Utah, 67

Cenic Pavillian Gret Salt Lake Utah, 63–64, 64

Cheta River through Mt Coole in Southern Alps near Christchurch New Zealand, 36, 37

Chieff Gray Eagle Squaw Wife of Ogalla of Jicarilla Tribe Reservation northe of Concord Newhampshire, 40, 40

Coupelow Peak of Rocky Mtn Range near Edson of Alberta Canada, 38–39, 39

Courrelles Mtn Range Veraincourtti Valley somewhere in France theres a Lilly, 13

Crater Head Mtns in Andes Mtn Range near Santiaf Chile South America, 35

Crater Head mtns of Honolula Hawaiia, 34, 35

Cyclone in Action at Iola Kansas in 1920, 95

Cyclone that Struck Susanville California in year of 1903, The, 8, 8, 95

Deming Suburb, 105

E. P Everest in Himilaya Mtn Range near Gyangtse East Asia, 85–86

Eastern Alps of Itely, 42

Egyption Desert, 102, 103

Ella Fitzgerald Moovie Star, 95

Enter in Man Onty Play House and at State and Polk
 Sts. Sept/1924, 21, 21

Ethel Watters Composer of Back Water Blues in 1921,
 94, 94

Farm Home of Edward D. Leevy President of the St.
 Louis & San Francisco Railway Co of Springfield
 Missouri, The, 9, 9

Fay King, wife of Batling Nelson Light Weight Pugelist
 Champion in year 1911, 89, 89

Fertel Loabs of Grand Prairie Nebraska, 63

Fertil Mounds near Wyanoka Kansas, 79, 79

Gascanade River in Ozark Mtn Range at Newburg
 Missouri on Frisco Railroad, 51, 52

Gascanade River through Dixon Hills Mtns near New-
 burg Missouri, 76, 77

Giant Rock Angles Landing Zion National Park Utah,
 103, 103

Granet Mts near Nome Alaska, 74, 75

Granit Center Mound in Rockey Mountain Range
 near Nome Alaska, 81, 82

Green Valley Ashville Kentucky, 71

Gulf of Mexico at Panama City Florida, 76, 77

Hills of Old Wyoming in the Valley of the Moon near
 Casper Wyoming, The, 39, 62, 71

Holly Hills of Canaan S.E. Asia, 93

Home of Cole Younger Cousin to Jesse James near Bon-
 ner Springs Missouri, 92, 92, 98

Hudson Bay and Mt Elbi near Quebec Canada, 12

Imperial Valley near town of Blyth in Imperial County
 California, 113, 114

Island of Sardinia in Mediterranean Sea Close to Italy,
 58

Jehol Mtn in Kuntsing Mtn Range near Tsingkin pro-
 viance of China Asia, 43–44

Jessie Willard 2nd Challenge to Champion Fight with
 Jack Johnson for Worlds Heavy Weight Prize fighting
 championship in year 1917 and 1920, Jack Johnson

then Champion Boxer Exhibit Ring PAPF, 89–90, 89

Lebanon Mountain Range in Phoenicia on Leontes
 River, The, 111, 112

Lebanon Mts near Sidon Phoenicia Asia, 100

Lucille Haggamon 1st End Lady with Williams and
 Walkers Minstrall Show in year 1901, 95, 99

Lucille Haggerman Mamie Smith's Competitor in 1927,
 95

Luella Ocondo Secretary of the American Indian Cen-
 ter 758 Sheridan Road, 65

Missouri-Kansas-Texas Railway Route from Parsons
 Kansas to Paris Texas on 10th month and 8th day
 1955 by request of MKT Advertising Department, 47

Monongahelia River Falls in West Virginia near River-
 side, 102

Moovie Show Building at Sidney Australia, 32

Mt Atzmon on Border of Lebanon and Palestine SEA,
 61, 86

Mt Baldy in Beaver Head Range near Humphery
 Idaho, 79–80, 81

Mt Baykal of Yablonvy Mtn Range near Ulan-ude
 near Lake Baykal of Lower Siberia Russia E. Asia, 58

Mt Blanc Grainan Alps near Chemoix France, 50, 51

Mt Bull Head of Adrondack Mtn Range near Glen
 Falls New York, 96

Mt Calvalery near Jeruselam So. East asia, 93

Mt Calvary, 93

Mt Cavalary near Jerusalam and Bethelam palestine
 se Asia, 93

Mt Cloubelle of West India, 79–80, 81

Mt Everest of himilaya Mtn Range in height 28027 ft
 in Nepal Distric of East India Asia, 83–84

Mt Fizroy Santa Cruz Argentina, 79, 80, 80

Mt Hugnaquilla in Wiklow Mtn Range near Dublin
 Ireland W. Europe, 37, 38

Mt Kanchen in Himilaya Mtn Range near Shara
 China East Asia, 75, 76, 102, 105

Mt Liotian in Greater Khiangian Mtn Range near
 Tritsihar Deep Southern China East Asia, 61, 74, 98

Mt Mauna Kea in Volcanoic Range in Central Hawaii
 County of Hawaii Islands, 72, 80

Mt Monte Rosa in Graino Alps near Little St Bernardo Pass and Aosta Italy W. Europe, 61–62, 62, 72

Mt Monte Rosa of Pennion Alps near Chasco Italy S.W. Europe, 73

Mt Mowbullan in Dividing Range near Brisbane Australia, 71, 106

Mt Negi in Transylvania Alps near Fagris Romania SE E, 83–84, 112

Mt of the Holy Cross near Basalt NW Red Clay Mounds, 56–58

Mt Olympus of Cumberland Mtn Range near Winchester Kentucky, 67, 67, 80

Mt Phu-Las Leng in Plateau near Xieng Laos East Asia, 84, 85, 115

Mt Pikes Peak the Mtn of Pleasure near Colorado Springs Colorado Highest foot Bridge in U.S.A., 37, 63, 64, 100

Mt Puyed Dome near Clermont France W.E. (some where in France theres a lily), 13

Mt Shasta of Coast Range near McCloud California, 35–37

Mt Sheridan in Gallation Mtn Range and Yellow Stone National Park near Canyon Wyoming, 54–56, 80–81

Mt Stinoblan near Capital City Jesselton of North Borneo Island in South China Sea Asia, 48, 49

Mt Thousand Lakes in Bryce Canyon National Park near Hanksville Utah, 69, 82

Mt Tingra Khan of Run Lun Mtn Range near Alzosu in Sinkiang Sector of SE China, 84, 85, 98, 106, 111

Mt. Tohakum Park 8170 ft near Pyramid and Lake Oslo Nevada, 54, 69–70

Mt Wallingwhoo of Varicruzs Mexico, 17

Nile River near Cairo Egypt and Gulf of Suez, 37, 93

Northern Tip of Rockey Mtn Range near Juneau Alaska, 62–63

Only Woman Ruler of Assirea, The, 30–32

Ophelia Billingsley imperfect in form of body danser from Hindu Dush India East Asia, 29

Paradise of the Pacific and Baywood Park near San Luis Obispo California, The, 15, 15

Persimmon Valley Chillacothie Missouri, 54, 55

Pine Mountain near Middleboro Kentucky, 51, 52

Poverty Hollar in Ozark Mts near Luck Green County Missouri, 72, 73

Poverty Hollar Walnut Grove Missouri, 7

Rain Bow Bridge in Bryce Canyon National Park near Henriville Utah, 61

Ranch #101 Red Cloud Nebraska, 41

Red Mtn Clay Pass in San Juan Range near Telluride Colorado, 101–02

Red Sea with Egypt and Arabia bordering on each side, 93

Route 66 via Albuquerque New Mexico, 63, 63

Sac River Ash Grove MO, 4

Sand Dunes Arabian Desert, 78, 79

Saxonia a Passenger Ship to Europe and Phillipine Islands from New York, 12, 60, 61

Section #2, 105

Seen between Carthage and Joplin Mo, A, 76, 78

Semi Granit Mtn Head Angles Landing near Forbs Valley Utah, 103–04, 104, 106

Sippie Wallace 2nd to Ethel Watters, 94, 95

Southwest Point of Ozark Mtn Range near Carthage Missouri, 42, 42

Spectacular Royal Gorge of Colorado Rockey Mtn Range, 51, 53, 86, 98

St Lawrence near Winnipeg Canada, 79, 80, 80, 81

Sullivan Brothers Coal Mine near Fort Scott Bourbon County Kansas, 10

Synthe Walwo the only Indian million air in U.S. derived from oil wells and refinery in Boley Oklahoma, 90

Syrian Desert Namrath Syria of Saudi Arabia S.E.Q., 56, 57, 103

Tampa Bay near Port Tampa Florida, 74, 74, 105

Teppeniah Ridge in Yakama Valley near Wapata Washington, 82

this Gunboat were stationed at Santiago de Cuba on Guantanamo Bay until beginning of worlds war one, 32, 33

This is Blue Mound Ridge Runs from Manhattan Kansas to Blue Mound Village near Village of Twin Oaks Kansas, 12

This is of Chick Beaman 1st End man with Williams & Walkers Minstrell Show in years 1916 to 1930, 88, 88

This is of Moro Bay in San Luis Obispo County San Luis Obispo California, 15, 74

This is our Remembrance of Old ex President William Jennings Bryan our 1st Democratic president, 7, 106

This is the flooding of Sock River through Ash Grove Mo on July 4th 1914 in that drove many persons from Homes I were with the Groupe leiving their homes for safety, 9, 95, 106

This Picture of a Valley Mound in Akron Ohio, 68

threat of weather change in spring months around Sidney and Perth Australia, A, 113, 113

Tishimingo Tunnel near Tishimingo Oklahoma, 46, 47

Tower and Mountain Range View of Jehol Proviance in Central Asia, 32

Town of Fergus Falls Minnesotta in Stream Thrift River, 99, 99

Turtle Dove Slew in Suwanee River Wilcox Florida, 112

Untitled (bowl of soup), 24

U.S. Army Machine Cannan Field Arms. Beulah Big Field Artillery in U.S. Army Big Bertha Field Artilliry Cannan, 13

View of Blue Mounds Kansas, 68, 100, 102

View of the Arctic Ocean at Sydnia Australia, 50, 51, 74

Weeping Pebble at Reno Nevada near Reno City Nevada, 107, 108

Weeping Pebble of Sira Range on Lake Shasta in Nevada State, 59, 59

Weeping Pebble of Sirrea Range, 59

Weeping Pebble of Sirrea Range in Virginia Park Nevada, 59, 62

West Coast Mtn Range on Pacific Ocean near Vancouver British Columbia, 67, 67

What I saw in Alberta B.C. Pacific Coastal Range, 63

Wonder of Assirea 310 B.C., The, 30–32, 31

Zain Grays Ranch in Siskayou County near Susanville California, 34, 35, 91, 98

Zain Gray's Ranch 101 near Susanville California, 91, 91